Perspectives on Reincarnation

Perspectives on Reincarnation

Hindu, Christian, and Scientific

Special Issue Editor

Jeffery D. Long

MDPI • Basel • Beijing • Wuhan • Barcelona • Belgrade

Special Issue Editor
Jeffery D. Long
Elizabethtown College
USA

Editorial Office
MDPI
St. Alban-Anlage 66
4052 Basel, Switzerland

This is a reprint of articles from the Special Issue published online in the open access journal *Religions* (ISSN 2077-1444) from 2017 to 2018 (available at: https://www.mdpi.com/journal/religions/special_issues/reincarnation)

For citation purposes, cite each article independently as indicated on the article page online and as indicated below:

LastName, A.A.; LastName, B.B.; LastName, C.C. Article Title. *Journal Name* **Year**, *Article Number*, Page Range.

ISBN 978-3-03897-535-9 (Pbk)
ISBN 978-3-03897-536-6 (PDF)

Contents

About the Special Issue Editor

Jeffery D. Long (Dr.) is Professor of Religion and Asian Studies at Elizabethtown College. He is the author of A Vision for Hinduism, Jainism: An Introduction, and The Historical Dictionary of Hinduism, as well as the co-editor, with K.T.S. Sarao, of the Buddhism and Jainism volume of the Encyclopedia of Indian Religions. Dr. Long's interest in reincarnation was sparked in his childhood, by the death of his father, becoming a lifelong preoccupation and propelling him into a career of studying traditions such as Hinduism, Buddhism, and Jainism, in which this idea is affirmed.

Editorial

Perspectives on Reincarnation: Hindu, Christian, and Scientific—Editor's Introduction

Jeffery D. Long

Religion & Asian Studies, Elizabethtown College, Elizabethtown, PA 17022, USA; longjd@etown.edu

Received: 24 July 2018; Accepted: 25 July 2018; Published: 27 July 2018

It has been an honor and a privilege, as well as a highly enjoyable experience, to serve as the guest editor of this special issue of *Religions* on the topic of reincarnation. As my own article for this issue elaborates, the topic of reincarnation is one that has fascinated me for many years, ever since a childhood tragedy led to me to reflect upon and question deeply what I had been taught on the topic of the afterlife by the religious tradition in which I was raised. That I am not alone in having a fascination with this topic is evidenced by the sheer volume of popular books and articles on the idea of rebirth produced and consumed every year. While it is a mainstream idea in those parts of the world where the Dharma traditions (Hinduism, Jainism, Buddhism, and Sikhism) predominate, recent opinion surveys have shown that as many as one in five Americans also profess a belief in some form of reincarnation.[1]

Scholars are not exempt from this widespread interest. Indeed, there would seem to be an upswing in scholarly interest in this topic, as the articles in this special issue indicate. This interest ranges from the historical, to the literary, to the theological and philosophical. The articles gathered here raise varying questions from equally varying perspectives on the topic of reincarnation. What do particular traditions and texts teach about reincarnation? How is reincarnation conceptualized differently in different religious and cultural contexts? These are questions of a more historical and descriptive variety. What evidence can be presented either for or against reincarnation as a really occurring phenomenon, and not merely a subject of personal belief? What philosophical or theological arguments can be marshalled either for or against the idea of reincarnation? These are questions about the veracity of claims regarding reincarnation, about whether or not there really is such a thing, and what it might mean to answer this question either affirmatively or negatively.

The articles collected here take up these questions, and more, providing a broad (though I would not say comprehensive) overview of this topic. The primary focus of the articles in this collection has been upon reincarnation as approached from either Hindu or Christian perspectives. These are two traditions whose adherents have engaged with one another on this topic with some frequency. For many Hindus, some version of the doctrine of reincarnation is axiomatic, and foundational to spiritual practice. For Christians, reincarnation has been a vexed issue, with many Christians being attracted to the idea from the earliest days of the church to the present, but with the mainstream of the tradition rejecting the idea as incompatible with foundational Christian teachings. It has thus been a natural topic of Hindu-Christian polemics. Some of these polemics have been described in articles found in this collection (e.g., the articles by Nalini Bhushan, Gérard Colas, and Usha Colas-Chauhan), while other articles in this collection are themselves contributions to this polemical literature (e.g., the article by Bradley Malkovsky, which argues from a Christian perspective, and my own, which argues from a Hindu perspective). Some of the articles collected here describe, in depth, articulations of rebirth that arise from particular Hindu texts and traditions (e.g., the articles of Gerald Larson, Jonathan

[1] (Miller 2009).

Edelmann, Steven Rosen, and Ithamar Theodor). One article, that of Christopher Chapple, brings the Hindu tradition into a wider dialogue with Buddhism and Jainism, while Ted Christopher's article brings Buddhism into dialogue with science.

Science (along with philosophy more broadly) is an important interlocutor in the reincarnation discourse as well, being brought to bear especially by proponents of this idea in order to establish it on a more widely agreed upon foundation than the teachings of a particular, confessional tradition, though also by critics, in order to question its veracity. Ankur Barua's article, in particular, engages the topic of the verifiability of claims about reincarnation.

Additionally, both Lee Irwin, with his extensive survey of reincarnation beliefs in America, and C. Nicholas Serra, with his close study of reincarnation in the work of William Butler Yeats, draw our attention to the fact that it is not only in Hindu and Christian contexts that reincarnation has been considered, but that there is a wider Western civilizational conversation about this topic as well.

Francis X. Clooney, who is best known for his groundbreaking (and, in many ways, ground-*defining*) work in comparative theology, mainly involving comparison of Hindu and Christian texts, nicely ties together this entire work with his concluding reflections.

As Clooney notes, this special issue emerged out of a panel discussion held as part of the annual meeting of DANAM (the Dharma Academy of North America) and another panel discussion that was held jointly between DANAM and the Society for Hindu-Christian Studies, both held under the auspices of the American Academy of Religion. Everyone involved, to my knowledge, in both events found the conversation to be stimulating and well worth further exploration. My hope for this special issue is that it will mark only the beginning of this deeper conversation, in which there is insight to be had for Christians, for Hindus, and for any human being who has ever wondered what, if anything, awaits each of us beyond the inevitable transition of death.

Conflicts of Interest: The author declares no conflict of interest.

Reference

Miller, Lisa. 2009. We Are All Hindus Now. *Newsweek*, August 15.

Article

One Life/Many Lives: An Internal Hindu-Christian Dialogue

Jeffery D. Long

Religious Studies Faculty, Elizabethtown College, One Alpha Drive Elizabethtown, PA 17022-2298, USA;
longjd@etown.edu

Received: 25 December 2017; Accepted: 27 March 2018; Published: 31 March 2018

Abstract: This essay consists of philosophical and comparative theological reflections on the topic of rebirth, or reincarnation. Informed by the work of William James, John Hick, and Francis X. Clooney, the essay first establishes the author's stance that reincarnation is a plausible option for belief, at least as attractive as its two main rivals. These rival options are the belief in an everlasting life in either heaven or hell, characteristic of religions such as Christianity and Islam, and the materialist or physicalist belief that there is no afterlife, except in a highly attenuated sense. The essay then moves into a dialogical, comparative theological mode. It raises the question of whether traditional Christian rejection of rebirth, even if it is not something to which the author ultimately assents, might nevertheless carry with it an important insight that is worthy of serious consideration by those who accept the idea of rebirth. This is seen as an instance of the 'deep learning across religious borders' that is the main goal of comparative theology, as defined by Clooney.

Keywords: rebirth; reincarnation; Christianity; Hinduism; comparative theology; Roman Catholicism; Vedānta; theology; eschatology; afterlife; purgatory; past life memory; past lives; consciousness; *Bhagavad Gītā*

1. Introduction

This essay consists of philosophical and comparative theological reflections on the topic of rebirth, or reincarnation. Informed by the work of William James, John Hick, and Francis X. Clooney, the essay first establishes the author's stance that reincarnation is a plausible option for belief, at least as attractive as its two main rivals. These rival options are the belief in an everlasting life in either heaven or hell, characteristic of religions such as Christianity and Islam, and the materialist or physicalist belief that there is no afterlife, except in a highly attenuated sense. The essay then moves into a dialogical, comparative theological mode. It raises the question of whether traditional Christian rejection of rebirth, even if it is not something to which the author ultimately assents, might nevertheless carry with it an important insight that is worthy of serious consideration by those who accept the idea of rebirth. This is seen as an instance of the 'deep learning across religious borders' that is the main goal of comparative theology, as defined by Clooney.

2. Philosophical Methodology: Drawing from William James and John Hick

In his groundbreaking work, now a classic in the field of the study of religion, *The Varieties of Religious Experience*, William James says of philosophy that it:

> fails to prove its pretension to be 'objectively' convincing . . . It does not banish differences; it founds schools and sects just as feeling does. I believe, in fact, that the logical reason of man operates in this field of divinity exactly as it has always operated in love, or in patriotism, or in politics, or in any other of the wider affairs of life, in which our passions or our mystical intuitions fix our beliefs beforehand. It finds arguments for our convictions, for indeed

it *has* to find them. It amplifies and defines our faith, and dignifies it and lends it words and plausibility. (James 1982, p. 436)

Few topics are as emotionally sensitive or as susceptible to the influence of wishful thinking as human beliefs about what, if anything, happens to our consciousness after the death of the physical body. Our beliefs on this topic are tied to our intense desire not to be forever parted from our loved ones, by our sense of justice (that good should be rewarded and evil punished, especially if this did not occur during the life of the deceased person), and by our views about the limits and scope of the natural sciences. In addition, wishful thinking on this topic, as philosopher David Ray Griffin argues, can be 'positive' and 'negative' (Griffin 1997, pp. 26–33). In other words, it is not only that people believe in some kind of afterlife out of the hope of a possible reunion with their departed loved ones, or out of dread of their own mortality. It is also the case that there are people who *disbelieve* on a similarly non-rational basis: who are deeply invested in the idea that there is *no* afterlife.

Given the sensitivity of this topic, the depth of the feelings that it evokes, and the ambiguity of the available empirical data, such as it is, it is not at all likely that these questions—'What happens to our consciousness on the death of the body? What happens to us after we die?'—will be resolved in a conclusive and universally compelling way in the near future.

What *is* possible, as James asserts, is to develop "arguments for our convictions," to "amplify and define our faith," whatever it may be, "and dignify it and lend it words and plausibility." In short, whatever one's beliefs about an afterlife (or the absence thereof–or, in the case of this essay, about *afterlives*), even if it is not possible to develop an argument that will be universally persuasive, it *is* possible to show that one's choice to believe in a particular model of the afterlife can be given a rational defense. One of the chief aims of this essay is to begin the process of outlining just such a rational defense.

This essay thus takes a Jamesian perspective on the reflections it presents. It aims not to convince any and all readers that rebirth or reincarnation is a real phenomenon, but rather that belief in the reality of rebirth is at least as plausible as the other available answers to the question, 'What happens after we die?' Believers in rebirth are thus not, simply by virtue of this belief, irrational 'kooks,' but rational agents responding intelligently to the universal human phenomena of death and loss.

In another famous essay titled *The Will to Believe*, James argues that in those areas of life in which scientific answers are not forthcoming, we are justified in believing as our inclinations take us:

Science can tell us what exists; but to compare the *worths*, both of what exists and of what does not exist, we must consult not science, but what Pascal calls our heart. Science herself consults her heart when she lays it down that the infinite ascertainment of fact and correction of false belief are the supreme goods for man. Challenge the statement, and science can only repeat it oracularly, or else prove it by showing that such ascertainment and correction bring man all sorts of other goods which man's heart in turn declares. (James 2017, p. 23)

Philosopher of religion John Hick points to the chief difficulty of James' position, but then goes on to suggest a solution to it, building further upon James' thought:

The weakness of his position . . . is that it would authorize us to believe anything that we have a strong enough propensity to believe providing the evidence concerning it is inconclusive. If we would like some unprovable proposition to be true, then, given that the option is for us a live, momentous and forced one, James' argument would justify us in believing it. But this virtually amounts to a license for wishful thinking. (Hick 1989, p. 227)

Hick's modification of James' position to compensate for this potential weakness is to "substitute compelling religious experience for the mere desire to believe an unproved and undisproved proposition." As Hick elaborates:

James' basic argument then becomes an argument for our right to trust our own religious experience and to be prompted by it to trust that of the great religious figures. Thus if in the

existing situation of theoretic ambiguity a person experiences life religiously, or participates in a community whose life is based upon this mode of experience, he or she is rationally entitled to trust that experience and to proceed to believe and to live on the basis of it.[1]

This attitude of trust is not incompatible with, but indeed invites critical self-reflection, including reflection on the possibility that one's entire worldview may prove to be deluded:

> There is, then, on the one hand an 'experience of existing in the presence of God' [by which Hick means any given religious experience of a compelling nature], which may be approved as authentic by the criteria of the individual's tradition. Such experience constitutes a good *prima facie* ground for religious belief. But on the other hand there is the possibility that this entire realm of experience may be *in toto* illusory. I suggest that in these circumstances it is wholly reasonable for the religious person to trust his or her own experience and the larger stream of religious experience of which it is a part. Such a person will, if a philosopher, be conscious of the ever-present theoretical possibility that it is delusory; but will, I suggest, rightly feel that it would be irrational to base life upon this theoretic possibility. Why should one forego entry into a larger universe of meaning, which claims and seems to represent the actual structure of reality, simply because there is always the general possibility of delusion?[2]

The openness Hick describes to the possibility that one's experiences may be deluded need not be incompatible with a deep religious commitment. Indeed, world religious traditions themselves treat personal religious experience with some measure of skepticism, mindful of the possibility that an individual might be deluded by such experience into rejecting the worldview of the tradition in question.[3] Traditions even include the criteria to which Hick refers for differentiating authentic experiences from delusory ones.[4] Affirming an idea on the basis of experience and tradition need not imply an abdication of responsibility to the truth, and to norms of logic and critical thinking accepted regardless of religious affiliation.

This essay thus proposes to treat rebirth seriously as part of a total worldview in which the author and several considerable streams of religious tradition find a plausible account of their experiences. It is an account that is not incompatible with science, and that carries with it a strong capacity for allowing its adherents "entry into a larger universe of meaning" and an ability to transform the lives of these adherents in positive ways.

3. Approaching Reincarnation from a Comparative Theological Perspective

After outlining its argument for the plausibility of reincarnation, this essay will turn from philosophy to comparative theology, as defined by Francis X. Clooney: that is, "deep learning across religious borders" (Clooney 2010). As Clooney defines it, comparative theology is a mode of discourse pursued by committed adherents to a religious tradition who engage in a close study of another tradition. This study is pursued not with the aim either of converting or being converted, but for the sake of learning from the other and bringing back insight to the comparative theologian's own religious tradition.

> *Comparative theology–comparative* and *theological* [from] beginning to end–marks acts of faith seeking understanding which are rooted in a particular faith tradition but which, from that foundation, venture into learning from one or more other faith traditions.

[1] Ibid, p. 228.
[2] Ibid.
[3] A famous example of a mystic who questioned the veridicality of her own experiences is St. Theresa of Avila, from the Roman Catholic tradition of Christianity. See (Theresa of Avila 1979).
[4] This topic and that of the epistemic status of religious experience in general are explored in depth in (Alston 1991). Alston argues, like Hick, for the rational validity of using religious experience as a basis for knowledge claims.

This learning is sought for the sake of fresh theological insights that are indebted to the newly encountered tradition/s as well as the home tradition . . . Comparative theology thus combines tradition-rooted theological concerns with actual study of another tradition. It is not an exercise in the study of religion or religions for the sake of clarifying the phenomenon. It reduces neither to a theology about religions, nor to the practice of dialogue [although, as Clooney notes elsewhere, a 'theology about religions' (or theology of religions) and the practice of interreligious dialogue can and do inform the practice of comparative theology].[5]

4. A Catholic who became Hindu Looks Back at Christianity

The particular comparative theological project pursued in this essay has a somewhat idiosyncratic character. I am not a Christian studying Hinduism, nor am I a Hindu *by birth* who is studying Christianity. The theological dialogue presented here has the character of an *internal* dialogue pursued by a person who started out as a Roman Catholic Christian, but who later became an adherent of a Hindu tradition (specifically, the Vedānta tradition of Sri Ramakrishna and Swami Vivekananda), and who is now raising the question whether Christianity might have something valuable to offer to Hindus on the subject of rebirth.

One of the major reasons for my transition from Christianity to Hinduism was my strong preference for the idea of rebirth over traditional Christian ideas about the afterlife. As the essay will show, this essential preference has not changed. I still hold that rebirth is the most plausible of the available afterlife options, and as already stated, I hope to make, or at least outline, a case for its rational defensibility.

Another Hindu ideal that is central to my worldview, though, is *dharma samanvaya*, which means 'the harmony of religions,' or religious pluralism. This is the view that there is truth in all traditions. The challenge I have posed for myself in this essay is to address the question: Even if I do not agree with the Christian denial of rebirth, it being a central reason for my break with Christianity, is there an important truth that this denial captures?

Bradley Malkovsky has summarized this denial well in the abstract for his paper for this special issue of *Religions*:

Mainstream Christianity has always rejected reincarnation teaching in all its varieties . . . as being incompatible with the biblical understanding of the uniqueness, dignity, and value of the human person, a teaching that is ultimately rooted in the radical understanding of divine mercy and love toward every human being proclaimed by Jesus himself. (Malkovsky 2017)

My response is that, although there are strong reasons for finding the doctrine of rebirth persuasive, Christianity also makes a valid point in its emphasis on the "uniqueness, dignity, and value" of each lifetime. A dialogue with Christians on this topic is an occasion for highlighting dimensions of the idea of rebirth that may otherwise receive little attention in a conversation focused only on the contrasts between Hindu and Christian visions of the afterlife. The aim of this dialogical portion of my essay is not to show that one side or the other is right and that the other is wrong. My view on that issue should be clear, if for no other reason than my chosen religious affiliation, as well as the argument of philosophical section. The aim of this dialogue is a deepened *understanding* of the idea of rebirth by way of interfaith engagement. And, of course, faith seeking understanding is the definition of theology, dating to the work of St. Anselm: *fides quaerens intellectum*.[6]

This essay will also include reflections on a series of interactions I have had with a student whom I shall call Matthew (not his real name) who is inclined to believe he may be the reincarnation of a very well-known historical figure whose life and character are quite familiar to me. I am not

[5] Ibid, p. 8.
[6] See (Ward 1973).

entirely persuaded that Matthew is the reincarnation of this figure–nor, for that matter, is Matthew. We are both simply open to the possibility, based on a set of experiences that Matthew has had and which he has discussed with me in depth. Frankly, I have hesitated to include this material. Given privacy considerations, I offer the barest sketch of these interactions here. I have found, though, that entertaining the idea, as a thought experiment, that Matthew might indeed be the reincarnation of this particular famous person, has yielded insight into the topic of this special issue of *Religions* that I would like to include in it. This portion of the essay could perhaps be seen as an addendum, only to be read by those with an intense interest in this topic and my approach to it.

5. Religious Stance: Belief in the Reality of Rebirth in the Modern Vedānta Tradition

As a Hindu theologian in the tradition of Sri Ramakrishna and Swami Vivekananda, I am operating from a perspective which takes rebirth to be a real phenomenon. Both Sri Ramakrishna and Swami Vivekananda, as well as other teachers in the Vedanta tradition they established, make reference to rebirth in their teachings, and the ideal is presupposed throughout the premodern Vedanta tradition as well. The two main primary sources on the life and teachings of Ramakrishna—two Bengali texts called *Śrī Śrī Rāmakr̥ṣṇa Kathāmr̥ta* and *Śrī Śrī Rāmakr̥ṣṇa Līlāprasaṅga*—contain numerous references to rebirth, as do the *Complete Works* of Swami Vivekananda.

The fact that I am located in a tradition that affirms the reality of rebirth is not, of course, sufficient reason for anyone outside of that tradition to see the reality of rebirth as anything other than an assertion, or a statement of faith. My intent in this section is simply to give a sense of how the idea of reincarnation is viewed in the tradition in which I am located. There are many different models of rebirth, in both India and the West, as well as in other cultures, some of which are explored in other essays in this volume. This section should give some idea of what I mean by 'rebirth' and 'reincarnation' when using these terms and arguing for the plausibility of belief in this phenomenon.

In the *Kathāmr̥ta*, written by Mahendranath Gupta, a householder devotee of Sri Ramakrishna, and translated into English as *The Gospel of Sri Ramakrishna* by Swami Nikhilananda, Ramakrishna makes a casual reference to people who are very dear to him. "I feel as if they had been my friends in a former incarnation." At this, someone asks, "Sir, do you believe in the reincarnation of the soul?" Sri Ramakrishna replies, "Yes, they say there is something like that. How can we understand the ways of God through our small intellects? Many [authoritative] people have spoken about reincarnation; therefore I cannot disbelieve it" (Nikhilananda 1942, p. 153). He then cites an example from the *Mahābhārata*.

This is basically an argument on the basis of religious tradition. The idea of rebirth is ancient and widespread across the entire variety of Hindu traditions, and in other Indic traditions such as Jainism, Buddhism, and Sikhism. With this statement, Ramakrishna is simply locating himself in this larger cultural and religious current of thought.

Later, in the same text, Sri Ramakrishna is asked, "Sir, what is the nature of the life after death?" Ramakrishna replies, "As long as a man remains ignorant, that is to say, as long as he has not realized God, so long will he be born. But after attaining Knowledge he will not have to come back to this earth or to any other plane of existence."[7] This is a reference to the classical Vedāntic view that one is reborn, either on the earth or in another plane of existence, until one attains the realization of the identity of the self, or *ātman*, and *brahman*, the infinite being, consciousness, and bliss that forms the ground, source, and ultimate destination of all entities. With this realization comes freedom—*mokṣa* or *mukti*—in the form of release from *saṃsāra*, the cycle of birth, death, and rebirth. If, in his earlier statement, Ramakrishna is locating himself in the Hindu tradition—or family of traditions—broadly conceived, with this statement he locates himself specifically within the Advaita, or nondual, Vedānta tradition, which traces itself to the *Upaniṣads*.

[7] Ibid, p. 416.

Finally, Ramakrishna presents his distinctive approach to this topic, which marks the modern Vedānta tradition that takes him as its chief inspiration. Specifically, he gives an answer which emphasizes direct experience over the pronouncements of traditions and texts. He states that, rather than speculate intellectually about such topics, it is far better to seek the direct experience of God-realization. A devotee asks Ramakrishna, "Sir, is there such a thing as reincarnation? Shall we be born again?" Ramakrishna replies, "Ask God about it. Pray to Him sincerely. He will tell you everything . . . It is not right to try to know these things at the beginning. First of all realize God; then He Himself will let you know whatever you desire."[8] This statement of Ramakrishna's is evocative of Matthew 6:33: "But seek first the kingdom of God and his righteousness and all these other things shall be given to you as well."

In the other main source on the life of Ramakrishna, the *Līlāprasaṅga*, written by one of Ramakrishna's original monastic devotees, Swami Saradananda and translated into English by Swami Chetanananda as *Sri Ramakrishna and His Divine Play*, we find, first, a reference to the *Yoga Sūtras* of Patañjali, "Through the perception of past impressions comes the knowledge of past lives."[9] This is elaborated as follows:

> The scriptures say that aspirants attain the memory of past lives before they become fully established in pure consciousness by way of the nondual attitude. Or, at the culmination of that attitude, the aspirant's memory reaches such an advanced state that the aspirant remembers how, where, and how many times he was born, and also everything he did in every previous incarnation, whether good or bad. Consequently, the aspirant fully realizes the impermanence of all worldly objects and the futility of being born again and again to chase sense objects for enjoyment. An intense detachment then arises in the aspirant's mind, which makes that person free from all desires forever. (Chetanananda 2003, pp. 316–17)

The same text also includes an account of a prediction by Sri Ramakrishna that he would, himself, not attain liberation immediately, but that his mission to aid in the liberation of others would require him to be reborn:

> . . . [T]he Master realized that he would not attain liberation like other beings [jīvas]. It does not take long to understand this through ordinary reasoning: He who is always inseparable from God and is indeed a part of God, who is by nature pure, awakened, and free at all times, and who has no deficiency or any limitation—how can the question of liberation arise for such a person? As long as God continues to redeem all human beings, He will have to accomplish this by becoming incarnate in every age. So how could the Master have liberation? As the Master used to say, "An officer of the landlord must run to any part of the estate where there is trouble." He not only knew this about himself through his yogic insight, but he also told us many times, pointing to the northwest, that the next time he would reincarnate there. Some of us said that the Master even told them the time of his advent, stating, "I shall be born in that direction after two hundred years. Then many will be liberated, and those who fail at that time will have to wait a long time for liberation."[10]

In addition to these firsthand accounts by devotees of Sri Ramakrishna, which give an idea of his views on rebirth, there are also references to this concept in the *Complete Works* of his best known disciple, Swami Vivekananda.

Vivekananda presents a moral argument for reincarnation, connecting this idea with theodicy—the problem of evil. Rather than laying the responsibility for all our suffering at the feet of God, reincarnation, according to Vivekananda, makes us responsible for our own suffering. This is not seen

8 *Yoga Sūtras* 3:18.
9 *Yoga Sūtras* 3:18.
10 Ibid, p. 360.

as a message of blame or of guilt, but of hope; for what we can do, we can undo, given the potentially infinite second chances provided by the concept of rebirth:

> This idea of reincarnation runs parallel with the other doctrine of the eternity of the human soul. Nothing which ends at one point can be without a beginning and nothing that begins at one point can be without an end. We cannot believe in such a monstrous impossibility as the beginning of the human soul. The doctrine of reincarnation asserts the freedom of the soul. Suppose there was an absolute beginning. Then the whole burden of this impurity in man falls upon God. The all-merciful Father responsible for the sins of the world! If sin comes in this way, why should one suffer more than another? Why such partiality, if it comes from an all-merciful God? Why are millions trampled underfoot? Why do people starve who never did anything to cause it? Who is responsible? If they had no hand in it, surely, God would be responsible. Therefore the better explanation is that one is responsible for the miseries one suffers. If I set the wheel in motion, I am responsible for the result. And if I can bring misery, I can also stop it. It necessarily follows that we are free. There is no such thing as fate. There is nothing to compel us. What we have done, that we can undo. (Vivekananda 1979, p. 329)

Vivekananda also makes an argument for reincarnation on the basis of memory: that there are certain tendencies (*saṃskāras*) that can be found, particularly in children, which cannot easily be accounted for by training, or 'nurture.' The only explanations for these tendencies are genetics, or 'nature,' or, for those who believe in a soul, reincarnation:

> We gain all our knowledge through experience; that is the only way. What we call experiences are on the plane of consciousness. For illustration: A man plays a tune on a piano, he places each finger on each key consciously. He repeats this process till the movement of the fingers becomes a habit. He then plays a tune without have to pay special attention to each particular key. Similarly, we find in regard to ourselves that our tendencies are the result of past conscious actions. A child is born with certain tendencies. Whence do they come? No child is born with a *tabula rasa*—with a clean, blank page—of a mind. The page has been written on previously. The old Greek and Egyptian philosophers taught that no child came with a vacant mind. Each child comes with a hundred tendencies generated by past conscious actions. It did not acquire these in this life, and we are bound to admit that it must have had them in past lives ... Now if heredity alone explains this, there is no necessity of believing in the soul at all, because [the] body explains everything ... So far the way is clear for those who believe in an individual soul. We see that to come to a reasonable conclusion we must admit that we have had past lives."[11]

It is interesting to note that Vivekananda's stance in this regard is not unlike that which would later be taken by John Hick on religious experience, as discussed earlier, inasmuch as Vivekananda allows for the possibility that his belief in rebirth may turn out to be delusory. A materialist explanation for the tendencies he describes is available, in the form of heredity. However, the idea of reincarnation is available—and, according to Swami Vivekananda, inescapable—"for those who believe in an individual soul."

What is this 'individual soul,' according to the Vedānta tradition? What is it that is reborn? *Punarjanma*, or rebirth, in all the various systems of Vedānta, refers to the idea that each of us is, at our most basic level, a being of pure consciousness, or *jīva*, that has manifested on the material plane in, or as, a material form which is conventionally known as a body (a *deha* or *śarīra*, in Sanskrit). This jīva, as Vivekananda explains, has no beginning and no end in time. In the words of the *Bhagavad Gītā*:

[11] Ibid, pp. 329–30.

There never was a time when I did not exist, nor you . . . And there never will be a time when we do not exist. Just as the embodied one [*dehin*] experiences childhood, and youth, and old age, in this body, in the same way he enters other bodies. A wise person is not disturbed by this . . . Just as one discards worn-out clothes and gets others that are new, so the embodied one discards worn-out bodies and enters others that are new.[12]

In the Advaita, or nondualist, system of Vedānta, even the jīva does not define our ultimate identity. All of us are ultimately, according to Advaita, one with the singular ātman, the divine Self at the heart of all existence. From an Advaita perspective, belief in rebirth plays a soteriological role as one step in a longer process of destabilizing our conventional sense of identification with the physical body, and finally, our identification with anything other than consciousness itself.[13] The ātman is essentially pure consciousness; for Brahman is consciousness—*prajñānaṃ brahma*[14]—and the ātman is Brahman—*ayaṃ ātmā brahma*.[15] We therefore move from identifying with our physical body and with the personality we have developed in this lifetime to identifying with the soul, or jīva, which has assumed myriad forms throughout cosmic time, and then move from identifying even with the soul to identifying with the pure and infinite consciousness that manifests in and as all souls.

How did I, personally, come to hold this religious stance? To again cite Hick, what 'compelling religious experience' led me to adopt it? As I have recounted elsewhere, I first read the just-cited words of the *Bhagavad Gītā* at the age of fourteen, in the aftermath of my father's very public suicide, which was the culmination of his long struggle with physical disability.[16] Coming across the *Gītā*, seemingly by chance, in the most unlikely of places (a flea market in the parking lot of the Methodist Church of my small Missouri hometown), was an event that changed my life, resolving a host of issues that had arisen in my mind while coping with the tragedies and shocks that had befallen my family. I felt, in that moment, that I had been given a divine revelation.

From a perspective of scientific rigor, the fact that I find the doctrine of rebirth to be deeply reassuring—and moreover, that I ascribe my adoption of this doctrine to a personal divine revelation—probably disqualifies any further pronouncements from me on this topic from being taken seriously. However, it is, of course, also true that the fact that an idea is deeply reassuring does not mean it is necessarily false. The arguments for (and against) this idea need to be taken on their own merits.

Again, though, my aim here is not to prove conclusively that rebirth, as understood in the Vedānta tradition, is a real phenomenon. It is to prove that belief in this phenomenon is not unreasonable, particularly in contrast with the other possible answers to the question, 'What happens after we die?' So what is the case for the plausibility of reincarnation?

6. Why Believe in Rebirth? Outline of an Argument for the Plausibility of Reincarnation

Briefly, there are three basic arguments for rebirth. I call the first argument moral-theological. The second one is empirical. The third I call pragmatic-soteriological. None of these arguments is, by itself, completely airtight. Each of them can be rejected, or at least questioned, by reasonable persons. Cumulatively, however, they demonstrate that the idea of rebirth is not beyond the pale of plausibility for other, equally reasonable persons.

The arguments for rebirth function in a way that is akin to that in which arguments for the existence of God function, according to philosopher of religion Richard Swinburne. Swinburne sees the traditional arguments for the existence of God–such as the ontological argument, the cosmological argument, the teleological argument, and so on–not as airtight on an individual basis, but taken

12 *Bhagavad Gītā*, 2:12–13, 22. (Thompson 2008), with minor modifications on my part.
13 For more detailed discussion of the deconstructive soteriological strategies of Advaita Vedānta, see (Davis 2010).
14 *Aitareya Upaniṣad* 3:1:3.
15 *Maṇḍukya Upaniṣad* 1:2.
16 See (Long 2012, 2015).

together, to be cumulatively persuasive. Using an image of a set of leaky water buckets, he argues that each bucket, individually, may be unable to hold water, but that they can be stacked together in such a way as to render them capable of serving this purpose. As Swinburne explains, " . . . arguments that are not deductively valid are often inductively strong; and, if you put three weak arguments together, you may often get a strong one, perhaps even a deductively valid one" (Swinburne 2004, p. 13).

The moral-theological argument for rebirth operates on the assumption, shared by many religions, that there is a benevolent and ultimately just cosmic order which defines the wider context of human existence. This order—or *dharma*—can operate with or without the presence of a divine guarantor of that order, as the existence of both theistic and non-theistic Dharma traditions attests.[17]

From this perspective, given the alternatives normally presented in response to the question of the afterlife, rebirth is seen to fulfill the criteria of benevolence and justice in a more satisfactory way than either the model of an eternal heaven or hell that is upheld in the mainstream Christian and Islamic traditions, or the secular model in which there is no afterlife (except in the very attenuated sense in which persons and the effects of their lives continue on in the memories of others, or through the passing on of their genetic, cultural, or intellectual inheritance). What is the basis for this assertion? What makes reincarnation more consistent with a just and benevolent cosmic order than the heaven-and-hell model or the materialist model?

Put briefly, the problem with heaven and hell is that most people are neither good enough to spend an eternity in heaven nor evil enough to spend an eternity in hell. Even if one allows that a few beings in a given cosmic epoch might, as Dharma traditions affirm, attain perfection, one lifetime is not, as these traditions also affirm, time enough to achieve this ultimate goal. To say that a soul might reach a point of no return, without any ability whatsoever to improve, and thus spend eternity in hell, is a highly arbitrary and horrifying conclusion. Indeed, when combined with traditional theism, it suggests that God, knowing some beings will end up suffering forever, nevertheless goes ahead and creates them, thus becoming responsible for their torment. This is arguably a sadistic and psychopathic vision of divinity: the very one which we have seen strongly rejected by Swami Vivekananda as 'monstrous.' In addition, while ideals of divine mercy and unmerited grace certainly have a major role to play in many religious traditions, including many Hindu traditions, the idea that one is received into eternal bliss after one lifetime, even one riddled with imperfections, offends one's sense of justice. One is sympathetic, here, to the perspective of the brother of the prodigal son, who sees his brother welcomed home with open arms and a celebration after wasting his father's wealth, while he himself, who has been faithfully obedient, receives no such reward. Neither heaven nor hell, from this point of view, seems an appropriate or proportional outcome of the typical human life, with its mix of perfection and imperfection. Benevolence and justice together seem best fulfilled by an afterlife that contains a mix of happiness and sorrow, but also ongoing opportunities to improve oneself.

The Catholic perspective, with which I was raised, mitigates the problems of the heaven-and-hell model with the concept of purgatory, in which not-yet-perfected souls who are nevertheless in a state of grace, and so ultimately destined for salvation, continue to work out their imperfections in an intermediate state, between the time of the death of the physical body and the attainment of the beatific vision in its fullness.

As Bradley Malkovsky points out, though, in his contribution to this volume, this working out of imperfections in purgatory does not, as traditionally conceived, involve the cooperation of the free will of the individual soul. Though he ultimately rejects the idea of reincarnation, Malkovsky concedes that, on this point, the doctrine of reincarnation has an advantage over the traditional concept of purgatory:

> The doctrine of purgatory, it is true, also includes the notion of post-mortem transformation, Rahner points out, but *not on the basis of a continued exercise of freedom.* It is perhaps surprising, then, that Catholic teaching rejects the possibility that free will continues beyond earthly

[17] Buddhism and Jainism are thus non-theistic, whereas Sikhism and most Hindu traditions are theistic. See (Howard 2017).

existence into the afterlife. This is the advantage of reincarnation doctrine; it offers further opportunity for self-determining freedom.[18]

There are other issues with purgatory as well. Apart from the fact that it retains the possibility of eternal damnation for some—namely, those who did not die in a state of grace—another problem with the purgatory solution is that it raises the question of the point of one's physical incarnation on earth. If the soul still has work, perhaps a great deal more work, to do at the time of the death of the body, and if this work is to be done in purgatory, why did the soul not simply begin its journey in purgatory? What was the purpose of being born in the physical world at all? The idea of rebirth, in these terms, in effect amounts to the claim, that we are *already* in purgatory, doing the work—the *karma*—that we need to do for the sake of our eventual perfection. One's current life, in effect, is the purgatory of the one which immediately preceded this one.

Regarding the other alternative—that there is no rebirth because there is no soul or afterlife in any traditional sense—I am persuaded by John Hick's argument that this view is "bad news for the many" (Hick 2004, pp. 19–24). This is of course not an airtight argument. The fact that a worldview is incredibly bleak and suggests that the vast majority of human beings have lived lives that are, to quote Thomas Hobbes, "nasty, brutish, and short," with no ultimate redemption or sense that these persons have anything better to look forward to after death, does not mean it is necessarily false. It may simply be the case that we live in a horribly unjust and monstrous universe, not unlike that of the heaven and hell model, but without the comfort of a heaven for the chosen few. Such a materialist view does, however, raise troubling moral questions, such as the question "Why be moral at all?" These questions are not incapable of being answered, and thinkers such as 'new atheist' Sam Harris have been striving valiantly to answer them. However, as Hick has said:

> Why should one forego entry into a larger universe of meaning, which claims and seems to represent the actual structure of reality, simply because there is always the general possibility of delusion?[19]

In short, although the materialist rejects reincarnation because it has not been scientifically proven, so long as it has also not been scientifically *disproven*, it satisfies both Hick's and James' criteria as a valid option for belief.

As the next argument suggests, however, it may not actually be necessary, in light of recent scientific developments, even to contemplate casting aside the possibility of a spiritual realm in order to remain faithful to a scientific vision of reality. It may indeed be that, in the near future, the survival of consciousness beyond the death of the body will become a topic of mainstream scientific investigation.

The empirical argument for rebirth is based on the research into past life memory that was famously pursued by the late Ian Stevenson and that continues to be pursued by his successor, Jim Tucker, in the department of psychiatry at the University of Virginia.

To the possible objection that past life memory studies in the West are not relevant to Indic models of reincarnation, such as the Vedāntic model, and that past life memory is a relatively recent phenomenon, we have already seen mention made in an ancient Indic text—the *Yoga Sūtra*—to past life memory. The idea of past life memory, indeed, undergirds an entire genre of early Buddhist literature: the *Jātaka* tales, which claim to present the past life memories of the Buddha. In addition, in the *Bhagavad Gītā*, Krishna makes mention to Arjuna of his ability to recall past births:

> I taught this eternal yoga tradition to Vivasvat, the god of the sun. Vivasvat taught it to Manu, the Father of mankind. Manu himself taught it to Ikṣvāku, the first king.

> The royal seers knew this tradition, which was handed down from one to the other, but after a long passage of time, Arjuna, it became lost.

[18] (Malkovsky 2017).
[19] Ibid.

This ancient yoga tradition is what I teach to you today, for you are my devotee and my friend, and this is the deepest of mysteries.

Arjuna spoke:

Vivasvat's birth occurred a long time ago. You were born much later. How should I understand what you mean when you say that you taught this teaching in the beginning?

The Blessed One spoke:

I have passed through many births, and so have you, Arjuna. But I can recall them all whereas you, Arjuna, cannot.[20]

Stevenson's research on children who claimed to remember past lives, some of the details of which could be verified with further investigation, has been rightly questioned on a number of counts, including by Jonathan Edelmann, another contributor this volume (Edelmann and Bernet 2007). Such alleged memories are typically corrupted through the introduction of the idea of reincarnation and whatever biases in favor of or against the idea that the child or his or her family might have. The collection of these stories does not occur in laboratory conditions.

Tucker, however, as recounted in his recent popular works such as *Return to Life: Extraordinary Cases of Children Who Remember Past Lives* (Tucker 2015), has tightened the methods of his predecessor, exerting considerable effort to eliminate factors like leading questions, and treating with greater skepticism accounts emerging from cultural environments where the idea of rebirth is strongly affirmed. It is not that these accounts are necessarily false; but for an account to be taken as valid, all bias factors must be rigorously removed. In addition, again, to respond to the objection that cases from Western countries cannot have relevance to the Vedāntic model of rebirth, raising this objection would seem to be akin to arguing that Einstein's formula $E = mc^2$ applies only to energy and matter in Austria. The Vedāntic model teaches that the jīvas have been reincarnating throughout the multiverse throughout cosmic time. If anything, cases of past life memory from cultures outside of India would seem to lend weight to this model.

If large numbers of Stevenson's and Tucker's cases are invalidated, though, does this not suggest that the attempt to ground belief in reincarnation on the basis of past life memory is doomed to failure?

In the words of William James, who famously studied paranormal phenomena (as recounted by David Ray Griffin in his 1997 study of this topic) (Griffin 1997), "it takes only one white crow to prove that not all crows are black." In other words, even if, out of the thousands of accounts collected by Stevenson and Tucker, only one was to meet criteria of scientific rigor—not being prompted by parents or other relatives, not being derived from books or the Internet, not referring to a famous personage whose life details were well known, and not occurring in the context of a pre-existing belief in reincarnation—this alone would be sufficient to demonstrate, at minimum, that consciousness is not the mechanistically-based phenomenon that materialist ontologies presuppose: that information can transfer from one mind to another through means not yet recognized by the mainstream scientific community in the western world (but for which quantum theory creates an opening).

Such a case, it seems, exists: the case of Ryan, documented by Tucker in *Return to Life*, and appearing on the *NBC Nightly News* on 20 March 2015 (which is how I first became aware of this case). Ryan, a young boy from Oklahoma, is from a conservative evangelical Christian family. Belief in reincarnation is strongly rejected in this religious tradition as a false doctrine, and the broader American culture in which the family lives is strongly skeptical of the concept, with most Americans still rejecting this idea. There is thus, for Ryan or his family, no positive motive or cultural impulse to advance the idea of reincarnation. Indeed, the potential for ridicule and social sanctions such as ostracism is very real in this case, thus lending some weight to its validity from the outset.

[20] *Bhagavad Gītā* 4:1–5. Thompson, trans.

Around the age of four, "Ryan began talking about going home to Hollywood. He would cry and plead for Cyndi [his mother] to take him home so he could see his other family" (Tucker 2013, p. 88). These experiences were sufficiently disruptive that Ryan's family took him to the University of Virginia for a consultation with Tucker—who is, again, a well-reputed child psychiatrist. Collecting Ryan's detailed accounts of his alleged past life, and correlating them with carefully researched information, Ryan's parents and Tucker concluded that the life Ryan was describing was that of Marty Martyn, an agent from the golden age of Hollywood. This was not a person of any particular fame, and a person with no connection to Ryan or his family.

Importantly, the details Ryan articulated were not readily available, such as on the Internet, and no one in Ryan's family, nor Tucker, had any knowledge of Martyn prior to engaging in this research.

In the most striking portion of the entire story, Ryan at one point said, with some frustration, that he did not understand why God would allow someone to live for sixty-one years and then make them come back as a baby. All of Ryan's information about Martyn's life at this point had proven accurate, but on this one point of fact, his account was at odds with Martyn's official death certificate, which stated that Martyn had died at the age of fifty-nine. Given the rigor of his methodology, Tucker was prepared to see this one discrepancy as a sufficient basis for rejecting Ryan's story as a proof of the phenomenon of rebirth. Further research, however, proved that Martyn had in fact died at the age of sixty-one, and that the birth certificate was incorrect. Ryan therefore not only had detailed information about the life of a man no one in his family had ever met and about whom they had no prior knowledge, but his information actually led to a correction of the public record of the death of that same man.

Is Ryan's story scientific proof of rebirth? Not necessarily. The phenomenon described here is susceptible to a variety of interpretations, including a form of telepathic contact between the deceased Marty Martyn and the living Ryan.

It does, however, raise serious questions about the materialist paradigm used by many to explain phenomena such as consciousness; for even if Ryan's declarations are not repeatable or testable under laboratory conditions, they do leave us with the fact that a young child has been walking around, as far as can be discerned, with detailed memories from the life of a deceased person whom he never met and to whom neither he nor his family had access, in his mind. Even if, under the most rigorous definition of science, this information does not count as proof of rebirth, it certainly renders problematic the standard materialist idea that consciousness is nothing but an effect of neurochemistry, incapable of surviving the death of the brain, and opens up the possibility of the reality of rebirth. As Tucker argues, the development of quantum physics raises similar questions about the viability of materialism, which Tucker sees as having been essentially refuted:

> Findings in physics over the last hundred years—particularly in quantum physics or quantum mechanics, the study of the universe's smallest particles—have shown that the physical universe is much more complicated than it appears. They strengthen the view that there is a consciousness that exists separate from the material world. I now believe that the physical grows out of the mental, meaning that the physical world is created out of something you can think of as Mind or consciousness or the spiritual. Our cases, and the possibility of children remembering past lives, then fit in nicely with a new understanding of existence.[21]

The 'new understanding of existence' that Tucker describes is, of course, 'new' only in the sense that its possibility being undergirded by the natural sciences is a recent development. This understanding of existence, though, is of course ancient in India, Vedānta being one example of a

[21] Ibid, pp. 165–66.

tradition that has affirmed it for millennia. Brahman is consciousness—*prajñānaṃ brahma*. In addition, all this—the cosmos—is, indeed, Brahman: *sarvaṃ khalvidam brahma*.[22]

Finally, the third argument for rebirth is the pragmatic-soteriological one, based on the effects that believing in rebirth can conceivably have upon one's life, at least in the context of a deconstructive spiritual practice such as that of Advaita Vedānta: particularly one's relationship to others and to one's own experiences. These are effects to which I can attest, as my belief in rebirth has solidified from the time I began to entertain the concept, in my early adolescence, to the present. The concept of rebirth expands one's sense of self in way that paradoxically leads to a humbling realization of one's profound connections with all beings. The Buddha famously exhorted his followers to be mindful that, given the vastness of cosmic time and the rebirth process that occurs within it, every person that one meets has likely been one's beloved, one's mother, one's father, one's sister, one's brother, or one's dear friend at some point or other. An important Buddhist spiritual exercise is based on this insight. This exercise involves the recollection that all beings have at some point been one's mother:

> Why are all beings my relatives? As there is no beginning to the life-cycle, there has also been no beginning to my rebirths. In passing through these countless lives, there is no form of life which I have not adopted countless times, and there is no country or realm in which I have not been born. Of all beings, there is not one who has not been my mother innumerable times. Each has been my mother in human form countless times, and will become my mother many times again. (Thurman 1995, p. 137)

This realization, rooted in an assumption of the truth of rebirth, militates against prejudice, allowing one to see beyond such differences as gender, ethnicity, religion, nationality—or even species, if one is mindful that the soul is not specifically human, but is pure consciousness, which could well reside and has certainly resided in many forms of life throughout the cosmos. Belief in rebirth, in short, has soteriological benefits, at least within the framework of the Dharma traditions. There is not time or space to argue this in depth here; but I would say that believing in rebirth has made me a better person than I might otherwise be.

These three arguments do not, again, constitute an irrefutable or indubitable case for rebirth. They do, though, collectively suggest that rebirth is neither an unreasonable nor wholly unattractive option, and that assent to this doctrine is intellectually defensible.

7. Giving a Fair Hearing to Christian Reservations about Rebirth

Turning, now to comparative theology, and a dialogue between Hinduism and the Christian tradition, let us revisit Bradley Malkovsky's summary of the reasoning behind the mainstream Christian rejection of the idea of reincarnation:

> Mainstream Christianity has always rejected reincarnation teaching in all its varieties ... as being incompatible with the biblical understanding of the uniqueness, dignity, and value of the human person, a teaching that is ultimately rooted in the radical understanding of divine mercy and love toward every human being proclaimed by Jesus himself.

Finding the arguments for rebirth to be persuasive, and the model of the universe presupposed in a worldview in which rebirth is real to resonate with my own intuitions, as well as for a number of other reasons that go beyond the purview of this paper, I was drawn, from a young age, to embrace a Hindu spiritual path. I see the Christian tradition of my upbringing as a repository of much profound wisdom, and I will always be grateful for the spiritual formation I received in this tradition. Its model of the afterlife, however, is one that I ultimately found unsatisfying in contrast with the idea of karma and rebirth.

[22] Chāndogya Upaniṣad 3:14:1.

Another idea that drew me to a Hindu path, however, was religious pluralism—the idea that there is profound truth to be found in all paths, and that each path is a way to the highest realization. *Yato mat, tato path*, in the words of Sri Ramakrishna: Each tradition is a path to the ultimate reality. I would argue, as a Hindu, that even the rejection of the doctrine of rebirth by Christians carries within it an important truth.

This brings me to my student, Matthew, who believes he may be the reincarnation of a prominent historical personage whose life and character I know very well. If, simply as a thought experiment, I entertain the notion that Matthew really is this person reborn, I find that this yields an important insight into the idea of rebirth—an insight captured in the Christian affirmation of the "uniqueness, dignity, and value" of each person.

Of course, Hindu traditions, and all the Dharma traditions, also teach that each life is precious. A lifetime is an opportunity to advance toward the highest realization. We take rebirth in a particular form because that form and the experiences to which it lends itself are precisely what we need in order to advance at that point in our journey. A famous Hindu teaching is that, "Human birth is precious."[23] While the soul can take any form, and each form carries its own benefit for the soul, a human rebirth carries with it certain special abilities, such as the ability to comprehend the soul's situation, and to engage in *sādhana*, or intentional spiritual practice. In response to the concern that belief in rebirth might lead to a certain spiritual laziness, to a willingness to put off spiritual practice for a future lifetime, the idea that each human rebirth is precious, that there is no guarantee that one will be able to practice again for a very long time, militates against what might be called spiritual procrastination.

There is even more, though, to the matter than this. The *Bhagavad Gītā's* image of the rebirth process as akin to casting aside old clothes and putting on new ones carries with it a certain bravado in the face of death, which is certainly part of its appeal to those of us who have found reassurance, after the loss of our loved ones, in this idea. Reading the words of Krishna, "Just as one discards worn-out clothes and gets others that are new, so the embodied one discards worn-out bodies and enters others that are new," one wants to add, "Death, where is thy sting? O grave, where is thy victory?"[24] The image is an important one for conveying the immortality of the soul relative to the perishable nature of the material body, to which we ought not, because of this very perishability, to become attached.

Like all analogies, though, this one is imperfect. When I think of Matthew and the person whose reincarnation he might be, the two of them are not the same. Matthew is his own person, with his own aspirations, own experiences, own plans, own friends, own destiny.

At the same time, I can also see the undeniable connections and resonances that may link him to that other. He both is and is not the person whose inner essence he may well share. When I asked him if it was somehow to be proven that he is, indeed, this other person reborn, what difference this would make in his life, he told me that it would help him understand certain feelings that he had, certain likes and dislikes. He also said it would give him confidence. Knowing he had already achieved certain things in the other life would help him believe in himself, and that he could do great things in this life.[25]

The point is that, to be reborn is more than changing clothes (with all due respect to the profound import of that image, and its truth in another context). To be reborn is, in one sense, to carry on as oneself in another form. However, in another sense, from the point of view of that new lifetime, it is to carry within oneself the deep essence of another, who, while in many profound ways is oneself, is in other ways truly other. The destabilizing of the ego that reflection on this process evokes is, of course,

23 See (Mangla 2016).
24 1 Corinthians 15:55, *King James Version*.
25 Just as I am protecting the privacy of my student by giving him a pseudonym, I have also made a choice to respect the privacy of the famous person whose reincarnation he might be. If that person has chosen to reincarnate as my student, I assume that is his business. It is not for me to broadcast it, uninvited, to the world.

part of its whole point, as the pragmatic argument for rebirth suggests. It is part of the transformative soteriological value of this point of view.

This does not mean, though, that the uniqueness, dignity, and value of each person—of each incarnation—ought to be diminished by the concept of rebirth. Rather, the richness and value of the totality of being is increased as the soul takes on a new identity. Each of these identities is a new expression of an ancient reality; yet each also remains an irreducibly distinct contribution to the whole.

Conflicts of Interest: The author declares no conflicts of interest.

References

Alston, William. 1991. *Perceiving God: The Epistemology of Religious Experience*. Ithaca: Cornell University Press.

Translated by Swami Chetanananda. 2003, *Sri Ramakrishna and His Divine Play*. St. Louis: Vedanta Society of St. Louis, pp. 316–17.

Clooney, Francis X. 2010. *Comparative Theology: Deep Learning across Religious Borders*. London: Wiley-Blackwell.

Davis, Leesa S. 2010. *Advaita Vedānta and Zen Buddhism: Deconstructive Modes of Spiritual Inquiry*. London: Continuum.

Edelmann, Jonathan, and William Bernet. 2007. Setting Criteria for Ideal Reincarnation Research. *Journal of Consciousness Studies* 14: 92–101.

Griffin, David Ray. 1997. *Parapsychology, Philosophy, and Spirituality: A Postmodern Exploration*. Albany: State University of New York Press.

Hick, John. 1989. *An Interpretation of Religion*. New Haven: Yale University Press, p. 227.

Hick, John. 2004. *The Fifth Dimension: An Exploration of the Spiritual Realm*. Oxford: Oneworld, pp. 19–24.

Howard, Veena. 2017. *Dharma: The Hindu, Jain, Buddhist, and Sikh Traditions of India*. London: IB Tauris.

James, William. 1982. *The Varieties of Religious Experience*. New York: Penguin Books, p. 436.

James, William. 2017. *The Will to Believe*. Mexico: Midwest Journal Press, p. 23.

Long, Jeffery D. 2012. 'Never Was There a Time . . . ' Crossing Over to Hinduism through the *Bhagavad Gītā*. In *My Neighbor's Faith: Stories of Interreligious Encounter, Growth, and Transformation*. Edited by Jennifer Howe Peace, Or Rose and Gregory Mobley. Maryknoll: Orbis Books.

Long, Jeffery D. 2015. The *Gītā*: A Healing Revelation. *Sutra Journal*. August. Available online: http://www.sutrajournal.com/in-appreciation-of-the-gita-jeffery-long (accessed on 6 March 2018).

Malkovsky, Bradley. 2017. Belief in Reincarnation and Some Unresolved Questions in Catholic Eschatology. *Religions* 8: 176.

Mangla, Dharam Vir. 2016. *Buddhism and Hinduism: A Comparative Study*. Delhi: Geeta International Publishers and Distributors.

Translated by Swami Nikhilananda. 1942, *The Gospel of Sri Ramakrishna*. New York: Ramakrishna-Vivekananda Center, p. 153.

Swinburne, Richard. 2004. *The Existence of God*, 2nd ed. Oxford: Clarendon Press, p. 13.

Theresa of Avila. 1979. *The Interior Castle*. Mahwah: Paulist Press.

Thompson, George. 2008. *The Bhagavad Gita: A New Translation*. New York: North Point Press.

Thurman, Robert A. 1995. *Essential Tibetan Buddhism*. San Francisco: HarperCollins, p. 137.

Tucker, Jim B. 2013. *Return to Life: Extraordinary Cases of Children Who Remember Past Lives*. New York: St. Martin's Griffin, p. 88.

Tucker, Jim. 2015. *Return to Life: Extraordinary Cases of Children Who Remember Past Lives*. New York: St. Martin's Griffin.

Vivekananda, Swami. 1979. *Complete Works*. Mayavati: Advaita Ashrama, vol. One, p. 329.

Translated by Benedicta Ward. 1973, *The Prayers and Meditations of St. Anselm, with the Proslogion*. New York: Penguin Books.

 religions

Article

Pātañjala Yoga's Theory of 'Many-Lives' through Karma and Rebirth and Its Eccentric 'Theism'

Gerald James Larson [1,2]

1. Tagore Professor Emeritus, Department of Religious Studies, Indiana University, Bloomington, IN 47405, USA
2. Professor Emeritus, Religious Studies, University of California, Santa Barbara, CA 93106, USA; glarson@religion.ucsb.edu

Received: 30 July 2017; Accepted: 19 December 2017; Published: 23 December 2017

Abstract: This paper discusses the theory of rebirth as set forth in Classical Samkhya and Yoga and offers a new interpretive perspective.

Keywords: history of religions; India Studies; philosophy of religion; theology

1. Introduction

Michael Kinsley in his book, *Old Age: A Beginner's Guide*, quotes the following blunt question by Larry Ellison, CEO of Oracle:

> Death has never made any sense to me.
> How can a person be there
> and then just vanish,
> just not be there?[1]

Kinsley himself responds to Ellison's question with the following comment:

> Actually the question is not whether death makes sense to Larry
> Ellison but whether Larry Ellison makes sense to death. And I'm afraid
> he does.
> For someone born in the United States in 2013, the most recent year for which there are
> final figures, life expectancy is 78.8 years. That's 76.4 years for males and 81.2 years for
> females. But if you've made it to 65, your life expectancy is 82.9, if you're a man, and 85.5 if
> you're a woman.[2]

This is as good a way as any to introduce the "contemporary relevance" issue with respect to the purpose of our special issue on karma and rebirth, since all of of us who are contributing to this issue to some degree find ourselves wrestling intellectually and personally with the matter of death, regardless of how we handle this basic question, whether with Hindu, Christian, agnostic, atheistic or secularist reflections.

Equally blunt is the manner in which Samuel Scheffler raises the matter of death in his book, *Death and the Afterlife* by presenting two similar but interestingly different thought experiments regarding how we think about "death and the afterlife."[3] He asks us to think about how we would react to two doomsday scenarios, first, a sudden doomsday, and second, a 'softer' doomsday. First, says Scheffler,

1. (Kinsley 2016).
2. *Ibid.*
3. (Scheffler 2013) (first delivered as a Tanner Lecture at UC Berkeley in March 2012, copyright with The Regents of the University of California, 2012).

Suppose you knew that, although you yourself would live a normal life span, the earth would be completely destroyed thirty days after your death in a collision with a giant asteroid. How would this knowledge affect your attitudes during the remainder of your life?[4]

Or, (secondly) borrowing from a thought experiment from P.D. James novel, *The Children of Men*, Scheffler presents a 'softer' doomsday scenario. Suppose, he suggests, that human beings have become infertile, "with no recorded birth having occurred in more than twenty-five years," Scheffler continues,

It is entirely compatible [in such a 'softer' doomsday scenario] with every living person having a normal life span. So if we imagine ourselves inhabiting [such an infertile world] ... it is clear that those reactions would not include any feelings about the premature deaths of our loved ones, for no such deaths would occur (or, at any rate, none would occur as an essential feature of the scenario itself).[5]

The difference between the two doomsday scenarios, of course, is that the latter is a somewhat 'softer' doomsday than the former, since the latter does not involve the death of friends, loved ones and the common world that we all enjoy in our current lifetimes.

Scheffler, it should be stressed, does not himself believe in any sort of personal afterlife or personal immortality. Each of us has but one life, and each of us will personally die. There is, however, says Scheffler, an afterlife that in many ways is much more important than our personal life, and that, of course, is the collective afterlife. Human life and life in general continue to go on for all persons and/or sentient creatures after our particular personal life ends, and Scheffler wants to argue, or attempts to argue, not only that the understanding of the meaning of our personal life depends on the collective afterlife only for those who do not believe in a personal afterlife, but even for those who do believe in a personal afterlife. To oversimplify in the interest of time, Scheffler's basic thesis is that the meaning of "one life" or our "one personal life" presupposes the collective presence of "many lives" and that personal death is important for making sense of "(our) one life" as well as the "many lives" or, in other words, the "many lives that come after us" as well as "the many lives that have preceded us". The doomsday scenarios, says Scheffler, make quite clear why this should be the case.

Finally, it should also be noted, that Scheffler is inclined to agree for the most part with the argument of Bernard Williams that "immortality" as a general notion is as equally problematic as a personal after-life, because the reality of death that makes one life exciting and challenging precisely because of its constraints, would lead to an incoherent tedium or boredom with a state of immortality wherein all such constraints are absent.[6]

2. Karma and Rebirth in Pātañjala Yoga and the Issue of Theism

But turning now to South Asian Hindu notions of karma and rebirth and the implicit notion of theism that operates within the framework of a theodicy of karma and rebirth (at least in the Yoga of Patañjali), especially instructive is the discussion of these issues in the *Yogasūtra* (hereafter YS) and its accompanying *Bhāṣya,* and in particular YS II. 13 and YS I. 24. [In an Appendix A to this summary presentation, I am attaching a full translation of YS II. 13 and YS I. 24, with the accompanying oldest *Bhāṣya* (commentary) for those who would like to see the full textual presentation.[7]]

These Hindu arguments of Pātañjala Yoga, I am inclined to think, come close to what Scheffler is attempting to argue in his book, *Death and the Afterlife*.

In II.13, a sequence of four questions is posed as follows, namely,

[4] *Ibid.*, p. 18.
[5] Ibid., p. 39.
[6] See citation and discussion of Bernard Williams (1973).
[7] For the Sanskrit text of the YS and the *Yogasūtrabhāṣya,* I have used the (Bhattacharya 1963), pp. 61–65 (for YS II. 13) and pp. 24–27 (for YS I. 24). The English translation from the Sanskrit is my own.

(1) Is it the case that one karmic action is the cause of one rebirth?

Or, (2) Is it rather the case that one karmic action is the cause of many rebirths?

Or, (3) Is it the case that many karmic actions bring about many rebirths?

Or, (4) Is it the case that many karmic actions bring about one rebirth?

The first three questions are given a negative answer, the first, because one karmic action causing one rebirth would rule out a proper sequence for the fruition of the many other karmic actions in a single rebirth; the second, because one karmic action causing many rebirths would eliminate the requisite time for accommodating all the karmic actions (that need to be accommodated); the third, because if many karmic actions were causing many rebirths, there would be required a simultaneity of rebirths that is obviously not possible. Only the fourth question, then, can be answered in the affirmative, that is to say, many karmic actions come together at the conclusion of one rebirth to bring about a single subsequent rebirth (*ekabhavitka*, or one life) that has (*ekabhavika*, or one life) a distinctive species-identity (*jāti*), a distinctive length of life (*āyus*), and a distinctive quality of experience in that rebirth (*bhoga*) based upon the massive heritage of previous karmic residues, karmic traces and karmic predispositions (*āśaya*-s, *vāsanā*-s and *saṃskāra*-s).

Karmic actions are, thus, (beginninglessly!!) cumulative, with some immediately dominant and/or predictable karmic actions being manifested in the new (or present) rebirth (*prārabdha*), and others being unpredictable and/or un-fixed, with some being stored (*sañcita*) for a subsequent manifestation in the present rebirth or for a subsequent rebirth, and some generating new karmic action in the present rebirth (*sañcīyamāna*) that will have fruition in yet future rebirths. Regarding the unpredictable and/or un-fixed karmic actions, three outcomes are possible. First, some may be set aside completely because they have become overpowered by more powerful karmic actions. Second, some may be easily endured by becoming absorbed in a larger unfolding dominant karmic manifestation. Or third, some may be simply be waiting in abeyance over several rebirths until they can become activated at an appropriately ripe moment (the *a-dṛṣṭa* or *a-pūrva* fruitions) that appear to be un-expected or un-forseen. These latter, that is, the *adṛṣṭa* or *apūrva*, are obviously variable and impossible to specify, but these unpredictable and/or unexpected karmas are exceptions (*apavāda*) to the general rule, and, indeed, are mysterious (*durjñāna*) in the sense that they are exceptions to the general rule that karmic actions heap up at the end of a rebirth (one's personal death) and then become manifest in a single one life rebirth (*ekabhavika*) characterized by *jāti*, *āyus*, and *bhoga*.

Thus, there are cumulatively "many lives" over time issuing in single-life personal manifestations (like the personal life we are all experiencing in this present life) that will then transmute into a series of 'many lives' in the future. The entire unfolding process is a closed causal system of becoming (*satkāryavāda and traiguṇya*). One's personal life in a given rebirth is not negated but, rather, greatly expanded, in the sense that our personal identity is part of a continuing diachronic series of variable rebirths, informed by many lives that have gone before and many other lives that are yet to come.

If one asks, then, what role does God play in such a closed, comprehensive system of synchronic phylogeny (the co-presence of all species) and diachronic ontogeny (the historical or real time becoming of life after life), the philosophy of Yoga (in keeping with the Sāṃkhya dualism) suggests the following in YS I. 24:

> "God (**Īśvara**) is a particular or unique consciousness (*puruṣa*) (among a variety of manifestations of consciousness) (*puruṣa-bahutva*) untouched by the afflictions (*kleśa*-s) [*avidyā, asmitā, rāga, dveṣa, abhiniveśa*], karmic actions (*karman*), karmic fruits (*vipāka*) and long-term karmic pre-dispositions (*āśaya*-s) (that are characteristic of all other sentient beings associated with manifestations of consciousness)."[8]

8 *Ibid.*, p. 24 in the Sanskrit edition.

God, in other words, is not part of the karma and rebirth system of becoming, and, hence, cannot be a creator (since God is not associated with the cause and effect system), nor can God be personal (since God is disconnected from the notion of "person" as *ahaṃkāra* or *asmitā* in the karma and rebirth scheme of things).[9] Most puzzling of all, God is neither a cosmic Ātman nor Brahman or any other Absolute, but only a particular manifestation of consciousness among a variety of manifestations of consciousness. In other words, there is a strange reversal in Pātañjala Yoga (and Sāṃkhya) of the notion of the One and the Many. The realm of embodied becoming is a uniform and rational realm of cosmic, all-pervasive Unity (*prakṛti* = *triguṇa*) enveloped on all sides (and, again, all-pervasively) by a pluralized or quantized consciousness, one quantum of which consciousness is designated Īśvara.

Who or what, then, is this unique (*viśeṣa*) consciousness among the quantized varieties of consciousness, which together make possible the experience of all varieties of karmic becoming? God becomes manifest as the eternal excellence (*śāśvatika-utkarṣa*) that shows itself when the *citta-sattva* has been appropriately purified (through the practice of Yoga). The practice of Yoga, however, is not the cause of the manifestation of eternal excellence or the eternal presence of consciousness, since eternal excellence is not part of the causal order. The practice of Yoga only removes the obstacles for the manifestation of what has always been the case, that is, consciousness as the exemplar of complete freedom ["*tadā draṣṭuḥ svarūpe 'vasthānam*," YS I. 3], or, in other words, consciousness as the radical foundation of freedom.[10]

3. Conclusions

Let me share a few brief concluding observations. It was Max Weber who first highlighted in an essay entitled, "The Social Psychology of the World Religions" the three classic formulations of "theodicy" [that is, cogent explanations for the suffering and injustice that one finds in the world, including, of course, life and death.] Weber comments,

> The metaphysical conception of God and of the world, which the ineradicable demand for a theodicy called forth, could produce only a few systems of ideas on the whole—as we shall see, only three. These three gave rationally satisfactory answers to the questioning for the basis of the incongruity between destiny and merit: the Indian doctrine of Karma (and rebirth), Zoroastrian dualism, and the predestination decree of the deus absconditus. These solutions are rationally closed; in pure form, they are found as exceptions.[11]

The Yoga (and Sāṃkhya) view of karma and rebirth, puts great stress on the responsibility of the individual person to bear the consequences of his or her own becoming but does so by greatly expanding the notion of "person" or sentient being to an extent that it encompasses a great number of "many-lives" giving re-birth to a diachronic series of embodied behaviors for which this broader sense of "person" must bear responsibility. Such a view, therefore, looks upon the notion of "person" solely in terms of one single life as a rather naïve and afflicted (*kleśa*) view of personal life greatly out of touch with its truly vast identity and significance.

At the same time, the Yoga view, by greatly expanding the reality of the diachronic becoming of the "person" lessens seriously the work of God, who is neither a "person" nor a "creator", but, rather, is an all-pervasive presence of eternal and immutable consciousness that is always present as the certitude of freedom for those able (through Yoga) to get beyond the constraints or bondage of ordinary awareness (*citta*).

One need not buy into the archaic metaphysics used in ancient times to explain the process in terms of "transmigration," "reincarnation," "subtle bodies floating into new gross bodies," and so

[9] This understanding of Īśvara has been contested in recent scholarship—e.g., (Bryant 2009)—and in Sanskrit commentaries on the *Yoga Sūtras*.
[10] *Ibid.*, p. 6 in the Sanskrit edition.
[11] (Gerth and Mills 1946).

forth. It is perhaps possible simply to accept the idea that my one single life is hardly just an isolated event in time but, rather, that I am in a great company of companions, many of whom are nearly identical to myself, who have made my life possible and that what I do with my life will have profound implications in the lives who come after me in countless generations to come. I must take responsibility for the events that surround me and with which I have been involved in preceding trajectories in which I had a different name and a different behavior pattern. God has not created my life; I have through my deeds.[12] God's grace (*anugraha*), is the simple presence of the consciousness that illumines my particular life and enables me to have experience. More than that, it is a witnessing presence that reveals to each or any sentient being that it can only be what it has made itself to be, and that authentic spiritual freedom brings with it the terrible destiny that I must take responsibility for myself in the great hierarchy of unfolding life.

Conflicts of Interest: The author declares no conflict of interest.

Appendix A

Yogasūtra II.13 and I.24 with accompanying *Bhāṣya*:

(YS II.13)

-SO LONG AS THE BASE CONTENT CONTINUES TO EXIST, THERE IS THE RIPENING OF THAT STORED KARMA IN TERMS OF THE FORM OF LIFE, THE LENGTH OF LIFE, AND THE QUALITY OF LIFE (THAT A SENTIENT BEING WILL ASSUME IN THE NEXT BIRTH).

[sati mūle tad-vipāko jāty-āyur-bhogāḥ]

[The *Bhāṣya*:]

-When the afflictions are continuing to exist, there is the beginning of the ripening of the karmic residue (*karmāśaya*) but not if the root of the afflictions has been uprooted.

-Just as rice grains covered with chaff made up of unburned (living) seeds are capable of growing, but not the rice grains that have had their chaff removed and the seeds burned; so in a similar fashion karmic residues or propensities (*karmāśaya*) covered with afflictions are capable of ripening, but not those karmic residues whose afflictions have been removed by (what is called) "deep or supreme meditation" (*prasaṃkhyāna*).

-And that ripening is of three types, namely, form of life (*jāti*), length of life (*āyus*) and quality of life (*bhoga*).

-Now herein, the following is to be discussed. Is it the case that one karmic action is the cause of one rebirth? Or is it rather the case that one karmic action is indicative of many rebirths?

-There is also herein a second discussion (to be pursued). Is it the case that many karmic actions bring about or accomplish many rebirths? Or is it rather the case that many karmic actions bring about one rebirth?

-First of all, it is not the case that one karmic action is the cause of one rebirth.

-Why? There is entailed then a dissatisfaction (for those) in (their) present birth, since the remaining innumerable karmic actions heaped up from beginning-less time are not ordered in a proper sequence of fruits (ripening effects), and such is (obviously) not reasonable.

[12] Though this statement can be qualified with the understanding that my deeds are ultimately not 'mine,' but originate in the impersonal causal process of nature, or *prakṛti*.

-And likewise one karmic action is not the cause of many (or more than one) rebirths.

-Why? Since among many karmic actions only one would be the cause of many rebirths; and it would then be entailed that there would be insufficient time for the ripening of the remaining karmic actions. That also is (obviously) not reasonable.

-And, finally, more than one karmic action is not the cause of more than one rebirth.

-Why? More than one birth or many rebirths cannot occur simultaneously. They can only occur sequentially or one by one.

-Like the preceding two possibilities, this third possibility is also (obviously) not reasonable.

-[Only one plausible possibility remains as follows.] Therefore, the heaping up of the varied karmic actions (*karmāśaya*), both meritorious and de-meritorious, made or generated (*kṛta*) over the course of one life, from birth to death, organized (*avasthita*) in terms of primary and secondary (force), coming together in a single fashion, coalesce at the time of dying into a single mass and make or generate only one rebirth (*janma = jāti*).

-And that (form of) rebirth (*jāti*), by reason of (the accumulative) karmic force, determines the length of life (*āyus*) of that new rebirth.

-In this new form of life, again by reason of karmic force, the quality of life (*bhoga*) of this new rebirth comes forth or unfolds.

-This residue of karmic actions (*karmāśaya*) is called a threefold ripening, since the form of life (*janma = jāti*) (of the new rebirth) its length (*āyus*) and its quality of experience (*bhoga*) have been caused as has been just described.

-Hence, "the residue of karmic actions" (*karmāśaya*) is known or said to be a "single coming to be" or a singular rebirth (*ekabhavika*).

-Moreover, due to the causation (known as) quality of life (*bhoga*), there may be the appearing of one ripening in the present rebirth. Or, due to the causation (known as) length of life (*āyus*), there may be two sorts of ripening like in the instances of Nandīśvara and Nahuṣa (mentioned above).

-One's ordinary awareness (*citta*) is constituted by a variety of predispositions or traces (*vāsanā*) congealed from beginning-less time with the experiences of ripenings of karmic actions and afflictions, extended as it were like the knots of a fisherman's net. These predispositions (*vāsanā*) are (the markings) from multiple previous rebirths.

-That which is meant here, however, refers only to the residue of karmic actions (*karmāśaya*) from one preceding rebirth, hence known as a "single coming to be" or a "singular rebirth" (*ekabhavika*).

-Those predispositions (*saṃskāra*), known as (that group of) predispositions or traces (*vāsanā*), which are the causes of memory, (are derived) from beginning-less time.

-Furthermore, that karmic residue (*karmāśaya*) that pertains to a single rebirth (*ekabhavika*) has both a fixed or predictable ripening and an un-fixed or unpredictable ripening (*vipāka*).

-Therein, regarding the fixed ripening that pertains to a single rebirth in the present life, it follows the rule (*niyama*) of its designated fruition, but this is not the case for the un-fixed or unpredictable ripening.

-Why? What is not experienced in the present rebirth, and hence, un-fixed, is subject to three distinct outcomes. First, it may be destroyed without coming to fruition. Second, it may be dissolved in a more dominant ripening. And third, it may be postponed for a long time because of other fixed or predictable ripening.

-Therein (in regard to the first type) of un-fixed or unpredictable ripening, there is the possibility of the destruction of unpredictable black (negative) karma due to the "rising up of white (virtuous) karmic ripening. [And see YS IV. 7 for the discussion of "black" and "white" karma.]

-As has been said: "Two types of action must be understood! One heap of meritorious action destroys (the black action) of the doer of evil. Thus, choose good deeds to do. Here in this world, the poets make known proper action."

-(In regard to the second type, namely,) the dissolving of an un-fixed or unpredictable karmic action into a stronger or dominant karmic action.

-Wherein this has been said:

"Even a small mixture (of bad karma derived from sacrificial action) can be remedied and is endurable. It is not enough to drive away the good karma. Why? There is much in me which is good so that whatever (bad karma) is dissolved in the good karma will make only a small discomfort (for me) in heaven."

-(In regard to the third type, namely,) the karmic action that has been postponed for a long time by reason of having been overpowered by the fixed or predictable principal karma.

-How (is this third type to be explained)? The moment of death is said to be the cause of the manifestation of the karmic action that has a fixed or predictable ripening schedule in a future life, but death is not the cause of karmic action which does not have a fixed ripening schedule (because it is subordinated to the dominant predictable ripening).

-This un-fixed or unpredictable karmic action, not being experienced in the present rebirth and thereby destroyed (by the fixed karmic action) or dissolved into the dominant karmic action, would continue to abide for a long time in an overpowered state until such time as the manifesting general karmic action no longer interferes with the intended ripening of it.

-Since the ripening of it (that is, this third type in a future rebirth) is not ascertainable in terms of space, time and causation, the course of this sort of karmic action is variable and impossible to specify.

-This does not set aside the general rule, however. It is only an exception (*apavāda*). Hence, karmic residue or the residue of karmic actions (*karmāśaya*) can correctly be said to be (*anujñāyate*) "arising from one preceding rebirth" or "single rebirth" (*ekabhavika*) primarily.

(YS I.24)

[Preface by the *Bhaṣya*:]

-Is this God (*īśvara*) by name separate from materiality (*pradhāna*) and consciousness (*puruṣa*)?

-GOD IS A PARTICULAR OR UNIQUE CONSCIOUSNESS (AMONG THE MANY MANIFESTATIONS OF CONSCIOUSNESS) UNTOUCHED BY THE AFFLICTIONS, KARMIC TENDENCES, KARMIC FRUITS AND LONG-TERM KARMIC PRE-DISPOSITIONS (THAT ARE CHARACTERISTIC OF ALL OTHER SENTIENT BEINGS ASSOCIATED WITH PURUSAS).

[kleśa-karma-vipāka-āsayair aparāmṛṣṭaḥ puruṣa-viśeṣa īśvaraḥ]

[The *Bhāṣya*:]

-"Afflicitions" refer to the five, ignorance (*avidyā*) and so forth. "Karmic tendencies" refer to good and evil actions (or deeds). "Karmic fruits" refer to the result or consequence of those actions (or deeds). "Karmic pre-dispositions" refer to the long-term impulses (*vāsanā*) associated with those actions (or deeds) and pre-dispositions.

-And all these operating in the mind are ascribed to (or are reflected in) consciousness (*puruṣa*), for consciousness is the "enjoy-er" (*bhoktṛ*) of the fruit (or result) of these (operations);

-Just as (*yathā*) victory or defeat among soldiers is ascribed to the leader (of an army).

-God, however, is a particular consciousness untouched by this sort of experience.

-Now many (*tarhi...ca*) practitioners (*kevalin*) have attained spiritual release (*kaivalya*), for they have attained spiritual release having overcome the three types of bondage.

-There has not been or ever will be, however, any such relation to bondage by God.

-Although the consciousness (*puruṣa*) of a released Yogin has reflected earlier experiences of bondage, such is not the case for God.

-Or, as a later limit of bondage will come to be of a Yogin dissolved in materiality (*prakṛti-līna*), not so for God.

-In other words (*tu*), God is always released; is always just God!

-What is this eternal excellence of God because of an abundance of pre-eminent *sattva*, is it caused or not caused? [Answer:] Its cause is the Śāstra!

-But what then is the cause of the Śāstra? [Answer:] It is caused by the abundance of pre-eminent *sattva*! [In other words, each causes the other.]

-In regard to God's *sattva*, there is a beginningless relation between the abundance of pre-eminent *sattva*, on the one hand, and the Śāstra, on the other.

-Thus, therefore, God always exists and always is released.

-And the power of God has no equal and is incomparable, so that (God's) power cannot be exceeded by another power.

-If there were another power possessed of pre-eminence, that would then be the supreme power.

-Thus, wherein there is the highest limit of power, there is just God!

-And there can be no equality or equal power. Why? Since, when two comparable powers are seeking a separate purpose simultaneously, thinking, let this be a new (path to follow), or let this be an old (path to follow), there will be a diminution of the willfulness of the one or the other when a certain result is achieved.

-In other words there can be no attainment of a separate end or purpose by two equal powers, since the purposes contradict one another.

-Thus, whose power has no equal and is incomparable, that is just God!

-This is what is meant by referring to God as a "unique consciousness (among the many manifestations of consciousness)" (*puruṣa-viśeṣa*).

References

Bhattacharya, Ram Shankar. 1963. *Pātañjala Yogadarśanam*. Varanasi: Bharatiya Vidya Prakashan, pp. 61–65.

Bryant, Edwin. 2009. *The Yoga Sūtras of Patañjali: A New Edition, Translation, and Commentary*. New York: North Point Press.

Gerth, H. H., and C. W. Mills, eds. and trans. 1946, *From Max Weber: Essays in Sociology*. Oxford: Oxford University Press, pp. 275–79, 358–59.

Kinsley, Michael. 2016. *Old Age: A Beginner's Guide*. New York: Tim Duggan Books, Imprint of Crown Publishing Group, a Division of Random House, pp. 52–53.

Scheffler, Samuel. 2013. *Death and the Afterlife*. Edited by Niko Kolodny with Commentaries by Susan Wolf, Harry G. Frankfurt, Seana Valentine Shiffrin and Niko Kolodny; New York: Oxford University Press.

Williams, Bernard. 1973. The Macropulos Case: Reflections on the Tedium of of Immortality in *Problems of the Self*. In *Death and the Afterlife*. Edited by Samuel Scheffler. Cambridge: Cambridge University Press, pp. 88–100.

Article

Seeing in Eternal Return: Hermeneutical Perspectives on Karma and Rebirth

Jonathan Edelmann

Department of Religion, University of Florida, Gainesville, FL 32601, USA; jonathanedelmann@ufl.edu

Received: 15 September 2017; Accepted: 14 November 2017; Published: 16 November 2017

Abstract: This article is a reflection on a conception of death, that of karma and rebirth, and its value in interpreting one's life. I have thought about this conception in two ways. The first is that I can see the circumstances of my life as the result of causes of which I was the agent, and the second is that I can see my life and the relationships in my life as part of a much larger narrative that began before this life. Through an examination of Vaishnava and Advaita theology, Nyāya philosophy, and some Puranic and Epic texts, I argue for an interpretation of karma and rebirth as a rational system that allows one to see relationships as involving many layers of complexity.

Keywords: rebirth; Rāmānuja; Gauḍīya Vaiṣṇava; eschatology; karma; saṃsāra; hermeneutics; Indian philosophy; Uddyotakara (Nyāya); pratyābhijña; Advaita (Sureśvara)

Time is but the stream I go a-fishing in. I drink at it; but while I drink I see the sandy bottom and detect how shallow it is. Its thin current slides away, but eternity remains.

Henry David Thoreau, from *Walden*, "Where I lived, and what I lived for"

Fare you well, fare you wellI love you more than words can tell

Words by Robert Hunter, music by the Grateful Dead, "Broke-down Palace"

1. Introduction

This article is a reflection on a conception of death, that of karma and rebirth, and its value in interpreting one's life. I have thought about this conception in two ways. The first is that I can see the circumstances of my life as the result of causes of which I was the agent, and the second is that I can see my life and the relationships in my life as part of a much larger narrative that began before this life. My approach here is not argumentative; this article is not an attempt to assert the superiority or validity of one view over another. It is hermeneutical and interpretive; I reflect on what it means to see the events one's life through a many life theistic model. Simply put, what does belief in rebirth matter to *this* life?

The two quotations above are the sorts of ideas about death that were imprinted in my mind in my mid-teens; both express the fleeting nature of life and inspired me to think about what death means for life. In my late-teens and thereafter I began to study and reflect on Indian religious traditions, even performing the ritual, meditative, and ethical practices in my own life. I became especially aware of the "many lives theism" of the Gauḍīya Vaiṣṇava tradition and other related traditions. The "many life theism" of Gauḍīya Vaiṣṇavism and other many life scenarios of the Indian traditions offered

alternatives to the more familiar "one life theism"[1] and various forms of "physicalism,"[2] had access to as a young adult. The term "many life theism," as I use it here, is the view that there is *karma* (a "law" of action and reaction that governs or controls sentient beings) and *saṃsāra* (repeated birth and death with no beginning, *anādi*, but with an end, called *mokṣa*), all of which is overseen by God. Karma, then, is the determining power in life into which freewill might insert and assert itself in some way, and *saṃsāra* characterizes the soul's movement in the process of living over the course of unlimited embodied instantiations. While not all Indian religions are theistic, I explore a theistic models of *karma-saṃsāra*, one sustained by God in some manner, and one in which a real or eternal self is the experiencer of the various embodied existences. I make some attempts to distinguish this from single or one life theism (especially as found in the Abrahamic religions) and Buddhism (a *karma-saṃsāra* model with no God and no unchanging or eternal soul, *anātman*), and I acknowledge the more metaphysically reduced model of scientific reductionism (that consciousness is produced from the body and brain, an organism that is the result of a purely material process of evolution).

The introduction of these new ideas from the Indian traditions were a significant hermeneutical break with the conventional ideas with which I had grown up, a break that is significant enough to deserve a focused and critical reflection. This particular article was inspired by the questioning of Professor Francis X. Clooney, SJ, which led to a series of panels at the Dharma Academy of North America and the American Academy of Religion in 2015 and 2016. I have thought about rebirth scenarios Indologically, and philosophically and theologically. For me questions about death immediately led to questions about how I should live knowing that I shall die, about why we find ourselves in existence at all, or the cause of the brute fact of our existence, and why our individual life is the way it is and not some other way. The study of philosophical and theological texts has continued to enrich and refine the ways that I address these issues in my personal quest to make sense of the mystery of being.

2. Seeing One's Life as the Result of Causes from a Previous Life

The argument of this section is that the theistic *karma-saṃsāra* view can be interpreted as a rational system in the sense that the individual's will (*kratu*), which I understand as an agent's (*kartṛ*) desire (*kāma*) that has become a resolution or a decision to act in a particular way, is the cause of effect's in an individual's life. Effects are one's dispositions (*vāsanās*), socio-economic circumstance (*varṇa*, which we might, interestingly, think about as a form of class or even "caste"), as well as all the personal attributes of the body such as intelligence, physical strength, attractiveness, length of life (which we might think about as phenotype and the underlying genotype). The defining feature of the *karma-saṃsāra* model I wish to highlight here is that the effects are produced by causes (the "will") and that the cause-effect relationship is pre-determined, universal, and for the most part inviolable. These are the conditions that would make *karma-saṃsāra* "rational." It may or may not be rational to believe in rebirth,[3] but many sought to present a logically coherent picture of why a person has particular circumstances based on cause-effect reasoning. *Karma-saṃsāra*, then, is an explanatory model that

[1] These terms, many life theism and one life theism, are from Filice (2006). While recognizing the diversity of Abrahamic theologies, I would call them "one life theism," i.e., that the soul is born and dies once, after which an eternal destination is assigned. There is purgatory, particularly in the Roman Catholic tradition and to a more limited degree in the Church of England, a temporary place of venial-sin-expiation, espoused by Clement of Alexandria, Thomas Aquinas, the Council of Trent and the Tractarians (Cross and Livingstone 1974, *sv.* purgatory). While not argued here, I think the concept of purgatory is different from the *karma-saṃsāra*-many-life model discussed below because purgatory is a one time event, whereas rebirths are many. There is evidence that Christian authors new of a rebirth systems, probably from Plato, early on, but it was rejected, e.g., in Augustine's *City of God*, Book X, Chapter 30, *ff.*; he argues against reincarnation and the co-eternality of soul with God. Tertullian also argued against rebirth (Edwards 2001, chp. 14).

[2] Briefly, physicalism is the view that consciousness fully depends on the brain; for discussion and evaluation from a Vaiṣṇava point of view see (Edelmann 2012, pp. 61–92).

[3] In addition to Filice (2006), *op. cit.*, who argued for the philosophical consistency of many life over one life theism, the vast body of work by Ian Stevenson (1997) and his students attempts to ground rebirth in scientific terms using the methods of contemporary science. See (Edelmann and Bernet 2007) for discussion and evaluation.

eschews chance as an explanation as to why a being's particular effects are attached to his life and not some other.

Before I examine Sanskrit classical sources, let me begin with two different, but noteworthy, 20th century thinkers who argued that rebirth is a rational model. Bimal Krishna Matilal (1985, pp. 363, 366), a philosopher, wrote in an examination of *karma*: "The present comes out of the past and the shape of the future depends upon what we do in the present [...] The law of *karma* is a principle of moral causation. This principle of moral causation is an extension of the principle of causation in the field of physical or natural science to the field of ethics and moral responsibility." He goes on to say that the *karma* theory, "refuses to admit that the world is arbitrary and that there is anything called chance or caprice." His point is that there is a rational connection between an agent's moral choices in the past and the condition in which he presently lives, and that this form of causal relation is like the physical sciences, i.e., governed by cause-effect laws. Ian Stevenson (1997, p. 5), a parapsychologis, was led to think about this issue as follow:

> During the last century medical research has increased our knowledge of some of the proximate physical causes of birth defects ... But causing them in which persons? Why is one person born with a birth defect when another—his twin brother perhaps—is not?"

He goes on to say that those who hold a conventional medical or scientific view can examine physical causes, but they "cannot—without violating their principles—ask about more ultimate causes, such as why a particular *person*, as opposed to a particular *body*, has a congenital malformation" (ibid., italics in original). Reincarnation tells us why a particular good or bad situation in life belongs to a particular person; it explains not just the cause of the effect, but why an effect is located on a specific agent.

2.1. Karma-Saṃsāra Explains the Circumstances

The early Vedic tradition centralized the human will or intention (*kratu*) as the determinative force and it is from the will, a cause, that effects, the circumstances, are produced. While the Veda Saṃhitās are generally seen to have not said anything about *karma-saṃsāra*, the *Śatapatha-brāhmaṇa* (10.6.3.1) says:

> Let one meditate on the truth that is brahma! Now this person here is indeed made of will. According to his will, when he departs from this world, he becomes of similar will in the next world beyond.[4]

For the *Śatapatha-brāhmaṇa* it is undoubtedly a sacrificial context in which this will would have been exercised and the results of the exercising of this will would have also been understood in a cosmology defined by the Vedic ritual, but it makes a lot of sense that the will would be seen as so important since the sacrificer, in this context, by choosing to a particular ritual, is shaping his future.

The view that one's will could determine one's future was articulated in the *Bṛhadāraṇyaka-upaniṣad* (4.4.3, cf. *Chāndogya-upaniṣad* 3.14.1), using much the same terminology as the *Śatapatha*, but in a more general context than ritual. It likens the death experience to reaching out or stepping toward another body (*anyam ākramam ākramya*), just as a caterpillar moves from the tip of one blade of grass to another.[5]

[4] satyaṃ brahmety upāsīta | atha khalu kratu-mayo 'yaṃ puruṣaḥ sa yāvat kratur asmāl lokāt praityevaṃ kratur hāmuṃ lokaṃ pretyābhisambhavati (Kane 1962, p. 1535). Kane clearly based his translation on Eggeling (1897, p. 400), yet the latter translates *kratu* as "understanding, or will, purpose," and he notes a very similar passage as the *Śatapatha's* in the *Chāndogya-upaniṣad* (3.14.1), along with Śaṅkara's commentary, which seems to justify this translation. The context for the *Chāndogya* is a discussion on how one should meditate on brahman. Śaṅkara writes: "How should one meditate? One should set to a will. A resolution or will is an intentional cognitive episode that is fixed, like 'it shall be so,' which is unwavering; by this means one should meditate (on *brahman*)" (Jha 1942, p. 151). katham upāsīta | kratuṃ kurvīta kratur niścayo 'dhyavasāya evam eva nānyathety avicalaḥ pratyayastaṃ kratuṃ kurvītopāsītetyanena vyavahitena sambandhaḥ. Sanskrit text from: http://gretil.sub.uni-goettingen.de/gretil/1_sanskr/1_veda/4_upa/chupsb_u.htm.

[5] When introducing the analogy of a craftsman (perhaps a weaver or goldsmith) who creates an artifact out of the old material that is newer and more beautiful (*navataraṃ kalyāṇataraṃ*), the Upaniṣad introduces an implicit progressiveness to the process, but later accounts are not as optimistic (ibid., 4.4.4).

The clincher for a *karma-saṃsāra* view is in 4.4.5: "If one acts good (*sādhu*), one becomes good; if one acts negatively (*pāpa*), one becomes negative. One becomes something positive (*puṇya*) by positive action, something bad by bad action." The Upaniṣad goes on to say that as one desires (*kāma*), one then forms a resolve or will (*kratu*), from which one then acts in particular ways, and that action determines one's future (Olivelle 1999, pp. 120–24). Śaṅkara notes something very important here, i.e., that "desire is the root or foundation of rebirth" (*kāmo mūlaṃ saṃsārasya*, comments Bṛhadāraṇyaka 5.4.7, see (Kane 1962, p. 1548)). This model looks to the future, providing a chain-linked explanation—i.e., from desire, to will, to action, and finally, to result—but one only needs to reason *back* (into an infinite past[6]) to conclude that one's present situation is the result of the same chain-linked explanation.[7]

The manner in which this will manifests is explained in, for example, the *Mānava-dharma-śāstra* (or *Manu-smṛti*) (12.3)[8] as well as Vātsyāyana's commentary (*bhāṣya*) on the *Nyāya-sūtra* (1.1.2–3), both of which say action can be of body, speech, and mind. For Vātsyāyana the *adharma*, or inappropriate and demerit accruing activity of the body is killing, of the speech is lying, and of the mind is malevolence, whereas the *dharma* of the body is charity, of the speech is truth-telling, and of the mind is compassion. Thus, in each of these three ways the will is expressed and the activities of each would produce good or bad results; there is, then, an attention to ethical considerations if for no other reason to create a better future for one's self. And yet the Upaniṣads, as well as Yoga and Puranic Hinduism, will come to reject the sufficiency of "good" (i.e., *puṇya*, *dharma*, etc.), as discussed below.

The genius of the Yoga tradition was its ability to locate the individual will in a larger karmic cosmological and psychological context. It attempts to explain our habits and dispositions by *karma-saṃsāra*. For example, Vācaspatimiśra I (c.mid-9th century) in his *Tattva-vaiśāradī* (a sub-commentary on the *Vyāsa-bhāṣya* attributed to Vyāsa) on *Yoga-sūtra* 1.24 begins by saying that good and bad actions ripens (*vipāka*) into good and bad results, e.g., into the length and quality of one's life. He goes on to say:

> "Pre-dispositions" (*āśaya*) to action refer to those deep impulses (*vāsanā*) that are commensurate with "ripenings" and that reside in the deep recesses of ordinary awareness. For no behavior typical of a young elephant is conducive towards experience suitable to a young elephant so long as that action does not manifest the type of becoming brought about by the experience of a young elephant in a preceding rebirth. Therefore, the unfolding experience of a young elephant is in conformity with the "ripening" from a (previously existing) young elephant (Larson Forthcoming).[9]

I understand Vācaspati as saying that our present is a constructed result of the our past, that our habits of mind and body, which lead to actions, and which are a fundamental part of our becoming in this world, must be seen in the context of a larger narrative, a story about cause and effect, from a previous life, and by extension that this story was also the continuation of a story that preceded it, and so forth back into eternity. Thus, just as the details of the quality of my life are explained in terms

[6] The *Vedānta-sūtra* (2.1.35 *ff.*) and the commentaries will say that the process of *karma-saṃsāra* must have had no beginning to avoid partiality on the part of God.

[7] Madhva, the Dvaitva theologian, would seem to undermine this rationalistic interpretation in his interpretation of this part of the *Bṛhadāraṇyaka* in saying that "all beings are always under the direct will of the Lord. The desires of a being have their origin in the desires of Viṣṇu, so the beings act in obedience to the desires of Viṣṇu" (Vasu and Bhattacharya 1916, p. 538). Thus our desires would not be our own, nor, then, our fate. B.N.K. Sharma, however, interprets Madhva as saying here that Viṣṇu "causes Jīvas [souls] to do things according to His will in conformity with their deserts. The Lord being possessed of such a nature, the Jīva does what the Lord implies him to do in keeping with his deserts. Hence they say the Jīva follows the Lords will (*Kāmayamānaḥ*) (Sharma 1988, p. 160)."

[8] śubhāśubha-phalaṃ karma mano-vāg-deha-sambhavam | karmajā gatayo nṝṇām uttamādhama-madhyamāḥ || (Mandlik 1886, p. 1478). Karma has a result that is pure or impure; they are created by the body, words, and mind. People proceed to a [position] that is middle, terrible, or great from karma.

[9] vipākānuguṇā vāsanās tāś cittabhūmāv āśerata ity āśayāḥ | na hi karabhajātinirvartakaṃ karma prāgbhavīyakarabhabhogabhāvitāṃ bhāvanāṃ na yāvad abhivyanakti tāvat karabhocitāya bhogāya kalpate | tasmād bhavati karabhajātyanubhavajanmā bhāvanā karabhavipākānuguṇeti | Translation based on Larson, and Sanskrit text from SARIT: http://sarit.indology.info/exist/apps/sarit-pm/works/.

of cause-effect, so are the particulars of my impulses, but they are themselves constructed by actions of the past. Does Vācaspatimiśra give one a fuller sense of the "will" (*kratu*) than in the Upaṇsads, it now being seen as a construction from *karma-saṃsāra*? Should we thus consider our individual will not as an autonomous entity, but as something that is itself a "karmic effect," a feature of our cognitive and psychological life, just as the body is also a "karmic effect"? These are in some sense classical questions in philosophy about *freewill*.

Some Hindu traditions restrict agency to a conventional (*vyāvahārika*) level of reality, one that needs transcendence, and which is ultimately not real. Sthaneshwar Timalsina (2014, p. 207) has argued that Śaṅkara negotiated between the Advaita theologies of earlier figures like Gauḍapādā (c.600 AD) and Bhartṛprapañca (c.550 AD) by saying that freewill and agency operate, in a mediated fashion, within the convention reality (*vyāvahārika*), but not within the unconditioned level of being that is the unqualified brahman. In Advaita theologies there is not only rejection of agency at the ultimate ontology, but even in a poetic and symbolic sense. For example, in his *Naiṣkarmya-siddhi* (1.41–44) Sureśvara (c.740 AD) of the early Advaita tradition presents a particularly dramatic critique of agency. The person whose mind is covered by ignorance (*avidyā*) is bitten (*daṣṭa*) by the teeth of scriptural injunctions to perform action in the Veda, thinking them the causes of his qualification to be the agent of such action. As such he goes up to the level of a god (*deva*) or down to a lower region (*nāraka*) by following or not following the rules, or he becomes a human by mixing good and bad, but in all cases he is *avaśa*, "not free." One is pushed around, "like an empty gourd is violently knocked around with fierce and chaotic fury when in the midst of the ocean."[10]

Sureśvara presents a startling and unsettling *existential* rejection of agency. The embodied self (*jīva*) is helplessly subjected to unwanted pain due to the overwhelming forces of nature, an experience everyone can identify with, even if one does not accept the larger *karma-saṃsāra* model or nondualistic theology. Sureśvara does problematize a rationalistic interpretation of *karma-saṃsāra* since the gourd, even if it could desire, is hardly the cause of action, and we can sympathize with a feeling that we are not always in control of our lives; even our desires might seem well beyond our control at times.

Vaiṣṇavas do accept agency as an inherent feature of the self,[11] even if that agency is a complex and multifaceted concept, one that is often constrained or limited by the material circumstances in which the self is placed, and even if they might agree with the troubled existential picture painted by Sureśvara, and. Nevertheless, much work is still needed to think about how freewill would or could be exercised on the *karma-saṃsāra* model.

2.2. Explaining Experience

The *karma-saṃsāra* model also attempts to explain in rational terms why a person experiences the world the way he does. To use a term from Western philosophy, for Nyāya experience is "theory-laden," but the theory that lades or filters the raw sense data fed into the senses must be constructed in a previous life. The *Nyāya-sūtra* (3.1.18) argues for the existence of rebirth to justify the eternality of the soul by an examination of experience:

> There is the appropriate experience of joy, fear, and sorrow in a new-born because of a connection with memory [produced from] repeated experience in a previous [life].[12]

The commentary (*vārttika*) of Uddyotakara (c.mid-6th century) is particularly helpful in this regard:

> When a child is first born, the senses, (on their own), are unable to comprehend (*adhigama*) sense objects, [and yet] it is seen that a new born child experiences joy, fear, and sorrow,

[10] caṇḍotpañjalaka-śvasana-vegābhihatāmbhodhi-madhyavarti-śuṣkālābuvat (Balasubramanian 2016, p. 107).
[11] For Vaiṣṇava theological concepts of freewill, agency, and self, see the chapters on Rāmānuja, Madhva and Jīva by Martin Ganeri, David Buchta, and Satyanarayana Dasa and Jonathan Edelmann, respectively, in Dasti and Bryant (2014).
[12] pūrvābhyasta-smṛty-anubandhāj jātasya harṣa-bhaya-śoka-sampratipattam.

which is inferable from smiling, trembling, and crying. These arise from an uninterrupted connection with memory, and there is no uninterrupted memory without a previous body. Birth is a connection with feeling, intellect, senses, and body, which is formed as a whole. Joy is the experience of happiness or pleasure upon obtaining what one had hoped for as the intended object. Fear is the experience of the inability to avoid that which one hopes to avoid as it is about to occur. Lamentation or sorrow is when one is separated from a desired object, and one hopes, but is unable, to obtain it. The word *sampratipattiḥ* refers to the proper experience of them [joy, etc.]. Repetition is the occurrence of many direct experiential episodes of an object.[13]

The word "comprehend" (*adhigama*) seems to be key in Uddyotakara's argument, for if infants do not comprehend objects, that is, if they were passive screens, or "tabula rasas," again a term in Western philosophy, upon which stimuli were projected, then they would not have the correct responses to stimuli, or perhaps none at all. Since, for an infant, there is no previous experience to build on, for Nyāya we need to posit a previous birth to make sense of their proper responses to stimuli, e.g., the prick of a needle or the taste of the mother's milk. Let me first say a bit more about what comprehension might mean before exploring why past life experience is needed for an infant. The *Nyāya-kośa* (Jhalakīkar 1928, qv. adhigama) provides these definitions of comprehend (*adhigamaḥ*) (translations my own):

1. *jñāna* or cognition,
2. *prāpti* or apprehension,
3. *svīkāraḥ (vāca-)* or words that have been understood.

Comprehension is thus a cognitive state, one in which there is a particular type of apprehension, and one with a linguistic component. The Nyāya school holds that intentional action—laughing because of joy, crying because of pain, etc.—requires some sort theoretical construct about what is desirable and undesirable. Yet this construct, which results in the experience of joy, etc. is inferable from laughing, etc., and it requires knowledge derived from past experiences, about which one has formed opinions, and that since an infant has joy, etc., the construct must have been created in a previous life. Thus, for Nyāya, previous lives are also necessary for us to make sense of our *present life*. Rebirth rationalizes not only the circumstances of my life, but the reasons why I *interpret* my life as I do. While not discussed here, one could extend the Nyāya model to suggest that the way I interpret my experiences today is also the result of repeated interactions with particular objects.

I conclude this analysis of *karma* in saying that no school of Hindu thought of which I am aware affirms the reality the *person* as a physical and mental being. For Nyāya the "I" that is the person who is joyful is merely an abstract and subtle locus of being. The "I" is not the person that is carried over into the next life, but it is a subject that provides the conditions for the person. Describing the Nyāya thinker Udayana (c.10th century), Chakravathi Ram-Prasad (2011, p. 325) writes, "The Nyāya *ātman* [self] provides no personal identity but provides the condition through which a formal consciousness unifies the psychophysical complex that makes the person." It must be different than the body and mind because it persists through their changes. This leads into important questions about what exactly is the "I" that would reincarnate, but I shall reflect on that below.

[13] jātaḥ khalv-ayaṃ kumsārako viṣayādhigamāsamartheṣu indriyeṣu harṣa-bhaya-śokān pratipadyamāno dṛṣṭaḥ smita-kampa-ruditānumeyān te ca smṛty-anubandhād utpadyante | smṛty-anubandhaś ca nāntareṇa pūrva-śarīram iti | tatra janma nikāya-viśiṣṭābhiḥ śarīrendraya-buddhi-vedanābhiḥ sambandhaḥ | abhipreta-viṣaya-prārthanā-prātau sukhānuvabho harṣaḥ | aniṣṭa-viṣaya-sādhanopanipāte taj-jihāsorhānāśakyatā bhayam | iṣṭa-viṣaya-viyoge sati tat-prāpty-aśakya-prārthanā śokaḥ | tad-anubhavaḥ sampratipattiḥ | eka-viṣayāneka-vijñānotpādo 'bhyāsaḥ (Nyaya-Tarkatirtha and Takatirtha 2003, p. 741). For translation and discussion see Dasti and Phillips (2017).

2.3. Rationality and Theism

One might object that many life theism cannot be rational as I have defined it above since theism suggests that God is in control of one's life and thus the effects that one experiences. This would negate self-responsibility and negate the efficacy of the will that would create good or bad karma. There may be theistic models in which this is true—I had alluded to this in Madhva's commentary on *Bṛhadāraṇyaka* 5.4.7—but here I examine the theism of Rāmānuja (early 12th century), especially his commentary on *Vedānta-sūtra* 2.1.34. Therein he argues God is merely the arbiter, or the distributor of a soul's own karmic deserts.

The *Vedānta-sūtra* characterize God's manner of creating the world as one of distributing the karma of the souls in the world:

> There is no partiality or cruelty (in *brahman*) because he is dependent (on karma when making the world), as seen [in the *śruti*].[14]

There seems to be an allusion to what we might call the problem of evil in Western philosophies; there is an attempt here to show why God is not malicious despite being all-powerful and despite the world being a mixture of pain and pleasure. Rebirth is needed for Rāmānuja to maintain that God is all-powerful and all good. Rāmānuja writes in his *Śrī-bhāṣya* commentary:

> If the manifestation of the world—a diverse mixture of conscious and unconscious things—did belong to the supreme being [Viṣṇu, Nārāyaṇa, Vāsudeva, etc.], who is different from objects in this world that are conscious or unconscious, and all else because of being connected to a paradoxical (*acintya*) power, who existed before the manifest world, who is one and also impartite, [if all that is true] then one would be led to the unwanted conclusion of a created world made of superior, mediocre, and inferior things, consisting in plants, men, animals and gods; [in such a case] since [Viṣṇu] would be the cause of extremely fearful suffering, there would be the unavoidable conclusion of [Viṣṇu] being cruel.[15]

Here Rāmānuja wants to emphasize the impartite nature of Viṣṇu as opposed to the hierarchical and partite nature of the world. How to account for this difference? And given the hierarchical nature of the world, if Viṣṇu were responsible for it, he would be cruel. To avoid this conclusion, Rāmānuja replies,

> The creation or manifestation of this unequal world is dependent upon the *karma* of the living beings (*kṣetra-jña*), i.e., the gods, humans, etc., who are being created.[16]

For Rāmānuja God is the creator, but he makes the world according to the karma of the living beings in the world. From this one can conclude that since *I* performed actions in the past of which *I* am now experiencing, *I* alone am accountable for my present situation and *I* alone am responsible for my future. Thus, there can be the sort of rational cause-effect relation on the *karma-saṃsāra* model, even in a theistic context.

2.4. Hermeneutical Reflection

When thinking about the rationality of *karma*, one of the first questions I would have is *how exacting is karma*? If I get punched in the face by a stranger on the street, is it because I punched a stranger on the street in a past life, or are there just risks and rewards associated with the *karma*

[14] vaiṣamya-nairghṛṇye na sāpekṣatvāt tathā hi darśayati | | (*Vedānta-sūtra* 2.1.34).
[15] yadyapi parama-puruṣasya sakaletara-cid-acid-vastu-vilakṣaṇasya acintya-śakti-yogāt prāk-sṛṣṭer ekasya niravayasyāpi vicitra-cid-acin-miśra-jagat-sṛṣṭiḥ saṃbhāvyet tathāpi deva-tiryaṅ-manuṣya-sthāvarātmanā utkṛṣṭa-madhyamāpakṛṣṭa-sṛṣṭyā pakṣa-pātaḥ prasajyeta | atighora-duḥkha-yoga-karaṇāt **nairghṛṇyaṃ** cāvarjanīyam iti | (Karmarkar 1962, pp. 640–41, para. 292).
[16] sṛjyamāna-devādi-kṣetrajña-karma-sāpekṣatvāt viṣama-sṛṣṭeḥ | (ibid.).

of walking on streets, and the details—getting punched or bumping into an old friend—are left to chance? If I decide to move to a particular place, am I then subject to the general conditions—e.g., storms, violence from other human beings or wildlife, etc.—independent of my personal *karma*, or was it my personal karma that impelled me (through my *vāsanās* and other residues from past lives) that compelled me to move to a particular place? Likewise, is the *karma* of being a human being with a particular race, gender, etc. subject to karmic deserts that are generally related to that race, etc.? In other words, does being a white man have its own karmic deserts that are not *specifically* created by the soul that inhabits the body?

These questions, which I have not found clear answers to in Sanskrit literature, get to the core of what "rationality" might mean in this context, that is, whether the connection between cause and effect is specific or general. To frame the question in the familiar "seed" analogy: do specific karmic seeds, or causes, produce specific fruits or effects, or should we think about karmic seeds, causes, as group-able into general categories that produce effects that are also group-able into general categories? Perhaps one type of seed produces one type of effect, but within each type there is a lot of variation. I do not know of specific answers to these general questions. Perhaps they are best answered through stories.

Having said that, when I have used the ideas above to make sense of my life the result is a radical sense of self-responsibility (e.g., "I did this to myself") and self-empowerment (e.g., "I can remake myself as I like"), coming with this the sense that I do in fact deserve the good and the bad that happens to me and I can in fact change my future irrespective of the particular material circumstances in which I find myself. There is a type of radical libertarianism associated with *karma* theory to think about it in the landscape of American politics, but one with a greatly expanded notion of self since it says that I made my life as it is, even the events that occurred before I had agency (e.g., as an infant) and I can remake my life as I want it; even God is not directly and immediately involved in this, but God acts the distributor of karmic results and the sustainer of existence in which karma operates.

Moral choices can reduce, then, to questions about what kind of being I want to be within the karmic world, and the abandonment of all *karma*, for example by seeking liberation or devotion (*bhakti*), as the case may be, are about not wanting to be anything that the world of *karma* has to offer. But sticking to a discussion about how to understand *karma* within the world (and even if you seek liberation of devotion you still have to decide what kind of being you want to be who seeks those ends while you are in the world of karma), it opens up a lot of questions as to how particular events—e.g., loss of a loved one, an illness, the attainment of a fortune, etc.—were caused by events in the past, events that I, under normal states of mind, have no awareness of. If I am in a painful accident, I do not *know* that this was caused by some choice I made in the past. Therefore, there is something very theoretical in the form of explanation it provides. The notion of self-responsibility is therefore the result of a cosmological theory, not something I derive from my direct and immediate experience, but as an explanation it does explain "scientifically" (i.e., cause-effect reasoning) my phenomenological experience.

Taking for granted that I would not do something that would cause me pain, or I would only do something that would cause me pain if I thought it was worth the bad effect (e.g., I know eating sugary cakes is bad for my health, but sometimes it is worth it), thinking about karma is something of a negotiation with myself about what I'm willing to suffer in order to enjoy. Maybe killing the spiders in my bathroom is worth a little bad karma so I can enjoy an spider-free shower? This itself gets into questions about what really is good and bad karma, or how much something will cost, so to speak. The Sanskrit literature on this subject is vast, but is all of it to be taken seriously? And if not, then how does one decide what is good and bad? One is immediately thrust into the ethical and meta-ethical theory, and there is a sense in which solipsistic questions about what I want to construct out of karma are deeply dissatisfying, whereas moral questions about how to benefit others through action are more satisfying.

One of my first professors of philosophy, Peter Angeles, argued that there is a cold rationality to the *karma-saṃsāra* theory because if I deserve my circumstances in life, so do others, even the poor, sick, oppressed, etc. Rationality can replace compassion. Matilal (1985, p. 368) notes, "But it is highly interesting to see that the law of karma which was originally formulated to oppose fatalism and encourage free will became later on a plea for fatalism." And fatalism, he notes, can underpin a ridge social structure like that of the "caste system." Does believing that a baby born with a terrible disease because of past actions mean I feel less compassion for it? Possibly, but there are other ways to interpret it too, but this might go beyond my scope here. But it also means that karma theory is *not* moral theory, but an *explanatory* and *interpretive* model, and that we need to still consider how to prevent suffering in the world in spite of the rationality of karma.

3. Complex View of One's Self and Others

In this section I argue that *karma-saṃsāra* opens a complexity in how one can think about one's self and others. There is a temporal nature to this complexity. I can see my *present* and of others as multilayered, and the *future* of myself and others are unexpected. One of the things that gives life terror and bliss is the unexpectedness of the future, but karma adds another layer to that unexpectedness, and it adds a way of interpreting it as the rational outcome of the past and present.

3.1. Unforeseeable-Ness

The *karma-saṃsāra* model says there is an infinitely long story that explains how I got here today, and that many of the details of that story—for example the choices I made, the experiences I had, the feelings I felt—are just starting to show their effects, that some will show their effects later in this life, and others in a future life. It is as if I completely forgot that I bought a lottery ticket last week and I'm about to get the positive results, or that I forgot that I took a drug which is beginning to change my mind and body, or that I forgot I had planted a fruit tree long ago and it is about to bear a fruit I can enjoy. There is, then, a multilayered-ness to my material being. To develop this point, I will introduce some familiar terms from the *Vedānta-sūtra* (e.g., 4.1.13–15):

> Karmic residues are of three kinds. (1) There are those residues that were determined at birth to work themselves out during the present life (the one just ending)—these residues are called *prārābdhakarman*. (2) There are those residues that were produced by acts performed either in this life or in a previous one, but which remain latent during this present life—called *sañcitakarman*. (3) Then there are the results of acts performed during this very lifetime, which will mature in some subsequent lifetime in the normal course of events. This kind of karma is called *sañcīyamāna* or *āgamin karman* (Potter 1981, p. 23; cf. Rambachan 2006, p. 106; Buchta 2016, p. 34).

Much of the discussion in the *Vedānta-sūtra* and the commentaries thereon is about how to get free from all forms of karma, what the causes of that freedom are, and what occurs after freedom, but the more interesting phenomenological and hermeneutical question is what does this view of karma say to my present condition, especially (2), the latent karma I have yet to experience?

The complexity I wish to highlight here is that one's *prārābdha-karma*, one's presently experienced *karma*, may place one in either a very good situation (wealth, social prestige, beauty, intelligence, fame, power, etc.) or very bad situation (the opposite), and yet one's *sañcita-karma*, "latent karma," does *not* necessarily demand one's future will be the same as one's present, for the present *karma* and the latent karma might be very different. Because one has un-manifest *karma*, like a seed un-sprouted, there is an unexpectedness to one's life: one simply does not know what kinds of seeds one planted in the past that are yet to grow.

There is a sense, then, that this solves the problem of "why good things happen to bad people," even if that solution is coldly rational. I say this because one could be experiencing the results good karma now, but bad karma, that is latent, suddenly develops an unexpected

way. Bruce Reichenbach (1990, p. 24) notes, "Both sides [theistic and non-theistic Hindus] want to understand why it is that a person experiences pain and pleasure, fortune and misfortune in ways that seem unconnected with the moral quality of their present actions[.]" Good people can also be bad people, and bad people can be good; the ugly can be beautiful, and the beautiful, ugly—all this because there is a deep history to us. We might be good now, but experience the ripening of karmic results that are bad.

3.2. Morality as beyond Good and Evil

The complexity of the *karma-saṃsāra* model is that is also requires going beyond good and bad moral behavior. Hindu theologians mainly focus on entirety of the *karma-saṃsāra* system, that is, the ignorance that underlies the production of karma, arguing that even good karma is bad, and that good and bad must be gone beyond. For example, when discussing fire sacrifices, the *Chāndogya-upaniṣad* (5.24.3) argues, *sarve pāpmānaḥ pradūyante*, that knowledge of *brahman* removes all bad actions (*pāpa*). The Śrīvaiṣṇava theologian Vedānta Deśika, an inheritor of Rāmānuja's theology, discussed this passage. While talking about the contemplation (*upāsanā*) of *brahman*, Vedānta Deśika says in his *Tattva-muktā-kalāpa* (2.55) that the plural of "bad actions" (*pāpmānaḥ*) in the *Chāndogya* indicates that even good action (*puṇya*) must be removed.

S. M Srinivasa Chari (Srinivasa 2004, p. 303), a scholar of Śrīvaiṣṇava theology, summarizes Vedānta Deśika's view: "Since even *puṇya* [or a "good act"] is an obstacle for *mokṣa* [or liberation from *saṃsāra*], it has also to be got rid of [...] Even *dharma* [right action] becomes *adharma* [wrong action] from the standpoint of an aspirant for *mokṣa* [liberation]." This is not to say that good and bad have no meaning or that they are the same, but that good karma is an effect, one that the self would then be required to experience, and because one is required to experience it, one is bound by it. Imagine, if you will, that one plants a mango tree, a fruit that is delicious or good, but the condition is that one must also eat all the fruits it produces until it dies. This would be binding. Many life theism opens spaces for thinking about the good "beyond good and bad," even if it is not clear what that might be (the obvious reference to Friedrich Wilhelm Nietzche (1844–1900) is itself beyond the scope of this article). Part of the difficulty, then, involves knowing what actions, if any, are beyond the good and evil of karma—this seems to be a central issue in all of the native Indian religions.

3.3. Extended Picture of Relationships and Recognition (Pratyābhijñā)

Just as many life theism invites me to see myself in a larger narrative, it invites me to see relationships that define my life in larger narrative too. When my children were born, for example, there was this forceful thought as I gazed upon their faces for the first time: *had I known this soul before? If so, what was the nature of that relationship?* There are many friends and family relationships that seem so deep I wonder if they too had a beginning before my present life. On a *karma-saṃsāra* model it would not only be possible, but even likely, that many of the people in my life—parents and extended family, friends, teachers, co-workers, etc.—would be people with whom I had interacted in the past.

Many Indian epic (e.g., *Mahābhārata*, Purāṇas, *Rāmāyaṇa*, *Jātaka*, etc.), as well as parapsychological studies of reincarnation by Ian Stevenson, etc., depict a world in which the circle of relationships in a person's life are filled with people from a past life. One of the more gory stories is in the *Mahābhārata* (3.127). King Somaka had one hundred wives, but bore only one son. After an incident with an insect bite, Somaka realize that the boy could die at any time, leaving him sonless. His family priest describes a ritual that generate one hundred sons:

The family priest said: King Somaka, you should sacrifice [the body] of your son Jantu by the extension of my will (*kratu*), and thereafter you will quickly gain one hundred glorious sons.[17]

The sacrificed is described as involving the offering of bodily membranes, like skin and fat (*vapā*) into the fire, and that the wives should smell the smoke of it, which would thus produce the sons, one of which will be Jantu reborn. The women protest, but the sacrifice happens nevertheless, and Jantu is reborn in the same family. When the priest and king die they go to hell, a temporary place of suffering for this gory sacrifice, which was based on their (*kratu*) one might add, yet the king offers to share the priest's demerit, and they are both quickly released from hell. The story is outrageous, but it shows an entanglement of over lifetimes.[18]

Even the relationships between the God Kṛṣṇa and his earthly parents is the result of a set of interwoven past lives. The *Bhāgavata-purāṇa* says Devakī and Vasudeva, who were Pṛśni and Sutapā (10.3.34 *ff*.) in previous lives, had performed yogic austerities for many lives before becoming the "parents" of Kṛṣṇa. This, however, can be contrasted with the Joseph and Mary, the parents of Jesus. In Luke, we are told where Mary and Joseph are from, that Mary is a virgin to be married to Joseph, presumably that they are Jewish, and that Mary is visited by the angel Gabriel because she was "favored by God," but, at least from Luke (1:26 *ff*.), and my research here is limited, we do not know why it was Mary and Joseph *in particular* were the "parents" of the God Jesus; their relationship with Christ began in their lifetime, whereas Kṛṣṇa's relationship with his parents extended far into the distant past.

In returning to the moment when a parent looks upon a child for the first time, or likewise when two people who later become friends or lovers first meet, in a *karma-saṃsāra* model we might look at these interactions as recognition (*pratyabhijñā*) rather than a first introduction. "Recognition" is a technical term in Nyāya and Kashmir Śaivism, developed, for example, by the Śaiva theology Utpaladeva (c.925–975 AD); it involves an experience of an object (*anubhava*) when there is a memory of that object (*smṛti*), or the remembrance of one's self as Śiva. In Nyāya, for example Annambhaṭṭa's *Tarka-saṃgraha*, it has a more general sense of a perception of an object when one has a memory of that same object and then one recognizes the object as the same from one's memory, e.g., this is that person (Sastri 1951, p. 110). A fight with a parent, co-worker or friend might just be a dual that has played out before, and love at first sight might just be an old flame re-stoked, bringing with it the passions of the past. Seeing one's child at birth or the "first" pr meeting of a "new" friend, or "new" lover could very well be a "recognition" (*pratyabhijñā*) of a pre-existing relationship that was dormant. There is a lot of unexpectedness, then, when meeting new people on a *karma-saṃsāra* model.

3.4. Hermeneutical Reflection

One of the great enigmas of human history that has always fascinated me is that great men and women often have great flaws, and infamous men and women often have great qualities. On a karma theory, one can look at a person's present life, and one's own, in a much wider time slice, one that allows one to see good, bad, and mixed reactions all present in different phases of maturation in a single individual. It provides a theoretical model for understanding, whether correctly or not, why saints are sometimes sinners, and sinners sometimes saints. It also addresses the important question as why bad things happen to good people, and why good things happen to bad people. On the karma theory, we are witnessing the maturation of different causes, some of which have matured fully and some of which are just starting to present themselves.

[17] yajasva jantunā rājaṃs tvaṃ mayā vitate kratau | tataḥ putra-śataṃ śrīmad bhaviṣyaty acireṇa te | | (*Mahābhārata* 3.127.19). Based on Kisari Mohan Ganguli's edition, not the critical edition: http://www.sacred-texts.com/hin/m03/m03128.htm, http://www.sacred-texts.com/hin/mbs/mbs03127.htm.

[18] The relationship between Bhīṣma and Śikhaṇḍin in the *Mahābhārata* also has a multilife entanglement. The demonic brothers Hiraṇyakṣa and Hiraṇyakaśipu in the *Bhāgavata-purāṇa* are reborn three times together, having been kicked out of heaven.

4. Conclusions

I have emphasized the rationality and the eternal narrative of rebirth, and I have tried to express how these interpretations are rooted in classical Hindu texts, philosophies and theologies. Aside from providing a rational explanation and a multilayered perspective on human life, when I sat down to write this article I had found that there were many other ways that *karma-saṃsāra* might shape one's interpretation of this life. I have tried to develop just two, but there are more. From a physicalist point of view the fact that the death of this body means the death of my personhood, my memories, and my awareness is either very comforting since life is seen as suffering, or terrifying since life is seen as good. In a rebirth narrative there is no such relief as in physicalism, but most Indian traditions see *mokṣa*, liberation, as a type of ending of the narrative aspect of one's life, a destruction of the person but not the self. In the case of the Gauḍīya Vaiṣṇava tradition, there is the destruction of the human person, but there is also the development of a new person, with a narrative and personality that exists in eternal relation Kṛṣṇa. Thus in response to the question "what does belief in rebirth matter to *this* life?," in addition to what was said above, it will always be a challenge that *karma-saṃsāra* as it is construed in Hindu theologies makes little or no space for the eternality of my personhood as it is constructed by the processes of *karma-saṃsāra*, even if it does provide a rational way for interpreting life's events.

Much of what we do is to try to find meaning value and purpose in the space between birth and death and it is perhaps here that thinking of one's life as a rational development of one's own actions is most relevant. It provides a real sense of autonomy and self-responsibility; it orders an otherwise caprice and chaotic universe, wherein one seems to be tossed around like a gourd on the ocean, to borrow from Sureśvara, by saying that my life is in fact the result of my choices, even if they are choices I have no memory of making.

Conflicts of Interest: The author declares no conflict of interest.

References

Balasubramanian Rajangam, ed. 2016. *Naiṣkarmyasiddhi of Sureśvara*. Keral: Chinmaya International Foundation.

Buchta, David. 2016. Devotion and Karmic Extirpation in Late Vedānta: Viṭṭhalanātha and Baladeva Vidyābhūṣaṇa onBrahmasūtra 4.1.13–19. *The Journal of Hindu Studies* 9: 29–55. [CrossRef]

Cross, Frank Leslie, and Elizabeth A. Livingstone. 1974. *The Oxford Dictionary of the Christian Church*. Oxford: Oxford University Press.

Dasti, Matthew R., and Edwin F. Bryant. 2014. *Free Will, Agency, and Selfhood in Indian Philosophy*. New York: Oxford University Press.

Dasti, Matthew R., and Stephen H. Phillips. 2017. *Nyāya-Sūtra: Selections with Early Commentaries*. Indianapolis: Hackett Publishing Company, Inc.

Edelmann, Jonathan. 2012. *Hindu Theology and Biology*. Oxford: Oxford University Press.

Edelmann, Jonathan, and William Bernet. 2007. Setting Criteria for Ideal Reincarnation Research. *Journal of Consciousness Studies* 14: 92–101.

Edwards, Paul. 2001. *Reincarnation: A Critical Examination*. New York: Prometheus Books.

Eggeling, Julius. 1897. *The Satapatha-Brâhmana According to the Text of the Mâdhyandina School, Part IV*. Oxford: The Clarendon Press.

Filice, Carlo. 2006. The moral case for reincarnation. *Religious Studies* 42: 45–61. [CrossRef]

Jha, Ganganatha. 1942. *The Chāndogyopaniṣad: A Treatise on Vedānta Philosophy Translated into English with the Commentary of Śaṅkara*. Delhi: Chaukhamba Sanskrit Pratishthan.

Jhalakīkar Bhīmācārya, ed. 1928. *Nyāyakośa*. Poona: The Bhandarkar Oriental Research Institute.

Kane, Pandurang Vaman. 1962. *History of the Dharmaśāstra: Ancient and Medieval Religoius and Civil Law in India, Volume V, Part II*. Poona: Bhandarkar Oriental Research Institute.

Karmarkar, R. D. 1962. *Śrībhāṣya [Commentary on the Vedānta-sūtra] of Rāmānuja*. Poona: University of Poona Sanskrit and Prakrit Series.

Larson, Gerald. Forthcoming. *Classical Yoga Philosophy and the Legacy of Sāṃkhya. Translation of Yoga Sūtra of Patañjali, Vyāsa Bhāṣya of Vyāsa, and Tattvavaiśāradī of Vācaspati Miśra*. Buckinghamshire: Brill.

Mandlik, Vishvanātha Nārāyan. 1886. *Mānavadharmaśāstra, with Commentaries of Mdhātithi, Sarvajñanārāyaṇa, Kūllūka, Rāghavānanda, Nandana, and Rāmacandra*. Bombay: Ganpat Krishnajis Press.

Matilal, Bimal Krishna. 1985. Transmigration and the Moral Enigma of *Karma*. In *Logic, Language, and Reality: Indian Philosophy and Contemporary Issues*, 3rd ed. Delhi: Motilal Banarsidass.

Nyaya-Tarkatirtha, Taranatha, and Amarendramohna Takatirtha. 2003. *Nyāyadarśanam, with [Commentaries on the Nyāya-sūtra] Vātsyāyana's Bhāṣya, Uddyotkara's Vārttika, Vācaspati Miśra's Tātparyaṭīkā, Viśvanātha's Vṛtti*. New Delhi: Munshiram Manoharalal.

Olivelle, Patrick. 1999. *The Early Upanisads: Annotated Text and Translation*. New York: Oxford University Press.

Potter Karl, ed. 1981. *Encyclopedia of Indian Philosophies vol.3: Advaita Vedānta up to Śaṃkara and His Pupils*. Delhi: Motilal Banarsidass Publ.

Rambachan, Anantanand. 2006. *The Advaita worldview: God, World, and Humanity*. Albany: State University of New York Press.

Ram-Prasad, Chakravarthi. 2011. The Phenomenal Separateness of Self: Udayana on Body and Agency. *Asian Philosophy* 21: 320–40. [CrossRef]

Reichenbach, Bruce R. 1990. *The Law of Karma: A Philosophical Study*. Honolulu: University of Hawaii Press.

Sastri, Kuppaswami S. 1951. *A Primer of Indian Logic According to Annambhaṭṭa's Tarkasaṃgraha*, 2nd ed. Mylapore: Kuppaswami Sastri Research Institute.

Sharma, Bhavani Narayanrao Krishnamurti. 1988. *The Bṛhadārāṇyaka Upaniṣad: Expounded from Śrī Madhvācarya's Perspective*. Bangalore: Dvaita Vedanta Studies and Research Foundation.

Srinivasa, S. M. Chari. 2004. *Fundamentals of Viśistādvaita Vedānta: A Study Based on Vedānta Deśika's Tattva-muktā-Kalāpa*. Delhi: Motilal Banarsidass Publishers Private Limited.

Stevenson, Ian. 1997. *Reincarnation and Biology: A Contribution to the Etiology of Birthmarks and Birth Defects*. Westport: Praeger.

Timalsina, Sthaneshwar. 2014. Self, Causation, and Agency in the Advaita of Śaṅkara. Bryant. In *Free Will, Agency, and Selfhood in Indian Philosophy*. Edited by Matthew R. Dasti and F. Bryant Edwin. New York: Oxford University Press.

Vasu, Srisa Chandra, and Ramaksya Bhattacharya. 1916. *The Brihadaranyaka Upanisad with the Commentary of Śrī Madhvacharya Called also Anandatirtha*. Allahabad: The Pāṇini Office.

Article

Reincarnation: Mechanics, Narratives, and Implications

Christopher Key Chapple

Bellarmine College of Liberal Arts, Loyola Marymount University, Los Angeles, CA 90045, USA; cchapple@lmu.edu

Received: 12 September 2017; Accepted: 24 October 2017; Published: 27 October 2017

Abstract: This essay explores the mechanics associated with rebirth, noting differences between Hindu, Buddhist, and Jain narratives. It examines the concept of subtle body and the liṅgam in Sāṃkhya. According to the Hindu tradition, the remains of the departed person, when cremated, merge with clouds in the upper atmosphere. As the monsoon rain clouds gather, the leftovers mingle with the clouds, returning to earth and eventually finding new life in complex biological cycles. According to Tibetan and Chinese Buddhism, the remains of a person take a ghostly form for 49 days until taking a new birth. According to Jainism, the departed soul immediately travels to the new birth realm at the moment of death. According to Jain karma theory, in the last third of one's life, a living being makes a fateful choice that determines his or her next embodiment. The 20th century Hindu Yoga teacher Paramahamsa Yogananda, in his commentary on the Bhagavad Gita, provides an alternate description of a twofold astral and causal body. One hallmark of the Buddha and of the 24 Jain Tīrthaṅkaras was that they remembered all the lives they had lived and the lessons learned in those lives. The Buddha recalled 550 past lives and used these memories to fuel many of his lectures. Mahāvīra remembered his past lives and also the past lives of others. Patañjali's *Yoga Sūtra* states that through the perfection of giving up all things, including psychological attachments, one spontaneously will remember past lives. In the *Yogavāsiṣṭha*, a Hindu text, Puṇya remembers the past lives of his grieving brother as well as his own prior experiences.

Keywords: Buddhist rebirth; Jain karma theory; subtle body; astral body; reincarnation

Reincarnation, or *punar janma*, means birth again. Its conceptual origins remain obscure, though early passages from the *Bṛhadāraṇyaka* and *Chāndogya* Upaniṣads (ca. 800 B.C.E.) describe the sacrificial process through which the funeral fire allows a person's remains to ascend into the clouds, return to earth with the rains, become food, and then the semen that begets new life (BU 6.2; CU 5, 3–10). The idea of rebirth eventually gained traction as an eschatological tool, an incentive to improve one's moral standing. The *Kauṣītaki* Upanishad proclaims that those who do good deeds in the world will ascend to a heavenly realm; those who harm others will descend into animal births (KU I:2).

This essay will explore some of the mechanics associated with rebirth, examining the concept of subtle body and the *liṅgam* in Sāṃkhya—the process through which one remembers past lives according to the *Yoga Sūtra*. After noting the varied ways in which one life is said to move from one body to the next, specific rebirth narratives in Buddhist, Jain, and Hindu literature will be considered. The essay will conclude with an exploratory typology of how past life narratives function to communicate templates for behavior.

1. Mechanics

According to the Hindu tradition, an important task to be performed by the eldest son is to open the skull of his departed parent on the funeral pyre, releasing unresolved desires into the atmosphere, where they are carried by the smoke to linger in the upper atmosphere. As the monsoon rain clouds

gather, the leftovers mingle with King Soma until released by Indra's thunderbolt. They sink with the rain deep into the soil, where they are gathered up into plants. These plants become food eaten by all manner of animals, including humans. The quintessence of food finds its way into the semen of men. By depositing this semen into the warmth of the womb, life continues, and the subtle material of the departed starts a new course within life. This process can take several seasons. On the death anniversary of a parent or teacher, Brahmins are paid to perform Śraddhā rituals to guide the ancestor on his or her journey.

According to the story of the life of the Buddha, when he attained awakening under the Bodhi Tree, he sat there for seven days, working through his system of past life recollection and his profound understanding of dependent origination or inter-being (*pratitya samutpada*). Then he got up and walked, and sat again for a total of seven days. This repeated an additional five times, totaling seven weeks or 49 days. At the end of this period of reflection, he took up the resolve to teach. He first invited a monk to hear his insights who monk declined the offer. He met up with his former companions, who also had arrived in the town of Sarnath or Deer Park. Just as the Buddha went through a liminal period of 49 days before committing to full life as a teacher that lasted an additional 45 years, so also, according to the Tibetan Book of the Dead and Chinese Buddhist traditions, it takes 49 days for unresolved karmas to find a new home. In Buddhist tradition, the remains of a person take a ghostly form during this period, traveling at will to pursue unfulfilled desires without a body before finding a moment of sexual allurement through which one re-enters the realm of samsara precisely at the moment of union between one's new mother and father. Buddhist funerals, particularly in China and Tibet, last 49 days so that the family and well-wishers can guide their loved one to an auspicious new birth.

According to Jainism, the departed soul immediately travels to the new birth realm at the moment of death. According to Jain karma theory, in the last third of one's life, a living being makes a fateful choice that determines his or her next embodiment (Jaini 2000a). Extreme care to do no harm increases as one nears the golden years, reflected in more frequent fasting and the strengthening of an already vegetarian diet. Jains do not perform elaborate funeral ceremonies, due to their convincement that the soul determines its own path, and that the best preparation for death is a life well lived. Once one is dead, nothing more can be done, by oneself, for obvious reasons, or by others. According to Jainism, one is sole determiner of one's own path (ibid., p. 136).

The Buddhists, though they deny an enduring self, do posit that the nexus of human pain and suffering (*duḥkha*) resides in the residues of past karmas. The Jains similarly identify 148 karmic variations (*prakṛtis*) that define and constrain the condition of the soul. Buddhists seek to understand the origins of pain through meditation, and hence gain release from its group. Jains seek to live a life of utmost purity to undo the knots (*grantha*) of karma. Both assent to the basic premises laid out in one of the six schools of Hindu thought, the Sāṃkhya Darśana. By examining the mechanics of rebirth as outlined in Īśvarakṛṣṇa's *Sāṃkhya Kārikā*, the template for this important concept in Indian traditions can be discerned within a general conceptual framework.

2. Sāṃkhya: Emotions (*bhāva*) and the Transmigrating Subtle Body (*sūkṣma śarīra, liṅga*)

Sāṃkhya, one of the six foundational orthodox schools (*darśana*) recognized in Hinduism, sets forth a reciprocity between a seeing witness (*puruṣa*) and an ever-changing realm of mental, emotional, and physical activity (*prakṛti*) arrayed in a play of three factors: dullness, passion, and illumination (*tamas, rajas, sattva guṇas*). The word *liṅgam* appears in the *Sāṃkhya Kārikā* (ca. 300 C.E.) several times to explain the basic constituents or marks of personality. Knowing a person's general disposition allows one to make inferences about how they might respond in a particular situation (SK 5). Dispositions or emotions (*bhāvas*) take many forms. In the aggregate, they determine one's personality. All aspects of the manifest world are colored or marked through the constitution

of personality (SK10). The following sequence of verses explain the process of rebirth in largely psychological terms:[1]

> 39. Three distinct factors can be seen [in regard to life]:
>
> subtle, born of a mother and father, and acts of will.
>
> Subtle influences and acts of will in this life carry over to the next,
>
> even though the body born of a mother and father will pass away.

> 40. The personality (*liṅgam*), which is cloaked with *bhāvas*,
>
> has previously arisen but is not yet empowered.
>
> It endures within the *mahat* to the edge of the subtle.
>
> Because it has not experienced enjoyment, it transmigrates.

The *bhāvas* are the emotional states that govern human behavior. They are described in two schematics, one eightfold (to be explained below) and the other fifty-fold, accounting for the various ways in which an individual can survive and thrive or fail and fall. The *mahat*, like the *alaya-vijñāna* in Yogācāra Buddhism, serves as the repository for all karmic impressions (*saṃskāras* or *vāsanās*) contained within the realm of Prakṛti in her *avyakta*, her potential but as yet unmanifested form. In other words, certain yearnings remain unfilled. These desires, which reside in what modern psychologists might call the unconscious, fester and gnaw in a subtle state, seeking to be experienced.

> 41. Just as art requires color,
>
> and just as without pillars there can be no shadows,
>
> similarly, the personality cannot exist
>
> without the specifics (of the *bhāvas*).

The human person consists of a cluster of repeating experiences that arise due to one's past experiences, current accomplishments, and unfulfilled wants and dreams.

> 42. The personality performs like an actor
>
> due to its connection (*yoga*) with the allurement of Prakṛti.
>
> This is the cause of human exertion:
>
> yearning for both experience and its transcendence.

> 43. The *bhāvas*, including dharma and the others, are primary,
>
> whether natural or acquired.
>
> They are seen in the way life occurrences unfold
>
> and in the growth of an embryo.

The argument is being made, in keeping with the *satkaryavāda* or realist philosophy of Sāṃkhya, that the personality arises due to factors that carry over from one life to the next. In the next two verses, positive activities described in the *bhāvas* of dharma, *jñāna*, *vairāgya*, and *aiśvarya*, the dispositions of virtue, knowledge, non-attachment, and power, lead to positive results. Their inauspicious "evil twins" engender the opposite.

[1] These translations are by the author in collaboration with Ana Funes, Ralph Craig III, Daniel Levine, Wijnanda Jacobi, Natale Fereira, and Nadia Pandolfo.

44. With dharma, there is movement upwards.

Without dharma, things move downward.

With knowledge, freedom arrives;

from its opposite, bondage.

45. From nonattachment, things resolve themselves back into Prakṛti.

From passionate attachment, *saṃsāra* continues.

From power, obstacles dissolve.

Otherwise, they persist.

The text goes on to itemize fifty variant forms, stating that the personality utterly relies upon the *bhāvas* (SK 52). The forms include the five states of affliction also listed by Yoga (*avidyā, asmitā, raga, dveṣa, abhiniveśa*), 28 incapacities, nine complacencies, and eight perfections.[2] By reflecting on how these various factors of personality stem from past influences and condition future experience, one can move toward a place of knowledge, which, according to the Sāṃkhya system, is the only pathway to freedom.

3. Yogananda: A Modern View of Reincarnation

The 20th century Hindu Yoga teacher Paramahamsa Yogananda, in his commentary on the *Bhagavad Gītā*, provides an alternate description of what happens after death. According to Yogananda, the physical body perishes while the essence of a person ascends into a twofold astral and causal body:

In the physical world, the soul is encased in a fleshly body made of sixteen gross elements. After death, the soul is rid of its heavy overcoat of flesh but remains encased in its two other subtle garments—the astral body of nineteen subtle principles and the causal body of thirty-five ideas or thought forces ... when a man [sic] leaves the physical world in ignorance, he awakens in an astral world, encased in an astral body. In accordance with karmic law, he lives and develops in the astral for some time, working out some of his past tendencies. At the timing of cosmic law, man again experiences the death disintegration of the astral body and is reborn once more in the physical world.[3]

According to Yogananda, the human person is able to work out karmic issues while in the astral body in a process seemingly similar to what is described in the Tibetan Book of the Dead. Yogananda writes:

Then the ego sleeps for a while in the astral body, or is conscious of life in an astral world. After a while the ego begins to be disturbed by its innate subconscious material desires and by the muffled longing to express itself through a physical vehicle. At this time the cosmic law of karma, acting according to the desires and nature of the physically disembodied ego, sends it to be reborn on earth to parents similar in certain karmic respects to this wandering soul. (Ibid., p. 705)

[2] Sāṃkhya retitles the Yoga categories descriptively as heaviness, delusion, great delusion, gloom, and utter darkness. The 28 incapacities start with the failure of the eleven sensory and action organs. Their inability to function results in deafness, lack of touch, blindness, inability to taste, inability to smell, severe digestive disorders, sexual dysfunction, inability to use the hands, paralysis of the legs, muteness, and insanity. This brings the total to 33. The other 17 include infirm *bhāvas* dwelling in the *buddhi* or *mahat*, residues from past action that include inability to achieve the nine contentments and the eight powers. Four of the contentments are internal: satisfaction with the ways of nature, an innate proclivity toward spiritual practice, a reliance on the unfolding of time to resolve difficulties, and the notion that good luck governs all. The five external contentments arise from enjoying sound, touch, form, taste, and smell. The successes are eightfold: sound reasoning, the benefit of good instruction from a teacher, self-study, good friends, purity, and the overcoming of ignorance, weakness, and complacency. Each of these can present an opportunity for attachment and hence remain an impediment to freedom.

[3] (Yogananda 1999). Jensen Martin thoughtfully shared these passages.

Using biological language derived from 20th century science, Yogananda talks about sperm and ovum, adumbrating this physical explanation with discussions of astral light:

> The parents to be unknowingly generate, during coition, an astral light of united positive negative currents in their coccygeal regions, which is referred to the sperm and ovum. When the sperm and its genetic and karmic potential from the father unities with the ovum and its pattern from the mother, there is a flash of astral light from this fertilized cell that attracts and guides the physically disembodied ego with its compatible karmic blueprint into the haven of its new primal cell of life. (Ibid.)

Adding colorful language regarding "disgruntled goblins", Yogananda further explains how the subtle tendencies lodged in the astral body seek expression in the physical realm:

> At death, the sum total of man's tendencies are lodged in the brain of his luminous astral body. Mixed good and bad tendencies cause the soul to seek early rebirth in the physical world. When there is a predominance of good tendencies in the astral brain, the soul in its astral body encasement gravitates to a better environment on an astral planet. When evil tendencies predominate, the soul in its astral body gravitates to dark spheres of the beyond, where disgruntled goblin beings dwell. How long one remains in the brighter or darker astral regions before reincarnating on earth is karmically determined. (Ibid., p. 1025.)

Yogananda's details regarding the rebirth process interlace the traditional mechanics with some aspects of modern physiology and psychology. As a modern interpreter of Indian thought, Yogananda sought to explain reincarnation in terms that would make sense to his audience in the early 20th century while not contradicting teachings on reincarnation found in traditional literature.

Returning to the description of the rebirth process in classical Sāṃkhya, as long as the *bhāvas* persist in defining the *liṅgam*, the person takes rebirth. Only with the ascent of knowledge (*jñāna*) can one become free from the cycle of *saṃsāra*. This is a very specific form of knowledge that proclaims the abandonment of attachment to a fixed self, governed by desires, a formula found also in Buddhism: no doer, no self, no ownership: *nāsmi, nāham, na me*. All needs have been obtained. At death, one can look forward not to heaven nor to hell nor to birth in an animal or human realm, but an ascent to what the Jains call the Siddha Loka, a realm of undying repose and reflection.

Interestingly, this does not mean that the lives already lived are forgotten. One hallmark of the Buddha and of the 24 Jain Tīrthaṅkaras was that they remembered all the lives they had lived and the lessons learned in those lives. Patañjali's *Yoga Sūtra* states that through the perfection of giving up all things, including psychological attachments, one spontaneously will remember past lives: "Firmly established in non-possession (*aparigraha*), one comes to know the why and how of past lives" (YS II:39). The Buddha recalled 550 past lives and used these memories to fuel many of his lectures. Mahavira remembered his past lives and also the past lives of others. In the *Yogavāsiṣṭha*, Punya remembers the past lives of his grieving brother as well as his own prior experience. In the section that follows, narrative examples will be given from all three traditions, Buddhist, Jain, and Hindu.

4. Buddhist Jataka Tales

The Buddha told 550 stories of his past lives, recorded in the Theravada Canon. Half mention prior births of himself or others as animals or other non-human life forms.[4] Many of the stories directly and obliquely relate to Devadatta, the cousin of the Buddha who tried to kill him by hurling rocks and sending a raging elephant toward him. In the *Javasakuṇa Jātaka*, the Buddha was living as a woodpecker who helped a lion who was choking on a bone. At a later time, when the woodpecker was in need, the lion refused, and received a verbal upbraiding from the bird. This lion later became Devadatta.

4 This material is summarized from (Tucker and Williams 1997).

In another Devadatta story, a cruel elephant destroys a family of quail who take revenge by pecking out his eyes and lure the elephant to fall off a cliff to his death. The elephant in this story known as the *Laṭukika Jātaka* later becomes Devadatta.

In the *Suvaṇṇamiga Jātaka*, a stag became snared by a hunter. His devoted wife offered to sacrifice her life for the sake of her husband. The stunned hunter released both. The stag later returned to the hunter and implored him to give up killing. The stag later was reborn as the Buddha. In the *Dummedha Jātaka*, the Buddha recalls a past life as King of Varanasi. He recoiled at the excessive animal sacrifices performed by Brahmin priests and when he ascended the throne replaced this practice with vegetarian offerings to a banyan tree. In the *Kusanjāli Jātaka*, the future Buddha lived as a clump of grass under a beautiful tree. When the tree came under threat from woodsmen seeking a new central pillar for the palace of the king of Varanasi, the grass grew all night entwining itself into the tree causing it to look diseased. When the woodsman returned with their tools to fell the tree, they were convinced that it would not be suitable, thus sparing all the various forms of life that dwelt in and around the tree.

These Buddhist tales carry an implicit message: it is important to manifest positive qualities not only for the good of one's future birth, but for the sake of helping other living beings. Devadatta committed cruel acts life after life. The Buddha, in comparison, helped others, earning freedom for himself and bringing goodness to others.

5. The Prince Who Was an Elephant: A Jain Tale of Rebirth

Jainism posits that the soul (*jīva*) is eternal; it has existed from beginningless time and will live forever into an endless future. It takes birth after birth: elemental, microbial, as well as insect, fish, mammal, human, a god or goddess in one of several heavens, and, on occasion, as a dweller in one of numerous hells. Jain literature tells many stories of individuals who wander through various births before taking up the religious life and committing themselves to the practice of non-violence, essential for spiritual ascent. The goal of the Jain path is to move from the human realm to the Siddha Loka, the realm of perfect freedom, far beyond even the reach of the heavens.

In the *Gyātasūtra* of the Jain canon, also known as *the Jnātadharmakathaṅga*, the story of Meghkumar, or Cloud Prince, weaves past life memories in such a way that not only does a prince gain insight into his current state of affairs, but also in his immediate prior incarnation he recalls a lesson from an incarnation prior to that. Prince Meghkumar was born after his mother Dhariṇī recalled two dreams: one of a white elephant who came down from the sky and entered her womb through her mouth, and the second of an insatiable desire to ride through the city on a white elephant on a cloudy day. The king Shrenik and his queen consequently named their beloved son Cloud Prince and provided the happiest life possible for him, including his marriage to eight princesses.

Some years passed. The Tīrthaṅkara Bhagavan Mahāvīra came to the capital of Shrenik's kingdom of Magadha, the city known today as Rajagriha. After hearing the Bhagavan speak, Prince Meghkumar decided to leave behind his wives and princely comforts to take up the life of a Jaina monk. The day before his initiation his father arranged for him to be king for a day, lending even greater weight to the significance of Meghkumar's renunciation. After the ceremony initiating Meghkuma into monkhood was completed, the former prince settled on the floor to sleep. As the most junior monk, he was required to sleep near the door. All night long, the monks came and went in order to relieve themselves in the field, disturbing his sleep. He tossed and turned, receiving no rest. He fell into a deep sadness and yearning for his prior life.

In the morning, he approached Bhagavan Mahāvīra and asked to be released from his vows. Using his powers of omniscience, the Bhagavan told two stories of Meghkumar's prior lives when he lived as an elephant. In one story, he was an elderly pure white elephant named King Sumeruprabh. A forest fire swept through his domain, forcing all the animals to flee. Because of his advanced age, Sumeruprabh stumbled and fell into a muddy lake bed. A younger elephant took advantage of his plight and gored him to death.

The elephant was reborn again, this time as a bright red elephant named Meruprah, with four tusks, also king of his clan. While witnessing a fire from afar, he recalled the plight of his prior birth and urged his fellow elephants to clear an eight-mile meadow that would be safe in case of fire. Eventually, the summer fires came to the forest and all the animals, including antelope, deer, lions, jackals, cattle, and rabbits crowded into the meadow. Meruprabh lifted his foot to scratch his itchy stomach. A rabbit scampered into the space underneath his leg. For fear of killing the rabbit, Meruprabh stood on three legs for two and a half days. By this time, the fire had died down, but Meruprabh's leg had stiffened and he tumbled to the ground. He lay prone for three days, unable to move, suffering from pain, hunger, and thirst. However, because of the compassion he had manifested in order to save the rabbit, he felt peace even amidst the pain and took rebirth in the womb of Dharinī and was born as Prince Meghkumar. Having been reminded of this act of compassion, Meghkumar renewed his religious zeal and after twelve years of monastic life ascended to Mount Vipulchal where he engaged in a final fast, attaining a heavenly state as an angel in his next life.[5]

This story emphasizes the continuity of life from incarnation to incarnation. Elephants become elephants, and elephants become humans and humans become monks and monks become angels. Along the way, many other animals cross paths: antelope, deer, lions, jackals, cattle, and rabbits. One's actions toward other life forms determine one's status in the lives to come. If, even in the midst of a natural calamity such as a forest fire, one can seek to spare the lives of others, a reward will be gained.

Jain literature contains countless examples of rebirth narratives wherein the conditions and outcomes result in disgust toward and eventual abandonment of the world to pursue the monastic life. The merchant Maheśvaradatta discovered that his own presumed son was actually the reincarnation of a man he had killed while that same man made love to his unfaithful wife. A buffalo he had sacrificed in honor of his father was actually the reincarnation of his father and a nearby stray dog had been his mother (Granoff 1995). In the story of King Yaśodhara, the king discovers his wife committing adultery, who then poisons him and his mother. The poisoned mother and son are reborn in turn respectively as peacock and dog, mongoose and cobra, fish and crocodile, goat and goat, goat and buffalo, chicken and chicken, and finally again as twin children to the wife of Yaśodhara's son. The former king becomes a Jain monk and his mother becomes a Jain nun. They eventually fast to death and attain a heavenly realm.[6]

In Jain tradition, rebirth inevitably results in pain and misery. Monks and nuns recount these stories to inspire their lay students to understand the need to renounce the troubles of the world in order to avoid inauspicious rebirth. Eventually, as stated earlier, the goal is to ascend from human birth to the realm of perfection, a space beyond the heavens, wherein one dwells forever in a place of consciousness and bliss.

6. The Story of Puṇya and Pāvana from the *Yogavāsiṣṭha*

The *Yogavāsiṣṭha*, a Hindu text of Kashmir Śaivism also known as the *Mokṣopāya* that dates from the 1000s, includes a story of reincarnation that serves to underscore the connected nature of all forms of life. This story takes place on the Ganges River, where two brothers lose their parents. One laments excessively, prompting his older, wiser brother to use narrative to help bring his inconsolable brother back to a state of stability, a narrative that calls attention to the beauties of nature and the many forms of life that thrive upon the earth.[7] The strategy of this particular story falls into the methodological category of narrative theology. By telling a story, the author engages the reader and listener in a real-life situation that highlights the pastoral aspects of reincarnation narratives.

5 Vijayji (n.d.). *Inspiring Story of Meghkumar* (Mumbai: Mahavir Seval Trust, n.d.) *Jnatadharmakathanga (Nyayadhammakaao)*. The story is also in (Pupphabhikkhu 1952). It is also retold in (Jaini 2000b).
6 Summary of translation by Adam Hardy in (Granoff 1990).
7 This translation unfolded over the course of many months as a project of the Tuesday afternoon Sanskrit seminar at Loyola Marymount University. The translations are by Christopher Key Chapple unless otherwise noted and are based on the Sanskrit edition found in (Mitra 1998).

The story begins by describing a lovely family whose aged parents grow old and die. The two remaining sons adopt different approaches to their loss. The elder son, Puṇya, sets about performing the required rituals, which are designed to ensure safe passage of their parents into the state of freedom. The younger son, Pāvana, becomes disconsolate. Here is where the usefulness of reincarnation as a belief system takes hold. The elder brother uses stories of past lives as a way to shake his younger brother out of his despondency. It had already been established that the parents were, as one often hears at a funeral, "in a better place":

19. With death, the father flew into *samādhi*,

free from thought, into the abode of consciousness.

He went to the stage free from passion,

like the scent of a flower wafts up into the sky.

20. His wife, having seen the body of the lifeless sage,

fell to the earth, like a lotus without a stalk.

21. Through the discipline of Yoga taught to her by her husband over many years,

she renounced her delicate frame, like a bee flying from a lotus.

22. She followed her husband, departing to the place unseen by people,

the light of her soul fading in the sky like the half moon at sunset.

As described above, the elder son did what needed to be done, while his younger brother floundered:

23. With mother and father gone, Puṇya steadfastly focused

on the funeral ceremonies, while Pāvana descended into grief.

24. His mind afflicted with grief, he wandered the forest paths.

Having lost sight of his brother, Pāvana wailed: "Aaaaah!"

25. Having performed the appropriate funeral rites

for the bodies of his mother and father,

Puṇya ventured into the forest after Pāvana, who was afflicted with great sorrow.[8]

26. "Why, boy, this thick cloud of sorrow? It is making you blind and ignorant.

Your violent cloud of tears is like a monsoon season filled with rain.

27. Your mother and father, of great wisdom, have gone together to heaven,

indeed, to that highest Self, that place called Mokṣa.

28. That place is the goal of all people who have overcome this world of form.

Why mourn your parents? They have attained their true nature.

29. You are really bound to this state that is born of delusion.

You mourn for things in *saṃsāra* that should not be mourned.

8 Translation by Griffin Guez.

This line echoes the message of the *Bhagavad Gītā*, which pronounces "the wise do not mourn for the living or the dead" (BG II:11). By reminding Pāvana of the larger picture, Puṇya undertakes a form of pastoral counseling.

30. She is not your only mother nor is he your only father.

Nor are we the only two sons of the many who have been born of those two.

31. Child, our mother and father have passed through thousands of births,

as numerous as the streams running deep in each and every forest.

32. Honored son, we are not the only two sons.

Our parents have had countless children.

Multitudes of sons have passed through the generations like rapids in a river.

33. Our parents had innumerable distinguished sons

who have passed away long ago,

just as the branches of a creeping vine give forth many flowers and fruits.

34. Just as a great tree gives forth an abundance of fruits

with the passage of each season,

So also our many friends and relatives have experienced many births.

35. Son, if parents and children are to be mourned out of affection,

Then why should the thousands who die continually not also be mourned?

36. From your perspective of worldliness,

the affairs of wandering people are deemed important.

But from the highest perspective, knowledge reveals that

there is no lasting friend, no lasting relative.

37. On the other hand, brother, from the perspective of absolute truth,

no destruction is known either.

Everything happens only in the mind and then evaporates like water in the desert.

38. The beautiful things that you see are none other than a dream,

fluttering like feathers on a parasol, lasting three or five days in the great mind.

39. By seeing things from the perspective of the ultimate reality, son,

You must regard this truth: 'There is neither you nor we.'

You must renounce all your confusion.

40. Realize that all your previous negative views are now dead and gone.

Such tortures arise in your own imagination and must not be seen as true.

41. In a death characterized by ignorance,

The rolling waves of pure and impure vibrations

Cause past impressions to manifest without interruption

into the realm of name and form, like moonlight on water.

20.1. Who is the father? The friend? The mother? The relatives?

One's conception of them can be swept away as if they are dust in the wind.

2. Love, aversion, and delusion in regard to our friends, relatives, and offspring

are merely accomplished by the projection of our own conceptions.

3. The quality associated with 'relative' makes a relative.

The quality associated with 'stranger' makes one a stranger,

just as the conditions of poison or nectar

depend upon the appearance of fixity (in the mind).

4. How can this notion arise that 'this one is a friend, that one is a stranger'

when the mind of wisdom sees the oneness of the all-pervading soul?

5. Son, reflect on yourself through your mind.

Ask, 'Who am I? What could I be? Something other than the body?

A bony skeleton? A heap of blood, flesh, and bones?'

6. From the perspective of highest truth, there is no 'you,' there is no 'I.'

Only in delusion and ignorance do Puṇya and Pāvana spring forth.

7. Who is your father, who is your friend?

Who is your mother? Who is your enemy?

In regard to the endless luminosity of space,

What can be proclaimed to be the Self? Or not the Self?

After this philosophical reprimand, Puṇya then reminds Pāvana that he himself, like his parents and all other beings, have taken birth and rebirth countless times. He describes beautiful environments graced with trees, deer, and swans, reminding Pāvana of wider networks of family connections.

8. You are consciousness in the midst of many other prior births

where you have had friends and properties.

Why do you not grieve for them also?

9. Those many deer in the flowery meadow,

born of their mother does, were your relatives.

Why do you not grieve for them?

10. Regard the swans in the bouquets of lotuses on the riverbank.

Why do you not grieve for those swans who were your relatives?

11. Those fine trees in the splendid beautiful forests were also your relatives.

Why do you not grieve for them?

12. Those lions on the awe-inspiring peaks of those mountains

were also your relatives. Why do you not grieve for them?

13. Those fish among the beautiful lotuses in the clear lakes

were also your relatives. Why do you not grieve for them?

14. You were a monkey in the brown woods of the Ten River Land,

a prince in the land of snow, and a crow in the forest of the Pundras.

15. You were an elephant among the Haihaya people,

a donkey in the company of the Trigartas,

a puppy with the people of Salva, and a bird in that tree.

16. You were a fig tree in the Vindhya range, and an insect in a great tree.

You have been a hen on the Mandara Mountain.

You were born also as a Brahmin in Kandar.

17. You were a Brahmin in Kośala. You were a partridge in Bengal.

You were a horse in the land of snow.

And you were the beast killed at the Brahmana sacrifice.

18. The one who was an insect inside the root of a palm tree,

who was a mosquito on a big ficus tree,

the one who was previously a crane in the forest,

that one is now you, my son, my little brother.

19. That small red ant that lived for six months

in the hollow of the thin knotty birch tree bark

on the cliffs of the Himalayas is now you, my little brother.[9]

20. You were the beetle living for a year and a half

in cow dung at the edge of a frontier village.

O Sadhu, that was you, little brother.[10]

21. The child who sat on the six petalled lotus throne of the Pulinda tribal woman,

hidden in the forest, that one was you, little brother.

22. For thousands of prior births in these many woods

you were born of various wombs, my son,

And now you are born on Jambudvipa.

23. By the purified clear vision of my subtle intellect,

I see the previous successive lives of your self.

Punya also remembers his own past lives as a parrot, a frog, a lumberjack, a "Don Juan," a bird, a king, a tree, a tiger, and more.

24. I remember today my many past lives, born of many wombs

due to ignorance and indolence. This insight has arisen due to knowledge.

[9] Translation by Kija Manhare.
[10] Translation by Erika Burkhalter.

25. Having been a parrot in Trigarta and a frog on a riverbank,

and having been a lumberjack in the woods, now I am born here in this forest.

26. I ravished a royal woman in the Vindhyas.

I have been fashioned as a tree in Bengal as well as a camel in the Vindhya range.

I am now born in this forest.

27. That bird in the Himalayan town, that king in the Paundra region,

that tiger in the Salya region ... that one is now me, your elder brother.

28. I was that vulture who lived for ten years,

that shark who lived five months, and that lion who lived a full century.

That one indeed is now your older brother.

29. Can you believe it? I lived as a prince of a village in Andhra,

as a sovereign king in the Tuṣāra region, and as the son of the Śailācārya.

30. I remember from long ago all the various incarnations and all the various customs

that have arisen into manifestation due to confusion.

31. There, in that place [of memory], so many thousands of relatives

were born in those worlds that have now gone: fathers, mothers, siblings, and friends.

Having held forth like a circuit preacher on the various times and places that both he and his brother have taken birth, Puṇya then delivers a homily designed to stabilize his younger brother's mind and emotions.

32. Whom shall we two grieve? Whom shall we not grieve?

We grieve all relatives that die. This is the way of life in the world.

33. Like the endless passing of fathers and mothers in this world of *saṃsāra*,

souls drop like leaves, falling off the trees in the forest.[11]

34. Who can measure the varieties of pleasure and pain, O brother?

Therefore, renounce all of them. Let us take our place in the light.

35. Having renounced all cultivation of outward manifestation in the mind,

abiding in the Self, go happily to that place, that place where the wise ones go.

36. Inactive beings fall away. Active persons rise again.

Those with good thoughts do not grieve. They move gradually toward freedom.

37. Be free of confusion. Be free of [attachment to] existence and nonexistence.

Escape from old age and death. Be cool, always remembering your true Self.

38. You are not your suffering. You are not this birth.

You are indeed the Self, not this intellect.

Indeed, how could you be other than true Self?

[11] Translation by Natalé Ferreira.

39. Good man, ignorant people performing various dramas in this journey of *saṃsāra*
attach themselves to the sentiments of existence.

40. One can attain the goal of being the witness,

self-possessed in the midst of all that can be seen.

Such persons are established in the dharma of the observer,

being the knower and spectator at all times.

41. Whether engaged in action or inactive,

such persons regard actions as if they were the fading light

at the start of the night. The knower stands unperturbed by the world.

42. Those who have arrived at the illumination of the true Self

no longer see the reflection [as real], just as the jewels reflected in the mirror

are taken to be mere reflections by those with wisdom.

43. Through moving away from all this self-made darkness, dwell in your true Self, which
is like the radiant moon in the middle of your heart.

44. Son, find the Self in the Self. Be a sage like the great sages.

Having renounced all impure perplexity, be content!

This narrative, told over two chapters of the Upaśama Prakaraṇa of the *Yogavāsiṣṭha*, holds many insights Hindu attitudes toward reincarnation. We are not limited beings. We carry unfathomable histories and experiences; according to Hinduism, Buddhism, and Jainism, we have taken birth countless times. By adopting the long view suggested by Puṇya, that is, being cognizant of the wide range of past lives, we can move beyond the petty dramas that trap the mind and emotions in negativity. This does not mean that grief is to be avoided; Pāvana channeled his grief into the performance of the funeral rituals. Pāvana suggests that we must always take the wider perspective, surrendering attachments in favor of contentment and peace.

7. Implications

The mechanics of reincarnation are complex. All the traditions seem to agree that actions (karma) from the past determine one's present and future states. The residues of action (*saṃskāras* or *vāsanās*) in the case of Hinduism are released at the time of cremation and enter a period of transition that includes ascent into smoke, descent with rain into the earth, ascent into the stuff of food and semen, and eventual new life through the reproductive process. For Buddhists, the bundle of unresolved desires travels for 49 days of the funerary period in a subtle form before finding a new birth. For Jains, the karmic bundle moves directly from death into a new womb, already determined by actions performed toward the end of life. These three descriptions of how rebirth takes place are markedly different. The Hindus tend to a very physical explanation, while the Buddhists and Jains emphasize psychological states and yearnings. The Buddhist intermediary period of 49 days allows for the possibility that petitionary prayer by others may guide one toward a more auspicious rebirth, while the Jains place responsibility for one's next birth solely and squarely on the will and initiative of the individual.

The *Kauṣītaki* Upanishad takes a mechanistic view of the rebirth process. Do good and you will ascend to a better birth. Commit acts of evil and descend to a lower, animal birth. The Buddha used rebirth stories to convey ethical allegories and to chastise his listeners to remember the consequences of their actions. The Jain rebirth stories emphasize the continuity between animal and human life forms. The story of Puṇya and Pāvana provides a way of coping with grief by seeing the larger frame of repeated birth and rebirth.

Each of the narratives contains a message that serves to inspire a move away from attachment toward a state of acceptance and peace. The Jain stories of the reincarnations of merchants and kings encourage wariness of rebirth into the world of samsara. The narrative of Puṇya and Pāvana, rather than engendering feelings of disgust in regard to the world, shows the healing powers of connecting with animals and a broader sense of the beauties of nature in order to find solace and healing in a time of grief.

These stories of rebirth give voice to the ethic of nonviolence, the keystone of Jain and Buddhist and Hindu religious practice. In the Buddha's retelling of his own past lives, his virtue helped move him toward his eventual freedom. In the case of Jainism, the elephant, highly sensitive and intelligent, retained memories over a course of three lifetimes, using profound intelligence to help solve the recurrent problem of how to cope with wildfires. His profound emotional intelligence carried over from one lifetime to the next. In Hinduism, the insight and kindness of the elder brother Puṇya empowered him to cajole his younger brother out of his depression through regaling him with past life stories. Lessons from past lives shape and guide an individual into present and future lives. To have been an animal and to have recalled past animal experiences indicates a sign of greatness, an acknowledgement of one's ongoing connections and kinship with other species.

According to the *Yoga Sūtra*, recollection of past lives arises when one is able to relinquish all clinging, all possessions. Through this process of release, one comes to understand the operations of karma. Rather than clinging, regretting, or lamenting, one moves into the mode of acceptance.

Krishna teaches Arjuna in the *Bhagavad Gītā* the need to see the beginning and end of things as both inevitable and linked to an underlying sense of the eternal:

II:22. Just as a person casts off clothes and takes on new ones,

so the embodied one casts off worn-out bodies

and takes on others that are new.

26. Even if you think this is perpetually born

and perpetually dying, even so, Strong Armed One,

you should not grieve for this.

27. For to one born, death is certain,

and to one dying, birth is certain.

Therefore you must not grieve over what is unavoidable.

28. Beings are unmanifested in their beginnings,

apparent in their middle, and unmanifested in their ends.

What in this is to be lamented?

30. The embodied one in the body of each

is eternal and invulnerable.

Therefore, Arjuna, you must not grieve for any being! (DeNicolas 2004)

Knowing that the unfolding of life originates from seeds of karma, and understanding that these seeds will sprout, grow new fruit, ripen, and give way to new seeds, a sense of the flow of life can give comfort and solace. Rather than remaining attached to every single experience, through acceptance of rebirth, one can take the long view rather than obsessing over the preciousness of this very life. Whereas the poet Mary Oliver posed the question, "What is it that you plan to do with your one wild and precious life?" the teachings of reincarnation take a different approach, one that could perhaps be phrased as "How will you explore the many lives you have been and the many lives you will become?"

Teachings of reincarnation provide moral fables. As a form of narrative theology, reincarnation stories hold important pastoral implications. These stories, grounded in an expansive ontology and cosmology, encourage the listener to consider the ethical imperatives within one's own life.

Conflicts of Interest: The author declares no conflict of interest.

References

DeNicolas, Antonio T., trans. 2004, *The Bhagavad Gita: The Ethics of Decision-Making*. Berwick: Nicolas Hayes, pp. 33–34.

Phyllis Granoff, ed. 1990. *The Clever Adulteress and Other Stories: A Treasury of Jain Literature*. Oakville: Mosaic Press.

Granoff, Phyllis. 1995. The Story of Maheśvara from the *Dharmābhyudayamahākāvya*. In *Religions of India in Practice*. Edited by Donald S. Lopez Jr. Princeton: Princeton University Press, pp. 413–14.

Jaini, Padmanabh S. 2000a. Karma and the Problem of Rebirth in Jainism. In *Collected Papers on Jaina Studies*. Delhi: Motilal Banarsidass, p. 132.

Jaini, Padmanabh S. 2000b. *Collected Papers on Jaina Studies*. Delhi: Motilal Banarsidass, p. 261.

Mitra, Vihari Lal. 1998. *The Yoga-Vāsiṣṭha of Vālmīki Sanskrit Text and English Translation, Vol. II, Sthiti Prakaraṇa, Upaśama Prakaraṇa*. Edited and Revised by Ravi Prakash Arya; Delhi: Parimal Publications, pp. 254–60.

Pupphabhikkhu, ed. 1952. *Suttagame, Part 9*. Gudgaon: Sutragamaprakashaka Samiti.

Tucker, Mary Evelyn, and Ryūken Williams. 1997. Animals and Environment in the Buddhist Birth Stories. In *Buddhism and Ecology: The Interconnection of Dharma and Deeds*. Cambridge: Harvard University Center for the Study of World Religions, pp. 131–48.

Vijayji, Muni Shri Purnachandra. n.d. *Inspiring Story of Meghkumar*. Mumbai: Mahavir Seval Trust.

Yogananda, Paramahamsa. 1999. *The Bhagavad Gita: Royal Science of God-Realization*. Los Angeles: Self Realization Fellowship, p. 230.

Article

Reincarnation in America: A Brief Historical Overview

Lee Irwin

Religious Studies Department, College of Charleston, 66 George Street, Charleston, SC 29424, USA;
irwinl@cofc.edu

Received: 14 September 2017; Accepted: 3 October 2017; Published: 11 October 2017

Abstract: American theories of reincarnation have a long and complex history, dating from 1680s to the present. It is the purpose of this paper to highlight the main currents of reincarnation theory in the American context, giving a brief historical survey. Sources surveyed begin with Native American traditions, and then move to immigrant traditions based in Western Esotericism, Christianity, Judaism, missionary Hinduism and Buddhism, Spiritualism, Theosophy, Rosicrucianism, and concludes with more current theoretical influences, based in paranormal science research. The paper demonstrates that current theories of reincarnation are increasingly less dependent upon religious support and increasingly based in direct personal experience, paranormal research, and new therapeutic models. The paper concludes with some reflections on the complexity of reincarnation theory and raises questions concerning the future development of such theory.

Keywords: reincarnation; rebirth; past life memories; paranormal; out-of-body experience (OBE); near-death (NDE); retrocognition; survival of death; super-psi; regression therapy

1. Introduction

While reincarnation theory has a long history in Asian religious traditions, there is an equally long "Western" history, dating back to the early pre-Socratic period in ancient Greece (Irwin 2017). The earliest testimony of *metempsychosis* (rebirth) among Greek sources is found in the gold tablets of the Orphic tradition (c. 600 BCE) where the *psychê* (or "soul") was regarded as superior to the physical body, in comparison to the dim "shades" of the older Homeric *eidōlon*, or "image" that had minimal existence in Hades (Bremmer 1983). This elevation of the *psychê* was based in an ontological mythos (*soma-sema*, or "body as prison") that defined soul as intrinsically superior to any form of physical life. Through ritual participation in the mysteries, accompanied by living a just and disciplined life, initiates were "purified" and prepared for an escape from the "circle of necessity" or "wheel of birth"—that is, escape from rebirth in the human world. The Orphic deceased would "fly out of the circle of weary, heavy grief" as indicated by the sacred inscriptions on small gold leaf sheets, rolled into in a cylinder worn on a necklace (Graf and Johnston 2007, pp. 127–28). From this period forward, *metempsychosis* (rebirth) is a constant theme within the pre-Christian Mediterranean world.

The pre-Socratic philosophers such as Pythagoras and Empedocles taught reincarnation and Plato fully developed an intricate, cosmological theory of rebirth (Johnston 2011; Long 1948). According to Plato, the Creator gave the younger gods the laws by which mortals live where the first birth was the same for all souls (*Timaeus* 41d–e). Each soul must then discover love as a mingling of pleasure and pain, fear and anger, and other paired emotions. If these emotions were conquered through love and did not rule a human being, and if he (or she) lived a proper philosophical life, the soul could then return at death to the star from which it came. But a soul dominated by disruptive, bodily passions would be subject to rebirth (*metempsychosis*) in human or animal form and these incarnations would continue until, with the help of reason, such souls overcame the "turbulent and irrational mob" of

elemental influences that led to rebirth (*Timaeus* 42b–e). Thus rebirth, in the Platonic tradition was retributive and escape from rebirth was the ideal, even though eventually, rebirth was possible even for the philosophic soul (Kaplan 1996, pp. 14–17).

Neoplatonic authors further articulated theories of *metempsychosis* as found in the works of Plotinus where the intellective soul is the noblest aspect of every human being; in this sense, the body in Plotinus becomes only an externalized image of the soul. Every human being for Plotinus is distinctive, a *logos* (idea) that combines with the archetypal human form in conjunction with parents and location to create a unique individual (*Enneads* V.7.1). When life is lived through the cultivation of the higher, pure aspect, the soul takes flight to the One in unitary mystical visions; but if lower desires dominate, then reincarnation must necessarily follow in further human lives or possibly in animal lives for the overly sensual (*Enneads* III.4.2; Sorabji 2005; Remes 2008). Philosophers such as Iamblichus (*De Mysteriis Aegyptiorum*) and Proclus (borrowing from the *Chaldean* Oracles) further linked soul development to ritual (*theurgy*) practices that would, when carried out with purification rites and prayer, assist the practitioner to escape the wheel of rebirth. These theories of rebirth are also linked to an angelic cosmos in which angels may assist the soul to higher life and recollection (*anamnêsis*) of past lives, as in Plato, was a necessary step in attaining escape from rebirth and ascent to a divine, transphysical life (Dodds 1962; Irwin 2017; Rosán 2008).

Greco-Roman theories of rebirth were assimilated into Christian thought, primarily through Origen, whose theory of *transmigration* became a contested theme within Christian theologies. While Origen did not embrace reincarnation theory, nevertheless he speculated in his writings, that if the soul truly pre-exists, created before the body, then it may take a body or more than one body, as it is the soul which animates flesh in whatever form flesh takes (*Contra Celsus* I.32). Origen offers the unique idea that the *pneumatic* (spiritual) aspect of individual identity is capable of reincarnating (*metapneumatosis*) into another human being. Further, this personalized aspect of spirit, as the "spirit of Elijah," carries with it unique "power" and ability, as possessed by the actual person, and as such is not simply an abstract idea of transpersonal Spirit. Thus, while soul remains as the true source of human identity, incapable of another physical life, a subtle spiritual aspect of that identity is capable of reincarnation into other lives (Détré 2005, pp. 167–203). Origen's concept of preexistent soul marks the beginning of a long history of contestation within Christian theologies that rejected orthodox after-life theories of heaven and hell in Catholic, Eastern Orthodox, and Protestant teachings in favor of a theory of rebirth. Even though Origen's theory of the preexistent soul was pronounced *anathema* by the Fifth Ecumenical Council (553 CE), diverse Christian groups have continued to teach reincarnation into the present day (Givens 2010, pp. 94–96).

Foremost among those groups influenced by reincarnation theory were a variety of early Gnostic Christian groups (Layton 1987; Logan 1996; Pearson 2007), as well as more mainstream groups such as the Paulicians (fl. 850), the Bulgarian Bogomils (c. 1050), and the French Cathars (c. 1225), all of whom taught reincarnation for those who did not successfully escape the fallen, sinful world through dedicated, ascetic, devotional practices (Irwin 2017). Against this background of resistant Christian theologies, texts traditions that explicitly taught *metempsychosis* continued to circulate in monastic communities and secular libraries, specifically, the *Pistis Sophia*, the *Kore Kosmou*, the *Asclepius*, and the collected texts of the *Corpus Hermeticum*. The *Pistis Sophia* (c. 275 CE), the most explicit Christian text, describes the soul as led, through a series of stages, into the upper cosmos and taken before the Virgin of Light who, seeing it as a sinful soul, determined the bodily form it would take in its next life. The soul was then given over to the receiving spirits who induced forgetfulness and cast it into a certain type of physical body "worthy of the sins it has committed" (Mead [1896] 1989, pp. 233–43).

Various theories of reincarnation continued, based in oral traditions and alternate texts, into and throughout the Renaissance period. The *Corpus Hermeticum* (Copenhaver 1998), a compilation of 18 short texts that reflect a Greco-Egyptian orientation, was highly popular as an alternate *prisca theologia* (Walker 1954) claiming to be more ancient than Christianity and offering several theories of reincarnation. The process of rebirth was epitomized in a sacred cup of Nous, a bowl (*krater*, cup or

grail), offered to an aspirant who could plunge in (drink) and ascend, returning to source, or who could refuse and be led only by pleasures and desires of the body. Those who failed to drink would "pass through many bodies," through multiple cycles of death and reincarnation, until "leaving the familiar and present," the soul discovered the "ancient and original unity" beyond all bodily forms and attained true knowledge (*gnosis*) and union with the One (*Corpus Hermeticum* IV: 5–10; V.2; Copenhaver 1998).

Francesco Patrizi's *Nova de Universis Philosophia* (1591) was a popular compendium of texts and ideas, including reincarnation, from Hermetic-Platonist sources that traced "ancient wisdom" (*prisca sapientia)*, not from Aristotle, but from the Egyptian Hermes, Orpheus, Zoroaster, Plato and other Neoplatonists, especially Proclus (Leijenhorst 1998). Giordano Bruno (d. 1600) also wrote constructively on reincarnation as a necessary process for soul development through many incarnations. Bruno's theory is complex and based in "fateful justice" for each soul in a search of a more empowered sense of human personhood through a positive relationship with universal soul. Thus, there is only creative ongoing process, no final judgment. Bruno was burned at the stake by the Catholic Inquisition for his refusal to reject these ideas (Mendoza 1995).

During this same period, Jewish *Kabbalah* was popularized and the theory of *gilgul neshamot* (revolution or cycles of soul) became increasingly well-known among Christian and Jewish esotericists (Ogren 2009). Many Jewish renaissance writers expostulated on the theme of *gilgul* or rebirth, perhaps the most influential being a work by Hayyim Vital (d. 1620), a student of Isaac Luria, entitled *Sha'ar ha Gilgulim* ("Gate of Cyclical Return"). This very long and complex work offers a detailed description of soul cycles embedded in a cosmological theory of reincarnation (Wexelman 1999). Christians, influenced by Jewish Kabbalah and the theory of *gilgul*, also created works and text compilations in the form of Christian *cabala*, in which "soul revolution" was amalgamated to theories of resurrection such that the soul would reincarnate until the time the Final Judgment (Karr 2010). By the 17th Century, ideas of soul revolution in England and Europe were accessible and disseminated among Christian and Jewish esoteric theorists (Ogren 2009).

The most pronounced example is found in the first book-length work in English on reincarnation, articulated by the German esotericist Franciscus Mercurius van Helmont (d. 1698) while visiting England (Coudert 1999). Van Helmont was a Christian cabalist and a proponent of an emergent new anthropology arguing in favor of the necessity of "soul revolution" (reincarnation) as inseparable from human "progress" (Coudert 2008). Having read the *Sefer ha-Gilgulim*, van Helmont constructed a theory of soul evolution, limited to 12 possible incarnations (as in *ha-Gilgulim*) spanning a period of 1000 years, with at times long "periods of rest" between lives, all directed toward the perfection (or restoration) of the soul. George Keith attended meetings to discuss Kabbalah with Lord Conway and his wife, Lady Anne Conway, at their estate where van Helmont was the visiting physician for Lady Conway. In turn, Keith assembled the discussion notes into a single volume, attributed to van Helmont, entitled *Two Hundred Queries Moderately Propounded Concerning the Doctrine of the Revolution of Humane Souls, and Its Conformity to the Truths of Christianity* (1684). This is the earliest book-length volume on reincarnation in English (Irwin 2017, pp. 122–24) and consists of specific questions, each answered to show the rational legitimacy of the theory of reincarnation (and the irrational nature of belief in an eternal hell or heaven). George Keith subsequently became the person responsible for the transition of reincarnation theory to America in the 1690s where he wrote and published a pamphlet defending his views (Keith 1692).

2. American Traditional Reincarnation

Long before the coming of European immigrants, most native groups held some form of belief in rebirth into the human (and animal) world after death based on indigenous theories of soul life (Mills and Slobodin 1994). Native American soul concepts are complex and diverse; however, all indigenous groups believed in a post-mortem existence, in an afterlife that supported normal cognitive awareness, including a capacity to return to physical human life (Hultkrantz 1953; Hultkrantz 1998). The concept of soul was complex and usually consisted of multiple aspects, rather than being a

single entity; at death, these various aspects would depart to cosmologically defined domains; for example one aspect was intrinsic to the bones of the dead while another, like the breath of life, would return to the stars. The "free-soul" was that aspect capable of out-of-body journeys, linked to various types of shamanism, and was the aspect that departed to the post-mortem village of the afterlife (Hultkrantz 1953). Reincarnates were often given various names (over many years, through ceremony) that designated both a returned soul and past social accomplishments of that soul. The name was more powerful and *more significant* than the individual identity that reincarnates; it was the obligation of the person reborn to live up to his or her former accomplishments (Irwin 2017). Among numerous native groups, a disincarnate soul could also be reborn into multiple new bodies simultaneously, indicated by the naming practices, and all identically named individuals were believed to be actual incarnates of that soul (Mills 1994; Stevenson 1975, 1997).

In summary, there are three major perspectives on reincarnation among Native American peoples, especially reflective of traditional, very old beliefs. First, at death there is a post mortem existence that is similar to the physical life lived while incarnated and that return to embodied life is provisional. This *provisional* aspect is crucial because it clearly expresses the belief that only some individuals return to live additional human lives. A second perspective is that reincarnation is an open choice as is staying in the afterlife world, or a Village of the Dead. A third perspective is the culturally constructed process of naming which predetermines the social location of the returning individual. This *social-functional* view is strongly associated with either kinship relations or social hierarchy in which names, titles, and status are transmitted through naming rituals. Causality lies not with the shamanic power of the individual, nor with the sacred powers above, but with social practices that determine how a newborn child will fit into existing social roles (Irwin 2017, pp. 21–34).

2.1. American Esotericism and Transcendentalism

When George Keith arrived in Philadelphia in 1685, as a convert to the new Quaker movement, he brought with him van Helmont's theory of "soul revolution" (reincarnation) and promoted it among American Quakers (Fisher 1985). Controversy over rebirth split the Philadelphia Quakers, with a smaller group supporting reincarnation theory while the larger group, at George Fox's command, rejected the theory (Coudert 1976). Thus, from the earliest period of immigration the theme of reincarnation became a contested subject, both for Europeans and later native converts to Christianity. The theory of one life, one death, one judgment, and one afterlife as promoted by Christian missionaries, Catholic priests, and Protestant ministers, made reincarnation a liminal theme among mainstream Christians. However, those less identified with mainstream Christianity maintained a consistent dedication to Western esoteric traditions, including esoteric Christian beliefs in rebirth.

Among well-educated individuals the assent to reincarnation was based in the study of esoteric texts (Versluis 2001). This was particularly true among the New England Transcendentalists, most of whom supported the theory of reincarnation. Emerson was an outspoken supporter of the theory, as was Edgar Allen Poe, Walt Whitman, Henry Thoreau, Bronson Alcott, George Ripley, Frederic Hedge, and James Freeman Clarke, among many others (Head and Cranston 1967, pp. 260–339). Emerson's theory is a unique blend of enlightenment rationalism, the perfectibility of the individual, and various esoteric, often Asian, concepts, resulting in an early version of "American metaphysical" beliefs not moored to any specific religious tradition (Albanese 1997). According to Emerson, the "complete human" requires multiple lives that will allow the soul "to drink the healing waters of illumined thought" (Larson 2001). However, this process of progressive discovery is not simply individual but part of a greater *"metempsychosis of nature"* through which every creature, indeed all of nature, evolves toward its higher potential (Corrigan 2012). However, the process of sympathetic discovery and development has no teleological, predetermined outcome; the long process of incarnations remains open-ended and souls can slip back to former states or cycle in repeating patterns (Obuchowski 1979). Influenced by Goethe's scientific treatises, Pythagorean *metempsychosis*, Hindu sacred texts (the *Upanishads* and the *Bhagavad Gita*), and a host of other esoteric ideas, Emerson sustained a positive belief

that each textual source could "provide the materials necessary for "progressive" observation and experimentation" that would further promote human development through continued incarnations (Corrigan 2012, pp. 41–42). What was required was a synthesis of both scientific investigation, poetic genius, and a spiritual metaphysic that reflected a "new oldness" that, like the honey bee, could create a sweet metaphysical elixir out of disparate elements (Irwin 2017, pp. 131–35).

In the emergent American context, as illustrated by Emerson, reincarnation shed its classical European alignment with a static, hierarchical ontology and offers a view which is dynamic and historically open-ended. There is forward development but no pre-determined end. The agency for reincarnation is "naturalized" in the sense that deity recedes and natural law implies a cycling of souls whose life conditions reflect past life experience. The goal of human life is not a disembodied ascent to a higher domain, as an escape from physical life, but an emphatic embrace of physical life as the evolutionary locus of embodied consciousness. There is also a participatory theme developed as American intellectuals claimed to recall actual past lives. For example, Thoreau made experiential claims about past lives in his letters and journals, as did Emerson's brother Thomas, the poet Nathaniel Willis, and Louisa May Alcott among others, thus providing a new participatory context for reincarnation theory distinct from any religious beliefs (Head and Cranston 1990, pp. 242–51).

2.2. The Afro-Caribbean Synthesis

Another influence in the development of American reincarnation theory derives from the importation of African peoples as slaves into the Caribbean and North and South America. African indigenes had strongly developed, very old traditions of reincarnation as a widely shared belief pattern, particularly throughout West Africa. Reincarnation theory takes a different turn, similar to Native American traditions, through emphasis on the role of ancestral souls. To become an ancestor means to live a long, exemplary life, gaining the respect and appreciation of others. After death, the ancestors assist the living who must remember them with proper ceremony. Rebirth of ancestral persons is usually within the kinship lineage, often skipping a generation, from grandparent to grandchild (Mazama 2002). Social position and status of living individuals is linked to specific ancestral qualities he or she embodies, as recognized through naming practices. The identity of the departed individual retains its primal location in the realm of the ancestors, while various attributes and personal qualities are distributed into the lives of one or more individuals. A given ancestral name represents the ancestral spirit or soul and thus influences the social standing of the individual, particularly if the ancestor was a figure commemorated in ceremony, was head of a household, or held an important title (Mbiti 1970; Onyewuenyi 1996).

Among African slaves, a receding belief in reincarnation is found in various records that constitute the history of slave religion. For example, as recorded from one African American woman named Bell, concerning African American slaves in the 1830s, there was a "universal belief" that "at death they shall return to their own country and rejoin their former companions" (rebirth). Another example is recorded by an African born woman slave "who wished for death" because she believed that "the first infant born into a [African] family ... was the individual come back again" (Raboteau [1978] 2004). Folk tales narrated by African Americans recorded clear beliefs in reincarnation well into the 20th Century, tales particularly congruent with African Igbo beliefs, as argued by Jennifer Hildebrand (Hildebrand 2006). In a collection of folktales gathered by Edward Adams in 1927 among African American Sea Island Gullah and the swamp Congaree of South Carolina, he recorded (in vernacular language) several tales about "transmigration." One tale tells of a "nasty lookin' buzzard" interpreted as the reborn soul of an African chief who sold his people into slavery and who was thus condemned to live many lives eating dead animals. Another tale tells of a giant yellow crane who was the embodied soul of a mulatto doctor, trained in Europe, who was believed to have purposely killed his black patients (Adams 1927). Among the African Igbo, those who committed a crime against the community and who did not emulate ancestral values and behavior were condemned to be a ghost or to be reborn as an animal who could do no harm to humans.

As slaves developed their African traditions in the Americas, explicit transcultural religions were created based on a synthesis of influences from African, Amerindian, European (particularly Catholic), and post-African *creole* persons born into the Afro-Caribbean context. The emergent *creole* amalgamation, that is, the creative integration of diverse elements of class, race, gender, and power, led to a variety of religious syncretic traditions, all embracing various forms of reincarnation theory, best represented by Vodou (Voodoo), Santeria (Lecumi), Candomblé, and Umbanda, all present in contemporary American cities. One shared characteristic of *creole* traditions can be identified as the belief in a variety of soul aspects making up the person, some elements of which can be reborn in living humans after death (Olmos and Paravisini-Gebert 2003).

For example, Santeria was brought to Cuba by captured Yoruba slaves, where the "saints" tradition was named as Lukumi (Lucumi) or *Regla de Ocha* (Rule of the Orisha). Human beings, after living a long, natural life with a good death, may become an ancestor (*egun*) and live in the invisible world, watching over his or her living family. Those best qualifying for ancestral remembrance are those who "fulfilled their destiny" (as in Yoruba belief), contributed to the community, lived exemplary lives, and did not die young or act in cruel or criminal ways. Ancestors are believed to reincarnate usually into their family lineages as a grandchild; however, it is also possible for reincarnation to occur outside the family lineage. Before rebirth, ancestral spirits restore themselves in the "good heaven" (*orun rere*) while watching over the family, and some may become revered Orisha (spirits). Individuals guilty of crimes, cruelty, theft, slander, of using magic to harm others are not reborn but sent by Olodumare to the "bad heaven" (*orun bururu*), the place of broken pots which cannot be repaired, and are thus unable to reincarnate (Clark 2007; De La Torre 2004; Sandoval 2007).

2.3. Spiritualism and Theosophy

The link between reincarnation and spiritualism (or Spiritism) was primarily through Hippolyte Rivail (d. 1869), better known under his pen name of Allan Kardec, the French esoteric writer on mediumship. Rivail was attracted to "spirit manifestations" as seen and heard in mediumistic sessions, such as those of the American Fox sisters (1848), with rapping, knocking, and moving of objects attributed to spirit presences (Irwin 2017, pp. 168–70). Subsequently, he wrote a series of books based on spirit answers to research questions he asked of several mediums, which resulted in the construction of an explicit *Spiritist* worldview (1857) in which reincarnation was a central theme. The soul is like an embryonic seed surrounded by the *perispirit* and then by the body, though the *perispirit* radiates beyond the body to create a surrounding field (aura). Through multiple incarnations, the *perispirit* becomes increasingly etheric "until it reaches complete depuration [purification] which is the state of all pure Spirits" (Kardec [1857] 1987), a condition that is more likely to occur on more advanced and etheric worlds than present day earth. The purpose of reincarnation is to "attain perfection" through contributing to creation by assisting in progressive development and by undergoing necessary expiations of impurities resulting from the challenges of embodiment (Kardec [1857] 1987). The length of time between new lives is variable, self-chosen, though at times rebirth becomes a consequence of compulsions based on past deeds. At the time of reincarnation, the spirit can choose the mother, gender, and a body, though a specific bodily incarnation may be imposed if a spirit is "too backward to be able to choose wisely" (Kardec [1857] 1950, p. 149–50, 184).

Rivail's influence in America was extensive throughout the 20th Century, particularly among those interested in mediumship and spirit communications. By the 1860s, there were reputedly over two million American spiritualists, some of whom accepted Kardec's writing as authoritative and many of whom regarded Spiritism as a legitimate branch of international mediumship. An internal conflict around the theme of reincarnation resulted in the formation of the Independent Spiritualist Association which supported the theory of rebirth. When the National Spiritualist Association of Churches (1893) issued a strong counter-statement rejecting reincarnation, the majority of the New York membership withdrew and formed the General Assembly of Spiritualists (1930) which affirmed reincarnation. Spiritism is also integral to various Caribbean island traditions imported into America, all of which

use Rivail's writings to enhance mediumship practices. Further, these traditions engage guides that are distinctively non-white, that is, African, Indian, and Creole spirits, a phenomenon also found among some Anglo spiritualist mediums. The blurred racial boundaries within certain spiritualist groups allowed for social realignment of minority members by instilling greater moral authority on mediums who could cross racial boundaries in giving advice to clients (Peréz 2011). The threatening impact of reincarnation theories that recognized the spiritual authority of marginal peoples created a climate of resistance. Such theories overturned the social hierarchy, challenged racial exclusivism, and violated the sanctity of the self-assumed superiority of birth, race, and social rank (Irwin 2017, pp. 170–71).

The Theosophical Society was founded in 1875 in New York by co-leaders Helena Blavatsky, Henry Olcott, and William Q. Judge. Synthesizing ideas from Mesmerism, New Thought, European Esotericism, Asian Religions, and Spiritualism, the Society sought to promote Universal Brotherhood and to discover "universal laws" which would explain phenomena found in the history of occultism. Blavatsky, strongly influenced by Asian terminology, offers the following description of the incarnational process: there is "no immediate reincarnation on Earth for the Monad, as falsely taught by the Reincarnationists and Spiritists" (Blavatsky 1882), nor any second incarnation for the *perispirit* or personal ego, but there are "periodical reincarnations for the immortal Ego" not more often than "once every 1500, 2000, or 3000 years." The *jiva* or "incarnating entity" at the death of the body cannot assimilate to the higher Immortal Ego (*manas*) and subsequently, is unfit for Devachan, the eternal domain of the *manas*. The "personal ego" must perish as a slowly dissipating image "reflected in the mirror of Astral light." Only through a "series of rebirths" of the Immortal Ego is it possible for a human being to (eventually) attain "physical, moral, and spiritual perfection" (Blavatsky 1882). Blavatsky offers the interpretation that human development and perfection necessarily occur in stages of incarnation, over a long period of time, never allowing, like Rivail, for regression to lesser states. Other Theosophists, such William Judge, founder of the American Theosophical Society (1895), Gottfried de Purucker, head of The Theosophical Society in Pasadena, California (1929 to 1942), and many others built on the early rebirth theories and assimilated evolutionary theory into their reincarnation models in an attempt to bring Theosophical theory into alignment with some aspects of current, post-Darwinian science. The best assimilation is found in (Judge [1893] 1987) whose book is complex and engaging as well as being one of the earliest English books on reincarnation theory (Irwin 2017, pp. 174–81).

2.4. Occult Science and Esoteric Groups

In 1882, the Society for Psychical Research (SPR) was formed in Britain to undertake scientific inquiries into a variety of psychic abilities, primarily those manifest in mediumship, such as transference (telepathy), hypnotism, mesmeric trance, clairvoyance, past-life recall, and interaction with post-mortem entities such as apparitions and ghosts. In 1885, the American Society for Psychical Research (ASPR) was formed in Boston with the support of William James, as Chair of the Committee on Hypnotism and of the Committee to Investigate Mediumistic Phenomena. In 1889, the ASPR became an affiliate of the SPR, forming a joint research agenda to explore psychic or paranormal phenomena such as reincarnation and information gained through mediumship (Taylor 1999). Founder of the American Institute for Scientific Research (1904), James Hyslop in 1905 absorbed the ASPR into his own organization, forming a separate section dedicated to the study of "all claims to supernormal abilities." In discussing reincarnation, Hyslop identifies Plato as the primary source for the theory, linked with other Greek philosophers through a commonly shared conception that "substance is imperishable and passes from generation to generation constituting the matter out of which the individual is made" (Hyslop 1906). Posited as a "universal law" in Greek philosophy, the theory of imperishable substance established for Hyslop an ontological principle of nature as underlying the more explicit belief in *metempsychosis* in which the surviving entity was a reconstruction from the underlying universal "substance" constituting the human species. No "individual" survived, there was only a newly created entity without memory or knowledge of any previous existence (Irwin 2017,

pp. 189–90). From this time forward, reincarnation would be increasingly investigated within the context of paranormal research.

During this same period, esoteric American groups also promoted reincarnation as part of higher degree teachings. Early Masonic literary sources for reincarnation, or *metempsychosis*, reference Pythagoras, the Greek mysteries, and the later Neoplatonists as examples of "ancient mysteries" linked to the archetypal origins of Freemasonry. For example William Preston, in *Illustrations of Masonry* (1772), refers to the "philosophical notions of Pythagoras" as including a doctrine of "metempsychosis or transmigration of souls into different bodies" and to the belief that "as the soul was of celestial origin and could not be annihilated, and therefore, upon abandoning one body, it necessarily removed into another and frequently did penance for its former vicious inclinations in the shape of a beast or an insect, before it appeared again in that of a human creature" (Preston 2016). According to Albert Pike (1872), the famous Freemason author, the 17th York degree of the Knight of East and West, is based on the doctrine of rebirth, as is the 24th degree, the Prince of the Tabernacles, where he notes the importance of the teaching of *metempsychosis* as taught in the "Indian mysteries" and the fate of the soul to reincarnate in order to atone for sins that could only be overcome by "voluntary penance" in the form of another physical life (Pike [1872] 2005). Ideas borrowed from Jewish Kabbalah, such as *gilgul* (rebirth), are also found in Masonic teachings (Irwin 2017, pp. 192–94).

Of all esoteric traditions, the most consistent in teaching reincarnation are the various American Rosicrucian orders, all of which currently promote multiple human rebirths. Paschal Randolph (*Fraternitas Rosae* Crucis (FRC), 1861), Freeman Dowd (FRC, 1897), Max Heindel (*Rosicrucian Fellowship* (RF), 1909), and H. Spencer Lewis (The *Ancient Order of the Rosae Crucis* (AMORC), 1930) all wrote formative, detailed works on reincarnation. In terms of American esoteric theories, the Rosicrucian (RC) orders have consistently supported the theory of rebirth through membership instruction in "higher grade teachings" similar to those noted by Pike in the more advanced Scottish Rite grades of Freemasonry. Randolph published a work on afterlife and rebirth entitled *Dealings with the Dead* (1862), the same year that he formed the first American FRC lodge in San Francisco. In this work, Randolph offers a remarkable, creative account of the afterlife and transmigration, based in what he claims as direct visionary, participatory experience. The core of Randolph's theory is the monad, a term he consciously borrows from Leibnitz, where every "soul seed" is an immortal, indestructible monad whose "soul form" is a winged globe and whose origin is the "Eternal Heart" or Divine Mind (Randolph [1862] 2012).

Through "stages of unfolding," each soul, reflecting a divine origin, seeks to overcome lesser entrapments and, as "developing monads," to become fully conscious beings in human form (Randolph [1862] 2012). Thus, all human souls "transmigrate" through multiple species and forms (as retained in soul memory) in relationship to a cosmic process of progressive complexity in development. The monad takes a series of progressive forms—minerals, plants, animals—and, in the process, does not lose its inherent divine nature, which can only be fully known in its human form. Subsequently, a soul can take multiple human forms as it seeks to fully realize its latent divine potentials. Randolph's pre-Darwinian theory maintains that the human soul is present in, but distinct from, each of the embodied forms. In a high enough stage of development ("soul vastation"), the conscious soul can rise to full self-awareness and enjoy conscious existence in the post-mortem state, not necessarily returning to mortal form. Only those lacking fully conscious awareness must reincarnate (Irwin 2017, pp. 194–99). Freeman Dowd further developed and routinized these ideas as foundational to FRC teaching in the present.

Both Max Heindel (b. Carl von Grasshoff) and H. Spencer Lewis likewise developed foundational teachings in which reincarnation is intrinsic to the cosmological order in a generally evolutionary process of human development. Heindel has a highly complex cosmology (1909) that emphasizes multiple stages of soul incarnation, through multiple worlds in a long series of physical lives, each requiring the interaction of multiple psychic vehicles that are necessary to sustain each new material body. These vehicles consist of four distinct aspects, or "higher bodies," each with its own unique

characteristics—the vital-etheric body, the desire body, the mind, and the Ego (Heindel [1909] 1973). Ego is the core of the God-created pure, virgin spirit but has lost awareness of its divine origin, enfolded into the various subtle bodies over millennial cycles of involution. Ego must undergo multiple rebirths "to gather experience" in order to reclaim and affirm the divine nature of soul's origin (Irwin 2017, pp. 199–202).

Spencer Lewis (1930) wrote an entire work on reincarnation in which the evolutionary cycle of the soul, from birth to rebirth, has two phases: the Mundane phase from birth to death, and the Cosmic phase from post-death to rebirth. At birth, the entering soul is "an aggregate of personalities" composed of the essential elements of all previous personalities. Out of this aggregate, a "present personality" is formed, representing a current incarnation, strongly informed by past skills, knowledge, and beliefs. In a present lifetime, new experiences, beliefs, and attitudes are formed to further soul development (Lewis [1930] 1956). At death, or "transition," the soul withdraws with its light and aura properties into the Ego identity of soul (consisting of mind, memory, and personality) and is absorbed into the Oversoul, leaving the body to decay and disintegration. The transphysical Ego-souls of the departed dwell in one of twelve Mansions of the Soul, each of which is "given various names and allegorical representations" (Lewis [1930] 1956). Here Ego-souls receives knowledge and Divine benedictions, knowing they must return to incarnation in accord with the Law of Compensation (*karma*) in a long cycle of multiple lives meant to actualize progressive soul development (Irwin 2017, pp. 203–5).

2.5. Asian Influences: Hinduism and Buddhism

The topic of Asian influence in America is highly complex and cannot be easily summarized in a review article. There are at least three primary vectors for the infusion of Asian ideas of reincarnation in the American context. The earliest influence is text translations which were first popularized by the New England Transcendentalists through journal publications like *The Dial*. In 1842, they began publishing "Ethnical Scriptures," highlighting Asian texts like the *Manu-Samhita* (*Laws of Manu*), which explicitly mention "transmigration" of the soul and the consequences of rebirth resulting from previous actions in a former incarnation. Many other Asian texts with rebirth themes were published in translation for various volumes of *The Dial* (Fuller 1843–1844). In 1843 the American Oriental Society was founded, and in the following year, produced the first edition of the *Journal of the American Oriental Society* (JAOS) which also published translated Asian texts with reincarnation themes (Salisbury 1847; Jackson 1981, pp. 180–82). Another good example of Asian textual resources relevant to theories of reincarnation is found in the compilation of the *Sacred Books of the East* (1879–1910) under the direction of Max Muller. Volume one of the series starts with a fully annotated English translation of five major *Upanishads*, and is followed by nineteen more volumes of Hindu texts, ten volumes of Buddhist texts, and three volumes of Jain texts (Muller 1879–1910). The growing field of Asian studies also produced texts; for example the *Harvard Oriental Series* published many scholarly text translations from Indic classical religious literature (Jackson 1981). Increasingly, American publishers discovered a growing market for Asian texts, eventually leading to an increasingly rich array of texts, many promoting reincarnation (Irwin 2017). Additionally, Christian missionaries to Asian countries also wrote descriptions of Indic religious beliefs and later shared those descriptions in a variety of public forums.

A second influence developed through esoteric interpretations of Asian ideas assimilated from text traditions but then amalgamated into popular forms of American "Hinduism" or "Buddhism" based on a synthesis of occult ideas and piece-meal borrowing from Asian traditions. For example, Charles Johnston, a professed Theosophist and an immigrant to America, translated numerous Sanskrit texts, many with materials on transmigration, as well as his more relevant work *The Memory of Past Births* (1899), one of the first texts written on the topic of past-life memory recall (Johnston 1899). In this volume, Johnston describes the soul's journey to *Devachan*, the higher Theosophical plane of soul renewal, and then its return to rebirth where "its affinities draw it to that land, and class, and family

whose life is most in harmony with its own nature" (Johnston 1899, p. 8). As a result of the "great law of Karma" the soul must then undergo various trials and events based on past actions, including the necessity of lives in both male and female bodies (Irwin 2017, pp. 213–14).

Another such example. is William Walker Atkinson (writing as Swami Ramacharaka) who published over thirty volumes under various "Hindu" authorial names, primarily on divination and mediumship. In 1908, Atkinson published *Reincarnation and the Law of Karma* (under his own name) a work reflecting an eclectic blend of American occult beliefs strongly informed by Theosophical theory and key ideas from classic Hindu texts. The strength of Atkinson's book is not in the rather vague Hindu references, but in his review of various rebirth theories or terminologies, and in his ability to summarize and compare those theories (Atkinson 1908).

The third stream of influence is found in indigenous teachers from India, Southeast Asia, and primarily Japan, first represented in 1884 by the Indian author Ram Chandra Bose when he published his work, *Hindu Philosophy Popularly Explained: The Orthodox Systems*, in both London and New York City (Bose 1884). Bose's account is detailed, rich with newly translated Sanskrit-to-English texts, and very readable. As an early resource for Hindu theories of rebirth and transmigration in the American context, he offers concise definitions of differences between the Indian philosophical schools and does so with direct primary text citations. In September of 1893, the World's Parliament of Religions was held in conjunction with the Chicago Columbian Exposition; this event marks the beginning of popular, charismatic indigenous teachers of Asian religions in America. In Swami Vivekananda's opening address at the Parliament, he specifically addressed the theme of reincarnation. He writes, every human being is a "spirit living in a body" and, while every physical body dies, the "I" will not die, but continues on; there are "two parallel lines of existence, one of the mind, and one of the body" (Ellwood 1987). While bodies may inherit "certain tendencies" from parents (genetics), it is the condition of the soul, based on past actions, that leads the soul to take on a particular body following the "law of affinity," which "is in perfect accord with science," as a result of former habits and patterns of repetition (Ellwood 1987). In 1897, Swami Abhedananda, appointed by Vivekananda, began a twenty-five-year tenure in America as resident teacher of Vedanta, during which time he wrote a small work entitled *Vedanta Philosophy: Five Lectures on Reincarnation* (1907). This work gives an excellent account of Neo-Vedanta philosophy of rebirth as a "rational and scientifically congruent idea," and Swami Abhedānanda argues persuasively for a convergent theory of scientific evolution and Vedanta teachings on the inevitability of rebirth according to laws of cause and effect (Abhedananda 1907).

Perhaps the most influential individual in popularizing traditional Indian ideas on reincarnation in America was Paramahansa Yogananda, founder of the Self-Realization Fellowship (1920). Yogananda was one of the first Indian teachers to live in America, where he resided for over 30 years, primarily in the SRF retreat center in Encinitas, California after 1935. His very popular work, finished toward the end of his life (1946), *Autobiography of a Yogi* (1979), an all-time best seller, remains in print to this day. Yogananda explains the teachings of his guru Sri Yukteswar that after the death of the physical body, the soul takes on an astral form (with its implicit casual body); what maintains the interconnectedness of the three bodies (physical, astral, causal) is the "power of unfulfilled desires," and each domain has characteristic desires. Physical body domain has desires "rooted in egotism and sense pleasure," while astral desires "center around enjoyment of etheric vibrations, music of the spheres, and the phenomenal play of light energies and the process of manifesting diverse etheric forms" (Yogananda [1946] 1979). Causal desires "are fulfilled by perception only" and beings who focus primarily in this domain are co-creators with divinity, helping to manifest the "dream-ideas of God" (Yogananda [1946] 1979). The highest, supreme accomplishment is to transcend the casual body, and by reaching complete and total desirelessness, shedding all bodies, to merge with the Immeasurable Fullness, the One Cosmic Ocean, to become one with the Ineffable Ever-Existent. Based on *karma*, individuals must reincarnate in this world, or other subtler worlds, in order to reach the highest goal (Yogananda [1946] 1979).

In Buddhism, the same historical influences can be tracked: Buddhist text translations; esoteric influences amalgamated by various non-traditional teacher or writers claiming knowledge of Buddhist

theories of reincarnation; and actual indigenes from India, Tibet, Southeast Asia, and Japan acting as charismatic proponents of Asian ideas of rebirth. Texts such as Sir Edwin Arnold's *The Light of Asia: The Great Renunciation* (1879), on the life of the Buddha, certainly popularized ideas of reincarnation. Throughout the work, references are made repeatedly to rebirth, including the Buddha's former lives, the "wheel of change" or rounds of many painful births and deaths, and the realization of how these rounds or rebirths are ended in Nirvana (Arnold 1879). As early as 1878, Rhys-Davids offered an English translation of the many past lives of the Buddha (*Buddhist Birth-Stories: Jataka Tales*), and his work *Buddhism: Being a Sketch of the Life and Teachings of Gautama* (1912) also includes discourses on past lives (Rhys-Davids [1877] 1912, 1878). Henry Warren's collection of Pali texts has a central section on "Karma and Rebirth" that gives a substantive basis for Buddhist theories of rebirth (Warren [1896] 1922). Buddhist text translations increased over time and offered explicit themes on reincarnation based in various ethnic traditions intrinsic to the history and spread of Buddhism.

Individuals claiming esoteric knowledge of Buddhism are also apparent. Henry Steel Olcott's *Buddhist Catechism* (1881) was a very popular pro-Buddhist work and widely read not only in America (40 editions) but also in Europe, Japan, and other Asian countries. Olcott's vision of Buddhism was imbued with his own belief in "core tenets" as definitive for every religious worldview and illustrated through a series of rational, demythologized questions, with replies bolstered by frequent references to the Pali canon (from English translations) and further supplemented by references to Western science. The primary cause of rebirth, according to Olcott, is "unsatisfied desire" and an "unquenched thirst for physical existence" impacted by the degree of "individual merit or demerit" earned in the previous lifetime and leading to either a good rebirth or one "wretched and full of suffering" (Olcott [1881] 1886). The theory of "soul" as an immortal entity is repudiated ("that which is subject to change is not permanent"), and the "person" is defined as "an aggregate of five qualities (*skandhas*)" shaped by karma. The reborn individual is not an immortal soul but "new aggregation of Skandhas" that reflect constant changes throughout each life, shaped by merit and demerit, leading to a new life formed as a "consequence of his action" (Olcott [1881] 1886). The goal of Buddhism is, however, to escape rebirth and attain the realization of *Nirvana*, which Olcott defines as perfect rest, cessation of changes, absence of desire (Irwin 2017, pp. 234–35).

As with Hinduism, the Buddhists were also represented at the Chicago World Parliament of Religions in 1893, notably Anagarika Dharmapala (Theravada Buddhist) and Soyen Shaku (Rinzai Zen master). In Dharmapala's Parliament address, he references rebirth and notes that "until you realize Nirvana, you are subject to birth and death. Eternal changefulness in evolution becomes eternal rest . . . there is no more birth, no more death" (Dharmapala 1999). Rebirth is here linked to evolutionary theory, and progress culminates in Nirvana, thus linking Buddhist stages of rebirth to a generic science concept, illustrating a contemporary theme in Buddhist thought as rational and scientific. However, the most influential individual in popularizing Buddhism in America was Dr. Walter Evans-Wentz, an American follower of Hinduism and yoga, who edited a series of translated works from Tibetan (1927), the most well-known of which is *The Tibetan Book of the Dead: Or The After-Death Experiences on the Bardo Plane* (Evans-Wentz [1927] 1960).

While the *Tibetan Book of the Dead or The After-Death Experiences on the Bardo Plane*, is "fraught with problems, errors in translation, inaccurate dates, misattributions of authorship, [and] misstatements of fact" (Lopez 2011), it is nevertheless a classic, popular text on the afterlife and the process of dying, transition, and rebirth that has influenced many generations of American readers, including scholars and Tibetan teachers, selling over 500,000 copies. This work is too complex to summarize but it is a text that gives credibility to the processes of dying, staged afterlife transitions, and rebirth choices based on karma and initiate training. A substantive review and analysis of the text can be found in Irwin 2017. While the *Tibetan Book of the Dead* now has many diverse translations and an entire scholarly literature bolstering a variety of "Tibetan" interpretations, usually subject to various Western perspectives on the text, the Evans-Wentz version remains the classic "esoteric" account of the Tibetan theory of death and rebirth (Lopez 1998).

A final example of metaphysical eclecticism in the Asian context is a work by Manly Palmer Hall, *Reincarnation: The Cycle of Necessity* (1999). In a broader sense, Hall's well-known syncretic construction, *The Secret Teachings of All Ages* (1928), epitomizes the esoteric metaphysical tradition in America as a synthesis of classic texts, ranging from Plato to his present day, including over 600 text references from alchemy, Gnosticism, Hermeticism, Rosicrucianism, Freemasonry, magical lodges such as Golden Dawn and Anthroposophy, as well as research from anthropology, myth and symbol studies, comparative religions, Asian traditions, literature, philosophy and science. Hall demonstrates with great panache the textual influences that became primary resources for the construction of "ancient wisdom" as a perennial secret tradition "concealed within the rituals, allegories and mysteries of all ages" (Hall [1928] 2010). Taking the stance that reincarnation is an ancient mystery teaching, universal in its articulation through a multitude of cultures, he gives an historical overview of the belief as originating in India and most clearly expressed in Buddhism. He makes a crucial distinction between East and West—"the Western school accepts reincarnation as a means of unfolding the individual while the Eastern school accepts reincarnation as a means of eliminating the individual" (Hall [1939] 1999, pp. 47, 38). The "fundamental impulse" of the law of rebirth is to make "the present inadequacy unbearable" through a deep aspiration to greater perfection. The highest perfection is *nirvana*, which ends the cycles of necessity and which Hall defines as "an experience of the final personality returning to the unconditioned consciousness of the entity itself"—not the end of evolution, but the end of evolution "as we know it" as incarnate physical beings (Hall [1939] 1999, pp. 163–74; Irwin 2017, pp. 247–51).

2.6. Esoteric Christian Reincarnation

While normative Christianity has denied reincarnation, there is nevertheless a long unbroken history of writings on rebirth by Christian authors that extends from the Gnostics to medieval theories into present day America. An excellent example of this trend is a work by the Protestant theologian James Pryse, *Reincarnation in the New Testament* (1911). Pryse offers the view that a human being has three bodies—physical, psychic, and spiritual—and that each body corresponds to its appropriate world—material, etheric, and heavenly—while the deepest center of soul, the Self, is "identical in essence with Deity" (Pryse 1911). It is the material and psychic aspects that relate to reincarnation or the "wheel of birth" (James 3: 6), while the essential Self is ever free and divine. The soul retains all memory of past lives, but recall by the "external consciousness" can only succeed if the outer life is purified to such a degree that it correlates with the inner reality of the deeper Self (Pryse 1911). He describes Jesus as the "son of David," indicating that Jesus is King David, therefore Abraham reborn, and that Peter is Jonah reincarnated. The reference to "the generations that will not pass away until these things come about" (Matthew 14: 34) refers to the necessity of reincarnation, as those souls with Jesus must be reborn until the full realization of his end-time promises (Pryse 1911).

Another Christian author writing on reincarnation is Ray Goudey, *Reincarnation: A Universal Truth* (1928). This volume is a summary overview of early 20th Century metaphysical ideas, centered on Christianity in conversation with other religious traditions, scientific research, and popular press accounts of participatory encounters. The human construct is a layered entity with spirit inmost, encompassed by soul, which contains memories of all past lives, united with a characteristic mental body, emotional body, and physical body, for each lifetime. The immortal monad is indestructible and capable of "continual progress upward and onward" and requires multiples lives in both male and female bodies to develop sensitivity and perspectives on both bodied ways of life (Goudey 1928, pp. 43–46). The heart of the book is an analysis of Christian beliefs in reincarnation as held by specific individuals, primarily Church Fathers, Catholic and Orthodox, including "non-orthodox" Christians found among the Gnostics, Basilidians, Valentinians, Marconites, Manicheans, and Essenes—all as groups who promoted theories of reincarnation. Taking an esoteric Protestant view, he then plunges into "Biblical evidence" and examines over 50 references in the Christian Bible, which he interprets as confirming a belief in reincarnation (Goudey 1928).

The actual history of Christian reincarnation theory in the 20th Century is dense and complex, heightened by a new element, the participatory account of select mediums and psychics who draw upon personal intuition as much as scripture for authentication. Edgar Cayce (d. 1945), a deeply committed Christian, epitomizes this metaphysical trend. Cayce became an early classic example of an American medium who validated reincarnation through his own and others' (about 2500) past life readings (Cerminara 1950). In Cayce's theory of reincarnation, the "soul-entity" is shaped by two fundamental influences: *karma* and the "ideal" that guides and inspires each soul. The "ideal" is primarily informed by foundational Protestant Christian virtues and "Christlike" attitudes that emphasized working for the good of others, through healing, charity, kindness, and love (Cerminara 1950). The "person" is a conjunct of body, mind, soul, and a divine aspect that motivates actions according to inherent purpose (a positive Christian world) and undergoes development through multiple lives, every aspect of embodiment etched in detail in the indelible Akashic records (Irwin 2017).

At death, the soul-entity ascends to a higher state where it becomes "superconscious" and more ecstatically self-aware. At rebirth, the higher conscious mind reverts to a subconscious state while all past knowledge remains identified with the superconscious state (as repressed past-life memories). The newly embodied individual thus acquires a new, unformed conscious mind identified with a new body that is only vaguely aware of the deeply quiescent, now latent superconscious mind (Smith 1989). Casey also gave detailed accounts of seven of his past lives and described his relationships to others in terms of "group soul" relations extending over thousands of years (Langley 1967).

In 1949, The Order of Christian Mystics published a collection of four essays by the founder, F. Homer Curtiss on reincarnation. He defines reincarnation as "the repeated, cyclic embodiments on Earth in human form, of the same Spiritual Being or individual Soul. In thus incarnating you do not become someone else but are always yourself" (Curtiss 1949, p. 10). He bolsters this definition by citing Hindu scriptures (*Bhagavad Gita*), though he repudiates the "repulsive doctrine" of transmigration of soul to animal reincarnation. He notes that it is not the "personality" which reincarnates, but the "spiritual self" as an "incarnating Ray upon which all the transient personalities are strung" (Curtiss 1949, p. 11). Curtiss lists primary reasons for reincarnation: a single life is too short for the realization of one's chosen destiny or desires; to prove through trial the lessons learned in previous lives; to redeem past mistakes and reap rewards from good deeds; to continue strong ties of love and companionship and secure forgiveness to others for past harms; and to radiate the Christ-force to advance evolution (Curtiss 1949, pp. 22–24). Curtiss contends that his interpretation of reincarnation is perfectly consistent with Christian teachings. Using biblical citations and referencing early church fathers, he argues that a just God has created a world that requires multiple incarnations in order for all peoples to hear the teachings of Christ and then to live up to those teaching through multiple incarnations leading to spiritual perfection.

In the post-World War II context, the theory of reincarnation continued to grow and gain increasing numbers of adherents among Catholic, Protestants, and Evangelical Christians. In a 2009 PEW survey of American religious beliefs, 22% of Christians confirmed belief in rebirth (PEW 2009). Two prime examples from this period are Dr. Quincy Howe Jr.'s *Reincarnation for the Christian* (Howe 1974) and Dr. Geddes MacGregor's *Reincarnation in Christianity: A New Vision of the Role of Rebirth in Christian Thought* (MacGregor 1978). These authors are academic scholars; Howe taught classics at Scripps College and MacGregor was a distinguished professor of philosophy at University of Southern California. Both books have been, and continue to be, popular and easily available and are written as an appeal to Christians to rethink theories of afterlife and post-mortem events. Both promote a point of view that reincarnation is completely compatible with a liberal interpretation of scriptures and with normative doctrines within a wide range of Christian denominations. Both are explicitly historical, contextualizing reincarnation theory as an implicit teaching of Jesus repressed by institutional churches to better support ecclesiastical power and social control; both draw on comparative (Asian) religious

sources to bolster their theories. And both authors claim to be devoted Christians whose education led them to believe that rebirth is a rational and believable doctrine (Irwin 2017, pp. 264–68).

A final example is a work by Elizabeth Clair Prophet, *Reincarnation: The Missing Link in Christianity* (1997). Her esoteric message (received through mediumship) on Christianity and reincarnation is an engaging review of contemporary theories in biblical criticism, allied with interpretations of scriptural passages written to show the "secret teachings" of Jesus as similar to teachings found in select "Gnostic" texts. One of the few esotericists who has incorporated biblical criticism into her theory of reincarnation, she recreates the Jesus context in concord with contemporary scholarship on the life of Jesus and uses copious references from the Dead Sea Scrolls, the Old Testament Pseudepigrapha, the Nag Hammadi texts, and other early non-canonical text sources to support her theory, as well as materials from current parapsychological research (Prophet 1997).

She presents Jesus as "an esoteric wisdom teacher" whose "secret teachings" were directed toward the attainment of *gnosis* and the soul's union with God, as reflected in specific Gospel passages, further amplified by references to Gnostic texts. The human sojourn in the world may require many lifetimes or rebirths to reach the necessary degree of purity for attaining mystical insight that leads to "resurrection"—defined as direct mystical knowledge of God in the present lifetime. She also places emphasis on the "body as prison" (*soma-sema*, citing Neoplatonism) as a true description of the material world incarnations where attachments to "transitory [worldly] beauty" draws the soul back into new bodies. The challenge of rebirth must be overcome through four basic aspects: fulfilling all karmic obligations; identification with the true spiritual self; receiving divine grace that awakens a person to spiritual practices; and focusing "all your mind on the purpose of reunion with God." According to Prophet, only when *karma* is "balanced" can a person "find the nonlocal state, the kingdom of God," (referencing quantum theory) and attain liberation from rebirth (Prophet 1997, pp. 298–318).

3. Trans-Traditional American Reincarnation

While strictly fictive accounts of "past lives" are too numerous to survey, nevertheless such narratives introduce the theme of multiple past lives as imaginative constructions in a variety of genres whose authors mix fictive narratives with past life claims. Such claims are often interwoven with participatory encounters that combine *déjà vu*, past life memories, dreams, visions, and intuitive perceptions with imagined constructions of alternate lives in distinctive social or cultural settings. These "spiritual autobiographies" of past lives in storied form, imaginatively reconstructed and given legitimacy through claims of evidential memory and detailed information of the period, represent a new genre in reincarnation theory. They also set the stage for the popularization of reincarnation in a variety of media whose readers increasingly seek more information and rebirth stories based in popular claims of direct personal experience. The tendency that manifests is an interesting mix of imagination, memory, creative fiction, and revelations about human existence no longer reducible to any religious theory but often eclectic and, at times, eccentric and individual (Irwin 2017, pp. 295–96).

Augustus Marion Fulk, a highly-respected Arkansas judge from a distinguished family of lawyers in Little Rock, is an excellent example of the syncretic, imaginative, and eccentric. Fulk's work, *Reincarnation: Time, Space, Matter* (1940), is a large, dense volume which offers a unique American account of rebirth that is philosophical, scientific, and "divorced from religion" (Fulk 1940, p. 13). While Fulk's theory is highly idiosyncratic, it represents a strong commitment to "*a priori*" intuitions based on his personal past-life *knowledge* (rather than past-life memories), aligned with theories in science (particularly physics and astronomy), without reference to any esoteric school of thought. However, in many ways his theory is alchemical and hermetic, as it describes a reiterative structural set of correspondences from the eternal atom of the soul, through the periodic table, processes of nature, the person, the world, the solar system, the galaxy, to the macrocosmic universes in an infinite scalar system. While the system is much too complex to fully summarize (Irwin 2017, pp. 297–300), Fulk's work is based on his creative interpretation of the periodic table and atomic structure as a basis for a cosmic model of interlinked, scalar universes from the smallest to the largest.

The narrative is a series of reflective essays on the imagined significance of proton and electron configurations of the elements as a base model applied to human life and soul existence; as an imaginative construction, it is a unique synthesis of science theories and intelligent, eccentric ideas. Fulk clearly professes an early form of process theology; as souls evolve within the vastly contained universes of Being, through the agency of all souls, Being also evolves. In this divine process, every human being has a soul, a divine atom which is a "round objective reality containing subjective knowledge" and which is enhanced and developed over many lifetimes (Fulk 1940). Through recurrence, the soul retains and enhances specific contents of knowledge, which is forever held within the vast and immortal sphere of the soul particle. Reincarnation describes this process of gradual development through learning, lived experience, and integration; only through recurrent processes of life embodiment (rebirth) can the soul develop, just as God develops through the lived knowledge gained by every soul. Human *a priori* insight is the surfacing of that innate knowledge of soul, bringing forth past insights in relationship to new discoveries and needs. Thus, it is not "past life memories" that matter but past insights and *knowledge* that can, often unconsciously or as recovered in dreams, be applied to current desires and circumstances (Fulk 1940).

Another example of creative, fictive construction of reincarnation is found in L. Ron Hubbard, founder of *Dianetics* (1950) and the Church of Scientology (1953). The goal of the Dianetic therapy is to produce a "clear," defined as a person who has been "audited" to rid him or her of all traumatic "engrams" that reside in cellular memory acquired in traumatic circumstances, starting with prenatal traumas. The relevance of Dianetic theory to reincarnation is that when auditors (who direct the clearing process) identified past traumas in preclears, they discovered that imprints were attributed to past-life events. This opened a new field of inquiry which Hubbard addressed in *The History of Man* (2007). The theta, or soul, as the main target of auditing, is the "I" of the preclear, the true core identity of the person; "it is immortal and cannot die" but may succumb to deep conditioning by cellular memory or injected entities ("subpersonalities") and may be "asleep" and unrecognizable by the conditioned, conscious personality (Hubbard [1950] 2007). Thus, the individual incarnate is a combination of a "genetic being" and a "theta being," each with its own time track, the genetic representing the protoplasmic, genetic species evolutionary line and the theta representing a transphysical, psychic line combining with a different genetic line in every incarnation. Hubbard also notes that at death the theta goes to the "between-lives area" (usually Mars) where it reports in and is given a "strong forgetter implant and is then shot down to a body just before it is born" (Hubbard [1950] 2007). The elder phase of a "second childhood" is a prelude, reconstituted from theta memory, of the forthcoming death and rebirth (Irwin 2017, pp. 301–3).

Paul Twitchell, founder of Eckankar, is another example of an American spiritual teacher who embraced India as the source of wisdom but who then adapted his message based on his own out-of-body experiences (Twitchell 1969). Influenced by the Hindu teaching of Yogananda and later by Kripal Singh, a master in one of the Sikh lineages and founder of Surat Shabd Yoga (which teaches out-of-body projection), Twitchell constructed his theory of reincarnation as "ancient teaching" that he learned through soul travel. According to Twitchell, all humanity is linked through karmic bonds and every individual action affects the whole; thus the "law of Karma" is the "underlying principle of human responsibility" (Twitchell 1969). As the "fruits of action" are inescapable, they determine rebirth and events in future lives. All karmic obligations and consequences are stored in the *Karan Sarup*, the causal body which "never makes a mistake" recording deeds, and which requires that all karmic debts on the physical, astral, and mental planes be paid off on the plane to which those debts correspond. Those with very good, excellent karma will rise above these lower planes and ascend to higher planes in the "fifth world;" this is liberation, a return of the soul to God, the primary goal of Eckankar (Twitchell 1969; Irwin 2017, pp. 286–88).

3.1. Paranormal Science and Popular Rebirth Theories

A new approach to reincarnation theory began in 1960 when Dr. Ian Stevenson published his first article on the subject, offering evidential information. Chairman of the Department of Psychiatry at the University of Virginia in 1957, and later the founder and Director of the Division of Perceptual Studies (1967), Stevenson published prolifically on reincarnation and wrote many articles and books which have become classic examples of an evidential approach founded primarily upon material gathered from young children who claimed to recall past lives (Stevenson 1966). Stevenson assembled "cases of the reincarnation type" (CORT) that focused on children between the ages of 2 to 6 years old, who spontaneously claimed an identity as a "previous personality" who had lived before his or her current life. By 1966, he had gathered detailed information on 600 such cases, including cases in which he interviewed the children himself; by the end of his research he had documented over 2500 such cases.

In 1983 Stevenson analyzed 79 cases of past-life memory in American children, claiming that this is the first report of such cases (Stevenson 1983). He discovered that around three years old (the mean), an American child begins to claim memories of a past-life, giving proper names or persons and places, including the mode of death, and then around six to seven years old, ceases to mention these claims. The child also demonstrates unusual behaviors that often correspond to the behaviors of the claimed past-life individual or, in Stevenson's term, the "previous personality." Often parents claim that they do not know and have never heard of the claimed former personality; children may give up to 50 details of the previous personality and many of these are verifiable. Of the 79 American cases (43 male and 36 female), only 16% of the parents in 56 cases claimed to believe in reincarnation (23 cases could not be assessed), the other parents made no such claims, and many had never heard of reincarnation as a possible afterlife theory. In most cases, parents denied the validity of the rebirth, usually not taught by their religion, and often chastised or punished their child for claiming such memories (Stevenson 1983). In many ways, Stevenson's research marks a watershed in reincarnation theory, as it moves the center of focus away from a religious context entirely and relocates the center in an academic, evidential program of investigation.

In counterpoint to the development of past-life research in the academic context, popular American narratives on the subject continued to flourish based on direct personal encounters. For example, Marcia Moore published her popular book *Hypersentience* in which she articulates a variety of techniques for recalling past lives. Having observed the effectiveness of hypnotic regression, Moore rejected the concept of hypnotism as a form of "negative mind control" and instead formulated a theory of past-life recall which she termed *hypersentience* (Moore 1975). Rather than use the term "regression," she calls past-life memories "retrocognitions" or retrocognitive recovery. This technique echoes the increasing use of hypnotic techniques to invoke past-live memories through induced ASC in ordinary clients. Moore's detailed narrative accounts of client responses provides a fascinating record of past-life (and other dimensional) experiences in which almost all clients live mundane, often impoverished, troubled, and by no means exemplary lives in difficult, frequently prejudicial, cultural circumstances. The dramas in those lives turn around the most ordinary human circumstances, often with unhealthy or deceiving human relationships, amid violent events, social upheaval, wars, bias against women and children (causing future trauma), and punctuated by happy moments and positive love relations.

The narrative theory of past lives, that is the creation of a past-life story, has become a predominant interpretative frame for speculation about out-of-body perceptions, alternate reality formations, superconscious states, and paranormal capacities—all constructed on a loose thematic assemblage of diverse narrative elements often associated with reincarnation theory. The question of *imagination* brings additional complexity to this assemblage because there is no denying that imagination may play a significant role in the narrative process. The link with reincarnation as a narrative context for imagining a fictive past, seems to have therapeutic value that overrides the ontological presuppositions of actual multiple lives. Nevertheless, the resulting narratives are a foundational source for further speculation and theory-building and the syncretic, thematic, narrative method is typical of many

past-life accounts, increasingly so in contemporary writings, all divorced from any religious context (Irwin 2017, p. 328).

An outstanding syncretic and non-religious example of reincarnation theory is the writings of Jane Roberts, a very sophisticated writer, poet, and psychic explorer of the nature of consciousness. Her publications, including those under her own name and those authored by Seth, defined as an "energy essence personality" who spoke through Jane, are extensive, many dense volumes long. Jane summarized the Seth material on reincarnation in her own work, *Adventures in Consciousness* (1975), the core "aspect psychology" text. In this theory, the "focus personality" is the current identity of the embodied individual. However, a more deeply inherent "source-self" is the actual core of transphysical identity which manifests as a variety of "aspect selves" in various embodied and disembodied forms. The embodied forms are the physical lives, past, present, and future, of the source-self; the disembodied forms are identities immersed in other dimensional realities (Roberts 1999, pp. 95–99). Each person has many "aspects" which manifest through various incarnate lifetimes and each life is engendered and sustained by the transphysical source-self. All of these lives are concurrent.

The present "now" is the current life of the focus personality and, through psychic contact with the source-self, it is possible to perceive other lives. The interrelated lives mutually influence each other such that, in the current life, a person may influence both "past and future lives" and those lives may influence the current life. Other lives may appear as "personality aspects" (traits, characteristics, tendencies) within the current focus personality, and the source-self "can be thought of as an entity, a personified energy gestalt" that leaves "aspect prints written on the [current] psyche" (Roberts 1999, p. 100). Thus, every human being is a multidimensional being, with transphysical origins, and the embodied ego or focus personality functions in a twofold manner to coordinate with physical life and to receive inner perceptions related to the source-self and its diverse aspect prints (Irwin 2017, pp. 310–14).

Another influential individual who has strongly shaped past-life thought through popular publications is Dick Sutphen, author of *You Were Born Again to Be Together* (1976) and *Past Lives, Future Loves* (1978). Sutphen is not a medium but a facilitator who uses hypnosis to induce past-life recall in his clients, either in individual or in group sessions. Since 1971, Sutphen claims he has regressed thousands of individuals whose narratives are assembled into some interesting and creative theories about past and present lives. Subscribing to a general theory of karma as an "unerring universal law," Sutphen leads people through sessions, similar to hypersentience, into their "superconscious" mind, where explanations of current relationship issues are explored, often karmically linked to shared past events (Sutphen [1976] 2014). Sutphen theorizes that each soul may have up three or four *simultaneous* or overlapping lives, bound in a "soul matrix" often visualized as a linked series of past, present, or future lives. An extension of this theory is expressed in the concept of a "timeless" present in which all lives, past, present and future, are lived simultaneously, right now (citing Jane Roberts). In other words, all possible lives, including simultaneous lives, group soul lives, distant past lives, and far future lives, form a continuum that, when viewed from the timeless perspective, seem all to be active and alive concurrently. Only when the perspective shifts to a specific life does the continuum collapse, like a quantum wave function, into a local space-time condition representing the bound life and memories of one incarnation (Sutphen [1976] 2014). Additionally, Sutphen articulates a theory that each soul is a "creator" in a metaphysical sense: a single soul may generate after any one life multiple incarnations (e.g., three), and each of the three incarnations can then each generate three more incarnations, the soul dividing and multiplying progressively to form a vast tree of soul associations, any one incarnation of which might be accessed in a regression session (Sutphen 1978).

3.2. Regression Therapy and Interlife

Therapists also wrote popular works related to reincarnation, for example Edith Fiore, *You Have Been Here Before: A Psychologist Looks at Past Lives* (Fiore 1978), Helen Wambach, *Reliving Past Lives* (1978), and Morris Netherton, *Past Lives Therapy* (1978). These works all take the view that reincarnation

theory is a meaningful perspective when applied to helping clients overcome basic personality issues, fears, maladjustment, or a wide range of emotional concerns. The narrative contents of past lives are by no means romantic or ideal, but usually narrated as traumatic, violent, ordinary, or just difficult in terms of problematic relationships and everyday hardships (Netherton [1978] 2013). The crux of past life memories is resolving old, habituated tensions and discomforts. Wambach's research is distinctive, as she used group regression techniques to see if volunteers would give historically accurate data for a variety of historical time periods based on their subjective experiences. Her basic technique was to regress a group of volunteers in stages, to selected time periods, in silent reverie, and then, upon return to normal consciousness, ask each individual to record impressions on a questionnaire of her design (Wambach [1978] 2000). Asking regressed subjects to identify such features as clothing, food, or class in various time periods resulted in a remarkably consistent portrait of a given time period, very consistent with other cultural studies of those same eras. She found, to her surprise, that only 11 out of 1088 narrative reports had any "clear evidence of discrepancies," even when conscious subjects had inaccurate views about past eras. Thus, collectively induced past-life regressions seem to correlate well with accurate historical data from those periods (Wambach [1978] 2000).

Joel Whitton and Joe Fisher's *Life Between Life* (1986) supports a theory of reincarnation that includes "interlife" (the period between physical lives) narratives based on Whitton's regression case histories. Whitton developed a theory of *metaconsciousness* as an "extraordinary state of mind" attained during the interim period by the post-mortem individual. More explicitly, he defines metaconsciousness as "an extremely paradoxical state of memory awareness" that combines both a sense of mergence or union with "existence itself" and a heightened state of self-awareness which reveals "one's reason for being" and the personal significance of karma (Whitton and Fisher 1986). In releasing the body, clients report seeing the corpse, feeling a sense of liberation (or fear), floating away into another dimension, possibly encountering a guide, attaining metaconscious awareness resulting in a swelling up of recent past-life attitudes and emotions, and then being led to a benevolent "Board of Judgment" where the soul is confronted with a panoramic review of the past life. In consultation with compassionate members of the Judgment panel, usually not more than three judges, a new "life plan" is developed based on karmic debts, occurrences in need of rebalancing, and possible new avenues of experience. A "karmic script" is developed in relationship to other individuals, including time and place of birth, parents, gender, role assumptions and other existential details (Whitton and Fisher 1986).

Many Lives, Many Masters (1988) by physician Brian Weiss is the story of one client and how her recall of past lives transformed Weiss' worldview. As a Yale University M.D. and Chief of Psychiatry at a large Miami hospital, Weiss describes himself as a conservative and a scientist. Over an 18-month period, Weiss treated Catherine (a Catholic who did not believe in rebirth) using conventional therapy for treatment of her fear-based phobias and anxiety attacks. When this failed, he then tried hypnosis. Having been regressed to the age of two in search of a cause for her fear of water, Catherine suddenly named the year 1863 BCE as a barren place without water in where she saw herself as a young mother of a female child who was currently her niece. This rocked Weiss, who claimed to absolutely not believe in reincarnation, and Catherine, who rejected rebirth and had no knowledge of rebirth theory. Were these "memories" fantasies or imaginative constructions? The rest of the book is dedicated to a series of hypnotic sessions in which a series of lives (10–12) were articulated by Catherine. The book culminates in Weiss' belief that such narratives were not the product of psychosis, hallucination, or multiple personalities; and that their articulation, often in dramatic emotional expression, resulted in radically improved mental health (Weiss 1988).

Another example is found in the work of Roger Woolger, author of *Other Lives, Other Selves: A Jungian Psychotherapist Discovers Past Lives* (1988). Woolger earned a British PhD with advanced studies in philosophy, religion, and experimental psychology, trained at the C. G. Jung Institute in Zurich, and later immigrated to America as a college professor and successful psychotherapist. Woolger primarily regarded past-life regression narratives as a form of "active imagination" (without denying

the possibility of rebirth) and defines personal identity in terms of a self-aware, conscious ego and a deeper self that unites both conscious and unconscious aspects. Taking a somewhat middle ground approach, Woolger confirms that past-life memories may be expressions of actual past lives but, even so, such memory-impressions are inseparable from normative psychological processes and have, therefore, dynamic structural aspects intrinsic to the healing process (Woolger 1988). Insofar as past-life memories may reflect actual incarnate past experience, nevertheless, fantasy, collective influences, and inherited familial or communal psychic conflicts may shape the overall complex of specific past-life memories. The healing power of catharsis and re-enactment can tap ancestral dramas and contribute to the "memory" of a given past life, or, participation in an actual past life can result in the incorporation of past collective experience into the current psychic life of the individual (Woolger 1988).

3.3. Near Death and Out of Body Research

Near death accounts (NDE), beginning is the 1970s and continued into the present have contributed substantively to afterlife theory and indirectly to reincarnation (Atwater 2007; Carter 2010; Moody 1975). NDE evidence offers an opening for reincarnation theory by demonstrating the plausibility of a "surviving identity" whose cognitive capacities seem not only normative but enhanced in the post-mortem state (Greyson 2010). The most common NDE qualia are: a sense of separation from the physical body as a discreet mobile identity (OBE); intensification of feelings; lucid awareness of local physical surroundings; movement away from those surrounding, often into or through a velvet darkness; encountering a non-ordinary realm inhabited by postmortem others, including relatives, friends, animals, and "beings of light" who are perceived as helpful and supportive; intense feelings of peace, calm, and joy; and in deeper NDE, a cosmic encounter with Light, God, or other manifestations of great ontological import for the experient. These qualia are noted as occurring while the experient is clinically dead, that is in a medical context having no heartbeat, no eye reflex, no breathing and no measurable brain activity (Irwin 2017, p. 361). If there is a surviving identity apart from the physical body, as illustrated in thousands of NDE cases, then reincarnation is a possible outcome intrinsic to an afterlife process (Holden et al. 2009).

The out-of-body (OBE) aspect of the data refers to the state of an individual who can differentiate between his or her physical body and another more etheric "body-like form" that seems to have all the normative sensory functions of an embodied consciousness. The OBE often results in contact with post-mortem domains inhabited by a wide variety of entities, spirits, or deceased individuals. Insofar as a "projected self" can seemingly enter alternate worlds and return with lucid memory of such encounters, such a self may be an entity that survives death and, if so, then such encounters may support reincarnation theories (Irwin 2017). The best example is found in the writings of Robert Monroe whose "out of the body" narratives make a direct connection with reincarnation. Monroe lays out not only a theory of reincarnation but a topological description of afterlife domains that impinge upon and condition the cycles of death and rebirth. Monroe (1985, 1994) outlines a complex system of hierarchical domains, ranging from near physical earth-life, to an intermediary zone where the individual recognizes being dead, to a much vaster nonphysical domain (or "Belief System Territories") consisting of many sub-domains based on shared, communal beliefs. Post-mortem individuals tend to gravitate to sub-domains consistent with their dominant beliefs. The highest quasi-transhuman zone consists of "Last Timers" who are preparing for one final physical incarnation, after which the entity is free to explore even more advanced domains beyond the human world. Monroe claims to have visited and explored all these domains via OBE (Monroe 1994).

The elaboration of meta-domains of post-mortem life has continued to gain in popularity, not only from NDE and OBE narratives, but also from a specific technique in regression therapy structured around the interlife period. The best example is found in the popular publications of regression therapist Dr. Michael Newton (Newton 2001) who draws a specific parallel between OBE, NDE, and hypnotized clients talking about interlife experiences as a prelude to reincarnation. Newton's writing is strongly didactic, based on his own client cases and is replete with many leading questions during

hypnosis, resulting is a fixed, paradigmatic psychocosm that becomes the archetype for all human dead (irrespective of culture, ethnicity, or religion). Hypnotic regression, for Newton, is a means for accessing "superconsciousness," thereby acquiring multiple memories of existence *in-between lives* for any given individual client. Drawing upon his many cases, he assembles the material into discreet stages, based on specific visualization techniques that result in a composite, idealized view of the entire interlife process (not found in any one case)—which he sees as reinforced by narratives from OBE and NDE research, as well as past-life studies.

Newton's interlife stages are as follows: death and exiting the body (OBE); entering a near (lower) astral plane with awareness of local embodied life; "homecoming" (being met by transphysical others in a welcoming sense, what he terms "our reception committee"); the dispersion of "displaced souls" (the separation of souls "severely damaged," consisting of two types: haunting ghosts who resist advancement and those separated from others for "rehabilitation" in "a kind of purgatory") (Newton 2001). This leads to "orientation," which he describes as "a healing station" that involves "substantial counseling with one's guide," a "debriefing" to help the soul readjust to returning to the spirit world, "gentle but probing," where the previous incarnation's "performance is judged" in order to reveal strengths and weaknesses. This judgment, similar to Whitton's theory, occurs before a "panel of superior, wise beings," or "Council of Elders," consisting of three to seven members who examine the soul's conduct, with a guide acting as an advocate for the soul. This judgment usually occurs during "transition" in a "staging area," a vast interlife domain of many sub-domains, as in Robert Monroe, a hub of interlinked, transferring souls heading for specific sub-domains or group placement in "spiritual schools directed by teacher-guides" (Newton 2001, pp. 71–86). Working within a "maze of karmic issues," an individual must eventually select a body, gender, and family consistent with his or her "blueprint for the next life" developed with guides and soul-group members (as in Whitton). The selection may include choices for certain limitations, illnesses, or deficient conditions to strengthen soul development and to balance karmic debts (Newton 2001).

Clearly, the increasing popularity of reincarnation theory among various advocates of OBE and NDE narratives, coupled with evidential data from significant medical personnel, professional therapists, and scholarly, research-based analysis of relevant materials, has challenged conventional ideas about consciousness, personhood, and transphysical human identity (Irwin 2017). Academic philosophers have entered the fray, disputing theories and attacking or defending the plausibility of reincarnation, with parapsychologists mediating the stretch between competing theories. There are primarily only three such current theories: the *materialist position* of consciousness as utterly dependent upon and caused by a physical body and brain with a variety of epiphenomenal, eliminative, parallelist, and mentalist interpretations; therefore, reincarnation cannot possibly be true. Second, there are several types of *dualism* such as the Cartesian mind/matter distinction between an individual mind and a specific body, or more subtly "interactionism," in which mind or psyche may directly influences neural events; thus, dualism leads to *survival theory* in which (at the very least) some mental aspects of identity survive death. And third, the *heightened psi* theory that argues that all accounts of survival, mediumship, past-life recall, and so on, can be attributed to very developed ESP abilities such as telepathy, clairvoyance, or psychokinesis, as carried out by living, embodied individuals. This "super-psi" theory throws into question the legitimacy of reincarnation (and survival), while not denying the value and significance of psychic perceptions (Beauregard and O'Leary 2007; Braude 2003; Irwin 2017, pp. 369–70).

4. Conclusions

The history of belief in reincarnation, in the American context, reveals a complex pattern of interactive influences moving toward an increasing detachment from any specific religious tradition. Over the last fifty years, reincarnation theory has been increasingly identified with personal experience, therapeutic practices, paranormal studies, fictive or imaginative accounts, and a wide variety of American metaphysical teachings strongly influenced by esoteric ideas and organizations. This does

not mean, however, that we have a coherent theory of reincarnation (Irwin 2017). In fact, what we have are many convergent and contradictory views as well as some ill-defined or idiosyncratic, unprovable theories that lack conclusive evidence beyond the descriptive narrative of the propagators of those theories. If reincarnation theory is a suppositional or propositional construction that seeks to offer a plausible ontological account based on information, from diverse lines of research, then such theory is also subject to revisions based on additional information that might challenge original assumptions (Irwin 2017, p. 395). In this sense, reincarnation is a provisional theory with many alternative constructions.

The history of reincarnation theory has been moving away from doctrinal accounts and into a more mediated area in which personal, participatory events linked to paranormal studies offer a wealth of data for the formulation and reformulation of theory. However, there is another issue in which more ordinary accounts (as in regression therapy) are juxtaposed to accounts by those with unique capacities to interpret rebirth theory based on exceptional perceptual abilities. Paranormal studies clearly demonstrate that some persons have unique forms of participatory encounter, including NDE and OBE experiences (Palmer and Hastings 2013). To what degree is "special knowledge" or unique psychic capacities necessary for the formulation of theory? There is also the question of karma. Most theory of karma is remarkable simple and underdeveloped. Karmic influences as "causal" are surely part of a much larger, complex universe of interactive influences that far exceeds any linear theory that would equate action A with a given (post-mortem) effect B. Thus "an eye for eye and a tooth for a tooth" is not a working model for karmic influences. What exactly are the causal influences that might shape a future life based on a holistic theory of causal effects? A complexity model of karma might consider a multitude of influences in a "tangled hierarchy" of cross-related causes linked together by long-term relationships, collective developments, catastrophic events, climate change, cultural and historical transformation, ethnic differences, gender diversity, genetic coding, and a vast range of subtle psychic interaction. No such model currently exists.

In the cosmological sense, reincarnation theory points toward a "metacosm" in which there are multiple possible domains of lived, post-mortem experience. Such a cosmology is not reducible to the visible, even instrumental, observable physical universe. All reincarnation theories posit an interim period of existence in variable domains which tend to conform to or resonate with the beliefs and values of the post-mortem individual. In those domains, post-mortem individuals express a wide range of perceptual and cognitive functions, as well as distinctive motivations, desires, and a capacity, in some models, for learning and development. These alternate domains do not coincide; they seem to reflect cultural patterns and beliefs to some degree but they also appear to be uniquely distinctive, and thus only partially shaped by former embodied contexts. Perhaps there are multiple post-mortem domains, each coexisting as unique expressions of a unified, multidimensional metacosm. The interim between incarnation is also dynamic in the sense that most theories express a view that there are stages of transformation and an opportunity, or a compulsion, for return to another embodied life (Irwin 2017, pp. 396–400).

As a plausible theory, reincarnation challenges materialist views that deny all forms of survival and post-mortem existence. The denial of rebirth cannot be demonstrated or proven; it can only be a statement of *belief* with very little evidence to support its actuality. However, the contestation is not about belief as much as it is about *evidential sources* that might support a positive theory of survival and thus, possibly rebirth. The pervasiveness of rebirth accounts collectively challenges the minority views of materialist ideologues when brought into alignment with all the various strands of evidence that contribute to a transphysical model of human survival. While no one source may provide a convincing argument in favor of post-mortem life and rebirth, together all sources provide a strong collective body of evidence supporting the plausibility of survival as a valid theory, currently held by a majority of human beings. If there is survival, then there may be rebirth. While the two theories do not necessarily support each other (survival and rebirth), nevertheless, survival imputes a capacity for rebirth when linked to participatory narratives claiming evidential knowledge of

explicit past-life experience (Irwin 2017, pp. 400–3). Evidential sources from diverse fields of research, as well as a growing body of ethnographic and therapeutic accounts, strongly supports a historical trajectory in which reincarnation has become an increasingly believable possibility without dependency upon any specific religious convictions. Overall, reincarnation beliefs have increased in complexity, become intrinsic to a wide array of afterlife theories, and garnered increasing attention from multiple academic disciplines.

Conflicts of Interest: The author declares no conflict of interest.

References

Abhedananda, Swami. 1907. *Vedanta Philosophy: Five Lectures on Reincarnation*. New York: The Vedanta Society, Available online: https://archive.org/details/vedantaphilosop02abhegoog (accessed on 9 August 2017).

Adams, Edward C. 1927. *Congaree Sketches*. Chapel Hill: The University of North Carolina Press.

Albanese, Catherine. 1997. Dissent History: American Religious Culture and the Emergence of the Metaphysical Tradition. In *Religious History: Studies in Tradition and Cultures*. Edited by Walter H. Conser Jr. and Sumner B. Twiss. Athens: University of Georgia Press, pp. 157–88.

Arnold, Sir Edwin. 1879. *The Light of Asia*. Tullera: Buddha Dharma Education Association, Inc., Available online: http://www.buddhanet.net/pdf_file/lightasia.pdf (accessed on 9 August 2017).

Atkinson, William W. 1908. *Reincarnation and the Law of Karma*. Chicago: Yogi Publication Society. Available online: https://play.google.com/books/reader?printsec=frontcover&output=reader&id=HOA1AQAAMAAJ&pg=GBS.PA1 (accessed on 9 August 2017).

Atwater, A. Phyllis. 2007. *The Big Book of Near-Death Experiences*. Charlottesville: Hampton Roads Publishing Company.

Beauregard, Mario, and Denyse O'Leary. 2007. *The Spiritual Brain: A Neuroscientist's Case for the Existence of Soul*. New York: HarperCollins.

Blavatsky, Helena. 1882. Isis Unveiled and the Theosophist on Reincarnation. *Theosophist* 3: 288–89. Available online: http://www.katinkahesselink.net/blavatsky/articles/v4/y1882_091.htm (accessed on 8 August 2017).

Bose, Ram Chandra. 1884. *Hindu Philosophy Popularly Explained: The Orthodox Systems*. New York: Funk & Wagnalls.

Braude, Stephen E. 2003. *Immortal Remains: The Evidence for Life after Death*. Lanham: Rowman & Littlefield.

Bremmer, Jan. 1983. *The Early Greek Concept of Soul*. Princeton: Princeton University Press.

Carter, Chris. 2010. *Science and the Near-Death Experience*. Rochester: Inner Traditions.

Cerminara, Gina. 1950. *Many Mansions: The Edgar Cayce Story of Reincarnation*. New York: New American Library.

Clark, Mary Ann. 2007. *Santería: Correcting the Myths and Uncovering the Realities of a Growing Religion*. Westport: Praeger.

Copenhaver, Brain P. 1998. *Hermetica*. New York: Cambridge University Press.

Corrigan, John Michael. 2012. *American Metempsychosis: Emerson, Whitman, and the New Poetry*. New York: Fordham University Press.

Coudert, Allison P. 1976. A Quaker-Kabbalist Controversy: George Fox's Reaction to Francis Mercury van Helmont. *Journal of the Warburg and Courtauld Institutes* 39: 171–89. [CrossRef]

Coudert, Allison P. 1999. *The Impact of the Kabbalah in the Seventeenth Century: The Life and Thought of Francis Mercury van Helmont (1614–1698)*. Leiden: Brill.

Coudert, Allison. 2008. The Kabbalah, Science, and the Enlightenment: The Doctrines of *Gilgul* and *Tikkun* as Factors in the Anthropological Revolution of the Eighteenth Century. In *Aufklärung und Esoterik: Rezeption—Integration—Konfrontation*. Edited by Monika Neugebauer-Wölk. Tübingen: Max Niemeyer, pp. 299–316.

Curtiss, F. Homer. 1949. *Reincarnation*. San Gabriel: Willing Publishing Company.

De La Torre, Miguel. 2004. *Santería*. Grand Rapids: Wm. B. Eerdmans Publishing.

Détré, Jean-Marie. 2005. *La Réincarnation et L'Occident*. Tome II; Paris: Éditions Triades.

Dharmapala, Anagarika. 1999. The World's Debt to Buddha. In *Asian Religions in America: A Documentary History*. Edited by Thomas Tweed and Stephen Prothero. New York: Oxford University Press, pp. 133–37.

Dodds, Eric Robertson. 1962. *The Greeks and the Irrational*. Oakland: University of California Press.

Ellwood, Robert, ed. 1987. *Eastern Spirituality in America: Selected Writings*. New York: Paulist Press.

Evans-Wentz, Walter, ed. 1960. *The Tibetan Book of the Dead: Or The After-Death Experiences on the Bardo Plane*. Translated by Kazi Dawa-Samdup. Oxford: Oxford University Press. First published 1927.

Fiore, Edith. 1978. *You Have Been Here Before: A Psychologist Looks at Past Lives*. New York: Ballentine Books.

Fisher, Elizabeth W. 1985. Prophesies and Revelations: German Cabbalists in Early Pennsylvania. *The Pennsylvania Magazine of History and Biography* 109: 299–334.

Fulk, Augustus Marion. 1940. *Reincarnation: Time, Space, Matter*. Boston: The Christopher Publishing House.

Fuller, Margaret, ed. 1843–1844. *The Dial: A Magazine for Literature, Philosophy, and Religion*. Boston: E. P. Peabody, vols. 3, 4.

Givens, Terry L. 2010. *When the Soul Had Wing: Pre-mortal Existence in Western Thought*. New York: Oxford University Press.

Goudey, Ray. F. 1928. *Reincarnation: A Universal Truth*. Los Angeles: The Aloha Press.

Graf, Fritz, and Sarah Iles Johnston. 2007. *Ritual Texts for the Afterlife: Orpheus and the Bacchic Gold Tablets*. London: Routledge Press.

Greyson, Bruce. 2010. Implications of Near-Death Experiences for a Postmaterialist Psychology. *Psychology of Religion and Spirituality* 2: 37–45. [CrossRef]

Hall, Manly Palmer. 2010. *The Secret Teachings of All Ages: An Encyclopedic Outline of Masonic, Hermetic, Qabbalistic and Rosicrucian Symbolical Philosophy*. New York: Dover Publications. First published 1928.

Hall, Manly Palmer. 1999. *Reincarnation: The Cycles of Necessity*. Los Angeles: The Philosophical Research Society. First published 1939.

Head, Joseph, and Sylvia Cranston, eds. 1967. *Reincarnation: A Living Study of Reincarnation in All Ages Including Selections from the World's Religions, Philosophies, and Sciences, and Great Thinkers of the Past and Present*. New York: Julian Press.

Head, Joseph, and Sylvia Cranston, eds. 1990. *Reincarnation: An East-West Anthology*. Wheaton: The Theosophical Publishing House.

Heindel, Max. 1973. *The Rosicrucian-Cosmo-Conception*. Oceanside: The Rosicrucian Fellowship International Headquarters. First published 1909.

Hildebrand, Jennifer. 2006. "Dere Were No Place in Heaven for Him, an' He Were Not Desired in Hell," Igbo Cultural Beliefs in African American Folk Expressions. *The Journal of African American History* 91: 127–52. Available online: https://www.jstor.org/stable/20064067?seq=1#page_scan_tab_contents (accessed on 8 August 2017).

Holden, Janice M., Bruce Greyson, and Debbie James, eds. 2009. *The Handbook of Near-Death Experiences: Thirty Years of Investigation*. Santa Barbara: Praeger Publishers.

Howe, Quincy. 1974. *Reincarnation for the Christian*. Wheaton: The Theosophical Publishing House.

Hubbard, L. Ron. 2007. *Scientology: The History of Man*. Commerce: Bridge Publications. First printed 1950.

Hultkrantz, Ake. 1953. *Conceptions of the Soul among Native North Americans: A Study in Religious Ethnology*. Stockholm: Ethnographical Museum of Sweden. ASIN: B007F5YB6C.

Hultkrantz, Ake. 1998. *Soul and Native Americans*. Washington: Spring Publications. ISBN-10: 0882142232.

Hyslop, James H. 1906. *The Borderland of Psychic Research*. Boston: Herbert B. Turner & Co.

Irwin, Lee. 2017. *Reincarnation in America: An Esoteric History*. Lanham: Lexington Books (Rowman and Littlefield). ISBN-10: 1498554075. Available online: https://rowman.com/ISBN/9781498554077/Reincarnation-in-America-An-Esoteric-History (accessed on 15 September 2017).

Jackson, Carl T. 1981. *The Oriental Religions and American Thought: Nineteenth-Century Explorations*. Westport: Greenwood Press.

Johnston, Charles. 1899. *The Memory of Past Births*. New York: The Theosophical Society, Available online: http://books.google.com/books?id=FP8LAAAAIAAJ&printsec=frontcover&dq=the+memory+of+past+births&hl=en&sa=X&ei=qNnRUYCyM43C9gSz6oCAAw&ved=0CDUQ6AEwAA#v=onepage&q&f=false (accessed on 9 August 2017).

Johnston, Sarah Iles. 2011. In Praise of Disorder: Plato, Eliade, and the Ritual Implications of a Greek Cosmogony. In *Archiv für Religionsgeschichte*. Edited by John Assman and John Scheid. Berlin: De Gruyter, pp. 51–60.

Judge, William Q. 1987. *The Ocean of Theosophy*. Los Angeles: The Theosophy Company. First published 1893.

Kaplan, Steven, ed. 1996. *Concepts of Transmigration*. Lewiston: The Edwin Mellon Press.

Kardec, Allan. 1950. *The Spirit's Book (Le Livre des Esprits)*. Translated by Anna Blackwell. Sao Paulo: Lake Publishing. First published 1857.

Kardec, Allan. 1987. *The Gospel According to Spiritism*. Translated by J. A. Duncan. London: The Headquarters Publishing Co. First published 1857.

Karr, Don. 2010. *The Study of Christian Cabala in English*. Available online: http://www.digital-brilliance.com/kab/karr/ccinea.pdf (accessed on 6 August 2017).

Keith, George. 1692. *Truth and Innocency Defended against Calumny and Defamation, in a Late Report Spread Abroad Concerning the Revolution of Humane Souls*. Philadelphia: William Bradford. Available online: http://quod.lib.umich.edu/e/eebo/A47190.0001.001?view=toc (accessed on 6 August 2017).

Langley, Noel. 1967. *Edgar Cayce on Reincarnation*. New York: Warner Books.

Larson, Kerry. 2001. Individualism and the Place of Understanding in Emerson's Essays. *English Literary History* 68: 991–1021. [CrossRef]

Layton, Bentley. 1987. *The Gnostic Scriptures*. New York: Doubleday.

Leijenhorst, Cees. 1998. Francesco Patrizi's Hermetic Philosophy. In *Gnosis and Hermeticism from Antiquity to Modern Times*. Edited by Roelof Van Den Broek and Wouter J. Hanegraaff. Albany: State University of New York Press, pp. 127–34.

Lewis, H. Spencer. 1956. *Mansions of the Soul: The Cosmic Conception*. San Jose: Supreme Lodge of AMORC. First published 1930.

Logan, Alastair B. 1996. *Gnostic Truth and Christian Heresy*. Peabody: Hendrickson Publishers.

Long, Herbert S. 1948. A Study of the Doctrine of Metempsychosis in Greece from Pythagoras to Plato. PhD. dissertation, Princeton University, Princeton, NJ, USA.

Lopez, Donald. 1998. *Prisoners of Shangri-La: Tibetan Buddhism and the West*. Chicago: The University of Chicago Press.

Lopez, Donald. 2011. *The Tibetan Book of the Dead: A Biography*. Princeton: Princeton University Press.

MacGregor, Geddes. 1978. *Reincarnation in Christianity: A New Vision of the Role of Rebirth in Christian Thought*. Wheaton: The Theosophical Publishing House.

Mazama, Mambo Ama. 2002. Afrocentricity and African Spirituality. *Journal of Black Studies* 33: 218–34. [CrossRef]

Mbiti, John S. 1970. *African Religions and Philosophy*. New York: Doubleday & Company.

Mead, George R. S. 1989. *Pistis Sophia: A Gnostic Gospel*. Blauvet: Spiritual Science Library. First published 1896.

Mendoza, Ramon G. 1995. *The Acentric Labyrinth: Giordano Bruno's Prelude to Contemporary Cosmology*. Rockport: Element Books Limited.

Mills, Antonia. 1994. Rebirth and Identity: Three Gitksak Cases of Pierced-Ear Birthmarks. In *Amerindian Rebirth: Reincarnation Belief among North American Indians and Inuit*. Edited by Antonia Mills and Richard Slobodin. Ontario: University of Toronto Press, pp. 211–41.

Mills, Antonia, and Richard Slobodin, eds. 1994. *Amerindian Rebirth: Reincarnation Belief among North American Indians and Inuit*. Toronto: University of Toronto Press.

Monroe, Robert. 1985. *Far Journey*. Garden City: Doubleday.

Monroe, Robert. 1994. *Ultimate Journey*. New York: Doubleday.

Moody, Raymond. 1975. *Life after Life*. Atlanta: Mockingbird Books.

Moore, Marcia. 1975. *Hypersentience: Exploring Your Past-lifetime as a Guide to Your Character and Destiny*. New York: Crown Publishers.

Muller, F. Max, ed. 1879–1910. *The Sacred Books of the East*. 50 vols. Oxford: The Clarendon Press.

Netherton, Morris. 2013. *Past Lives Therapy*, Kindle ed. Seattle: Amazon Digital Services. First published 1978.

Newton, Michael. 2001. *Journey of the Soul: Case Studies in Life between Lives*. St. Paul: Llewellyn Publications.

Obuchowski, Peter A. 1979. Emerson, Evolution, and the Problem of Evil. *The Harvard Theological Review* 72: 150–56.

Ogren, Brian. 2009. *Renaissance and Rebirth: Reincarnation in Early Modern Italian Kabbalah*. Leiden: Koninklijke Brill NV.

Olcott, Henry Steele. 1886. *A Buddhist Catechism, According to the Sinhalese Canon*. Madras: Graves, Cookson, and Company. First published 1881.

Olmos, Margarite F., and Lizabeth Paravisini-Gebert. 2003. *Creole Religions of the Caribbean: An Introduction from Vodou and Santeria to Obeah and Espiritismo*. New York: New York University Press.

Onyewuenyi, Innocent. 1996. *African Belief in Reincarnation: A Philosophical Appraisal.* Lexington: BookSurge Publishing.

Palmer, Genie, and Arthur Hastings. 2013. Exploring the Nature of Exceptional Human Experiences. In *The Wiley Blackwell Handbook of Transpersonal Psychology.* Edited by Harris L. Friedman and Glenn Hartelius. Malden: John Wiley & Sons, Ltd., pp. 333–51.

Pearson, Birger A. 2007. *Ancient Gnosticism: Traditions and Literature.* Minneapolis: Fortress Press.

Peréz, Elizabeth. 2011. Spiritist Mediumship as Historical Mediation: African-American Pasts, Black Ancestral Presence, and Afro-Cuban Religions. *Journal of Religion in Africa* 41: 330–65. [CrossRef]

PEW. 2009. *Many American Mix Multiple Faiths.* Washington: PEW Research Center: Religion & Public Life. Available online: http://www.pewforum.org/2009/12/09/many-americans-mix-multiple-faiths/ (accessed on 13 August 2017).

Pike, Albert. 2005. *Morals and Dogma of the Ancient and Accepted Scottish Rite Freemasonry.* Whitefish: Kessinger Publishing. First published 1872.

Preston, William. 2016. *Illustrations of Masonry.* Reprint of 1867 edition; New Orleans: Cornerstone Book Publishers.

Prophet, Elizabeth Clare. 1997. *Reincarnation: The Missing Link in Christianity.* Corwin Springs: Summit University Press.

Pryse, James. 1911. *Reincarnation in the New Testament.* New York: Theosophical Publishing.

Raboteau, Albert J. 2004. *Slave Religion: The "Invisible Institution" in the Antebellum South.* New York: Oxford University Press. First published 1978.

Randolph, Paschal B. 2012. *Dealings with the Dead: The Human Soul, Its Migrations and Transmigrations.* Hong Kong: Forgotten Books. First published 1862. Available online: https://archive.org/details/DealingsWithTheDead (accessed on 9 August 2017).

Remes, Pauliina. 2008. *Neoplatonism.* Berkeley: University of California Press.

Rhys-Davids, Thomas William. 1912. *Buddhism: Being a Sketch of the Life and Teachings of Gautama.* London: Society for Promoting Christian Knowledge. First published 1877.

Rhys-Davids, Thomas William. 1878. *Buddhist Birth Stories: Jataka Tales.* London: George Routledge & Sons. Available online: https://archive.org/details/buddhistbirth00daviuoft (accessed on 9 August 2017).

Roberts, Jane. 1999. *Adventures in Consciousness: In Introduction to Aspect Psychology.* Needham: Moment Point Press.

Rosán, Laurence. 2008. *The Philosophy of Proclus: The Final Phase of Ancient Thought.* Wiltshire: Prometheus Trust.

Salisbury, Edward E. 1847. M. Burnouf on the History of Buddhism in India. *Journal of the American Oriental Society* 1: 275–98. Available online: https://archive.org/details/jstor-3217805 (accessed on 10 August 2017). [CrossRef]

Sandoval, Mercedes Cros. 2007. *Worldview, the Orishas, and Santeria.* Gainesville: University of Florida Press.

Smith, Robert C. 1989. *Edgar Cayce: You Can Remember Your Past Lives.* New York: Warner Books.

Sorabji, Richard. 2005. *The Philosophy of the Commentators: 200–600 AD.* Ithaca: Cornell University Press, vol. 1.

Stevenson, Ian. 1966. *Twenty Cases Suggestive of Reincarnation.* New York: American Society for Psychical Research, vol. 26.

Stevenson, Ian. 1975. The Belief and Cases Related to Reincarnation Among the Haida. *Journal of Anthropological Research* 31: 364–75. [CrossRef]

Stevenson, Ian. 1983. American Children Who Claim to Remember Previous Lives. *The Journal of Nervous and Mental Disease* 171: 742–48. [CrossRef] [PubMed]

Stevenson, Ian. 1997. *Where Reincarnation and Biology Intersect.* 2 vols. Westport: Praeger Publishers.

Sutphen, Dick. 2014. *You Were Born to Be Together*, Kindle ed. New York: Pocket Books. First published 1976.

Sutphen, Dick. 1978. *Past Lives, Future Loves.* New York: Pocket Books.

Taylor, Eugene. 1999. *Shadow Culture: Psychology and Spirituality in America.* Washington: Counterpoint Press.

Twitchell, Paul. 1969. *Eckankar: The Key to Secret Worlds.* San Diego: Illumined Way Press.

Versluis, Arthur. 2001. *Esoteric Origins of the American Renaissance.* New York: Oxford University Press.

Walker, D. P. 1954. The *Prisca Theologia* in France. *Journal of the Warburg and Courtauld Institutes* 17: 204–59. [CrossRef]

Wambach, Helen. 2000. *Reliving Past Lives: The Evidence under Hypnosis.* New York: Barns & Nobles. First published 1978.

Warren, Henry Clarke. 1922. *Buddhism in Translation*. Cambridge: Harvard University Press. First published 1896. Available online: http://books.google.com/books?id=7rooAAAAYAAJ&pg=PR9&dq=warren+buddhist&hl=en&sa=X&ei=6sEgUp3kE6-5sQSkuICADg&ved=0CEkQ6AEwBQ#v=onepage&q&f=false (accessed on 9 August 2017).

Weiss, Brian. 1988. *Many Lives, Many Masters*. New York: Simon & Schuster.

Translated by David M. Wexelman. 1999, *The Jewish Concept of Reincarnation and Creation [Sha'ar ha Gilgulim]*. Northwale: Jason Aronson. Available online: http://www.chabad.org/kabbalah/articlecdo/aid/380302/jewish/Gate-of-Reincarnations-Introduction.htm (accessed on 6 August 2017).

Whitton, Joel, and Joe Fisher. 1986. *Life between Life*. New York: Warner Books.

Woolger, Roger. 1988. *Other Lives, Other Selves: A Jungian Psychotherapist Discovers Past Lives*. New York: Bantam.

Yogananda, Paramahansa. 1979. *Autobiography of a Yogi*. Los Angeles: Self-Realization Fellowship. First published 1946.

Article

Hindu Students and Their Missionary Teachers: Debating the Relevance of Rebirth in the Colonial Indian Academy

Nalini Bhushan

Philosophy Department, Smith College, Dewey House 204, Northampton, MA 01063, USA;
nbhushan@smith.edu

Received: 25 July 2017; Accepted: 1 September 2017; Published: 19 September 2017

Abstract: This essay provides a meta-narrative for the philosophical dialogues that took place in colonial India between Scottish missionary philosophers and philosophers of Vedānta on the topic of karma and rebirth. In particular, it offers a reconstruction and analysis of the context and strategy that shaped the content of discussions that were initiated in the pages of the Madras Christian College Magazine in 1909 between Subrahmanya Sastri and AG Hogg and that inspired Radhakrishnan's response in his dissertation entitled "The Ethics of Vedanta and its Metaphysical Suppositions". The broad context is provided by a history of missionary presence in India. The context is further circumscribed by the 'hybrid' character of the position of the missionaries as teachers in departments of philosophy, teaching students of "upper-caste Hindus" in the English medium universities set up by the British in the late nineteenth century. The hermeneutics of form and context is essential to understanding the content of these debates about the ethics and metaphysics of Christianity and Hinduism, where the meaning and significance of the notion of rebirth took center stage. Importantly, these debates in turn shed light on the broader social and political context in which these debates took place.

Keywords: Karma; Rebirth; Radhakrishnan; Hogg; Christianity; Hinduism; Vedānta ethics and metaphysics; Scottish missionaries; philosophical and religious debate; colonial India

1. Introduction

The Madras Christian College is a liberal arts college in Chennai, Tamilnadu, South India. Founded in 1837 as a missionary endeavor by the Church of Scotland, MCC is one of Asia's oldest extant colleges.[1] It continues to flourish today as one of Southern India's most prestigious liberal arts colleges (and of which I am a proud alumna). In this essay I focus on a period in the College's intellectual history during colonial rule, and in particular on a Hindu-Christian debate about karma and rebirth that was initiated in 1904 in the pages of the local Madras Christian College Magazine. Each strand of the debate was subsequently developed into a work of global significance: a book by the missionary and philosophy professor AG Hogg, entitled *Karma and Redemption* (Hogg 1909); and a ground-breaking journal article by his student S. Radhakrishnan, entitled "The Ethics of Vedanta", published in the *International Journal of Ethics* (Radhakrishnan 1914).

Why look back on this ancient slice of debate in the philosophy of religion? Because it reveals the approach of a particular kind of missionary who taught in a number of the Indian universities during the colonial period, and crucially, because we can see first hand the response of an Indian student who represented a generation of globally aware and cosmopolitan Indian intellectuals who collectively

[1] It passed into the administrative hands of the Church of South India in 1947, following Indian independence from British rule.

crafted a modern Vedānta metaphysics that re-contextualized the role of karma and rebirth not merely for their narrow period in history but for the twenty-first century.

2. The Philosopher-Missionary: AG Hogg (1875–1954)

In this section I focus on a special category of missionary in India: the hybrid that I will term the philosopher-missionary.[2] These missionaries were typically trained in the UK in philosophy and taught philosophy in colonial Indian Universities. Some were attached to missions before they arrived; others were academics who returned to the UK to receive missionary training after a teaching stint in India. I'm interested in this category of missionary for three reasons: first, they were the professors of many of the Indian (Hindu and Muslim) students who would become the distinguished philosophers of their time; second, as philosophers by training who happened also to be missionaries, their primary loyalty was to philosophy, and therefore to the argument in support of their position, even if their ultimate goal was often to show the superiority of Christianity. Third, like the more obviously Indian philosophers who worked in British India, these missionaries were philosophers in India, engaging both with Indian and Western philosophy, and doing so in a self-conscious dialogue between traditions.[3] The community of missionary philosophers was thus in several respects a reflection of the community of indigenous Indian academic philosophers; perhaps more accurately, they were inextricably entangled members of a single community to which some members might nonetheless deny them admission.

Just as Scotts dominated the British neo-Hegelian scene in the UK, we find that Scots dominated the academic missionary scene in India.[4] Alfred George Hogg (1875–1954) was trained in philosophy at the University of Edinburgh, Scotland, under the great historian of philosophy Andrew Seth Pringle Pattison (1856–1931). In India Hogg became Professor of Philosophy at Madras Christian College, serving from 1902–1928, appointed after as Principal of the College, in effect serving MCC for almost 30 years. He was also acknowledged as a philosopher with broad credentials, elected president of the nationally renowned Indian Philosophical Congress in 1935.[5]

Hogg's most significant influence on Vedanta philosophy in India derives from his work *Karma and Redemption* (Hogg 1909) whose subtitle, "An Essay toward the Interpretation of Hinduism and the Re-Statement of Christianity" characterizes the hermeneutic methodology he preferred—that of selective contrast—rather than one of straightforward comparison (or, for that matter, simple dismissal, based on theological doctrine).[6] Selective contrast, as opposed to comparison, involves the reflective assessment of contrasting ideas and arguments relevant to a particular doctrine rather than merely noting similarities and differences. In a 1904 letter Hogg puts it this way: "I feel that if Christianity is to conquer India the old doctrines must go first and new ones—like the old and yet Indian in color—must take their place" (Reprinted in the introductory essay to the 1970 version of *Karma and Redemption* by Eric J. Sharpe, p. x). Notably, Hogg's book (1908) was reprinted in 1970. Here is

2 The category of *educational* missionary was recognized at the time; here I focus on the more specific kind of the educational missionary, namely, the trained *philosopher* serving in the mission. Other notables (in addition to Hogg) were JS Mackenzie (who wrote the *Manual of Ethics*, 1892), Alexander Duff (Calcutta, who studied philosophy at the University of Saint Andrews), John Wilson (Orientalist, Wilson College, Bombay) and especially WS Urquhart (philosophy professor at the Scottish Churches College in Calcutta).

3 Indeed, the *Indian Missionary Manual* (Murdoch 1889) admonishes aspiring missionaries not only to learn vernacular languages and local customs so as to facilitate sermonizing, but also to take an interest in classical languages and the philosophical systems of India in order to immerse themselves in the rich culture into which they are about to enter. The noted missionary Alexander Duff also advocated the study of English by Indians, and of Indian culture and history by missionaries (Duff 1889).

4 For more on the intellectual relationship between Cambridge and India during British occupation, see Bhushan and Garfield, Minds Without Fear: Philosophy in The Indian Renaissance, 2017, Chapter 9, entitled "The Cambridge Connection: Idealism, Modernity and the Circulation of Ideas" (Bhushan and Garfield 2017).

5 His student, S. Radhakrishnan, was elected earlier, as its third President, in 1927.

6 In this connection it is also important to note that it was Scottish Presbyterianism as the Christian religious sub-tradition that fostered Hogg's less doctrinal attitude in the Hindu-Christian debates.

how Eric Sharpe justified the decision to reprint this work. "This book occupies a place all its own in the history of Christian thought in India; in my judgment it is one of the most powerful and original works of Christian theology ever to have been written by a working missionary" (Duff 1889, Sharpe's introduction, pp. xv–xvi).

Although Hogg, as noted above, was professor of philosophy at Madras Christian College from 1902 to 1928; significantly, he joined the mission only after he was already teaching philosophy in India. This personal history is critical to understanding the attitude and sensibility that Hogg adopted in the debates between Hindu and Christian intellectuals, debates that were to engage him and in which he participated for much of his life. Philosophy *mattered* to this missionary professor. According to Hogg, "Theoretically, indeed, the claim of *philosophy* to be the final arbiter of truth is absolute . . . philosophy is simply the effort to think quite clearly and critically—to let no assumptions pass without question and to be content with nothing less than a completely intelligible account of the whole of experience. By its very definition, therefore, a perfect philosophy would give the fairest and truest possible interpretation of religious experience as well as of all other experience, and if *religious* belief ventured to interpret religious experience differently from such a perfect philosophy, its interpretation must be wrong. . ." (Hogg 1909, pp. vi–vii, emphasis added). Hogg, as a Christian missionary, however, simultaneously expressed his absolute commitment to Jesus. "In Jesus the man I meet God himself" (Ibid, p. viii). These twin convictions—one regarding philosophical method, and the other regarding religious faith—are evident in the argument of his book.

The genesis of Hogg's book *Karma and Redemption* is significant: it first appeared as a series of essays in the Madras Christian College Magazine, and was a response to an essay by Subrahmanya Sastri in the same magazine, entitled "Hindu philosophy", in which Sastri argued that, on the Indian view, there was no mystery regarding the existence of apparently unmerited suffering, in virtue of the Hindu belief in the doctrines of karma and rebirth. All suffering could be accounted for as a consequence of one's actions in past lives. Therefore, Sastri argued, neither justification for such suffering, nor, apparently, social or moral action was required. This therefore constituted the orthodox Hindu challenge to Christianity; the philosopher in Hogg accepted this challenge in the essays he wrote for the magazine.

Hogg argued that the central contrast between "higher" Hinduism (Advaita Vedānta and Christianity (Presbyterian, and focused on the person of Jesus, rather than on Church doctrine) is that between a system that views the universe as essentially juridical and one that views it as essentially moral. This is because, argues Hogg, the Vedānta view is focused on the doctrine of karma as a way of making sense of otherwise unmerited suffering in one's phenomenal life. This metaphysical theory of a cycle of causes and effects[7], in effect makes *punishment* (and reward) the primary Hindu concept; even aworse, argues Hogg, morality—actions being viewed as right or wrong—can only be justified as an accidental feature of the phenomenal world. This feature of morality as accidental is reinforced by the fact that for the Hindus, from a transcendental perspective (consistent with dharma), the distinction between the moral and the non-moral disappears. Thus the God of Vedānta is a juridical God, not a moral God. This contingency of the moral, argues Hogg—against Sastri—ought to be problematic for any philosopher who wants to take seriously the ethical perspective and use it to motivate individuals in society to do good.

In proposing a solution, Hogg identifies what he takes to be the central ideas in each tradition and effects a synthesis. He does not advocate for a removal of the doctrine of Karma; instead, he takes seriously the Hindu commitment to karma, suitably reinterpreted, so that it "does express an aspect of God's being" (Hogg 1909, p. 113). While the details of Hogg's synthesis are interesting in their own right, what is significant for the purposes of my essay is that Radhakrishnan, who was then Hogg's

[7] And it is metaphysics, not physics, a point to which Hogg returns at the end of his critique (an additional strike against the Vedānta view in the context of modernity).

student of philosophy at MCC, read the exchange between Sastri and Hogg in the pages of the MCC magazine. Radhakrishnan challenged Hogg's view in his doctoral dissertation entitled "The Ethics of Vedānta and its Metaphysical Suppositions." and responded to both positions, developing his own version of Vedānta idealism.[8]

3. S. Radhakrishnan (1888–1975): The Student Responds to His Teachers' Challenge[9]

In "The Ethics of of Vedānta" (1914) Radhakrishnan responds to the challenge posed to Vedānta by Christian missionaries, one not recognized as a challenge by orthodox Hindu scholars. He begins by agreeing that it is fair to ask "how far the Vedānta philosophy satisfies the demands of the moral consciousness" (Radhakrishnan 1914, p. 168). In this way he acknowledges Hogg's challenge to Vedānta. Radhakrishnan responds that indeed, the Vedānta does not contain an *explicit* set of ethical doctrines, and thus that "it is for the critical student of the Vedānta to bring together the scattered elements and present them as a whole" (ibid).

When approached critically, that is, as a *philosopher*, Radhakrishnan argues, the ethics of the Vedānta is seen to be not an independently justified set of doctrines but rather entirely dependent upon its metaphysics, which for him is the idealism of "the absolute oneness of all things" (ibid). With respect to individuals in human communities, then, it follows that every human being must be treated as such, that is, "as an end and not a means". And this in turn requires a life of reason. So, instead of taking the moral domain as self-evident, by asking what the features are of the *moral* life, Radhakrishnan argues that our starting point must be to identify the features of a *rational* life; this will issue in the moral actions that humans should take with respect to each other. Note here that the motivation of this Vedāntin, justified by Vedānta metaphysics, is, from one perspective, Kantian. But Radhakrishnan immediately juxtaposes this Kantian strand to a strand in *The Bhagavad Gita* with its emphasis on the control of the senses by reason. In his interpretation of the *Gita*, "a rational life is not a life of no desire, but a life of regulated desires". This is a feature of the rational life and for Radhakrishnan, constitutes the cornerstone of Vedānta ethics: to think before we act. Vedānta knowledge is "the knowledge that enables us to take a right view of things and our place in the world" (Radhakrishnan 1914, p. 172). And again, "The Vedānta ethics does not ask us to sit with folded hands or, like the mystic, look down on earth or up to heaven, at nothing in particular" (Radhakrishnan 1914, p. 174). The Vedānta focus on knowledge is therefore not an invitation to abstract contemplation.

Radhakrishnan goes on to argue for disinterested—rather than the *per impossible* unmotivated—action as the necessary consequence of a commitment to Vedānta metaphysics. "The Vedānta law of morality does not ask us to act without motives, but asks us to serve humanity, without any selfish desires or petty interests, without envy or jealousy, regardless of party or personality" (Radhakrishnan 1914, p. 175). Note his introduction of the notion of moral law (dharma) here, but along with it the risk of a problematic association between dharma and the orthodox caste system. Radhakrishnan however immediately offers the following *different* association and juxtaposition: "The Vedānta criterion of morality may well be expressed in the famous formula made familiar to the philosophic world by the Hegelian school of ethics: 'my station and its duties'" (Radhakrishnan 1914, p. 176). After a discussion regarding the very real situations in which we face a conflict of duties (in a return to the predicament of Arjuna in the Gita), he concludes: "It [The

[8] To complete one epicycle in this complex orbit, Radhakrishnan was later to lecture in the United Kingdom and the United States, discussing Indian idealism with British and American philosophers on their respective home turfs.

[9] Sarvepalli Radhakrishnan (1888–1975) was educated in India, at Madras, by missionary, Tamil and Sanskrit scholars. Radhakrishnan's early writings were reactions against the view that Vedānta is focused only on the goal of individual self-realization/transformation, without any ethical framework or social philosophy. He argued, demonstrating, contrary to the thinking of both AG Hogg and S Sastri, who were his teachers, that there was in fact an ethics that formed the core of Vedānta. Radhakrishnan's 1908 dissertation was devoted to making the argument in support of this position); he continued this focus in other work, including a comparative essay entitled "The Ethics of the Bhagavadgītā and Kant" which appeared in the *International Journal of Ethics* in 1911 and "The Ethics of Vedānta" (same journal as above, 1914).

Vedānta] holds that there can only be one Absolute in morality as in metaphysics . . . The ideal of unselfish service of humanity is the only absolute moral rule which ought never to be broken . . . It is the obedience to reason and its ideal of service and sacrifice that is the one supreme law, and all others are subordinate to it" (Radhakrishnan 1914, p. 178).

What just happened here? Far from seeing in Vedanta metaphysics a disconnect from any ethical imperative to care about others, as Christian critics like Hogg had argued, Radhakrishnan instead extracts from the core of Vedānta metaphysics an ethical "categorical imperative" to serve humanity unselfishly! And what about the doctrine of karma and rebirth, the metaphysical commitment that was the original source of Hogg's criticism of the Vedānta? In this connection, Radhakrishnan states: "'Karma' is a hypothesis devised by later Vedānta writers as an *explanation* of the inequalities of this life and a solution to the problem of future life" (Radhakrishnan 1914, p. 180, emphasis added). He proposes that karma guarantees continuity, but of a restricted kind: "man's past deeds are continued into this life in the form of tendencies or predispositions. But character is not the product of karma" (Radhakrishnan 1914, p. 181). The doctrine of karma, then, does not absolve human beings from ethical duties; rather, it acts as a constraint on our freedom to perform them. This constraint is not absolute; Radhakrishnan likens this constraint to others we face as finite beings (poverty, where we are born, to whom etc.). In this way, the role of karma as it operates in the actual world is not unlike the role of any other material constraint that operates on us even as we "fight for" standing firm and doing the right thing.

Finally, Radhakrishnan addresses the criticism that Vedānta cannot justify treating persons as individual selves, with their own autonomy and dignity, a core requisite of morality. If we are all slivers of Krishna or aspects of divine consciousness, so the argument goes, then others are simply an aspect of ourselves, and our treatment of them is justified on self-centered rather than on moral grounds. On this point, however, Radhakrishnan doubles down on the Vedānta position rather than retreat from it: "The Vedānta philosophy teaches us that our lives are not ours. They belong to humanity, which ought not to be deprived of its possessions. Render unto humanity what belongs to humanity" (Radhakrishnan 1914, p. 182). Rather than the missionary perspective of Vedānta metaphysics that would view others as a version of me (leading to a self-centered ethics), Radhakrishnan invites us to consider the reverse: a modern Hindu perspective on Vedānta metaphysics according to which me and my life are inconsequential absent the rest of humanity (leading to an other-centered ethics).[10]

4. Conclusions: Coming Back Full Circle to MCC and to the Case of the Hindu Student and His Missionary Teacher

My goal in this essay has been to use one example to showcase a practice of sustained critical discussion between ethnically British and ethnically Indian philosophers on metaphysical and ethical issues raised by both traditions. The circulation of ideas[11] between these communities is more representative of the history of Indian philosophy during this period than is a description in terms of hegemonic imposition of a Western canon.

Noteworthy as well is the reformulation and transformation of each of their ideas. Hogg brings nuance to the respective notions of Hindu karma and Christian redemption. His careful consideration of the doctrine of karma and of Vedāntin metaphysics leads him to write a text that, to use Sharpe's terminology, "is a work, not of Christian apologetics for India merely, but of universal Christian theology. It should have never been allowed to drift into oblivion" (Hogg 1909, p. xviii).

[10] Radhakrishnan subsequently put to one side his preoccupation with the challenge posed by his missionary teacher and concerned himself in his other writings with the challenge posed to all religions by modernity, and in particular by the advent of science.

[11] Also represented in a more explicitly theological register in Ram Mohan Roy's engagement with Christianity.

Radhakrishnan, for his part, continues to value karma, but justifies the equal ethical treatment to all human beings based on his metaphysical commitment to non-duality or essential "oneness".[12] The metaphysical truth of karma is only justifiably activated as an *explanation* (not a reason) for our suffering from the transcendental standpoint. In effect, Karma itself seems to be contextualized to a view that explains (seemingly) unmerited suffering but does not justify ignoring suffering and other forms of unequal treatment of other human beings in a particular life time.[13]

When we look back at the nature of this particular exchange, and others like it during the colonial period, we find that these intellectuals, while they approached thorny issues from their respective religious perspectives, nevertheless took each other as serious intellectual interlocuters. They also used ideas that were circulating globally in their time in the service of their particular arguments. As a result, Hindu and Christian perspectives in twentieth century modernity were better understood, respected and acquired more nuance. This respect for person and argument, however alien they may at first appear, and, respect for the notion of a world of ideas accessible and available to anybody, is a lesson we can learn as intellectuals and inheritors of their legacy in the twenty-first century.

It is equally the legacy of the very best teachers that their very best students outperform them. While Hogg fell into relative obscurity, Hogg's student, Radhakrishnan, became a professor of philosophy, serving at many of the top universities in India[14], acquiring an international reputation, invited in 1926 to Oxford to give the Upton Lectures, and in 1929 the prestigious Hibbert Lectures at the University of Manchester and University College, London. In 1936, Oxford University appointed him to the H.N. Spalding Chair of Eastern Religions *and Ethics*.[15] And, in 1962, he became the second President of an independent India.

Acknowledgments: This paper was presented at the AAR, under the auspices of the Dharma Academy of North America (DANAM), in San Antonio, Texas, 18 November 2016, as part of a panel entitled Interrogating Rebirth: Hindu-Christian Debates and their Contemporary Relevance. Many thanks to my co-panelists Jonathan Edelmann, Gerald Larson, Brad Malkovsky, Jeffery Long and Francis Clooney for a terrific discussion.

Conflicts of Interest: The author declares no conflict of interest.

References

Bhushan, Nalini, and Jay L. Garfield. 2017. *Minds without Fear: Philosophy in the Indian Renaissance*. New York: Oxford University Press.

Duff, Alexander. 1889. *India and Indian Missions including Sketches of the Gigantic System of the Hindus*. Edinburgh: John Johnstone.

Hogg, Alfred George. 1909. *Karma and Redemption: An Essay toward the Interpretation of Hinduism and the Re-Statement of Christianity*. Madras: Christian Literature Society.

Kalapati, Joshua. 2002. *Dr. S. Radhakrishnan and Christianity: An Introduction to Hindu-Christian Apologetics*. Delhi: ISPCK.

[12] Since there are two operational standpoints (Radhakrishnan uses the term "platform"), the metaphysical and the empirical, at the mundane level individuals do matter as distinct persons and are treated as such even as from a higher standpoint one recognizes that these persons are non-different. While the theory of non-difference is also a view from the transcendental standpoint, it does get activated at the empirical level. Radhakrishnan himself calls the doctrine of karma an explanatory theory while non-difference or the essential one-ness of things refers also to a state of being to be experientially realized. Vedānta ethics is dependent on this metaphysical truth and not justifiable independent of it. Thus neo-Kantian and Hegelian ethics is only justifiable in light of this higher purpose.

[13] For more details about Hogg's influence on the thinking of Radhakrishnan, see (Kalapati 2002).

[14] Including the Universities of Mysore and Calcutta, where he was appointed the King George V Chair of Philosophy in 1921.

[15] A chair later held by Bimal K Matilal.

Murdoch, John. 1889. *Indian Missionary Manual*, 3rd ed. London: James Nisbet and Co.

Radhakrishnan, Sarvepalli. 1914. The Ethics of Vedānta. *International Journal of Ethics* 24: 168–83. Available online: http://www.jstor.org/stable/2376505 (accessed 16 May 2016).

Article

An 18th Century Jesuit "Refutation of Metempsychosis" in Sanskrit

Gérard Colas [1,*] and Usha Colas-Chauhan [2]

[1] Centre national de la recherche scientifique, 55 rue du Mont Cenis, Paris 75018, France
[2] Independant scholar, 55 rue du Mont Cenis, Paris 75018, France; gucc@orange.fr
* Correspondence: colasg@ehess.fr

Received: 28 August 2017; Accepted: 11 September 2017; Published: 17 September 2017

Abstract: The *Punarjanmākṣepa*, a work in Sanskrit from the 17th–18th century Jesuit milieu, aims at refuting the notion of reincarnation as believed by the Hindus in India. It discloses an interesting historical perspective of missionary comprehension and criticism of the belief. This paper briefly examines the context, purpose and the rhetorical strategies of the work and incidentally situates the subject of reincarnation in the 18th century European intellectual ideologies.

Keywords: metempsychosis; Hinduism; Jesuits; Carnatic mission; Sanskrit; 18th century

The *Punarjanmākṣepa* ("Refutation of Metempsychosis"), a work from the 17th–18th century missionary Jesuit milieu, is exceptional not only with regard to the topic and the manner in which this is dealt with but also for the historical context in which it was written. Scholastic in nature, it aims at rejecting the belief of metempsychosis attributed to the Hindus in India. It exists in three south Indian languages and in Sanskrit but is presently published only in its Tamil version. The three other versions are still in manuscript form and most probably all are *codex unicus*. This paper aims to give a brief analyzis of the work as known from its Sanskrit version[1] and to examine certain rhetorical strategies in the Refutation. It incidentally situates the subject of metempsychosis in the contemporary European intellectual ideologies.

Created in 1695, the Carnatic mission, based in Pondicherry, started to develop from 1699 onwards disappearing in 1762 when the Society of Jesus was banished from France. The two aims assigned to it by the King of France, Louis XIV were the "defence of Religion", that is, Catholicism, and the "study of things that may contribute to the perfection of arts, sciences and navigation". Thus when a request from the King's Library for manuscripts reached the Carnatic mission in 1728, it sent Indian manuscripts in several successive consignments.[2] The 1735 consignment from Pondicherry mentions a *Punarjanmākṣepa* in Sanskrit, though the manuscript was retrieved in the Library after 1739.[3] It is the only known copy of this work to date.

This palm leaf manuscript, deposited at the Bibliothèque nationale de France under the accession number *Sanscrit* 1761, consists of 38 engraved leaves. It is written in Telugu script showing Kannaḍa traits. According to the post-colophon, which is in the Telugu language, the manuscript was copied by a Jñānambhaṭlu on Monday, 24 December 1733.[4]

[1] All references to the *Punarjanmākṣepa* in this article are to the Sanskrit manuscript preserved at the Bibliothèque nationale de France, Paris (De Nobili n.d.).
[2] See (Colas and Colas-Chauhan 1995a, pp. 7–8).
[3] See (Colas and Colas-Chauhan 1995a, p. 28).
[4] *pramādīca saṃvatsarada mārgaśira ba 30 somavāraṃ nāḍu jñānambhaṭlu vrāśina saṃskṛtasallāpaṃ samāptaḥ.*

The *Punarjanmākṣepa* exists in three other Indian languages: Telugu,[5] Kannaḍa[6] and Tamil.[7] Roberto De Nobili (1577–1656), to whom the work is attributed, arrived in India in 1605 and contributed to the development of the Jesuit Madurai mission.[8] According to his contemporaries, he quickly mastered Tamil, Sanskrit and Telugu. While there is no evidence to prove that the present Sanskrit version (represented by the BnF manuscript) was composed by De Nobili, Rajamanickam's hypothesis that De Nobili must have written an earlier Sanskrit version, now lost, is interesting but without sufficient proof.[9] All the extant works which can be ascribed to De Nobili with certainty are in Tamil, none in Sanskrit. Moreover, we learn from the Jesuit Archives that the *Punarjanmākṣepa* and other Jesuit texts were translated into Sanskrit at the request of an erudite Brahmin desirous of learning more about the doctrine of the Jesuits. The French Jesuit Jean Calmette (1692–1740) states in a letter dated 2 January 1735, from "Ballapouram" (today Chikkaballapur, 40 km north of Bangaluru): "The prime minister of the prince of Ballapouram [...] sent an eminent Brahmin scholar of the region who wanted to see our religious books and have an exact knowledge of our doctrine. We have had some books translated into Sanskrit such as a big Catechism of faith,[10] a Refutation of Metempsychosis, etc."[11] Here the expression "have had translated" (*avons fait traduire*) seems to indicate that Calmette or the French Jesuits did not themselves translate these works into Sanskrit but made (converted ?) Indians translate it under their supervision.[12] The Carnatic mission probably had or made several copies of its books in Sanskrit for it would not have given away or lent its sole copy. The BnF manuscript of the Sanskrit *Punarjanmākṣepa* pre-dates Calmette's letter by about one year. A rapid comparison of the Sanskrit *Punarjanmākṣepa* with the versions in the other three languages shows that it lacks the introduction (named *viveka*) present in them. The manuscript abounds in mistakes and dittographies pointing to the fact that it did not receive the customary post-scribal corrective reading.

It is not certain from which of the three Dravidian languages the Sanskrit *Punarjanmākṣepa* was translated. The Telugu version of the work conveys a text which is more developed and clearer in certain passages than in the Sanskrit version. The Sanskrit manuscript appears to have been copied among the Telugu-speakers. Its post-colophon is in Telugu. Curiously the Telugu expression *toḍameragānu* on fol. 11r (line 7) is also found in the corresponding passage of the manuscript of the Telugu version (BnF Indien 582, fol. 13r, line 7). Only a comprehensive philological study and comparison of the different versions could show their relative chronology. That the work in the three versions was copied (and distributed) in the 1730s seems to indicate that it was of great importance for the French Jesuit missionaries in their apostolate during those years.

1. Context and Purpose

In the early phase of its expansion in South India, the linguistic priority of the fathers of the Carnatic mission was to acquire vernacular (non-Sanskrit) languages to communicate easily with Indians of all social classes. The newly arrived missionaries learnt Tamil, Telugu and Kannaḍa (and Bengali for those who were sent to the Chandernagore branch of the mission) first and foremost to preach Christianity "*dans les terres*", in far away places outside Pondicherry.[13] Their sermons and

[5] Manuscript BnF Indien 582 (De Nobili n.d.), sent by the Carnatic mission in 1734, arrived at the Library in April 1737. See (Colas and Colas-Chauhan 1995a, pp. 26–28).

[6] Manuscript number 7078 in the Marsden Collection at the School of Oriental and African Studies, dated 1739, fols 143–163 (De Nobili n.d.).

[7] (Tattuva Pōtakar 1963) Edited by S. Rajamanickam, Tūttukkuṭi: Tamiḻ Ilakkiyak Kaḻakam, 1963.

[8] For De Nobili's life and achievements, see (Dahmen 1924). About his interest for transmigration, see (Clooney 2014, pp. 35–46).

[9] See (Rajamanickam 1972, p. 91).

[10] This could be the work entitled *Satyavedaprasaṃga* in Sanskrit and *Satyōpadēśamu* in Telugu. See (Colas and Colas-Chauhan 1995a, p. 17, note 84).

[11] See (Fonds Brotier n.d., vol 89, fol. 49v).

[12] See also (Colas and Colas-Chauhan 2014, p. 69.)

[13] See (Colas and Colas-Chauhan 1995a, p. 9.)

writings varied not only according to the language of the audience and readers but also according to the level of their education.[14] They later realized that they had to learn Sanskrit and produce a corpus of texts in that language to match the Brahmin scholars who had books in Sanskrit and conducted religious and metaphysical discussions in that language. They thought that converting elites like Brahmins would lead to the Christianization of the rest of the Indian society.[15] Several French Jesuits of the early phase of the mission[16] had learnt Sanskrit but the acquisition of that language in the mission become more systematic in the late 1720s.[17] The translation of the *Punarjanmākṣepa* into Sanskrit was perhaps part of the efforts of the Carnatic mission to build a collection of authoritative texts comparable to the Hindu *śāstra*s.

Though the *Punarjanmākṣepa* intended to refute the thesis of the Vaidikas (lit. the followers of the Veda, signifying the Hindus), it also aimed at the newly converted to Catholic religion who may still have been tempted to continue to believe in metempsychosis.[18] This belief was fundamentally incompatible with Catholic conceptions such as individual responsibility and divine justice. Christian missionaries feared that it would hinder a thorough conversion of the neophytes and would also leave Christianity in India fragile.[19] Moreover, the survival of this belief among Indian converts would have entailed serious condemnation from the numerous Catholic enemies of the Jesuits in Europe. The French Jesuits of the Carnatic mission were ready to compromise on certain articles of the Christian faith,[20] but they, like the other Jesuit missionaries in Japan, China and Tibet, rejected with abhorrence the notion of transmigration.[21]

By the 18th century, Jesuits posted in various parts of Asia had understood that metempsychosis was a deeply established conception in all societies and religions from Japan to India.[22] The Asian specificity of this conception in its various aspects probably prompted them to reconsider its supposed geographical and historical origin. Early missionaries in Asia thought that the so-called metempsychosis was an aberration mainly derived from Pythagoras, incidentally mentioned by Aristotle and Thomas Aquinas.[23] The second part of the 18th century saw the opinion of the Carnatic missionaries shifting from the thesis of a Greek origin of "metempsychosis" to that of an Indian origin, as seen in Cœurdoux's position. In 1769 Voltaire also adopted this new viewpoint.[24]

The French Jesuits were also attentive to the question of the metempsychosis because since the second half of the 17th century European intellectuals were inquisitive about that topic. While the Christian doctrines about the nature of soul were being questioned by the European intelligentsia, some of them, like the alchemist François Mercure van Helmont (1618–1699),[25] certain Platonists of Cambridge, among them Henry More (1614–1687),[26] philosophers such as John Locke

14 Their dictionaries and grammars sometimes distinguish the socio-linguistic levels of word meanings. See (Colas and Colas-Chauhan 1995b, pp. 382–83; Colas 2011, pp. 36–37).

15 Adopting De Nobili's doctrine of *"pénétration par en haut"* (Dahmen 1924, p. 30), they wanted to "crush the head of the serpent" (see Colas 1996, pp. 200–3, 213).

16 Such as Pierre Martin (1665–1716) and Pierre Mauduit (1664–1711).

17 With fathers Gilbert Ducros (1692–1730), Memmius René Gargam (1686–1754), the scribe and probably co-author of a Telugu–Sanskrit–French dictionary sent to France in 1730, Jean Calmette (1692–1740) who, in 1737, claimed to have written verses in Sanskrit and Jean François Pons (1698–1752 [or 1753]) who studied Sanskrit in Bengal in 1731–1732 and wrote a Sanskrit grammar. See (Colas and Colas-Chauhan 2014, pp. 65–67; Colas)

18 See *Punarjanmākṣepa*, fol. 1. Conversion to Christianity was not always taken seriously by the new converts and apostasy was frequent. See, for example, the *Iruvaiprasaṃgālu* sermons in Telugu (Colas and Colas-Chauhan 2014, p. 77).

19 The persistence of the belief in rebirth among converts was a subject of concern for ecclesial institutions: see (Clooney 2014, p. 33, fn 15).

20 See (Clooney 2014, p. 25); our observations on the *Iruvaiprasaṃgālu* (Colas and Colas-Chauhan 2014, pp. 80–81).

21 See (Clooney 2014).

22 See (Bouchet [*ca* 1714] 1781, p. 172). For an analyzis of Bouchet [*ca* 1714] 1781, see (Clooney 2005, pp. 54–65).

23 See Clooney 2014, *passim*. However Bouchet, in around 1714, mentions an opinion according to which the "peoples of India" invented the notion of metempsychosis: see (Bouchet [*ca* 1714] 1781, p. 175).

24 For Cœurdoux, see (Clooney 2014, p. 52); for Voltaire, see his *Dieu et les hommes*, (Voltaire 1769, p. 24).

25 In a work published in 1690. See notes 31 et 124 of Jacques Brunschwig's edition of (Leibniz [1765] 1966, pp. 57, 479).

26 See (Leibniz [1765] 1966, p. 57; Crocker 2003, pp. 119–20).

(1632–1704)[27] and, in the early 18th century, Gottfried Wilhelm Leibniz (1646–1716),[28] took an interest in transmigration; some even adopted it. It is difficult to evaluate to what extent the early missionary reports about the omnipresence of this belief in Asia kindled the interest of European philosophers in this conception.

The notion of metempsychosis also nourished scepticism among intellectuals vis-à-vis the traditional Catholic view that God, having created the individual soul, introduces it into the foetus at a particular stage of its development. The Catholic position lost ground during the 18th century and in 1769 the deist Voltaire mocked it and declared his preference for metempsychosis. Making fun of a God eternally lying in wait ("*éternellement aux aguets*") to create souls at moments of conjunction of seed and womb, he found the idea of the "Bracmanes" more ingenuous, adding: "*Il y a dans cet antique système de l'esprit et de l'équité*".[29] The doctrine of metempsychosis, wrote Voltaire *alias* Docteur Obern, is "neither absurd nor useless".[30] As early as 1756, Voltaire, in his *Essai sur les Mœurs et l'Esprit des Nations*, had stated that metempsychosis prevented bad actions and violence.[31]

The interest of the Carnatic Jesuits in this topic grew along with the pressing questions about metempsychosis from French enlightened intellectuals. Father Bouchet's letter to Monseigneur Huet, mainly on the subject of metempsychosis, confirms this concern at the beginning of the 18th century.[32] This however does not mean that the French Jesuits of the Carnatic mission wanted to eradicate the belief in metempsychosis in India merely because of the growing intellectual interrogations in Europe.

2. Summary[33]

The *Punarjanmākṣepa* is in the form of a dialogue between a master (*guru*) and a disciple (*śiṣya*). It contains eight chapters.

Chapter one (fols 1–3) presents the subject of the work, which is the refutation of the belief of Vaidikas in metempsychosis (*punarjanman*, literally, "re-birth"), synonymous with "the state after death", "future life" (*pretyabhāva*) for the soul. According to this belief, when a body is destroyed, its soul, abandoning its previous body, successively bears various kinds of animal bodies, enters stones, vegetation, etc. then again enters a human body.[34] The Vaidikas put forth four reasonings (*yukti*) in support of this belief. The first reasoning is examined in chapter two; the second in chapter three; the third in chapters four and five. The fourth reasoning, that metempsychosis should be admitted because it has the sanction of the Purāṇas which are authoritative texts, is rejected in the very first chapter on the grounds that the Purāṇas are not valid because they are not accepted as authoritative by a part of Vaidika scholars (*paṇḍita*).

Chapter two (fols 3v–6v) is devoted to the refutation of the first reasoning of the Vaidikas, according to which the soul (*jīva*) resides in the body like a human being in a house, like a bird in a nest. This refutation, based on Thomist hylomorphism, states that the soul and body are two parts (*aṃśa*) of a single entity (*vastu*) and are not comparable to the house and the resident of the house which are two whole entities, not parts of a single entity. The house does not grow, gain weight, etc. as a body does; the soul does not leave and re-enter the same body, as the resident of a house does. While the body manifests the emotions of the soul, the house is not affected by the resident's feelings. If the Vaidikas hold that the soul is a whole entity, then they have to accept that the soul by itself is the human being,

27 See (Locke [1689] 1864, pp. 300, 313).
28 See Leibniz's *Nouveaux Essais* written in 1703 (Leibniz [1765] 1966, pp. 198–210). On the speculations of abbé François de Lanion (165.?–170.?) on transmigration, see (Leibniz [1765] 1966, pp. 199, 479) (J. Brunschwig's note 122).
29 (Voltaire 1769, p. 25).
30 (Voltaire 1769, p. 24): "*La doctrine de la métempsicose surtout n'est ni absurde ni inutile*".
31 See (Voltaire [1756] 1963, p. 60).
32 See (Bouchet [*ca* 1714] 1781, especially p. 170).
33 For shorter summaries, see (Arokiasamy 1986, pp. 77–100; Colas 1996, pp. 204–7; Clooney 2014, pp. 42–46; Colas and Colas-Chauhan 2014, pp. 69–75).
34 Fol. 1v.

capable of continuing as a human being in whichever body, that of a dog for instance. But the reality is that the soul and body come together to form a whole entity, be it a human being, an animal, a tree, etc. and they acquire the power of performing different actions. The nature of being a whole entity is due to the coming together of a *form* (*mātrā*, lit. "measure"), namely, a soul, and a material support (*ādhāra*, lit. "support", "substratum", "receptacle") namely, a body. Of these, the soul is the main (*pradhāna*) cause whereas the body is the auxilliary (*sahakārī*) cause.

According to the *Punarjanmākṣepa*, human and non-human souls have two capacities (*śakti*) in common: growth and knowledge through the inner and outer senses. Human souls have two other specific capacities, intelligence (*buddhi*) and mind (*manas*), which are extra-corporeal and not dependent on the limbs of the body. The human soul is capable of producing activities through these two capacities even after the destruction of the body, while the souls of animals cease to exist when they do not have a body as support. Moreover, human souls cannot be the *forms* (*mātrā*) of the bodies of dogs, etc., nor can the bodies of dogs, etc., be the material support (*ādhāra*) of human souls.

Chapter three (fols 7–11) is devoted to the refutation of the second reasoning of the Vaidikas, that the innumerable souls which reside in different bodies are of the same nature. As in chapter two, the refutation is based on Thomist hylomorphism: (1°) A soul exists as the *form* (*mātrā*) of a particular individual body; (2°) Each individual soul possesses a fixed and distinct character; (3°) Therefore one particular *form* (*mātrā*) produces one particular entity (*vastu*), and not several particular entities. This is illustrated by two examples, that of an object (a plate) and of an elephant. A soul which is the *form* of the body of an elephant produces the entity "elephant"; it cannot produce an entity "ant". It cannot be said by the Vaidikas that the above *form* of the body of an elephant, having entered the bodies of mosquito, bug, etc., becomes the *form* of a mosquito, a bug, etc. The work also adds a social application of this view: while the classes (*jāti*s) among animals are on the basis of their natural differences, the classes (*jāti*s) among human beings are due to their worldly transactions linked with social convention.

The work then presents a sequence of (non-Thomist) attacks on three "untruths" connected with the above second reasoning of the Vaidikas. The first untruth is that one should perform good religious acts at the time of death for obtaining a pleasant body in the next birth. A list of objections follows: human souls in trees cannot perform such acts; the souls of animals and trees are destroyed on their death; religious post-mortem rites for the dead are the fruits of the imagination of poets; animals and trees do not possess the function of knowledge and no virtuous and sinful acts could lead them to Paradise (*mokṣa*) or Hell (*naraka*). The second untruth is that the human soul leaves one body and enters another non-human body. If so, it would be a crime to deprive any living being of life, for example, to cut vegetation and vegetables for cattle and oneself. The third untruth is that human soul indifferently enters the bodies of animals, birds, trees, etc. This would mean that all difference among living beings resides in bodies and that the degree of difference between a baby donkey and a baby dog would be the same as that between a baby donkey and a human baby.

Chapter four (fols 11v–14v) refutes the third reasoning, namely that the difference (*tāratamya*) in class, education, wealth, status and health, by birth or acquired during a life-time, can be explained only if it is admitted that they are produced by the virtue and sin (*puṇya* and *pāpa*) earned in previous lives. This chapter denies that good fortunes such as kingdom, wealth, health, beauty, pleasures, etc. enjoyed in this life are due to virtuous acts such as austerity, donations, prayers, sacrifices, etc. performed in a previous life.

It is questioned whether these virtuous deeds were performed by the force of destiny (*lalāṭalipi*, literally, "the writing [by the Creator] on the forehead") or by free will. In the first hypothesis, persons destined for good fortune would enjoy it even without having performed virtuous deeds. As regards the second hypothesis, the deliberate choice of sinful acts out of free will would lead to the breakdown of the society and of the institution of kingship. The text here draws the analogy in which the society is compared to a body and the king to its head. God who creates the body (the society) would not leave the creation of its head (the king) to causes like the virtuous deeds of human beings.

Then follows a series of "reasonings" (*nyāya*) which are disjointed laconic attacks, often sustained by striking illustrations, pointing out paradoxes and contradictions in the Vaidika position that virtuous acts in a previous life bring about good fortunes in the present life: renouncers would renounce enjoyment in the present life not for spiritual ends but to gain pleasures in the next life; enjoyment with many men by prostitutes would be the result of an earlier virtuous life and faithfulness in a couple would be an unfortunate consequence of a previous life; there would be inconsistency between the traditional belief that kingship is a good reward for a virtuous previous life and the Purāṇic statement that "Hell (inevitably) comes after kingship". Furthermore, if the Vaidikas admit that the very first members of privileged social classes (brāhmaṇa, kṣatriya) were created by Brahman from his different limbs, it would signify that their socially advantaged condition was not a reward of the virtuous deeds of a previous life.

Chapter five (fols 15–20) refutes another aspect of the third reasoning, that misfortunes such as poverty, disease, and the condition of belonging to the lowest social class, etc. in the present life are due to sins committed in a previous life. The question is raised, as in the preceding chapter, whether these sinful deeds were performed in the previous life by force of destiny or by free will. In the first hypothesis, predestined stealing, etc., cannot be considered as sinful actions. Moreover, misfortunes such as birth in an inferior class, poverty, etc., of the present life cannot be considered as the results of sinful deeds because actions done under duress are neither sinful nor virtuous. Regarding the second hypothesis, the text refers again to the argument based on its arbitrary and conservative monarchist conception of the society. Human beings would not perform by free will sinful deeds which would result in their birth in inferior classes. As a result, there would no inferior social classes such as *caṇḍāla*, etc., in the world, in which case the society would be like a body with a head (namely king) but without feet (servants).

The *Punarjanmākṣepa* employs the analogy between the human body termed microcosm (*piṇḍa*), and society, termed macrocosm (*aṇḍa*). The Creator who creates the human body, also creates the limbs, head, feet, etc.; limbs cannot arise from causes other than God, such as human deeds of previous life. God also creates kings etc. who are the head of the great body, which is this society, and low classes, such as *caṇḍāla*, etc., who are the feet of the society. If the fortunes and misfortunes of human beings were due to their past acts it would signify that God is not free in his governance of the world. Only God's desire (*cittavṛtti*) is the cause of the accomplishment of the world order (*lokakramapravṛtti*).

In order to illustrate that visible causes for fortunes and misfortunes should be accepted rather than invisible causes such as deeds of a past life, the text presents certain "cases" (*viśeṣa*): a person named Caitra afflicted by a disease of boils due to his association with prostitutes; another named Cakrāyudha decapitated for stealing from the king's treasury. The Vaidikas may attribute these misfortunes to prior sinful deeds or even argue that God procures the visible sinful deeds such as debauchery and stealing as a result of a sin committed in a previous life. But this reply is not acceptable because it involves three errors: favouring invisible over visible causes, attributing sinful intentions to God who would instigate human beings to sin, ignoring the sin-purificatory force of contrition (*paścāttāpa*). Another case is that of Sugrīva, afflicted by a terrible leprosy, whose suffering the Vaidikas consider as a punishment that destroys the sins of a previous life. They also believe that repentance (*paścāttāpa*) destroys the sins of a previous life. But since the sins of a previous life cannot be remembered in the present life, there could be no repentance with regard to them. The *Punarjanmākṣepa*, which believes in the virtue of contrition (*paścāttāpa*), adds that a person is called sinner (*pāpātman*) as long as his mind does not refrain from sin; suffering helps to adopt virtuous behaviour through contrition which consists in turning back mentally from sin. This is followed by the examples (*dṛṣṭānta*) of a servant who remained treacherous and unrepentant even after punishment and of the unrepentant Sugrīva mentioned above.

Chapter six (fols 20–25v) points out that, according to a Vedic statement, the creation of the universe occurred from nothing and according to a Purāṇa passage, Brahman created *brāhmaṇa*s from its mouth, *kṣatriya*s from the two arms, *vaiśya*s from the two thighs and *śūdra*s etc. from the

two feet. This signifies that there did not exist any cause such as virtuous and sinful acts of previous life, that created the world. The *Punarjanmākṣepa* declares that God created all beings and everything. He gave human beings and animals the possibility of reproducing themselves. But human birth is particular because when the foetus created by a father and a mother becomes fit to be connected with a soul, God himself creates the new human soul. At the time of death, the human soul, having earned the grace willed by God, leaves its body and reaches eternal Paradise (*mokṣa*). If it is devoid of the grace of God, it falls into Hell (*pātāla*) and never escapes from it.

The text presents several other reasonings (*yuktis*) against metempsychosis. This notion would challenge the existence and omnipotence of God who governs the world by his free will (*svātantryeṇa*) through just laws. If metempsychosis were admitted, it would signify that the world is governed by the sins and merits of individuals, which would render the existence of God superfluous. To explain why in spite of God's governance and appropriate laws, virtuous persons undergo suffering while sinners enjoy good fortune, it is stated that suffering helps virtuous souls to refrain from sin, to obtain more merits through forbearance and to be models for others through their ideal behaviour. On the contrary, God gives sinners wealth like money, grain, etc., to augment their punishment.

Another "reasoning" is that if the sufferings of this life were the result of sins committed in past life, such results being of limited duration, people would not hesitate to sin again. The "True Veda" (namely the Bible) proclaims eternal suffering in Hell for the sinners, which is the only means to make them fear sin. As earthly enjoyments are not the supreme aim of human beings, it is worth bearing earthly sufferings and renouncing the pleasures of the present life for reaching Paradise. The text compares God to a king who does not hesitate to punish culprits, even by death if necessary, to implement and maintain order. God creates all souls in order that they enjoy Paradise (*mokṣa*) which is called their own kingdom (*svarājyaṃ*), the earth being for them only a "foreign country" (*paradeśa*), a "territory of action" (*karmabhūmi*). Since the souls of animals are destroyed with their body, all pleasures are to be enjoyed by them only on the earth and the earth is said to be their "own country". Thus, God created animals with downward vision for them to gaze at the earth[35]. Paradise being the country and the supreme aim of human souls, God created them with upward vision.

Then follows a series of short random arguments. The thesis of metempsychosis lacks order: it is not coherent that the body which suffers is created now and that the sin which causes that suffering was committed even before the existence of that body. It is also not logical to say that the soul which has committed sin in a previous body is punished with disease, etc., in the present body. The holders of metempsychosis cannot explain good fortune in the absence of prior good deeds and misfortune in the absence of prior bad deeds. Moreover, if the sins and virtuous deeds of previous life were exhausted in the sufferings and enjoyment of the present life, there would be no Paradise and Hell for them to go to.

Chapter seven (fols 26–32) explains how divine design (*daivacitta*) and not metempsychosis legitimates social inequality (*tāratamya*). It takes the model of microcosm/macrocosm, which is said to be accepted "by all the people of this country", as the basis for discussion. Just as various limbs are needed for the functioning of the body, which is the microcosm, so also many kinds of human beings, comparable to various limbs, are required for the unimpeded functioning of the world, which is the great body or macrocosm. If there were no hierarchy between the limbs, the body would not function. Similarly, if there were no social hierarchy, society would be in chaos.

God is not partial in the creation of inequality because he is just (*nītisvarūpa*) and free since all his wishes are always fulfilled (*avāptasarvakāma*). Nor does he require the individual *karman* of human beings for the creation and governance of the world. He desires by his free will that each person conducting himself according to the function assigned by him reaches Paradise through meritorious behaviour. Fulfilling one's own social function and respective activities without jealousy is for the

[35] A commonplace topos gently mocked by Montaigne, who quotes Ovid's *Metamorphoses* I, 84, as being a mere poetical view: see (Montaigne [1595] 1962, p. 463) (*Essais* II, 13).

benefit of the whole society and for one's own benefit. The servant serves the king not because of the king's supremacy but for his own livelihood; the king spends his wealth, etc., not for the livelihood of the servant but for the stability, etc., of his own kingdom. An interesting story (*kathā*) on the conflict among limbs is told to illustrate the necessity of working together without jealousy for the good functioning of the society. Each part of the body one by one ceased to work, judging that they worked only for the benefit of the stomach. When the stomach was not longer fed, the whole body including the limbs, became weak. As a result, the limbs realized that they should abandon jealousy and work together. Another example illustrates the need to adhere to one's own position in the society. Just as a king assigns soldiers to different parts of a fort under siege, God assigns human beings to higher, middle and lower sections of the society where all should work properly at their places according to God's wish. Therefore, God's wish is the cause for the hierarchy among human beings and not virtuous and sinful deeds performed in the previous life.

Human hierarchy is also declared to reveal God's greatness. The example of the appointment of the soldiers at different places of the fort is significant because the existence of men on earth is nothing but a war against demons, sinners and the body. Demons, in order to make souls fall into Hell, make them unmindful of sins; sinners give wrong advice to virtuous persons to tempt them into sinful behaviour; the body diverts human beings from the path of righteousness through avidity, anger, etc. God bestows grace to help men fight these three enemies and win over them. Victory over sin by righteous souls at the various levels of society for the efficient functioning of the world pleases God; social hierarchy and victory over enemies manifest God's greatness.

The chapter concludes with the declaration of a "particular truth" (*satyaviśeṣa*) which explains why God did not create equality among all human beings. God desires all people to remain in their own rank in the society, win over the above-mentioned enemies and, without complaining, earn his grace obeying the order set by him. God sends to Paradise (*mokṣa*) those who succeed and to Hell those who fail. The means to save (*taraṇopāya*) human souls is the same for those in the higher and lower social conditions. Just as the food received by the mouth nourishes all limbs, the teaching provided by the "true preceptor" (*sadguru*) who is the mouth of the great body, helps people of all ranks, who are like limbs of that body, to reach Paradise. It should be known that the immoral sensual pleasures were not created by God nor are they favourable to the moral functioning of the world. Desires, like the unquenchable thirst of a sick person, are insatiable. These desires and fortunes etc., originated in sin such as illicit pleasure, stealing, killing, etc., are earned by the free will of the sinner and not by his previous virtuous or sinful deeds.

Chapter eight (fols 32v–36v) specifically discusses the question of innate handicaps and sufferings faced during a life-time. Handicaps and diseases at birth are to be attributed not to sins of a previous life but to unhealthy food, the fall of the pregnant woman, the wrong sexual behaviour of the parents during pregnancy, etc. Combining moral and embryological considerations and seeking the authority of medicine (*vaidyaśāstra*), the work states that the weakness of blood and sperm are due to immoral behaviour. Handicaps in new-borns are explained by taking the analogy of the bad quality of a field (womb) and grain (sperm) and the analogy of defective pots which are ill-baked because of an uneven or insufficient fire. Defective or incomplete limbs in the embryo are caused by defective sperm or blood.

There are four reasons why God produces suffering such as diseases, etc., in sinners. The first is the edification of others. On seeing the sinners suffer, others become convinced that the sufferings of the sinners will be greater in Hell and that they should avoid committing sins. God also gives suffering to the sinner on the earth so that he repents and decides to follow a virtuous path. A third reason for inflicting suffering on sinners is that they refrain from sin and remain firm in the practice of virtue, austerity, etc. Suffering is also sent by God to purify the sinner through pain, just as gold is purified by heat, in order that he reaches the supreme sojourn (*paramapada*).

God also gives suffering such as diseases, etc., to virtuous people, but out of compassion. Suffering encourages virtuous persons to earn further virtues on the earth for the enjoyment of supreme felicity in the other world. Secondly, God also makes good persons suffer because suffering increases their

faith; they understand that their suffering is in conformity with God's design. Suffering also intensifies their love (*prīti*) for God. Fourthly, virtuous persons gain patience through suffering which gives others the occasion to praise God and to follow the example of the virtuous. Thus ends the *Punarjanmākṣepa*.

3. The *guru* and the True Veda

The *Punarjanmākṣepa* is, as mentioned above, in the form of a dialogue between a master and a disciple. It is not certain whether this mode of presentation is merely rhetorical or if it corresponds to a particular historical or pedagogical situation. The master (*guru*) represents a Catholic doctrinal authority, apparently a Jesuit father, who is attributed, at least in the Sanskrit translation of the work, with a linguistic style fit for educated Brahmins. He names his doctrine "the True Path" (*sanmārga*)[36] and refers to his Scripture, that is, the Bible, as "the True Veda" (*satyaveda*) composed (*praṇīta*) by God himself,[37] or as the "Veda of the Lord of all (*sarveśvaraveda*)"[38] or simply "Veda".[39] He does not quote the Bible or any other Christian work, although he refers the readers to a work entitled *Ātmanirṇaya*, which is attributed to De Nobili.

4. Vaidikas and Veda

The *Punarjanmākṣepa* criticises the belief in metempsychosis of those whom it names Vaidikas. It states that some impure souls (*malinātman*), ignorant of the Lord of all, follow the doctrine (here named Veda doctrine, *vedamata*),[40] which has mutually contradictory meanings. Though they adhere to various paths (*mārga*),[41] they come together to admit the notion of metempsychosis. There are also some among the followers of the True Veda composed by the Lord (namely, the Bible) who wonder if this notion is true or not. Since their faith in the True Veda is not unfailing, they do not qualify to follow the True path and for the cessation of worldly existence (*saṃsāra*). The aim is to refute the notion of metempsychosis from the point of view of the True Veda, in order that all Vaidikas obtain faith in the True Veda by the grace of the Lord and follow only the True path.

The *Punarjanmākṣepa* occasionally distinguishes the Veda of the Vaidikas from a Purāṇa and also questions the authority of Purāṇas on the grounds that they are not accepted by all learned people (*paṇḍita*) among Vaidikas. It however quotes a Purāṇic statement as evidence.[42]

5. The *Punarjanmākṣepa*, a *vade mecum* against Metempsychosis

The purpose of the *Punarjanmākṣepa* could have been to furnish arguments to the Jesuits in their missionary work and to the converts as well, in their debates with Hindus. It is interesting to note that some of the arguments which Father Bouchet declared to have employed during his discussions with Indians on metempsychosis, are found in the *Punarjanmākṣepa*.[43]

The *Punarjanmākṣepa* seems to be a sort of handbook against metempsychosis with various kinds of arguments arranged more or less systematically, sometimes long, sometimes brief, sometimes

[36] Fol. 1.
[37] Fol. 23v.
[38] Fols 3, 29v.
[39] Fol. 30v.
[40] Fols 1, 14.
[41] Fol. 1. However, folio 1v refers to those who do not believe in metempsychosis and states that their view is discussed in another work, the *Ātmanirṇaya*.
[42] Fols 14, 21.
[43] See (Bouchet [*ca* 1714] 1781) (impossibility of justifying through metempsychosis the existence of social classes at the time of creation, model microcosm/macrocosm and Hell as the outcome of kingship, pp. 239–45) and *Punarjanmākṣepa* (respectively, fols 14v, 16 and 13v–14). See also (Clooney 2005, pp. 59–60). Bouchet's letter also reports that Indians compare the soul in a body to a bird in a cage (p. 181), a man in a house (p. 182) and a man in a jail (p. 187). These comparisons are mentioned in the *Punarjanmākṣepa*.

recurrent.[44] The disciple repeatedly calls for arguments which are designated as "reasonings" (*yukti, nyāya*). While most arguments involve reasoning, several are based on Christian presuppositions. Theoretical expositions alternate with polemical attacks, at times illustrated by instances and stories. Some reasonings point out real contradictions in the Hindu metaphysical tradition, for instance the incompatibility of God's omnipotent free will with the karmic constraints of individual souls which arise from past deeds.[45]

6. Ideological Strategies and Argumentative Tactics

At least five ideological strategies which also are the fundamental lines of reasoning may be distinguished in the *Punarjanmākṣepa*, besides its argumentative tactics. The first strategy is the belief in one omnipotent and supreme God. It is the keystone of the *Punarjanmākṣepa* and of the four other ideological strategies. God possesses infinite compassion (*anantakrpā*, also *karuṇā*)[46] and infinite justice (*atyantanīti*).[47] The creation and functioning of the world is based on the divine design (*daivacitta*).[48] God's free will is put forward as a main argument against the thesis of metempsychosis. He creates and governs the world, including its social hierarchy,[49] by his own free will,[50] promises Paradise,[51] and confers suffering on sinners and virtuous souls[52] for their own sake and for the benefit of the world, etc. Rejecting the Vaidika position that the good and bad fortunes of the present life are caused by the deeds of a previous life, the *Punarjanmākṣepa* declares that only God's wish is the cause and not *karman*.[53] God has no use of individual *karmans*.[54]

The second strategy, mainly exposed by the *Punarjanmākṣepa* in chapters two and three, is the Thomist scholastic hylomorphic reasoning. It aims to prove that there is one individual soul ("*form*") for each human being, which soul is associated with a single body ("matter"), a conception diametrically opposed to the thesis of metempsychosis. According to the Thomist doctrine, the human soul and its body are incomplete from a natural standpoint; their union forms the complete entity which is the human being. From the metaphysical point of view, however, the human soul is complete in itself because it continues to exist beyond death.[55] It may be recalled in this context that the Jesuits were followers of the doctrine of Thomas Aquinas and that from the 16th to the 18th century, several of them such as Francisco Suáres (1548–1617),[56] were important contributors to the second Thomist scholasticism of the Catholic Church.[57] But the belief in metempsychosis was not a common Thomist topic of discussion,[58] for Thomas Aquinas only briefly criticized the conception of metempsychosis

[44] The *Punarjanmākṣepa* to a certain extent can be compared to the *Iruvaiprasaṃgālu*, with the difference that it was intended for the educated higher classes of the society while the latter was intended for labourers, soldiers, etc. (see Colas and Colas-Chauhan 2014).

[45] See for example, fols 22–23.

[46] Fol. 35v.

[47] Fol. 27, 30.

[48] Fols 27, 35v.

[49] Fol. 27v.

[50] Fols 16v, 22.

[51] Fol. 27.

[52] Fol. 33v.

[53] Fols 22v and 23.

[54] Fol. 27.

[55] See (Gilson 1922, pp. 138–51; Peillaube 1930, col. 1043; Owens 1994, pp. 178, 180).

[56] For a detailed exposition of his theses about the individual soul, see (Gracia 1994).

[57] The second scholasticism also includes the extra-European scholasticism sometimes named "colonial scholasticism", that is, works written in Latin America under Spanish domination. See (Hofmeister Pich and Culleton).

[58] See (Hedde 1929, col. 1592), quoted in (Colas 1996, p. 216, note 20).

attributed to Pythagoras.[59] Therefore, besides the Thomist arguments, the Jesuits in India had to search for new reasonings better adapted to the cultural context. The *Punarjanmākṣepa* testifies to this effort.[60]

Social reinterpretation of the model of the microcosm and macrocosm is the third ideological strategy noticed in the work. It intends not only to explain human suffering and social inequality, but also to legitimate them.[61] The place of the individual in the social hierarchy is due not to the deeds of past lives, but to divine design. The macrocosm (*aṇḍa*), that is, the whole universe including the society, is considered a "great human body" comparable to the microcosm which is the human body (*piṇḍa*). The *Punarjanmākṣepa* states that this conception is accepted also by "all the people of the country"[62] because their scriptures declare that the Creator created the superior classes from the head of the great human body, the lower classes from its feet, etc.[63] It however pays no attention to the real meaning of the notion of *aṇḍa* which signifies the whole material universe and applies the analogy only to the social dimension of *aṇḍa*, emphasizing that everyone should remain in his own social condition for the welfare of the whole society. Contrary to the Thomist reasoning, which would have been unfamiliar to Indians, the above model perhaps better appealed to them because it had the sanction of Hindu scriptures[64] and because it confirmed social conservatism. It may be noted that the socio-political interpretation of the microcosm/macrocosm model was also common in European thought, especially among the Jesuits of the 16th–18th century who followed Albertus Magnus (c. 1200–1280) and Thomas Aquinas (1225–1274) in this regard, as it contributed to legitimate monarchy.[65]

The fourth ideological strategy is an empiricism according to which visible causes have precedence over the invisible. The *Punarjanmākṣepa* clearly rejects that an invisible cause like the sins of a previous life could produce diseases, etc., while there exist visible causes like debauchery.[66] Socio-medical empiricism makes this work attribute defects at birth not to metempsychosis but to causes such as wrong diet, defects of the sperm, etc.

The fifth ideological strategy is of a metaphysico-moral nature. Chapter eight supplants metempsychosis with a simple pattern that is typically Christian. A single life which ends with the ascension to Paradise for the right-doers and a fall to Hell for sinners supersedes the succession of many lives preconized in metempsychosis. The *Punarjanmākṣepa* considers that the terror of eternal suffering in Hell is a better deterrent than the fear of temporary sufferings in posterior lives.[67] God sends suffering to virtuous people for their own spiritual benefit and to sinners to lead them to contrition, thus enabling contrite souls to escape eternal Hell.

Apart from these five main ideological strategies, the *Punarjanmākṣepa* displays argumentative tactics. Random successions of brief reasonings point to the contradictions in the Vaidika viewpoint.[68] The work also presents particular cases (*viśeṣas*), stories (*kathās*) and examples (*dṛṣṭāntas*). The Vaidika explanation for particular cases of suffering are presented and rejected and valid alternative

[59] In his Commentary on Aristotle's *De Anima*, I, 8. See (?, pp. 117–18). This work was part of the education of Jesuits in Europe (Mesnard 1966, p. 71). Thomas Aquinas mentions the Pythagorean example of the soul of an elephant leaving the body of the elephant and entering the body of a fly. A similar example (elephant and ant, mosquito or bug) is employed in the *Punarjanmākṣepa*. See fol. 4v, 7v, 8v, etc.

[60] According to Cronin (1959, p. 145) De Nobili searched in Rome for books on metempsychosis to strengthen his arguments against this belief, a subject on which he corresponded with other Jesuits in 1607–1609 (Županov 2001, pp. 155–57).

[61] See fols 12, 14, 16, 21, 26–26v, 32v–33v.

[62] Fol. 26.

[63] Fols 12v, 14, 16, 21. The notion of the "great body" as a cosmical man who symbolizes the ideal society is referred to in the *Puruṣasūkta* (*Ṛgveda* 10.90) according to which each limb represents a social class.

[64] Indian illustrations of the duad microcosm/macrocosm are found in works of all periods, in the Upaniṣads (*Aitareya* 1.1.1–4, *Muṇḍaka* 2.1.1-10, *Chāndogya* 8.1.1–3, etc.), as well as in Tantric and Nātha works (see for example, Mallik 1954, pp. 21, 39–40, etc.). See also the Sanskrit maxim *yathā piṇḍe tathā brahmāṇḍe*, "As in the body so in the universe".

[65] For Albertus Magnus, democracy is the worst of political regimes and is like a monster with multiple heads. For his views and those of Thomas Aquinas, see (Molnár 2002, pp. 75–76; Bigongiari 1957, pp. v–xxiv, xxvii). Renaissance philosophers and humanists too adhered to the microcosm/macrocosm conception: see (Oosterhoff 2015, p. 29; Conger 1922, pp. 55 ff).

[66] Fol. 17.

[67] Fol. 23v.

[68] Fols 9v–11, 12v–14v, 25v–26.

explanations are given (see especially chapter five). Stories and examples have a unilateral anti-Vaidika explanation. They bear resemblance to the *exempla* which the Jesuits used in works like the *Iruvaiprasaṃgālu*, a collection of Telugu sermons.[69] A typical story is that of the conflict between the limbs of a human body.[70] Examples like that of the treacherous servant who remains so even after punishment and without repentance,[71] of the king who does not hesitate to inflict severe punishment[72] and of the king who assigns soldiers to high and low positions[73] illustrate the discussions.

7. Linguistic Affinity and Ambiguity

The Sanskrit version of the *Punarjanmākṣepa* to a certain extent overcomes the difficulties with regard to the equivalence between Christian and Sanskrit religious terminology. For instance, the work employs the Hindu generic designations of God and never sectarian personal names of Viṣṇu, Śiva, etc. God is referred to as "Lord of all" (*Sarveśvara*), "Supreme Lord" (*Parameśvara*), "Lord" (*Īśvara*), "Fortunate One" (*Bhagavant*), "God" (*Deva*), "Creator" (*Kartṛ*), "Master" (*Svāmin*), "Supreme One" (*Sarvottama*) and "Dear One" (*Vallabha*), terms which do not deprive the work of its Christian flavour nor contradict Christian doctrine.[74] Certain common Sanskrit terms of Hinduism denoting moral qualities and emotions of God and the feelings of devotees, for instance, "pity" (*dayā*) and "compassion" (*kṛpā*) of God[75] and "faith" (*śraddhā*)[76] and "devotion" (*bhakti*)[77] of the believers, also appropriate to Christianity, are employed.

A number of common Sanskrit terms, however, stand for particular Christian notions. For instance, *pāpa* designates "sin"[78] which is very different from the meaning it has in the Hindu context of the karmic retributive process. Thus *mokṣa* also stands for Paradise as conceived in Catholicism and does not refer to the Hindu notion of liberation from the cycle of successive existences.[79] Moreover, *mokṣa*, believed to be a particular topographical site,[80] is referred to in compounds such as "country of Paradise" (*mokṣa-deśa*), "kingdom of Paradise" (*mokṣa-rājya*)[81] and called "supreme sojourn" (*paramapada*).[82] *Saṃsāra*[83] denotes a single existence whereas in Hinduism it designates the flow of successive lives. The *Punarjanmākṣepa* also adds completely novel significance to various Sanskrit words. Thus, in its Thomist hylomorphic demonstration, *mātrā* and *ādhāra* respectively denote the Thomist notions of *"form"*, that is, soul, and *"matter"* or *"material support"*, that is, body.[84]

In its search for points of convergence with the Vaidikas, the *Punarjanmākṣepa* is keen to show that it shares some fundamental notions with them. But as we saw with the duad microcosm/macrocosm said to be accepted by Indians, the similarities are either partial or ambiguous. The notion of *paścāttāpa*, for example, is declared to be common to Christians and Vaidikas.[85] But in fact in the *Punarjanmākṣepa* it corresponds to the precise Catholic belief of contrition and not to repentance as held

[69] See (Colas and Colas-Chauhan 2014, p. 79).
[70] Fols 28–29.
[71] Fols 19v–20.
[72] Fol. 24.
[73] Fols 29–29v.
[74] However, the expression "Supreme soul" (*śrīparamātman*, fol. 32v) is specifically Hindu.
[75] Fol. 17v.
[76] Fol. 1.
[77] Fols 6, 12v, 19, 35v.
[78] The Telugu–Sanskrit–French dictionary BnF Indien 601 translates *pāpa* as *"péché"*, *"crime"* and *"vice"*.
[79] See the dictionary BnF Indien 601, s.v.
[80] See fols 10, 22, etc.
[81] See fols 25, etc.
[82] Fol. 35.
[83] See for instance, fols 1 and 30v.
[84] The Jesuit dictionaries BnF Indien 600 (Telugu-French, copied before 1730) (n.d.) and Indien 601 (Telugu–Sanskrit–French) (Cœurdoux n.d.) do not note the Thomist sense of these Sanskrit terms. On these dictionaries, see (Colas and Colas-Chauhan 1995b; Colas 2011, pp. 34–42).
[85] Fol. 18v.

by the Indians. Just as the Carnatic Jesuits accommodated the way of life of Brahmin renouncers,[86] they also adapted their discourse, language and vocabulary to the public or readers[87] for whom their message was intended. The absence of direct references to the life and death of Jesus-Christ or citations from the Bible, for instance, could be understood in a similar perspective of adaptation.[88] The linguistic accommodation of the Sanskrit *Punarjanmākṣepa* perhaps helped attract the attention of Indian interlocutors. But it also created a semantic area of such ambiguity that it is not certain that the Vaidikas apprehended the real significance of the arguments.

8. Conclusions

The Jesuits followed Thomas Aquinas's recommendation that in the debates with Pagans and Muslims, who did not acknowledge the authority of the Bible, Christians should resort to "natural reason" acceptable even to non-Christians.[89] Thus De Nobili and early Jesuit missionaries in South India were convinced that reason was adequate to defeat Brahmins and their doctrines.[90] The *Punarjanmākṣepa* is an important testimony to this conviction. The topic of metempsychosis above all was crucial to them because the eradication of this belief was essential for an in-depth conversion of Indians. But the impact of the *Punarjanmākṣepa* and the role played by Jesuit reasoning in converting Indians to Catholicism remain difficult to assess.

The Sanskrit *Punarjanmākṣepa* resorted to an argumentative style and adapted to the vocabulary, social norms and socio-religious disposition of Hindus, but it perhaps failed to acquire the aura of a śāstric treatise among Hindu erudites. No extant work from the Hindu side is known which would have responded to the *Punarjanmākṣepa*. Nor does this work show evidence of any counter-argument from the Vaidikas. As the *Punarjanmākṣepa* did not direct its criticism towards a well-defined adversary[91] or quote arguments, etc., from any particular Indian school of thought, it perhaps did not evoke a polemical opposition from any group. Refutation of metempsychosis isolated from the notions associated with it, such as the nature of soul in the Indian philosophical systems, could have deprived the *Punarjanmākṣepa* of the seriousness and solemnity it sought among Indian erudite circles. Above all, the most scholastic line of argumentation of the work, namely, Thomist hylomorphism, being based on unfamiliar presuppositions, would have been impossible to debate for Vaidika scholars. When the Carnatic Jesuits had the *Punarjanmākṣepa* translated into Sanskrit, they do not seem to have added any further elements within this version. Nor did they later compose any new work on this topic, even though they had gathered enough intellectual resources to further indianize their philosophical argumentation.[92] Thus the debate or intercultural exchange between Jesuit and Hindu scholastics, which modern indologists and historians may aspire to see illustrated in the *Punarjanmākṣepa*, remains elusive.

As mentioned above, several 17th and 18th century European philosophers were interested in the notion of metempsychosis, but such new ideas did not find their way into the then Jesuit perspective which was nearer to the 17th than the 18th century. An objective report from the Jesuit missionaries placing the Indian notion of metempsychosis in the context of Indian metaphysics could have contributed to furthering interest in this topic among certain European philosophers. But this was not ultimately to be the case, as Occidental idealization of the philosophical notion of "reason",

[86] For the method of adaptation (*accommodatio*), see (Dahmen 1924).

[87] See (Colas 1996, pp. 203–10; Colas and Colas-Chauhan 2014, pp. 68–83).

[88] See (Clooney 2014, p. 25).

[89] See (Goss 1998, p. 70; Aquinas 2016, I, 2).

[90] Colas 1997, pp. 211, 213. See Calmette's letter to Father Delmas (dated 17 September 1735) from Chikkaballapur (Martin 1840, pp. 621–22) and the undated letters of Jean Venant Bouchet and Pierre Martin (De Querbeuf 1781, pp. 8, 115, 116, 118) quoted in (Colas); see also (Gelders and Balagangadhara 2011, pp. 108, 112).

[91] For an exceptional mention of the Mīmāṃsakas, see fol. 22v.

[92] Father Jean François Pons who wrote a grammar of Sanskrit and had studied in Bengal the Indian systems of scholastic philosophy including logic was in Pondicherry from 1733 till his death (1752 or 1753). See (Colas).

associated with socio-political and economic development, had already become a dominating trend in the evolution of European thought.

Author Contributions: Colas and Colas-Chauhan jointly prepared the material and together wrote the article. Colas also researched on the European archival material and on the interest in metempsychosis in 18th century Europe, while Colas-Chauhan looked into the Telugu version of the *Punarjanmākṣepa*.

Conflicts of Interest: The authors declare no conflict of interest.

References

Anonymous. n.d. *Dictionnaire Telougou François*. Manuscript Indien 600; Paris: Bibliothèque nationale de France.

]B2-religions-08-00192 Aquinas, Thomas. 1923 [ca 1269-1270]. *Commentaire du Traité de l'âme d'Aristote*. French translation by Armand Thiéry; Louvain: Institut supérieur de philosophie.

Aquinas, Thomas. 2016. *Summa contra Gentiles. Book One*. Translated by Anton C. Pegis. Available online: http://dhspriory.org/thomas/ContraGentiles1.htm#2 (accessed on 7 December 2016).

Arokiasamy, Soosai. 1986. *Dharma, Hindu and Christian According to Roberto De Nobili. Analysis of Its Meaning and Its Use in Hinduism and Christianity*. Rome: Editrice Pontificia Università Gregoriana.

Bigongiari, Dino. 1957. *The Political Ideas of St. Thomas Aquinas. Representative Selections. Edited with an Introduction*. New York: Hafner Publishing Company.

Bouchet, Jean Venant. 1781. Lettre du Pere Bouchet, Missionnaire de la Compagnie de Jesus, à Monseigneur Huet, ancien Evêque d'Avranches. In *Lettres Edifiantes et Curieuses Ecrites des Missions Etrangères. Nouvelle Edition. Mémoire des Indes. Tome Douzième*. Edited by Yves Mathurin Marie Tréaudet de Querbeuf. Paris: J.G. Merigot, pp. 170–255, First published *ca* 1714.

Clooney, Francis X. 2005. *Fr. Bouchet's India: An 18th Century Jesuit's Encounter with Hinduism*. Chennai: Satya Nilayam Publications, ISBN 81-901345-9-0.

Clooney, Francis X. 2014. The Pre-Suppression Jesuit Case against Rebirth, with Special Reference to India. In *Intercultural Encounter and the Jesuit Mission in South Asia (16th–18th Centuries)*. Edited by Anand Amaladass and Ines Županov. Bangalore: Asian Trading Corporation, pp. 25–61. ISBN 978-81-7086-690-9.

Cœurdoux, Gaston Laurent. and other anonymous authors. n.d.; *Dictionnaire Telingua et François [Telugu-Sanskrit-French Dictionary]*. Manuscript Indien 601; Paris: Bibliothèque nationale de France.

Colas, Gérard. 1996. Vie légumineuse et pensée travestie. Sur les jésuites en Inde aux XVIIe et XVIIIe siècles. In *Islam et Christianisme en Milieu Hindou*. Edited by Jackie Assayag and Gilles Tarabout. Paris: EHESS, Puruṣārtha 19, pp. 199–220.

Colas, Gérard. 2011. La contribution des jésuites du Carnate à la grammaire et à la lexicographie du télougou. In *L'œuvre Scientifique des Missionnaires en Asie*. Edited by Pierre-Sylvain Filliozat, Jean-Pierre Mahé and Jean Leclant. Paris: Académie des Inscriptions et Belles-Lettres, pp. 31–56.

Colas, Gérard, and Usha Colas-Chauhan. 1995a. *Manuscrits Telugu. Catalogue Raisonné*. Paris: Bibliothèque nationale de France, ISBN 2-7177-1928-8.

Colas, Gérard, and Usha Colas-Chauhan. 1995b. Five Dictionaries in the Telugu Manuscript Collection of the Bibliothèque nationale, Paris. In *The Journal of Oriental Research, Madras*. Madras: Kuppuswami Sastri Research Institute, vol. 56–62 (1986–92); pp. 379–92.

Colas, Gérard, and Usha Colas-Chauhan. 2014. *Une Pensée en Morceaux*. Two Works from the Carnatic Mission: A Refutation of Metempsychosis in Sanskrit and a Collection of Sermons in Telugu. In *Intercultural Encounter and the Jesuit Mission in South Asia (16th–18th Centuries)*. Edited by Anand Amaladass and Ines Županov. Bangalore: Asian Trading Corporation, pp. 62–87. ISBN 978-81-7086-690-9.

Colas, Gérard. Forthcoming; Les traditions sanskritistes de la mission du Carnate entre oubli et réinvention. In *Antoine-Léonard de Chézy et les débuts des études sanskrites en Europe, 1800–1850*. Edited by Jérôme Petit. Paris: Bibliothèque nationale de France.

Conger, George Perrigo. 1922. *Theories of Macrocosms and Microcosms in the History of Philosophy*. New York: Columbia University Press.

Crocker, Robert. 2003. *Henry More, 1614–1687: A Biography of the Cambridge Platonist*. Dordrecht: Kluwer Academic Publishers, Archives Internationales d'Histoire des Idées 185.

Cronin, Vincent. 1959. *A Pearl to India. The Life of Roberto De Nobili*. London: Rupert Hart-Davis.

Dahmen, Pierre. 1924. *Un Jésuite Brahme, Robert de Nobili, S. I. 1577–1656, Missionnaire au Maduré*. Bruges: Charles Beyaert.

Fonds Brotier. n.d. Vanves: Archives de la Province de France de la Compagnie de Jésus (AFPCJ), vol. 82, 89, fol. 49v.

Gelders, Raf, and S. N. Balagangadhara. 2011. Rethinking Orientalism: Colonialism and the Study of Indian Traditions. *History of Religions* 51: 101–28. [CrossRef]

Gilson, Étienne. 1922. *Le Thomisme: Introduction à la Philosophie de Saint Thomas d'Aquin*. Paris: J. Vrin.

Goss, Robert E. 1998. The First Meeting of Catholic Scholasticism with dGe lugs Scholasticism. In *Scholasticism. Cross-Cultural and Comparative Perspectives*. Edited by José Ignacio Cabezon. Albany: State University of New York Press, pp. 65–90.

Jorge J. E. Gracia, ed. 1994. Francis Suáres (B. 1548; D.1617). In *Individuation in Scholasticism. The Later Middle Ages and the Counter-Reformation, 1150–1650*. Albany: State University of New York Press, pp. 475–510.

Hedde, René. 1929. Métempsycose. In *Dictionnaire de Théologie Catholique*. Edited by Alfred Vacant, Eugène Mangenot and Émile Amann. Paris: Librairie Letouzet et Ané, tome X, 2nd part, col. 1574–95.

Roberto Hofmeister Pich, and Alfredo Santiago Culleton, eds. Forthcoming; *Scholastica colonialis—Reception and Development of Baroque Scholasticism in Latin America, 16th–18th Centuries*. Turnhout: Brepols.

Leibniz, Gottfried Wilhelm. 1966. *Nouveaux Essais sur l'Entendement Humain*. Edited, annotated and introduced by Jacques Brunschwig; Paris: Garnier-Flammarion, First published 1765.

Locke, John. 1864. *An Essay Concerning Human Understanding*. New York: Valentine Seaman, First published 1689.

Mallik, Kalyani. 1954. *Siddhasiddhāntapaddhati and Other Works of the Natha Yogis*. Poona: Oriental Book House.

Aimé Martin, ed. 1840. *Lettres Édifiantes et Curieuses*. Paris: Auguste Desrez, vol. 2.

Mesnard, Pierre. 1966. La pédagogie des jésuites (1548–1762). In *Les Grands Pédagogues*, 3rd revised ed. Edited by Jean Château. Paris: Presses Universitaires de France, pp. 45–107.

Molnár, Péter. 2002. Saint Thomas d'Aquin et les traditions de la pensée politique. *Archives d'Histoire Doctrinale et Littéraire du Moyen Âge* 69: 67–113. [CrossRef]

Montaigne, Michel de. 1962. Essais. In *Œuvres Complètes*. Edited by Albert Thibaudet and Maurice Rat. Paris: Gallimard.

De Nobili, Roberto. (attributed to). n.d.a [copied before 1735]; *Punarjanmākṣepa*. Sanskrit translation by an anonymous translator. Manuscript Sanscrit 1761; Paris: Bibliothèque nationale de France.

De Nobili, Roberto. (attributed to). n.d.b [copied in 1739]; *Punarjanmākṣēpam*. Kannaḍa translation by an anonymous translator. Manuscript Marsden Collection 7078, ff. 143–163; London: School of Oriental and African Studies.

De Nobili, Roberto. (attributed to). n.d.c [copied before 1734]; *Punarjanmavivēkamu and Punarjanmākṣēpamu*. Telugu translation by an anonymous translator. Manuscript Indien 582; Paris: Bibliothèque nationale de France.

Oosterhoff, Richard J. 2015. Jacques Lefèvre d'Étaples. *Stanford Encyclopedia of Philosophy*. Available online: http://plato.stanford.edu/archives/sum2015/entries/lefevre-etaples/ (accessed on 7 December 2016).

Owens, Joseph. 1994. Thomas Aquinas (B. ca. 1225; D. 1274). In *Individuation in Scholasticism. The Later Middle Ages and the Counter-Reformation, 1150–1650*. Edited by Jorge J. E. Gracia. Albany: State University of New York Press, pp. 173–94.

Peillaube, Émile. 1930. Âme. Sa spiritualité. Démonstration rationnelle d'après la philosophie de saint Thomas. In *Dictionnaire de Théologie Catholique*. Tome I, 1st part; Edited by Alfred Vacant, Eugène Mangenot and Émile Amann. Paris: Librairie Letouzet et Ané, pp. 1029–41.

Yves Mathurin Marie Tréaudet De Querbeuf, ed. 1781. *Lettres Édifiantes et Curieuses Écrites des Missions Étrangères. Nouvelle Édition. Mémoire des Indes. Tome Douzième*. Paris: J.G. Merigot.

Rajamanickam, S. 1972. *The First Oriental Scholar*. Tirunelveli: De Nobili Research Institute.

Tattuva Pōtakar. 1963. [= Roberto De Nobili] (attributed to); *Punar Jenma Ākṣēpam*. Edited by Ca. Irācamāṇikkam. [= S. Rajamanickam]; Tūttukkuṭi: Tamil Ilakkiyak Kalakam.

Voltaire. 1963. *Essai sur les Mœurs et l'Esprit des Nations et sur les Principaux faits de l'Histoire depuis Charlemagne jusqu'à Louis XIII*. 2 vols.; Edited and introduced by René Pomeau; Paris: Éditions Garnier, First published 1756.

Voltaire. 1769. *Dieu et les Hommes, Œuvre Théologique; Mais Raisonnable. Par le Docteur Obern, Traduit par Jaques Aimon*. Berlin: Christian de Vos.

Županov, Ines G. 2001. *Disputed Mission. Jesuit Experiments and Brahmanical Knowledge in Seventeenth-century India*. New Delhi: Oxford University Press, First published 1999.

Article

To Never See Death: Yeats, Reincarnation, and Resolving the Antinomies of the Body-Soul Dilemma

C. Nicholas Serra

School of Liberal Arts Faculty, Upper Iowa University, 605 Washington Street, P.O. Box 1857, Fayette, IA 52142, USA; serran@uiu.edu

Received: 31 July 2017; Accepted: 27 August 2017; Published: 5 September 2017

Abstract: This essay addresses the ideas and schemas of reincarnation as used in the poetry and prose of William Butler Yeats, with particular focus on the two editions of *A Vision*. It contrasts the metaphysical system as given in *A Vision* (1937) with a number of inconsistencies found in Yeats's poetic corpus, with an emphasis on how one might interpolate an escape from the cycle of lives, in at least one possibility while still maintaining corporality. The justification for this last comes from an analysis of complex cabalistic metaphors and teachings that Yeats learned as a member of MacGregor Mathers' Hermetic Order of the Golden Dawn.

Keywords: A Vision; Golden Dawn; cabala; Aleister Crowley; Theosophy; Yeats; reincarnation

Among the literary schools of the twentieth century, the Modernists are unquestionably among the most taxing for readers, not least because they undertook diverse and highly individual experiments in their attempt to redirect and reinvent Western literature in the aftermath of World War I, but also because, in company with the neoclassical writers of the eighteenth century, many delighted in what might be seen as egotistical displays of erudition, patching together dense patterns of language, symbols, and symbolism, daring readers to prove their wittiness (or worthiness) by excavating the clearly present but often inscrutable authorial intentions. Of them all, William Butler Yeats is perhaps the most challenging. There are, literaly, thousands of articles, overviews, and book-length studies on almost every influence on Yeats's *oeuvre*, often taking the form of "Yeats and X": symbolism, the theatre, the theatre of "desolate reality," the visual arts, the ideal of unity of being, the occult, fascism, Japan, Noh, Sligo, European drama, Nietzsche, Rabindranath Tagore, Anglo-Irish Modernism, W.T. Horton, Theosophy, philosophy . . . the list is seemingly endless.

Despite the fact that Yeats himself would certainly have deplored such sharp, Aristotelian circumscriptions—attempts to distinguish the dancer from the dance—of what he perceived as a single, fluid unity of thought, such artificial divisions are an unfortunate necessity: the scope of his grand design, like Géricault's *The Raft of the Medusa*, is simply otherwise overwhelming. Joyce's *Finnegans Wake* takes in the entirety of time and history in a single, cyclical, discontinuous dream-narrative. By comparison, scattered among hundreds of poems, twenty-six plays, and dozens of essays, Yeats's vision encompasses time before time and worlds before creation, a thousand myriads of worlds ultimately extending outward into unutterable realms of Negative Existence and no-thing-ness. He attempted to chart the psychology of incarnation, the interplay of the individual soul and the World Soul, the *Anima Mundi* and the Divine, the immanent divinity and the transcendent and Absolute—of which the metaphysical calculus surrounding his theories of reincarnation are only one fraction.

Unfortunately, Yeats's thoughts on any subject are usually widely scattered, recurring with variations and contextual shadings across the body of his plays, prose, poetry, and correspondence—as well as in his copious body of draft manuscripts and the marginal notes within his surviving books. He was perfectly willing to intermingle seemingly disparate, even clashing ideas, and stir them together in any given work—often interspersed with and illustrated by autobiographical references unintelligible

to anyone lacking an intimate knowledge of the poet's life. Both his prose style and poetic method are often maddeningly associational, frequently flitting from idea to idea, theme to theme, touching lightly and moving on like a rock skipped across the surface of a pond. Yeats was a master of framing through the literary equivalent of negative space; what he leaves unsaid or assumed is often more fundamental to his themes than what is concretely shown. He favored rhetorical questions over definitive statements and, based on his years of study as a practicing occultist, espoused the belief that symbols, correctly used, would take on lives of their own in the minds of readers and thereby do half of his work on their own. To make matters worse, when dealing with metaphysical ideas such as reincarnation that touched upon or stemmed from his esoteric studies, bound by oaths of secrecy, Yeats often pulls up short: unabashedly admitting his refusal to explain himself in any meaningful way.

Consequently, when one asks a blunt question such as "What did Yeats think about reincarnation?", it is often an uphill battle to formulate a straightforward answer—even though the subject was of paramount importance to him, and the focus of decades of research. It would be nice to be able to say, "Read *A Vision*: Yeats's final word on the subject," but that problematic, meandering tome is itself fraught with ambiguities and questions. Likewise, his use of the subject within the poetic corpus is complicated by the fact that it is rarely an explicitly central theme *in se*, functioning rather at the subtextual level admixed with any number of seeming tangential elements (qv Shin 1995). As an illustration, I would begin with a pedagogical example.

One of the things that I am infamous for among Upper Iowa University's undergraduates is a week-long writing-about-literature exercise utilizing the text of William Butler Yeats's "Among School Children." At a mere 64 lines, the poem is short enough to be fairly non-intimidating, yet dense enough to provide at least five-dozen "Yeats and—" topical questions for exploration. For example, the first two lines—"I walk through the long schoolroom questioning;/A kind old nun in a white hood replies"—easily yield "Yeats and" education, Irish education, private education, Catholic education, one-room-schoolhouse education, the Socratic method ("questioning" in a classroom setting), educational philosophy, philosophy generally, classical Greek philosophy, Platonic recollection (the object of the Socratic method), nuns (and the connotative clash of a "kind" nun), women, Catholics and Catholicism, and youth *versus* age—as well as a discussion about the necessity of establishing that the first-person narrative voice really is the author's own before automatically making that assumption.

As a group, the students having already done a bit of biographical research on Yeats himself and the history of the period 1865–1939, we spend four days dissecting the text, exploring the repetition of ideas at various places, and generating various thesis statements that might evolve from initial observations. In this way, one finds much beyond the "broad side of the barn" reading of "Among School Children" as Yeats's thoughts on the unity of youth and age, certainly more than the author's own statements of "meaning" that "even the greatest men are owls, scarecrows, by the time their fame has come" (Wade 1955, p. 719), or that "life will waste [school children] perhaps that no possible life fulfill their own dreams or even their [sic] teacher s hope [. . . and] that life prepares for what never happens" (Yeats 2007, p. 361).

While the initial stanza certainly opens up topics for discussion, the second widens the field tremendously. One finds (arguably) a between-the-lines evaluation of the non-riveting nature of the curriculum Yeats is observing, biographical references that need to be connected to the text ("she" who?), intertextual references to other poems in the Yeatsian canon ("Leda and the Swan"), and obvious clashes between connotative and denotative value in word choice ("Plato's parable") with therein the first of Yeats's erudite, extra-textual allusions: all stirred together.

The majority of students instinctively understand that the Yeats-narrator is bored and has gone off into a daydream, and with the help of *Wikipedia* have no problem assigning the unnamed "she" to Yeats's great unrequited love, Maud Gonne. They are often titillated in the discussion that follows to find that the question of whether Maud ever broke down and had pity-sex with the poet is hotly debated at scholarly conferences, and rather appalled to be told the story of the 51 year-old Yeats's final proposed to Maud in 1917, followed by his proposal to her 23 year-old daughter Iseult, herself

conceived in a magical experiment on the tombstone of her dead brother, followed closely by his proposal to fellow Golden Dawn initiate Georgie Hyde-Lees whom he ultimately married on October 20. Most pick up on the obvious recurrent references to "Leda and the Swan"—both myth and poem—in lines 9, 20, and 29, but invariably miss the less titular connection to "Sailing to Byzantium" in the scarecrow image of lines 32 and 48.

On the other hand, possibly because of a lack of a philosophy general education requirement, very few catch the oddity of Yeats's phrasing of "Plato's parable" in the stanza's close:

> [...] it seemed that our two natures blent
> Into a sphere from youthful sympathy,
> Or else, to alter Plato's parable,
> Into the yolk and white of the one shell. (ll. 13–16)[1]

To be sure, "allegory," "myth," and "metaphor" all lack the alliterative element of "parable," and would require some major reworking for the sake of meter. Likewise, none of the more orthodox options would capture the pagan-Christian fusion motif that often fascinated Yeats. And, of course, only two or three students, ever, have shown the curiosity to actually track down *which* of the Platonic allegories fits within the context of Yeats, Maud Gonne, eggs, and two things merging into one. In fact, that's usually the assignment that they take home that night.

Most come back with the answer, "The Allegory of the Cave?"—because that's the most popular Platonic allegory discussed on Google. It's not the right answer, but not a total loss, either, since that snippet from the *Republic* does bear looking at in terms of Yeats's later statement, "Plato thought nature but a spume that plays/Upon a ghostly paradigm of things" (ll. 41–42), as well as the implied reference to Platonic *anamnesis* mentioned previously, and the direct reference to "recollection" in line 36. However, there's nothing at all in the Allegory of the Cave that suggests some kind of merging, much less eggs or some connection to the tempestuous relationship between the poet and Maud Gonne. The only bit of Plato that fulfils *all* these criteria is the myth presented in the *Symposium*'s speech of Aristophanes on the whys and wherefores of True Love:

> You must first learn human nature and its condition. For our ancient nature was not what it is now, but of another kind. In the first place, there were three sexes among men, not two as now, male and female, but a third sex in addition, being both of them in common, whose name still remains though the thing itself has vanished; for one sex was then derived in common from both male and female, Androgynous both in form and name, though that name is now applied only in reproach. Again, the form of each human being as a whole was round, with back and sides forming a circle, but it had four arms and an equal number of legs, and two faces exactly alike on a cylindrical neck; there was a single head for both faces, which faced in opposite directions, and four ears and two sets of pudenda, and one can imagine all the rest from this [...]
>
> The reason there were three sexes of this sort was that the male originally was the offspring of the Sun, the female of the Earth, and what has a share of both of the Moon, because the Moon also has a share of both. They were spherical both in themselves and in their gait because they were like their parents. Well, they were terrible in strength and force, and they had high thoughts and conspired against the gods, and what Homer told of Ephialtes and Otus is told also of them: they tried to storm Heaven in order to displace the gods.
>
> Well Zeus and the other gods took counsel about what they ought to do, and were at a loss, for they did not see how they could kill them, as they did the giants, whose race they

[1] All Yeats poetry will be cited by line numbers as given in volume I of the Collected Works of W.B. Yeats series: (Yeats 1983).

wiped out with the thunderbolt—because the honors and sacrifices they received from human beings would disappear—nor yet could they allow them to act so outrageously. After thinking about it very hard indeed, Zeus said, "I believe I've got a device by which men may continue to exist and yet stop their intemperance, namely, by becoming weaker. I'll now cut each of them in two," he said, "and they'll be weaker and at the same time be more useful to us by having increased in number, and they'll walk upright on two legs. But if they still seem to act so outrageously and are unwilling to keep quiet," he said, "I'll cut them in two again, so that they'll have to get around on one leg, hopping."

So saying, he cut human beings in two the way people slice serviceberries to preserve them by drying, or as they cut rggs with a hair [...]

When the lover of boys and every other lover meets his own particular half, they are then marvelously struck by friendship and kinship and Eros, and scarcely willing to be separated from each other even for a little time. These are the people who pass their whole lives with each other, but who can't even say what they wish for themselves by being with each other. No one can think it is for the sake of sexual intercourse that one so eagerly delights in being with the other. Instead, the soul of each clearly wishes for something else it can't put into words; it divines what it wishes, and obscurely hints at it. (Plato 1993, 189d–190a, 190b–e, 192 b–d)

This, of course, leads to a discussion in which I try to see whether my students can logic their way out of a paper bag. If Plato's theory of education rests on *a priori* knowledge (in opposition to "solider" Aristotle's *a posteriroi* understanding of things), then Plato obviously believed in the preëxistence of souls. For Aristophanes' myth to explain the kind of true love Yeats's felt he shared with Maud Gonne, in what concept must one believe? Usually it's rather like pulling teeth, but eventually someone in the class usually ventures, "Reincarnation?" Of course—or, at the very least, metempsychosis, which is close enough for government work. In fact, reincarnation and/or metempsychosis comes up in other places in the poem, too: by implication when Yeats mentions Pythagoras in line 45, and in the *very* obscure allusion to the Neoplatonic philosopher Porphyry's *On the Cave of the Nymphs* in lines 34–36, where an infant, "Honey of generation had betrayed," must "sleep, shriek, struggle to escape/As recollection or the drug decide."

Did Yeats believe in reincarnation? Of course he did. That's why Iseult Gonne was conceived on the tombstone of her dead brother. That's what Yeats's largest and most ambitious prose work, *A Vision*, is all about: "begun" in October of 1917 during his honeymoon with the 25 year-old "George" Hyde-Lees—after both Iseult and Maud Gonne rejected his final offers of marriage—a book whose first iteration was seven years in the making, followed by a major revision that took an additional decade. The vast majority of his later poetry is connected to its "system" in one way or another, and in it he addresses any number of the above "Yeats and" topics with specific reference to the subject: reincarnation and Platonism, reincarnation and Christianity, reincarnation and Neoplatonism, *et cetera*.

This is not to say that Yeats's ideas on reincarnation grew out of a Platonic, classical, or even Western understanding. For example, Yeats was introduced to esoteric Indian themes and theology beginning at least as early as 1884, when his mother's sister, Isabella Pollexfen Varley, presented him with a copy of A. P. Sinnett's *Esoteric Buddhism*. His first (1889) volume of poems, *Crossways*, includes three poems with "Indian" themes ("Anushuya and Vijaya", "The Indian to his Love," and "The Indian upon God") influenced by his 1885 meeting with Theosophist Mohini Chatterjee: as well as the eponymous poem "Mohini Chatterjee" in the 1932 Cuala Press collection *Words for Music Perhaps and Other Poems*, expanded as the mass-market *The Winding Stair* the following year. Indeed, later in life he "translated" the *Upanishads* with Purohit Swami.

And yet Yeats was no strict philosopher, Indian or otherwise. Like his first mentor, Madam Blavatsky, and his later, most influential esoteric teacher Macgregor Mathers, Yeats engaged in esoteric eclecticism, if not syncretism. That is, his ideas about reincarnation were affected at least as

much by his readings in Platonism and Neoplatonism, the fireside "fairy" stories narrated throughout the west of Ireland, arguments with his longtime friend George Russell ("Æ"), and the works of John Rhys, Walter Evans-Wentz, and Alfred Nutt to name only a very few sources—to say nothing of his own personal research and experimentation. As he says in *Wheels and Butterflies'* 1934 introduction to his play *The Resurrection*,

> All ancient nations believed in the re-birth of the soul and had probably empirical evidence like that Lafcadio Hearn found among the Japanese. In our own time Schopenhauer believed it, and McTaggart thinks Hegel did [. . .] It is the foundation of McTaggart's own philosophical system. Cardinal Mercier saw no evidence for it, but did not think it heretical [. . .] In a few years perhaps we may have much empirical evidence, the only evidence that moves the masses of men to-day, that man has lived many times. (Yeats 1934, pp. 106–7)

Masochistic scholars have been arguing and weeping over the complexities of *A Vision*'s system for eighty years—and yet it remains problematic for a variety of reasons. First and foremost, the assertions that Yeats makes about the psychology behind human personality in any of his hypothetical 28 stages or "phases" of incarnation, his exposition on the progression of the various discarnate states between incarnations, and his cyclical theory of human history that mirrors the progress of the individual soul on the macroscopic level: all were distilled from information provided by spirit communicators working through George Yeats in an extended series of experiments involving automatic writing and exposition in sleep and dreams carried out between 1917 and 1923. As Yeats explained in the introduction to the 1937 edition:

> On the afternoon of October 24th 1917, four days after my marriage, my wife surprised me by attempting automatic writing. What came in disjointed sentences, in almost illegible writing, was so exciting, sometimes so profound, that I persuaded her to give an hour or two day after day to the unknown writer, and after some half-dozen such hours offered to spend what remained of life explaining and piecing together those scattered sentences. 'No,' was the answer, 'we have come to give you metaphors for poetry.' (Yeats 2015, p. 8)

For many, one life preserver of reason in dealing with this material that certainly did infuse much of his later poetry with complex and often recondite metaphors has been George Yeats's frank admission that, in the beginning, she "faked" the automatic writing: in an attempt to distract her husband and set to rest his vacillation about the wisdom of his marriage and relationship with Maud and Iseult (qv Moore 1954, p. 253; Ellmann 1988, pp. 239–55). And, as Ann Saddlemyer rightly observes in *Becoming George*, George Yeats also was well aware that, having made the admission, despite her assertion that subsequently her hand really was seized by an unknown power and therefore 99.99% of the material was genuine as presented, "The word 'Fake' will go down to posterity" (Saddlemyer 2002, p. 103). As Virginia Moore once encapsulated the consequent questions: "Was it really spirit-controlled discourse? Or was it, on Mrs. Yeats' part, either a garnering of her subconscious, or a telepathic reading of her husband's mind, neither of which requires extranatural help? Or was it a fabrication on the part of Yeats and/or his wife? or something else?" (Moore 1954, p. 256). In the words of Margaret Mills Harper, "Through several generations of Yeats scholarship, discussion of the Yeatses' occult experimentation still tends to begin, and often to end, at the question, Did they, or Do you, believe it?, with lines drawn between camps drawn on the basis of the answer to the latter. The Yeatses themselves were by no means distracted by such compulsions" (Harper 2006, p. 21). Regardless, the fact that Yeats was engaged in spiritualistic experiments at best, and perhaps even astrology, occult rituals, and sex magic at worst, makes most academicians profoundly uneasy, and this uneasiness has colored much of the foundational scholarship on Yeats's metaphysical theories.

This essay is not, however, an exposition on the system of *A Vision per se*, nor an attempt at detailing its literary, philosophical, or theological precursors. For those who wish to study the complexities of Yeats's metaphysical calculus, the primary and secondary source-works are readily available. The

1925 and 1937 editions of *A Vision* comprise volumes 13 and 14 of Scribner's *Collected Works of W.B. Yeats*, and are heavily annotated by editors Margaret Mills Harper and Catherine Paul. The surviving original documents were compiled and edited by George Mills Harper as the four volumes of *Yeats's Vision Papers* (Yeats 1992a, 1992b, 1992c, 2001). The seminal commentary on the evolution of the 1937 edition from the earlier text remains Barbara L. Croft's *Stylistic Arrangements: A Study of William Butler Yeats's A Vision* (Croft 1987). The best online resource covering all aspects of Yeats's system is Neil Mann's superb yeatsvision.com, supplemented by the breadth of recent scholarly essays in *Yeats's "A Vision": Explications and Contexts*. Furthermore, although there is no "reader's guide" to the text, one helpful publication is G.A. Dampier's thesis *Incarnation and the Discarnate States: An exposition on the Function of the Principles in the System of W.B. Yeats's A Vision* (Dampier 2007), and Colin McDowell's more specific "The Six Discarnate States of A Vision (1937)" (McDowell 1986).

Instead, what follows deals with a much narrower and somewhat more manageable topic: What can be said about Yeats's ideas on the process by which one might be freed from the ongoing process of continual rebirth? That is, for most people other than Yeats scholars, the complexities of the Yeatsian system beg the question: So what? Reincarnation happens. Death happens, and the soul goes through six distinct discarnate states and sub-states. Then reincarnation happens, again. The question is, as the Soul in Yeats's "Dialogue of Self and Soul" phrases it, how can one ascend "to heaven," be delivered "from the crime of death and birth," from, as the Self depicts incarnation:

> [...] that toil of growing up;
> The ignominy of boyhood; the distress
> Of boyhood changing into man;
> The unfinished man and his pain
> Brought face to face with his own clumsiness;
> The finished man among his enemies?—
> How in the name of Heaven can he escape
> That defiling and disfigured shape
> The mirror of malicious eyes
> Casts upon his eyes until at last
> He thinks that shape must be his shape?
> And what's the good of an escape
> If honour find him in the wintry blast? (ll. 38, 24, 44–56)

There are three—perhaps four—possible answers that arise in reading Yeats, though not all, or even most, are given much space in *A Vision* itself. Yeats never liked to make anything that easy. Therefore, while the first two *may* be somewhat explicit, the latter (characteristically) present themselves only by implication or interpolation.

First, there is obviously simple subjugation to what Yeats calls "the winding path" or the "Path of the Serpent"—a symbol taken from the earliest lessons of the Hermetic Order of the Golden Dawn: gradual perfection achieved through a laborious journey of lifetimes that may or may not lead to anything more (Yeats 1994, p. 28). As he says in his introduction *to The Resurrection*: "There is perhaps no final happy state except in so far as men may gradually grow better" (Yeats 1934, p. 108). The subjunctive highlights one of the several disjunctions between the system of *A Vision* as it is presented in the primary texts and that system as Yeats used it to create "metaphors for poetry."

In *A Vision*, there are 28 discrete incarnations, each of which is structured by a given proportional and oppositional arrangement of the four microcosmic faculties: Mask and Will, Creative Mind and Body of Fate. Each incarnation, arguably, presents a specific "lesson" that the soul needs to learn in order to achieve its freedom from the cycle of births, and an individual may be forced to repeat a given phase up to four times in order to internalize the lesson sufficiently: "To [phases 8 and 22], perhaps to all phases, the being may return up to four times, my instructors say, before it can pass on. It is claimed, however, that four times is the utmost possible" (Yeats 2015, p. 86).

In "Among School Children" this is alluded to in Stanza V, where the child laid upon the youthful mother's lap "must sleep, shriek, struggle to escape/as recollection or the drug decide" (ll. 35–36). It should be noted that in the Automatic Scrip itself there is a confusion of contradictory information that does not appear in the final published volume, including which phases can be skipped and under what circumstances, and which cannot.

For the average person, Yeats ties the length that one is bound to the wheel of incarnations to a period of approximately 26,000 years, matching the "Perfect" or "Great Year" in Plato's *Timaeus*. Afterward, hypothetically, the soul attains freedom. However, in Yeats's explanatory poem "The Phases of the Moon" that introduces both the 1925 and 1937 editions of *A Vision*, the narrator Michael Robartes—who is represented as one who understands the system much moreso than Yeats himself—paradoxically asserts that (emphasis mine) "When all the dough has been so kneaded up / That it can take what form cook Nature fancies," one is not automatically set free; rather, "*The first thin crescent is wheeled round once more*" (ll. 114–16).

As an aside, *A Vision* makes no provision for the transmigration of souls into lower forms, but Yeats himself tackled this idea in a much earlier poem, "The Three Hermits," in the 1914 volume *Responsibilities*. While the third hermit bemoans the fact that the dead may be reincarnated "Into some most fearful shape," he is mocked by the second, who maintains that:

> They are not changed to anything,
> Having loved God once, but maybe
> To a poet or a king
> Or a witty lovely lady. (ll. 23, 25–28)

It should be noted, however, that—interestingly—the first hermit, apparently wiser and certainly closer to death than either of the others, "Giddy with his hundredth year," says nothing to confirm or refute these assertions, but "Sang unnoticed like a bird" (ll. 31–32). Furthermore, in other places Yeats does indeed suggest that even animals, as part of nature, are caught up in the process of gradual perfection (Yeats 1994, p. 28).

The second option for an individual tied to the wheel of phases or incarnations is mentioned explicitly, again, in Yeats's introduction to *The Resurrection*: "escape may be for individuals alone who know how to exhaust their possible lives, to set, as it were, the hands of the clock racing" (Yeats 1934, p. 108). This statement implies that *only* those who somehow manage to exhaust their possible lives by learning the lessons of multiple lifetimes in one, thereby skipping phases of incarnation, may manage to "escape" from bondage to the wheel. In the terminology of Robartes in "Phases of the Moon" one must, perhaps volitionally, leave the two dimensional plane of the diagrammatic representation of the phases and assume a new direction: straight up the axis of rotation following the path of the arrow shot from the "burning bow" "drawn betwixt/Deformity of body and of mind," "Out of the up and down, the wagon wheel/of beauty's cruelty and wisdom's chatter—/Out of that ravening tide" (ll. 119, 120–23). In this way one obtains "the thirteenth sphere or cycle which is in every man and called by every man his freedom" (Yeats 2015, p. 302).

The average person might certainly use Yeats's material on the four faculties as they relate to each of the twenty-eight phases in book one of *A Vision* (1937)—fully half of the complete text—to achieve this end through some form of self-analysis. Furthermore, Yeats would have undoubtedly recommended the study of astrology as well. However, exactly how a person would initiate such a change of "motion" Yeats does not reveal: only that it is a possibility.

Option three is closely related to the above, but not as clearly apparent: become an initiate in an occult body such as the Hermetic Order of the Golden Dawn (in which Yeats himself was deeply involved for nearly thirty years, George Yeats almost ten), and work toward the highest level of adeptship that ultimately confers union with God: arguably the unexplained but clearly singular "man's enterprise" that Yeats refers to in line 56 of "Among School Children."

At this juncture, I must make it clear that I differ from many other Yeatsians in that my primary methodology for interpreting Yeats's ideas lies in the esoteric-magical-cabalistic system that he learned

as a member of the Hermetic Order of the Golden Dawn. Before proceeding, a few words must be expended upon this subject in order to justify the remarks that follow.

As will be touched upon later, the Golden Dawn was not the first esoteric society with which Yeats involved himself, nor was it the only one that he explored later in life. However, among the multitude, it was the only one to which he dedicated *decades* of his life, striving to master grade after grade, initiation after initiation. He rose as high in the Order as it was possible to go without becoming what one might call a merely titularly-advanced administrator. When he ended his formal, dues-paying association in late 1922 or early 1923, it was only because of "quarrels caused by men, otherwise worthy, who claimed a Rosicrucian sanction for their own fantasies" (Yeats 1999, pp. 454–55, n. 117). He married a fellow Golden Dawn adept in 1917, summered in his renovated tower-house outside of Gort whose ceilings were painted with Golden Dawn designs in esoteric color-schemes, and he was still dreaming of gathering the energy—and money—to establish his own sister-order, the "Castle of the Heroes" in the months leading up to his death.[2] Furthermore, the extant quires of the *Vision Papers* themselves are sprinkled with extra-system queries for his communicators about Order affairs. Yeats corresponded with members of the remaining active membership during the composition of *A Vision*, and in various ways he dedicated both editions to his "fellow students": Golden Dawn initiates all. To my mind (to use an academic metaphor), facts like these establish "*Per Amica Silentia Lunae*," *A Vision*'s theoretical forebear, itself scattered with clearly identifiable Golden Dawn symbolism, as Yeats's esoteric Master's thesis, and *A Vision* his dissertation: his personal contribution to human knowledge gained through original research. For a much more thorough and extended justification for this argument, see "Esotericism and Escape" in (Mann et al. 2012, pp. 307–28).

Moreover, the Golden Dawn provided Yeats with something that went far beyond simple information: an esoteric schema that could be used to harmonize diverse and otherwise seemingly unrelated and perhaps otherwise conflicting ideas, symbols, and schools of thought. An accessible example has been published as *777* (Crowley 1955), which volume was in large part originally compiled by Yeats's fellow adept Allan Bennett. In its final form the text contains 183 columns of up to 35 rows each, cataloguing and cross-indexing such things as the various astrological and planetary associations for the cabalistic Tree of Life, orders of angels and demons, the symbolism of tarot cards, the Hindu centers of prana, mineral and vegetable drugs, the pantheons of multiple religions, officers in a Masonic lodge, the forty Buddhist meditations, and the Arabic mansions of the moon that Yeats references in *A Vision*.

In my reading of Yeats, it is this harmonizing schema, along with the interlinked ritual practices that so many Yeatsians view as "ludicrous" (Murphy 1995, p. 375), "embarrassing," "nonsense," or even "Southern Californian" (Auden 1948, pp. 188–89) that allowed Yeats to bring together ideas—often otherwise contradictory—and merge them into his own personal, esoteric unity. Thus, a more traditional Yeatsian such as Matthew Gibson may take one of Yeats's sweeping but question-begging statements out of *A Vision*, such as "The *Passionate Body* is in another of its aspects identical with physical light; not the series of separated images we call by that name, but physical light, as it was understood by medieval philosophers, by Berkeley in *Siris* [. . .] the creator of all that is sensible" (Yeats 2015, p. 140)—and, very profitably, proceed to unpack the philosophical implications with reference to Yeats's reading (*qv* "Timeless and Spaceless?" in (Mann et al. 2012, pp. 103–35)). I, on the other hand, suggest that, while Yeats certainly seized upon Berkeley's assertion that "light was the animating substance of the world through allusion to ancient authority, and [. . .] gave sensory form to spirits" (Mann et al. 2012, p. 107), unlike Gibson, who merely notes that "Through various earlier occult sources, Yeats had understood light as constituting the substance of spiritual incarnation" (ibid.), I would say that Yeats indeed "understood" light in this way, but also seized upon Berkeley's ideas

[2] The rituals for this organization had been worked up years before, with assistance from Golden Dawn chief Macgregor Mathers and his wife; (qv Breidenbach 1992).

because they tended to bolster his own cabalistic preconceptions: that "light" was the substance of the Divine outside of material creation in ever finer forms represented by the cabalistic terms *Ain* ("light" or "nothing"), *Ain Soph* ("limitless light" or "not even nothing"), and *Ain Soph Aur* ("light in extension" or "not even nothing always")—otherwise known as the "Veils of Negative Existence," and frequently referenced within the Golden Dawn's rituals and lectures under a variety of other terms. Nor, I might add, does Gibson note that Wynn Westcott, one of the Golden Dawn's three founding chiefs, primed Yeats with an esoteric understanding of Berkeley, as he asserts is his essay on the dogmatic "kabalah" that the Bishop of Cloyne promulgated a number of philosophical ideas (his ideal theory in particular) that are "nearly identical" with the cabalistic doctrines taught in the Order (qv "The Dogmatic Kabalah" in (Westcott 1910)). To put it a simpler way, the Golden Dawn's version of cabala was Yeats's "horse," and every other idea he encountered—Neoplatonic philosophy, Irish folklore, the Upanishads, Noh drama, Zen Buddhism, Eliphas Levi, Bishop Berkeley et al.—went into the cart behind.

In brief, the occult ideas that underlie much of Yeats's work come from a variety of sources, but the single consistent thread goes back to the cabalistic ideas of William Robert Woodman, William Wynn Westcott, and Samuel Liddell MacGregor Mathers as taught in the "original," pre-1900, Golden Dawn (and, in its historical background, to Robert Wentworth Little, Kenneth Mackenzie, Frederick Hockley, John Yarker, F. G. Irwin, Benjamin Cox and other figures involved in late nineteenth-century English fringe-Masonry).

The order was structured around a series of initiatory grades tied to the various cabalistic spheres or *sephiroth* as depicted on the glyph of the Tree of Life (Figure 1 is the most basic version). Following the initial, probationary grade of Neophyte 0 = 0, the grades of the Outer or "First" Order were four in number (Zelator 1 = 10, Theoricus 2 = 9, Practicus 3 = 8, Philosophus 4 = 7) followed by the intermediate "Portal" grade: all broadly focused on basic hermetic and cabalistic symbolism. Members passing through these grades were "initiates." Initiation into the Inner or "Second" Order (technically known as the *Rosae Rubeae et Aurae Crucis* or "R.R. et A.C.": Red Rose and Gold Cross) began with the Rosicrucian grade of Adeptus Minor 5 = 6 (which many have claimed contained the core and indeed pinnacle of Golden Dawn teaching), followed by Adeptus Major 6 = 5 and Adeptus Exemptus 7 = 4. As the last three names indicate, members of the Inner Order were "adepts," qualified to practice many sorts of ceremonial magic and, indeed, with the permission of superiors, to create spin-off organizations. As an example of the last, J.W. Brodie-Innes, "Deputy Archon Basileus" of the Order's Amen-Ra Temple in Edinburgh, subsequently founded a sister organization known as the Cromlech Temple.

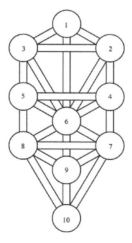

Figure 1. A Schematic of the Tree of Life as Taught in the Golden Dawn.

The three highest grades that made up the Third Order—Magister Templi 8 = 3, Magus 9 = 2, and Ipsissimus 10 = 1—were something else again. Originally, these were reserved for members of the so-called Secret Chiefs, roughly equivalent to Madam Blavatsky's Mahatmas (in that it was through them that all doctrinal authority emanated), although many members seem to have equated them to beings more similar to the Ascended Masters of Theosophical splinter groups. It is unclear whether orthodox adepts ever considered that these three highest grades could be achieved by living adepts, except in a purely honorary or titular way. Regardless, it is safe to say that moving upward in reverse order on the Tree of Life (see Figure 1) and achieving initiation into the Golden Dawn's Third Order promised union with God and, arguably, freedom from the bonds of subsequent involuntary incarnation.

To explain the process by which this happened as given in Robartes' metaphor of the "burning bow" referenced above, one must understand that the Golden Dawn assigned each of the 22 letters of the Hebrew alphabet to one of the 22 paths on their version of the Tree of Life glyph. With respect to Figure 1, the letter qoph ("Q") was placed on path 29, between spheres 10 and 7; shin ("Sh") on path 31, between spheres 10 and 8; tau ("T' or "Th") on path 32, between spheres 10 and 9. In Hebrew, the word QShTh—*qesheth*—signifies among other related concepts "bow," "archer," "rainbow," and "Sagittarius." The bow is "burning" because the letter shin looks rather like three tongues of flame.

Moreover, the term *qesheth* was also applied to path 25, between spheres 9 and 6, because the zodiacal sign Sagittarius was assigned here (between the sun in sphere 6 and the moon in sphere 9: qv Mann et al. 2012, p. 310). Therefore, what Robartes indicates is that the path that takes one perpendicularly out of the system of phases is not the winding, zig-zagging path from sphere 10 to sphere 1 in order, but rather the so-called "middle pillar" of the tree that connects the lowest order of creation directly with the highest (and, incidentally, all three major levels of initiation) in a straight line. This symbolism had particular significance for Yeats since in 1896, following an extended cabalistic invocation of the lunar powers, he received a vision of "a naked woman of incredible beauty, standing upon a pedestal and shooting an arrow at a star" (Yeats 1999, p. 280; cf Yeats 1994, p. 14). As further particulars are *much* too involved for a journal article, I point interested readers to the chapter "Esotericism and Escape" in *Yeats's "A Vision": Explications and Contexts* for a more detailed exploration (Mann et al. 2012, pp. 307–28).

The final possibility is strongly related to the last and is, unfortunately, even more complex. Yeats certainly strove to move upward as a member of the Golden Dawn. After being expelled from the Theosophical Society for advocating for a more pragmatic curriculum of esoteric studies, Yeats joined the Golden Dawn on 7 March 1890, taking the Theosophically-based motto Demon Est Deus Inversus: "The Devil is God Turned Upside-Down." Rather amusingly for anyone familiar with Yeats's outspoken personality, he was frequently referred to as "the Demon" by his peers in the order. Three years later, on 20 January 1893, he was initiated into the Portal and—somewhat inexplicably and against what this writer understands as Order policy of the time, also into what was then the lowest sub-section of the Adeptus Minor grade, and the two subsequent sub-grades of the 5 = 6 the following day. On 14 October 1914 he underwent the 6 = 5 Adeptus Major initiation and, according to the later report of George Yeats, was elevated to the grade of Adeptus Exemptus 7 = 4, the highest grade in the Second Order, sometime in 1916 (Moore 1954, p. 170). He remained active in the Golden Dawn, serving as advisor to the chiefs of the Amoun Temple—although he refused a high administrative position, perhaps as one of the chiefs, in 1920 (Harper 1974, pp. 129–30)—and, again, the *Vision Papers* are sprinkled with questions about Order matters that he posed to his communicators. Although Yeats apparently resigned from active membership in the early 1920s, he nevertheless maintained contact with his former associates and, again, explicitly dedicated both versions of *A Vision* to them.

Unsurprisingly, bits of Golden Dawn symbolism are scattered throughout Yeats's body of work—sometimes incidentally, as "The banners of the East and West" that appear in "He Hears the Cry of the Sedge," and sometimes quite explicitly as in "The Two Trees," "Vacillation," "Magic," *Autobiographies* and *A Vision*. If one understands the curriculum of the various grades, it is even

possible to connect subtextual themes in Yeats's writing directly with his Golden Dawn studies at the time. For example, one fact that Yeats was at pains to record about the initial automatic writing sessions was that "The unknown writer took his theme at first from my just published *Per Amica Silentia Lunae*" (Yeats 2015, p. 8), what (comparing himself to Paracelsus among others) he calls his "spiritual history" that he identifies as a prerequisite to obtaining "the secret" (Yeats 2015, p. 9).

Although there is little curricular information available relating to the higher grades of the Golden Dawn's Inner Order, Yeats's one-time colleague Aleister Crowley provides a number of salient remarks concerning the Adeptus Exemptus degree in his own spin-off organization, the *Argentum Astrum*:

> The Adept must prepare and publish a thesis setting forth His knowledge of the Universe, and his proposals for its welfare and progress. He will thus be known as the leader of a school of thought.
>
> (Eliphas Levi's *Clef des Grands Mysteres*, the works of Swedenborg, von Eckartshausen, Robert Fludd, Paracelsus, Newton, Bolyai, Hinton, Berkeley, Loyola, etc., etc., are examples of such essays.)
>
> He [. . .] should be already prepared to perceive that the only possible course for him is to devote himself utterly to helping his fellow creatures. (Crowley 1994, p. 483)

Elsewhere, Crowley advises his students to undertake seemingly innocuous magical practices that relate directly to Yeats's composition of his memoirs, begun in 1914, and particularly *A Vision*'s direct antecedent *Per Amica Silentia Lunae*:

> It is absolutely essential to begin a magical diary, and keep it up daily. You begin by an account of your life, going back even before your birth to your ancestry. . . . [Y]ou must find an answer to the question: 'How did I come to be in this place at this time, engaged in this particular work?' . . . [T]his will start you on the discovery of who you really are, and eventually lead you to your recovering the memory of previous incarnations. (Crowley 1945, "Letter A")

Clearly, by the very act of publishing *A Vision*, Yeats can be seen as trying "to help his fellow creatures" understand what he saw as the mechanism that determines their lives, and the eventual escape from the very system of incarnation and discarnate experiences he elucidates—despite the fact that (as Harold Macmillan observed to Yeats's literary agent regarding the 1937 edition) "the subject matter of the book is one that makes a very limited appeal. To most ordinary minds it appears to be quite mad" (Yeats 2015, p. xxiii). Indeed, Yeats's friend Ezra Pound pulled no punches when he described Yeats's "whole new metaphysics about 'Moon,' very very very bug-house" (as quoted from materials held in the collections of the New York Public Library in (Foster 2003, p. 157)). Equally clearly, when one looks at Yeats's poetic corpus, his thoughts about the subject stretch back far further than the creation of "*Per Amica Silentia Lunae*." As the poem "The Three Hermits," referenced above, shows: Yeats was thinking about issues of reincarnation at least as far back as 1912, when composing the material that would eventually be published in *Responsibilities*. Indeed, many of those poems contain language that would eventually end up featuring prominently in *A Vision*, such as his thoughts on passion and "escaping" from the cycles of rebirth and thereby "Running to Paradise." Furthermore, many also feature distinctly occult and Rosicrucian themes taken directly from the Golden Dawn: "The Mountain Tomb" of Christian Rosenkreuz, the hermetic-alchemical "Peacock" that symbolizes the Third Order grade of Magister Templi that also featured prominently in the 1897 Michael Robartes narrative "*Rosa Alchemica*," "The Magi" (also connected with Michael Robartes in the notes to the 1899 edition of *The Wind Among the Reeds* (Yeats 1965, p. 803)), and even, perhaps, "A Coat" with its final lines about "more enterprise."

However, at this point, in order to come to grips with Yeats's hypothetical fourth option regarding the soul's bondage to the cycle of rebirth, one must consider that there is a marked disjunction between

the themes of many of Yeats's later poems and the material presented in *A Vision*. The Yeatsian system is concerned almost entirely with the soul, as Yeats's title for the fictional antecedent of the 1925 edition, *The Way of the Soul between the Sun and the Moon*, shows. By comparison, the themes of Yeats's poetry became more and more earthy as he aged. To give a few examples from the most famous poems: In "A Dialogue of Self and Soul" the self dominates, is "content to live it all again/and yet again" (ll. 57–58) and effectively has the last word in the argument. In "Among School Children" "The body is not bruised to pleasure soul" (l. 58). In "Sailing to Byzantium" the soul must "clap its hands and sing, and louder sing/for every tatter in its mortal dress" in that "holy city" (ll. 11–12). And in "Vacillation" Yeats exults in human excellence ("What theme had Homer but original sin?" (l. 77); answer: *arête*) and professes a belief in and fascination with the "miracles of the saints," the uncorrupted body of Saint Teresa in particular, "Bathed in miraculous oil" (l. 81).

Likewise, the poet's own life reflected his growing fixation with the body. He purchased and renovated (with Golden Dawn color motifs) the sixteenth-century Norman tower house "Thoor Ballylee" as a magical oratory that Ezra Pound referred to in a 1 June 1920 letter to John Quinn as Yeats's "phallic symbol on the bogs—Ballyphallus" (as quoted from materials held in the collections of the New York Public Library in (Foster 2003, p. 84)). He engaged in numerous affairs with the full knowledge of his wife. Indeed, to combat issues with erectile dysfunction and impotence, he agreed to undergo the so-called Steinach procedure: a one-sided vasectomy designed to recirculate semen and thereby restore both his virility and creativity (qv Ellmann 1985).

Yeats was a magician. As he freely admits in the opening to the second section of "*Per Amica Silentia Lunae*": "I have murmured evocations and frequented mediums"—and such a statement does not *begin* to scratch the surface of his experiments over three decades (Yeats 1994, p. 16). In fact, in addition to his involvement with the Golden Dawn, he dallied with the Dublin Hermetic Society, the Esoteric Section of the Theosophical Society, the Society for Psychical Research, and the Ghost Club, among other groups. Yeats meditated and took hashish with Martinists in Paris and attended ceremonies in Dublin to observe communication with evil powers. Daniel Dunlop describes rituals in which Yeats sprinkled blood from a slaughtered cockerel over a chalked pentagram "in accordance with the instructions of those versed in the black arts" (Young 1971, p. 7). Yeats even took information from the infamous Aleister Crowley *via* Golden Dawn Imperator Robert Felkin. In fact, Crowley's copy of *The Goetia*, now in the Warburg Institute, contains some very suggestive marginalia in the hand of Gerald Yorke regarding the doings of Yeats and a certain Irish seer.

Magicians do not, for the most part, simply wish to "know" and pile up knowledge for its own sake. Rather, they wish to use their secret knowledge to effect change, to *do* things, indeed to circumvent the normal progression of evens and subvert it to their own ends. Thus (to highlight with one of many examples), one sees Yeats's character Michael Robartes, the image of an hermetic adept, lead the narrator of "*Rosa Alchmica*" away from the aesthete's apartment where he has simply collected occult and alchemical implements into an actual temple where occult theory is turned into practice.

Moreover, despite Yeats's poetic prowess (as the man who single-handedly "rescued English lyric from the dead hand of Campion and Tom Moore," he was very much of an elitist (Auden 1948, p. 195)). His involvement with the Golden Dawn made him feel special, initiated, in-the-know. He frequently described it as "my" order, and seems to be forever hinting, hinting, hinting . . . only to stop short of any real revelation. Of course he was bound by an oath of secrecy regarding Order matters, but this often seems like a convenient excuse, as he is only reticent about particulars.

It is almost unthinkable that Yeats, who spent decades studying and practicing magic, would suddenly decide to give up on the Golden Dawn's magical system with grades left to conquer, honors yet unearned. Equally, although it sounds rather absurd, if the plebes and *hoi polloi* could use *A Vision* to escape from the curse of repeated cycles of incarnation and attain union with God, then union with God was, perhaps, not good enough for Yeats. He was very much a have-his-cake-and-eat-it-too sort of person. Herein lies the fourth option, as I reconstruct it.

Yeats's remarks in the final pages of *A Vision* (1937) leave readers with a sense of disquiet and even dejection. Life imitates art as the poet in his own person mimics his decades-old persona from "The Phases of the Moon," sat in his tower, "a place set out for wisdom" that he will never find, cracking his wits day after day without hope of discovering meaning (1.27 ff), or perhaps emulating his even older character from *The Secret Rose*'s "The Heart of the Spring," who has spent his life waiting to capture the precise moment to perform the magic that will make him one with the Immortal Powers:

> Day after day I have sat in my chair turning a symbol over in my mind, exploring its details, defining and again defining its elements, testing my convictions and those of others by its unity, attempting to substitute particulars for an abstraction like that of Algebra. I have felt the convictions of a lifetime melt through at an age when the mind should be rigid, and others take their place, and these in turn give way to others [...] Then I draw myself up into the symbol and it seems as if I should know all if I could but banish such memories and find everything in the symbol.

> But nothing comes—though this moment was to reward me for all my toil. Perhaps I am too old. Surely something would have come when I meditated under the direction of the Cabalists. (Yeats 2015, p. 301)

Clearly Yeats expected something to happen—which *clearly* didn't: some event, revelation, or transformation ... but what was it?

Without a doubt, a few words must be devoted here to those pinnacles of mature Yeatsian lyric, the Byzantium poems, centered not only on the body-soul dilemma, but on artifice, artificiality, death-in-life and life-in-death, and the poet's triumphant paean, "I hail the superhuman" ("Byzantium" l. 15). Those readers who wish to sample a cross-section of the foundational criticism on these works are directed toward Richard Finneran's anthology *William Butler Yeats: The Byzantium Poems*. For my own part, despite the fact that there have been volumes written in the intervening years, I stand in general with Richard Ellmann, who received so much assistance and approbation directly from George Yeats herself and centers his reading on the symbol of the golden bird: "The eternity into which the poet longs to be gathered is described with deliberate ambivalence ... those personages to whom he prays ... are already removed from life, but he wishes to escape even further ... to be turned into a beautiful mechanical bird ... liberated not only from life but from all responsibilities ... transmuted into an image" (Ellmann 1948, p. 256).

Indeed, Ellmann phrases it softer than Yeats, who closes "Sailing to Byzantium" not with a wish, but a declaration:

> Once out of nature I shall never take
> My bodily form from any natural thing,
> But such a form as Grecian goldsmiths make
> Of hammered gold and gold enamelling
> To keep a drowsy Emperor awake;
> Or set upon a golden bough to sing
> To lords and ladies of Byzantium
> Of what is past, or passing, or to come. (ll. 25–32)

And Yeats returns to the same symbol and setting in the purgatorial "Byzantium":

> Miracle, bird or golden handiwork,
> More miracle than bird or handiwork,
> Planted on the starlit golden bough,
> Can like the cocks of Hades crow,
> Or, by the moon embittered, scorn aloud
> In glory of changeless metal

> Common bird or petal
> And all complexities of mire or blood. (ll. 17–24)

Nevertheless, to my mind the most incongruous element is that Byzantium, the city that serves as a weigh-station for souls waiting to be transported out of life "Astraddle on the dolphin's mire and blood" (l. 33) and welcomed into life by the cocks of Hades, is haunted by a mummy with "A mouth that has no moisture and no breath" that nevertheless summons (l. 13).

Perhaps Yeats saw Thanhouser's film *The Mummy* during his 1911 American tour with the Abbey players, or a later production by Pathé, Gaumont, or Essanay. However, he was more than familiar with the rituals of the Golden Dawn that drew on complex, somewhat fanciful, and now largely outmoded ideas about esoteric Egyptology. Beyond this, Florence Farr—Yeats's one-time lover, fellow-adept, leader of the so-called Sphere Group that contacted a discarnate Egyptian adept *via* a fragment of cartonnage, and dedicatee of *A Vision* (1925)—composed a monograph on the subject of *Egyptian Magic* that he must have known reasonably well. While mummies were popular Victorian curiosities, it is a picturesque yet inexplicable inclusion in "Byzantium," for as Farr "explains":

> There is every reason to suppose that only those who had received some grade of initiation were mummified; for it is certain that, in the eyes of the Egyptians, mummification effectually prevented reincarnation. Reincarnation was necessary to imperfect souls, to those who had failed to pass the tests of initiation; but for those who had the Will and the capacity to enter the Secret Adytum, there was seldom necessity for that liberation of the soul which is said to be effected by the destruction of the body . (Farr 1998, p. 2)

Elsewhere in her exposition, perhaps setting the stage for *A Vision* in some fundamental way, Farr observes. "[W]e have hitherto written of man as composed of soul and body; but the Initiated Egyptians regarded themselves as being far from simply soul and body. They gave names to several human faculties, and postulated for each a possibility of separate existence" —and she goes on the elucidate them, including the *Khat, Hammemit, Kab, Sahu, Hati, Khaibt, Ka, Ab, Baie*, and *Khou* (Farr 1998, p. 3).

She continues:

> Of course in thousands of cases the celestial body was restricted; the fatal moment of conception loaded the terrestrial being (composed of the Sahu, Hati, and Ab within the Kab or material body) with chains of destiny too strong for him to break through. And the Ka or Ego had to return to the Hammemit in the Place of Spirits and await the time when it might again have a chance of regenerating matter Astral and Material, and become of the number of these "Shining Ones," who are set like Jewels in the Diadem of the Lord of Spirit and Life, made One (Farr 1998, p. 5)

Who and what are these "Shining Ones" who seem to be the *crème de la crème* of successful adepts? They are those individuals who have cultivated "the seed of the Tree of Life-Eternal" implanted in their hearts, ultimately allowing the individual to become "either an Evil Demon or a God" (Farr 1998, p. 12).

Moving back to "Among School Children," Yeats includes a remarkable quasi-theological statement in lines 20–21: "For even daughters of the swan can share/something of every paddler's heritage" that represents an inversion of conventional Christian thought. In the creation myth given in the opening chapters of *Genesis*, the body is mud, animated by the breath of God, and this divine pneumatic component is the soul that makes mere matter an image of the creator. In Christianity, this myth is transmuted into the Johannine theology of the Alexandrian school, eventually adopted by all orthodox Christian denominations, in which the most important aspect of the Christ story is that the logos, immortal God, humbles Himself to become man.

However, it is clear that Yeats often gave credence to tradition over current usage. The more ancient a mode of thought, the greater validity it possessed—orthodoxy notwithstanding. Alexandrian doctrines were not the only theology circulating in the early Church, and they are in opposition to

the direction that Yeats's observation takes readers. Rather, Yeats stresses that even those heroes and demigods of Greek myth have a *human* component. In an early Christian context, this is the theology of the Syrian school at Antioch that would later be condemned as part of the Nestorian heresy; that is, the most important aspect of the Christian story is that Jesus, a man, ultimately becomes God.

This observation would remain a puzzling bit of trivia, except for the fact that references to this strain of Syrian Christianity recur again and again in Yeats's mythology. In terms a *A Vision*, in Owen Aherne's fictional introduction to the 1925 edition, it is claimed that the (equally fictional) source documents, the *Speculum Angelorum et Hominorum* (sacred book of the quasi-fictional Judwali sect of Arabs known for "their licentiousness and their sanctity . . . tolerant of human frailty beyond any believing people") and *The Way of the Soul between the Sun and the Moon* "attributed to a certain Kusta ben Luka, Christian Philosopher at the Court of Harun Al-Raschid" both had "some remote Syriac origin" (Yeats 2008, pp. lx–lxi). Kusta ben Luka, an historical Melkite Christian known to and admired by Albertus Magnus, was specifically included in Yeats's myth as the author of a number of philosophical and magical treatises and translations, including "*Physical Ligatures* dealing with the virtue of the mind whereby the physical body is changed & influenced" (Taylor 1969, p. 86). More complete specifics can be found in Suheil B. Bushrui's essay, "Yeats's Arabic Interests" in (*In Excited Reverie* Bushrui 1965.)

Likewise, in *The Resurrection*—whose introduction is littered with remarks pertaining to Yeats's views on reincarnation and escape—Yeats plays three strains of theological thought off of one another in the characters of The Hebrew, The Greek, and The Syrian: gathered with the eleven disciples on Easter Sunday prior to Christ's first visitation (while a procession honoring Dionysus, who has overtones of Attis, goes on in the street outside). For the Hebrew, Christ was simply Jesus, a man born of woman. For the Greek, He was a phantom who "only seemed to be born, only seemed to eat, seemed to sleep, seemed to walk, seemed to die" (Yeats 1934, p. 116). Both are appalled to discover, when Christ actually appears, that he is a "phantom with a beating heart." Only the Syrian is prepared and exultant to report, and indeed embrace, the irrational.

To be sure, all orthodox Christians profess a belief in the ultimate resurrection of the body on the last day, in which the souls of the righteous dead will be reunited with their bodies, raised from the dust but "glorified" and remade with neither material limitation nor defect. However, who knew how long it would be until the Last Day when the tombs would be opened and the faithful souls reunited with their scattered bodies? Nor was there any promise that such a resurrection also entailed any of the earthly delights in which the aging Yeats took such pleasure—other than the promise of singing hosannas before the throne of God in company with the two seraphim. Furthermore, as before, if such a salvation was available for all, then there was nothing "initiated" about it for a magician like Yeats and, alike with those who attain what the *Bhagavad Gita* calls *brahma-nirvana* (5:24–26) and are freed from the cycle of rebirth at death, one does have to suffer death first, without any guarantees.

Regardless, while Yeats was a student of many religions and theologies, he had been purged of the ability to subjugate himself to the doctrines of conventional religion under the often harsh tutelage of his father—who nevertheless failed to eradicate in his son the human need for some sort of belief system larger than one's self. Much to J.B. Yeats's dismay, Yeats filled this void with esoteric studies and the practice of magic. As he so adamantly states in an often-quoted 1892 letter to John O'Leary:

> It is surely absurd to hold me "weak" or otherwise because I choose to persist in a study which I decided deliberately four or five years ago to make next to my poetry, the more important pursuit of my life [. . .] If I had not made magic my constant study I could not have written a single word of my Blake book, nor would *The Countess Cathleen* ever have come to exist. The mystical life is at the centre of all that I do and all that I think and all that I write. It holds to my work the same relation that the philosophy of Godwin holds to the work of Shelley and I have always considered myself a voice of what I believe to be a greater renaesence [sic]—the revolt of the soul against the intellect—now beginning in the world. (Wade 1955, pp. 210–11)

Similarly, in a letter to Lionel Johnson from the same period he comments on both religion and magic in no uncertain terms: "My own position is that an idealism or spiritualism which denies magic, and evil spirits even, and sneers at magicians and even mediums (the few honest ones) is an academical imposture. Your Church has in this matter been far more thorough than the Protestant. It has never denied *Ars Magica*, though it has denounced it" (Yeats 1986, pp. 355–56). In short, Yeats's occult ideas, those stemming from his long tenure in the Golden Dawn in particular, were his religion, and it is unquestionably to the Golden Dawn that one must turn for any final or esoteric answer to the problems posed by a system of reincarnation posed by two Golden Dawn adepts working in tandem.

To begin with, Yeats was certainly aware of the fundamentals of *gilgul*, or cabalistic reincarnation, and used it in some of his early poems (qv Serra 1998). Furthermore, similar to Farr's Egyptian schema outlined previously, the cabalistic system conveyed to initiates of the Golden Dawn taught that the spiritual constitution of a human being is made up of at least four distinct principles: the passions and senses (*Nephesh*), the intellect (*Ruach*), and the immortal spiritual soul (*Neshamah*), all of which exist within the physical body (*Guph*) that was nevertheless classified as a spiritual principle. To complicate things, the individual *Neshamah* is connected to a higher "animating" soul, *Chiah*, that is common to every living thing, which itself proceeds from an even higher soul, *Yechidah*: The One. These cabalistic ideas as taught by the original Golden Dawn are most fully expressed in two works by the Order's founders: MacGregor Mathers' translation of Christian Knorr von Rosenroth's 1684 *Kabbala Denudata* (Mathers 1887), and Wynn Westcott's *An Introduction to the Study of the Kabalah* (Westcott 1910). Both are rather stiff reads (the former moreso than the latter), written as they are in rather heavy, old-fashioned Victorian prose. However, a much more succinct, accessible, and lighthearted treatment of the same information can be found among the essays of contemporary esotericist and occult scholar Bill Heidrick, who has written extensive exegetical commentaries on the Golden Dawn's cabala (or "qabalah" as the post-Renaissance, quasi-Christian adaptation is more correctly transliterated to distinguish it from its strictly Jewish antecedent). Thus:

> In Qabalah there is a series of souls. There's even a soul for the physical body that IS the physical body. Wonder of wonders, it's called the "Goof"—whence we derive our word "goofy". Then there is the Nephesh, which is what keeps the Goof running. That's in animals too. A Nephesh sometimes lingers after death. When the body drops, this soul tries to look for another one. That's the ghost. It's not particularly intelligent. It's just able to hold the pattern it had. A wandering Nephesh will generally look like the can it was in. Electrical, who knows? It may have an explanation, and it may not. It's there. It doesn't seem to require an explanation to exist. Beyond the Nephesh is the human identity, something called the Ruach, the intelligent or human soul. This is the "somebody in there." [...]

> [T]he Neshamah [is] the first immortal part of the soul, or the first immortal soul. Calling these entities parts or souls doesn't matter. If you insist on having just one soul, call them parts. If you don't have a problem with that, call them souls. The Egyptians had a group of terms for them. The Neshamah is the first immortal part of you. Your body will rot, smell bad and become a mess some day—unless you are weird enough to have it stuffed. Neshamah is not like that.

> Nephesh, the animal principal, is corruptible. The Nephesh is the memory people have of you as though you were in the room. It's the thing that makes friends think your ghost is present when they feel some intangible thing and suddenly see it as you. When a friend dies, a week or a year later, you may see that friend walking down the street. You hurry to catch up, because you don't understand what is going on. Suddenly, it's somebody who doesn't look at all like that person. For a moment it did. That's the ghost. Shade is another word just as good. The Nephesh eventually will die. When the last person who sees you in things or remembers you in mind passes away, when the last person who has heard stories

about you goes, your Nephesh dies. There are ways to keep it alive independently for a time. Some theories of Magick describe how to make a house for the soul or help it live in a tree. That can be done, but many people doubt whether those things work in themselves or only because the person who performed the appropriate ritual made a conscious effort to keep this spirit around.

If you write a book or leave a journal, it's possible to call your Nephesh back from the dead. A sympathetic person may read your literary effects. It's not enough to imagine seeing a person or to imagine what they are like. That won't bring back the Nephesh. The person must be seen as though physically present. It's quite a spooky thing to start thinking someone's thoughts and later see that person. Another way to approach this idea: to understand what life was like 300 years ago in some other part of the world, reading a book or visiting a place isn't enough. It's necessary to hallucinate what it would have smelled like. The impressions must be more real than imagined. It's one thing to read a book and imagine the life of some famous person. It's quite another matter to read the same book and begin to think like that person.

The Ruach survives well in books, buildings and works of art. That's the next soul after the Nephesh. If you don't smell the animal soul, you can still get ideas from the intellectual soul. Things that a deceased person left behind still function in the world as products of the personality. The Nephesh and the Ruach can be kept alive, but they will pass away if not deliberately kept alive. They depend on physical things or people still living. The Neshamah doesn't. The Neshamah is immortal by itself. It always existed. It always will exist. In a sense it is divine. [...]

Consider the concept of reincarnation: you're born and born and born again until finally you get it together with your Neshamah; finally the part of your [sic] that's immortal unites with the part of you that's mortal. After that occurs, you don't have to be born again (Heidrick 1994–1995)

MacGregor Mathers, Yeats's long-time chief in the Golden Dawn, therefore concluded, "[I]f you can once get the great force of the Highest [Yechidah] to send its ray clean down through the Neschamah into the mind, and thence, into your physical body, the Nephesch would be so transformed as to render you almost like a God walking on this Earth" (Mathers 1987, p. 136).

Was Yeats's answer to the "remorse" of a repeated cycle of births and deaths (*remordere*: literally being "chewed up, again!) to become *as* God, or even *a* god? ("Vacillation"l. 8), to become, like the patriarch Enoch, "not?" *Perhaps* this is an extreme possibility, and perhaps not. Without question Yeats announced to Ezra Pound that his intent in *A Vision* (1937) was to "proclaim a new divinity"—the individual perfected—and that his paradigms were the oppositional figures of Oedipus who, when the "earth opened, 'riven by love', [...] sank down soul and body" balanced against "Christ who, crucified standing up, went into the abstract sky soul and body" (Yeats 2015, p. 27): to use a term from *A Vision*, the most complete Unity of Being in both cases.

Regardless, Yeats exulted to Dorothy Wellesley in May of 1937 that the final proofs of *A Vision* were out of his hands (Wade 1955, p. 886). A scant eighteen months later, at the end of January, 1939, reading Vedanta and still daydreaming about the possibility of restarting his long-aborted project to form a Celtic sister-order to the Golden Dawn, he took the advice of his echo to "lie down and die" ("Man and Echo" l. 19), in his own estimation nothing but "a broken man" ("The Circus Animals' Desertion" l. 3). His intellectual soul lives, in the words of W.H. Auden's "In Memory of W. B. Yeats," "scattered among a hundred cities" though "modified in the guts of the living." His body went into the ground—"an honoured guest"—at Roquebrune, on the French Riviera, "Emptied of its poetry" And his Neshamah? It's certainly not with the dry bones reinterred in County Sligo's Drumcliff cemetery. As his tombstone advises admirers, "Horseman, pass by."

Conflicts of Interest: The author declares no conflict of interest.

References

Auden, Wystan H. 1948. Yeats as an Example. *The Kenyon Review* 10: 187–95.

Breidenbach, Kathleen Patricia. 1992. Patterns upon a Persian Carpet: Symbolism and Occult Ritual in the Plays of W.B. Yeats. Ph.D. dissertation, State University of New York at Stony Brook, Stony Brook, NY, USA.

Bushrui, Suheil B. 1965. Yeats's Arabic Interests. In *Excited Reverie: A Centenary Tribute to William Butler Yeats, 1856–1939*. Edited by A. Norman Jeffares and Kenneth Gustav Walter Cross. London: Macmillan.

Croft, Barbara L. 1987. *Stylistic Arrangements: A Study of William Butler Yeats's A Vision*. Lewisburg: Bucknell University Press.

Crowley, Aleister. 1945. *Magick without Tears*. Hampton: Thelema Publishing Company. (Unpaginated Digitized Typescript in Author's Possession)

Crowley, Aleister. 1955. *777*. London: Neptune Press.

Crowley, Aleister. 1994. *Magick: Liber ABA: Book Four, Parts 1–4*. Edited by Hymenaeus Beta. York Beach: Weiser.

Dampier, Graham A. 2007. Incarnation and the Discarnate States: An exposition on the Function of the Principles in the System of W.B. Yeats's *A Vision*. Master's thesis, University of Johannesburg, Johannesburg, Gauteng, South Africa.

Ellmann, Richard. 1948. *Yeats: The Man and the Masks*. New York: Macmillan.

Ellmann, Richard. 1985. *W.B. Yeats's Second Puberty*. Washington: Library of Congress.

Ellmann, Richard. 1988. *A Long the Riverrun*. New York: Alfred A. Knopf.

Farr, Florence [S.S.D.D.]. 1998. Egyptian Magic. In *Collectanea Hermetica*. Edited by William Wynn Westcott. York Beach: Weiser. N. pag.

Foster, R. F. 2003. The Arch-Poet. In *W.B. Yeats: A Life*. Oxford: Oxford University Press, vol. 2.

Harper, George Mills. 1974. *Yeats's Golden Dawn*. New York: Barnes & Noble.

Harper, Margaret Mills. 2006. *Wisdom of Two: The Spiritual and Literary Collaboration of George and W.B. Yeats*. Oxford: Oxford University Press.

Heidrick, Bill. 1994–1995. An Abramelin Ramble. Available online: digital-brilliance.com/kab/abramel. htm (accessed on 17 June 2017). (Originally serialized March 1994–January 1995 *Thelema Lodge Calendar*/Newsletter).

Mann, Neil, Matthew Gibson, and Claire Nally, eds. 2012. *W.B. Yeats's A Vision: Explications and Contexts*. Clemson: Clemson University Digital Press.

Mathers, S. L. MacGregor. 1887. *The Kabbalah Unveiled*. London: George Redway.

Mathers, S. L. MacGregor. 1987. *Astral Projection, Ritual Magic, and Alchemy*. Edited by Francis King. Rochester: Destiny Books.

McDowell, Colin. 1986. The Six Discarnate States of *a Vision* (1937). *Yeats: An Annual of Critical and Textual Studies* 4: 87–98.

Moore, Virginia. 1954. *The Unicorn: William Butler Yeats' Search for Reality*. New York: Macmillan.

Murphy, William M. 1995. *Family Secrets: William Butler Yeats and His Relatives*. Syracuse: Syracuse University Press.

Plato. 1993. The Symposium. In *The Dialogues of Plato*. Translated by R. E. Allen. New Haven: Yale University Press, vol. 2.

Saddlemyer, Ann. 2002. *Becoming George: The Life of Mrs W.B. Yeats*. Oxford: Oxford University Press.

Serra, C. Nicholas. 1998. Crowley, Continuity, and Qabalah: Yeats's Over-System in "The Two Trees" 1892 and 1929. *Yeats Eliot Review* 15: 33–44.

Shin, Mi-Jeong. 1995. W.B. Yeats and the Concept of Reincarnation. Ph.D. dissertation, University of Georgia, Athens, GA, USA.

Taylor, Richard, ed. 1969. *Frank Pearce Sturm: His Life, Letters, and Collected Work*. Urbana: U. Illinois Press.

Wade, Allan, ed. 1955. *The Letters of W.B. Yeats*. New York: Macmillan.

Westcott, William Wynn. 1910. *An Introduction to the Study of the Kabalah*. London: J. M. Watkins. Available online: http://www.hermetics.org/pdf/Westcott.Kabalah.pdf (accessed on 21 August 2017).

Yeats, William B. 1934. *Wheels and Butterflies*. London: Macmillan.

Yeats, William B. 1965. *The Variorum Edition of the Poems of W.B. Yeats*. Edited by Peter Allt and Russell K. Alspach. New York: Macmillan.

Yeats, William B. 1983. The Poems. In *The Collected Works of W.B. Yeats*. Edited by Richard J. Finneran. New York: Macmillan, vol. 1.

Yeats, William B. 1986. *The Collected Letters of W.B. Yeats 1865–1895*. Edited by John Kelly and Eric Domville. Oxford: Clarendon.

Yeats, William B. 1992a. *Yeats's Vision Papers: The Automatic Script: 5 November 1917–18 June 1918*. Edited by Steve L. Adams, Barbara J. Frieling and Sandra L. Sprayberry. Iowa City: University of Iowa Press.

Yeats, William B. 1992b. *Yeats's Vision Papers: The Automatic Script: 25 June 1918–29 March 1920*. Edited by Steve L. Adams, Barbara J. Frieling and Sandra L. Sprayberry. Iowa City: University of Iowa Press.

Yeats, William B. 1992c. *Yeats's Vision Papers: Sleep and Dream Notebooks, Vision Notebooks 1 and 2, Card File*. Edited by Robert Anthony Martinich and Margaret Mills Harper. Iowa City: University of Iowa Press.

Yeats, William B. 1994. Later Essays. In *The Collected Works of W.B. Yeats*. Edited by William H. O'Donnell. New York: C. Scribner, vol. 5.

Yeats, William B. 1999. Autobiographies. In *The Collected Works of W.B. Yeats*. Edited by William H. O'Donnell and Douglas N. Archibald. New York: Scribner, vol. 3.

Yeats, William B. 2001. *Yeats's Vision Papers: "The Discoveries of Michael Robartes" Version B*. Edited by George Mills Harper and Margaret Mills Harper. New York: Palgrave.

Yeats, William B. 2007. *The Tower (1928): Manuscript Materials*. Edited by Richard J. Finneran, Jared R. Curtis and Ann Saddlemyer. The Cornell Yeats. Ithaca: Cornell University Press.

Yeats, William B. 2008. A Vision (1925). In *The Collected Works of W.B. Yeats*. Edited by Catherine E. Paul and Margaret Mills Harper. New York: Scribner, vol. 13.

Yeats, William B. 2015. A Vision: the Revised 1937 Edition. In *The Collected Works of W.B. Yeats*. Edited by Margaret Mills Harper and Catherine E. Paul. New York: Scribner, vol. 14.

Young, Edith. 1971. *Inside Out*. London: Routledge and Kegan Paul.

Article

The Reincarnation(s) of Jaya and Vijaya: A Journey through the Yugas

Steven J. Rosen

Journal of Vaishnava Studies, New York, NY, USA; stevenrosen32@yahoo.com

Received: 31 July 2017; Accepted: 31 August 2017; Published: 4 September 2017

Abstract: Among the earliest reincarnation narratives found in India's Puranic texts, we find the stories of Jaya and Vijaya, the two gatekeepers of the spiritual world. Though there is little in these stories to explain reincarnation in a philosophical sense, the teaching of transmigration is implicit in the stories themselves, for we follow the two gatekeepers through three successive incarnations (along with the three incarnations of the divine who follow them through their various lifetimes).

Keywords: reincarnation; Jaya and Vijaya; Narasimhadeva (Nṛsiṁha); Rāma; Krishna; Avatāra; Śrīmad Bhāgavatam; Śrī Chaitanya; yuga

Reincarnation, of course, is accepted as a given in India's mystical literature, and, according to Eastern sensibility, its truth undergirds any genuine metaphysical understanding of life. We are spirit-soul, say texts like the *Bhagavad-gītā* (2.13, 21, 22, among others), and not the material body. We are a quantum of energy, and energy, we learn from the natural sciences, is never created or destroyed. It continues to exist in some form. God, too, is spiritual substance, and He/She/It reincarnates as well.[1] But whereas regular souls are forced to incarnate according to their karmic activity—for every action there is an equal and commensurate reaction—God appears in various forms according to His sweet will, for the sake of play (*līlā*) and to educate.

This paper will focus on three such incarnations of the Supreme—three of His most important manifestations—and, alongside those appearances of divinity, we will discuss three incarnations of ordinary beings who challenged the Lord and battled Him to the "death."

The three incarnations of the Divine, in the order in which they appeared in the material world, are Nṛsiṁha, Rāma, and Krishna. Confidential wisdom texts of India describe them as Parāvastha Avatāras, or "perfect" incarnations. The *Śrīmad Bhāgavatam* (1.3.26), known as the "ripened fruit" of the Vedic tree of knowledge, tells us that: " . . . the incarnations of the Lord are innumerable, like rivulets flowing from inexhaustible sources of water." Normally, all of these incarnations are considered equal, as just various forms of one divine being, and yet, according to the *Padma Purāṇa* (Uttara 226.42),[2] the three mentioned here are singled out as most important, as embodying the ultimate and most complete form of divinity.

For the Gauḍīya Vaishnava tradition, this is confirmed in Rūpa Goswāmī's *Śrī Laghu-bhāgavatāmṛta* (1.5.16–64), where he echoes the *Padma Purāṇa* and adds that Krishna, in particular, is *avatārī*, or the source of all incarnations (*Laghu-bhāgavatāmṛta*, 1.5.303–7). We will return to this concept of Parāvastha Avatāras, with special attention to Krishna's supreme position, after following the ongoing narrative of Jaya and Vijaya, the two gatekeepers of the spiritual world.

1. The word "incarnation" or even "reincarnation" when referring to God is used simply as a matter of convenience. While ordinary souls *incarnate* in terms of taking on a material body (the word *incarnate* literally refers to being clothed in a "carnal" or fleshy form), God is always spiritual, and His "body" is never composed of material elements.
2. *nṛsiṁha-rāma-kṛṣṇeṣu ṣāḍ-guṇyaṁ parikīrtitam | parāvasthā tu devasya dīpād utpanna dīpavat | |.*

1. Jaya and Vijaya

As the story goes, there were once four little boys, the Kumāras, who tried to gain entrance into Paradise, the spiritual world, known in the Indic tradition as Vaikuṇṭha.[3] Though they looked like five year olds, they were actually very old and spiritually very advanced—but not advanced enough. At the entrance to Paradise were two gatekeepers whose names were Jaya and Vijaya, and it was their job to allow or prevent, as the case may be, living beings who propose to enter.

Now, these four little boys, though spiritually advanced, were impersonalists.[4] According to Vaishnava tradition, an impersonalist is someone who thinks of God as not having form and is thus not ready to enter the spiritual world, where one has sweet interaction and relationship with God's form. Because of this, when the four little boys tried to enter Paradise, the gatekeepers, Jaya and Vijaya, stopped them from doing so.

As little boys often do, the Kumāras became angry for not getting their way, and they placed a curse on the two gatekeepers, forcing them to take birth in the material world.[5]

Immediately fearing for their own well being, Jaya and Vijaya asked the four little boys for forgiveness, and it was at that moment when the Supreme Person Himself—Vishnu—appeared on the scene to intervene on their behalf.[6] Placating the small boys, Vishnu convinced them to allow Jaya and Vijaya, as penance for their offense, to, yes, take birth in the material world, but, after some time, to return to Vaikuṇṭha, the spiritual realm. With that being said, the two gatekeepers lost their effulgence. Their countenances having fallen and becoming deeply saddened, they fell to the material world, taking birth as demons.[7]

2. Hiraṇyākṣa and Hiraṇyakaśipu

We will now see Jaya and Vijaya take three births each throughout cosmic history—in each part of the world cycles, that is, in each of the initial three *yugas*—and then a very special birth in the fourth. Jaya becomes Hiranyaksha, Rāvaṇa, and Sishupala[8] in Satya-, Treta-, and Dvāpara-yuga, respectively.[9] The sequence for Vijaya similarly manifests as Hiraṇyakaśipu, Kumbhakarṇa, and Dantavakra.[10] Though this might seem a little confusing, we will now see how it all plays out.

Once, millions of years ago, twins were born.[11] Their names were Hiraṇyākṣa and Hiraṇyakaśipu. The former means "one who loves gold and does his best to look for it, mine it, and collect it," and the latter means "one who loves gold and soft bedding," with the latter point subtly referring to a desire for sexual pleasure.[12]

In other words, both Jaya and Vijaya, in their births as Hiraṇyākṣa and Hiraṇyakaśipu, were of unfortunate mentality, rascals who were always looking for material comforts as well as always

[3] This story of the gatekeepers can be found in numerous Puranic texts. This version is found in A. C. Bhaktivedanta Swami Prabhupada, *Śrīmad-Bhāgavatam* (SB) (Prabhupada 1977–1982), beginning with Canto 3, Chapter 15, Text 12. Similar "gatekeeper" stories can be found in other religious traditions. For example, in the Christian tradition, St. Peter has often been depicted as "holding the keys" to Paradise, and in Islam, to cite one other example, we learn of heaven (Jannah) as having eight doors or gates.

[4] Ibid., 3.15.33, 43.

[5] Ibid., 3.15.34.

[6] Ibid., 3.15.37.

[7] Ibid., 3.16.33.

[8] http://www.vedabase.com/en/mbk/appendix-5-main-characters.

[9] SB 10.74.46 Purport.

[10] Ibid., 7.1.35. Purport. Tradition holds that Vishnu gave Jaya and Vijaya an option to choose one or the other, i.e., seven births as devotees or three births as demons and that Jaya and Vijaya chose the latter. One will not find, however, any real scriptural evidence for this. The closest reference would be SB 7.8.56, purport, where Prabhupāda writes, "Jaya and Vijaya were very much perturbed, but the Lord advised them to act as enemies, for then they would return after three births; otherwise, ordinarily, they would have to take seven births."

[11] Ibid., 3.17.2.

[12] *Īśopaniṣad*, Translation and explanation by Prabhupāda (Los Angeles: Bhaktivedanta Book Trust, 1970).

challenging the Supreme Person.[13] While such a mindset is normally an impediment to *bhakti*, or devotional service, it was in this instance the result of God's will, as we shall see.[14]

Because of the elder brother Hiraṇyākṣa's constant desire to mine for gold in the Earth, our planet gradually became unstable and detached from its position of floating in the universe. Thus, she eventually fell down into the cosmic ocean.[15]

Meanwhile, Hiraṇyākṣa underwent tremendous austerities and thus received the blessings of Brahmā, the first created being, who allowed him to become undefeatable by man or beast. In due course, Hiraṇyākṣa took the Earth, already loosened by his mining activity, as already noted, and plunged her into the primordial depths of the cosmic ocean. All seemed lost.

However, when procuring his boon from Brahmā, Hiraṇyākṣa had not mentioned the boar in his list of animals that would not be able to conquer him, and in light of this, Vishnu assumed just that form—Varāha Avatāra—with huge tusks and other assorted boar features. Diving down into the primordial ocean, he saved the earth as only a boar could, lifting it up with His transcendental tusks. But while in the ocean, He encountered Hiraṇyākṣa, who was ready for combat. They charged toward each other with rage. Finally, after a thousand cosmic years of battle, Hiraṇyākṣa was slain, ready for his next birth.

Although both Hiraṇyākṣa and Hiraṇyakaśipu received the blessing that they would never be killed by any living being in the universe,[16] Hiraṇyakaśipu asked for additional boons from Lord Brahmā. Specifically, he wanted to become totally immortal, but Brahmā said that even *he* could not overcome death and consequently could not grant such freedom to Hiraṇyakaśipu.

Hiraṇyakaśipu then tried to circumvent this obstacle: He asked that he not be killed by any man, animal, god or, in fact, anyone in the material universe. He also asked that he not die on land, in the air, water, nor by any weapon.[17] Lastly, he asked that he not be killed in the daytime or nighttime.[18] He thought that this would effectively make him unconquerable. Brahmā granted him these boons.

Now, Hiraṇyakaśipu was angry with Vishnu for killing his brother Hiraṇyākṣa and it was in his anger that he asked Lord Brahmā for the above blessings, hoping to use his invulnerability to destroy the Earth's saintly culture and to subjugate the entire universe—what to speak of destroy Vishnu Himself.[19] More, he had legions of followers to assist him in his ugly plan, and they were only too glad to carry out his orders.

> *"Thus the demons, being fond of disastrous activities, took Hiraṇyakaśipu's instructions on their heads with great respect and offered him obeisances. According to his directions, they engaged in envious activities directed against all living beings."* (SB 7.2.13)

And yet, in spite of all his wealth and influence, all his endeavors to "overturn the established practices within [the] world,"[20] to conquer the universe and planets of all human beings and bring them under his control, along with all his opulence and power,[21] bodily strength, and enjoying all types of sense gratification as much as possible,[22] ultimately he failed and was killed by the Supreme Person[23]—Nṛsiṁhadeva, the half-man/half-lion incarnation, battled with him and ripped him to shreds.

13 SB, op. cit., 3.17.16 Purport.
14 Ibid., 5.1.5 Purport.
15 Ibid., 2.7.1 Purport.
16 Ibid., 3.17.22 Purport.
17 Īśopaniṣad, Mantra 11, purport.
18 SB 7.3.36–38.
19 Ibid., 7.2.11.
20 Ibid., 7.3.11.
21 Ibid., 7.4.8.
22 Ibid., 7.4.19.
23 Ibid., 7.8.18–31.

To fulfill the benedictions given to him by Lord Brahmā, Hiraṇyakaśipu was killed after he had been placed on Nṛsiṁha's lap and therefore not by any created being; during dusk and therefore not during day nor night; not inside or out but on the terrace, and on the lap of the Lord; wasn't killed by any "person" but by an incarnation of God; and not by any manmade weapon,[24] but by the claws of Nṛsiṁha, the Supreme Person Himself.

3. Rāvaṇa and Kumbhakarṇa

Rāvaṇa and Kumbhakarṇa, the second incarnations of Jaya and Vijaya, were *rākṣasas*—demons who ate humans—and were brothers born into the family of Viśravā and Keśinī. *Rāvaṇa* means "one who causes trouble for others and makes others cry,"[25] and it is said that he was a ten-headed monster—literally. Kumbhakarṇa, the younger brother of Rāvaṇa, means "pot-eared," and he was called this specifically because of the shape of his ears. Kumbhakarṇa, we are told, slept a lot and upon waking had a big appetite—for people.[26]

The story of the two *rākṣasa* brothers is predominantly found in the *Rāmāyaṇa*—an ancient Indian epic of approximately 24,000 Sanskrit verses—and in the 9th Canto, Chapter 10 of *Śrīmad-Bhāgavatam*, among other places. In any case, the point is this: Rāvaṇa wasn't able to control himself; he was a demon of the worst order, setting any kind and altruistic ideas aside in favor of self-aggrandizement and complete selfishness. He apparently had lusty desires for Rāma's wife Sītā, too, who he kidnapped by subterfuge and took to Laṅka.[27] Kumbhakarṇa was similarly uncontrolled. He is briefly mentioned in SB 9.10.18, and in the 7th, 4th, and 9th Cantos, but it is usually only in passing.

There's more information about Kumbhakarṇa in the *Rāmāyaṇa*, but even that seems negligible. Another source has Kumbhakarṇa telling Rāvaṇa that the way he abducted Sītā wasn't proper (Narayan 2006, p. 125). That same source tells how it was difficult to arouse Kumbhakarṇa from his deep sleep[28] and that if you were the one unfortunate enough to be given the task of awakening him, you would likely end up becoming his breakfast.

Rāvaṇa and Kumbhakarṇa were later killed by Lord Rāma, the incarnation of Vishnu in the Tretā age. First Kumbhakarṇa was killed, but not before he killed thousands of the monkey warriors of Hanumān's brother's army.[29] As for Rāvaṇa, he was killed in Laṅka[30] when Rāma shot an arrow into his heart.[31] The fatal blow had to be in his heart because he had been given a benediction that if any of his ten heads were destroyed, another would take its place.[32] Interestingly, Rāvaṇa's original nature came through after he was killed by Rāma.

> "Rama's arrows had burnt off the layers of dross, the anger, conceit, cruelty, lust, and egotism which had encrusted his real self, and now his personality came through in its pristine form . . . "[33]

4. Śiśupāla and Dantavakra

For their third (and ostensibly last) incarnation, Jaya and Vijaya took birth in a *kṣatriya* family as the cousins of Yudhiṣṭhira.[34] Oddly, Śiśupāla is said to have had three eyes and four arms when he was born.[35] He was the son of Damaghoṣa (Prabhupada 1972–2010, p. 356), later became the King

[24] Ibid., 7.8.29 Purport.
[25] See SB 9.10.26, purport; and http://vaniquotes.org/wiki/Rāvaṇa_means.
[26] https://en.wikipedia.org/wiki/Kumbhakarṇa.
[27] SB 9.10.10.
[28] Ibid., p. 136.
[29] Ibid., p. 137.
[30] Ibid., 7.1.44,45, 7.10.37, 9.10.23.
[31] Ibid., 9.10.23.
[32] R. K. Narayan, op. cit., pp. 145, 146.
[33] Ibid., p. 147.
[34] SB 7.1.46, 7.10.38.
[35] http://www.bhagavatam-katha.com/mahabharata-story-lord-damodar-and-shishupala-deliverence/.

of Chedi, a kingdom in ancient India, and was an enemy of Krishna. Śiśupāla's cousin, Dantavakra (they weren't brothers in this birth) was so named because of his crooked teeth[36] and he was the king of Karūṣa.[37]

Both Śiśupāla and Dantavakra were killed by Krishna,[38] with the first being Śiśupāla. It happened that King Yudhiṣṭhira decided to have a big consecration ceremony and invited all the demigods and qualified Brahmins to attend.[39] He also invited other family members who were less than qualified. One of them was Śiśupāla, who was also one of Krishna's cousins. He was angry with Krishna for many reasons, but one of them was that he, Śiśupāla, was supposed to marry Princess Rukmiṇī and the very day of her wedding, Krishna kidnapped her as per her desire and she married Him instead.[40]

Back to Yudhiṣṭhira's ceremony: The most important people of the clan were invited to speak, and when it came to Śiśupāla's turn, he remained seated which in itself was disrespectful, and, then, what's worse, he began to berate Krishna. Śiśupāla didn't just give his opinion about things—he suggested that Krishna wasn't fit to be honored the way the others were honoring Him. He kept going on and on and became more and more offensive as he continued.[41] Some of those present actually covered their ears or left the assembly. Others were so offended by Śiśupāla's words that they threatened to kill him. It was then that Krishna, seeing that the ceremony was about to be disrupted, threw his Sudarśana *chakra* at Śiśupāla, cutting his head off—giving him liberation.[42]

After Śiśupāla's death, Dantavakra became extremely angry and in his anger challenged Krishna to battle, bringing only his anger and a single club to the fray. Krishna, following the rules of military etiquette, armed Himself in a commensurate way, using only a club. As is usual for a demon, Dantavakra hurled meaningless insults at Krishna. Then they fought.

At first he tried to placate the Lord by reminding Him that they were cousins, but then he started to boast again, saying he would tear Krishna into pieces. Just then, he hit Krishna in the head with his club, and not feeling any pain or discomfort, Krishna retaliated by hitting Dantavakra in the chest, splitting his heart wide open.[43] Those present at the confrontation say they saw a small spiritual spark go from Dantavakra's body into Krishna's.

This birth was special for Jaya and Vijaya.

According to Rūpa Goswāmī's *Laghu-bhāgavatāmṛta* (1.5.41–64), the order of births in which Jaya and Vijaya were killed is significant. In their first birth as Hiraṇyākṣa and Hiraṇyakaśipu, they did not realize that Varāha and Nṛsiṁha were Vishnu. They weren't conscious of who it was they were battling with. Similarly, as Rāvaṇa and Kumbhakarṇa, they didn't know who Lord Rāma really was.

However, in their maturity, having evolved over two prior births, things were different. As Śiśupāla and Dantavakra, they were able to perceive that Krishna was in fact the Supreme Lord. More, due to their growing hatred of Him over the two prior lifetimes, they consistently chanted His names, if, unfortunately, in disgust, and that too led to their liberation, so holy is His name. Therefore, as Śiśupāla and Dantavakra, they are described as attaining supreme release. But they did not immediately go to the spiritual world, to be reinstated as the eternal gatekeepers of Vaikuṇṭha. First, they were to undergo one more incarnation—one that would bestow upon them special mercy.

5. Liberation of Jāgai and Mādhāi

In Kali-yuga, the fourth age cycle in which we currently exist, there is a special incarnation of Krishna who not only partakes of His supreme position as *avatārī*, thus allowing Him to be counted

[36] https://en.wikipedia.org/wiki/Dantavakra.
[37] Prabhupada 1972–2010, op. cit., p. 537.
[38] SB 10.78 Purport.
[39] Prabhupada 1972–2010, op. cit., p. 515.
[40] Prabhupada 1972–2010, op. cit., p. 355.
[41] Prabhupada 1972–2010, op. cit., pp. 518, 519.
[42] Prabhupada 1972–2010, op. cit., p. 520.
[43] Prabhupada 1972–2010, op. cit., pp. 536, 537.

amongst the Parāvastha Avatāras, but who has the esoteric dimension of being Krishna in the mood of Rādhā, the female Absolute. This means that He is essentially not only God but also an incarnation of Love Supreme.[44]

This dynamic and confidential *avatāra* is Śrī Chaitanya, appearing on Earth some 500 years ago in Bengal, India.

On one occasion pertinent to our discussion, He asked His chief associates, Nityānanda and Haridāsa: "Please go through the streets of Navadvip, door to door, and ask one and all to sing the name of Hari with devotion."[45] The two enthusiastic preachers went out on the Lord's behalf and accomplished miracles. Soon they met Jagāi and Mādhāi, two wayward Brahmin brothers. Sacred texts tell us that these brothers were the fourth and final incarnation of Jaya and Vijaya.[46]

Addicted to wine and women, Vaishnava texts describe them as debauchees of the worst caliber. When Nityānanda and Haridāsa confronted them, the two missionaries were ridiculed, with Jagāi and Mādhāi saying that they were fools to work on Śrī Chaitanya's behalf.

The two brothers further showed their lack of character by shouting obscenities at Nityānanda and chasing him down the street. Thankfully, the unseemly incident was prematurely aborted, and no harm was done. When Śrī Chaitanya learned later that day that Nityānanda had attempted to preach to such wayward individuals, He commended him.

The next day, however, Nityānanda tried again, but this time it would not end so easily. As soon as he approached the iniquitous brothers, Mādhāi had the audacity to throw a piece of broken pot at him. And when it reached its target, it slightly pierced Nityānanda's forehead, causing blood to flow. He was not swayed. Despite the injury, he quickly forgave them, insisting that they chant the holy name.

Jagāi was impressed. He had never seen such compassion. Nityānanda was clearly in a category of his own, an embodiment of love. As this realization made its home in Jagāi's heart, he began to beseech Nityānanda to excuse his foolish brother. But it was clear from Nityānanda's merciful glance that the pardon was already in effect. Nonetheless, Mādhāi was about to cause Nityānanda more pain. Jagai, however, would not tolerate it, and he stopped him, insisting that they both surrender to Nityānanda Prabhu.

In the midst of this exchange, Śrī Chaitanya suddenly appeared on the scene, furious that someone had offended his dear devotees. Raising His arm in the air to summon His famous weapon—the disc of Vishnu—He prepared to kill the two offenders. Just at that moment, however, Nityānanda stepped in, insisting that the Lord show mercy. He reminded Him of His mission to liberate the most sinful, which was one of the purposes of the Chaitanya incarnation. In essence, Nityānanda reminded him that His was a mission of love, and that the only killing would be that of the demoniac mentality, not a literal taking of life. Nearly everyone in this age, said Nityānanda, is comparable to Jagāi and Mādhāi. To be consistent, wouldn't Śrī Chaitanya have to kill everybody?

44 See *Śrī Caitanya-caritāmṛta*, Ādi 7.9: "Lord Krishna Himself appeared as Śrī Chaitanya Mahāprabhu with all His eternal associates, who are equally glorious." (*sei kṛṣṇa avatīrṇa śrī-kṛṣṇa-caitanyasei parikara-gaṇa saṅge saba dhanya*) Also see *Caitanya-caritāmṛta*, Ādi 4.55: "The love of Śrī Rādhā and Krishna are spiritual aspects of the Lord's internal pleasure potency. Although Rādhā and Krishna are one supreme entity, they separate eternally as two to enjoy the relish of relationship. Now, in the form of Śrī Krishna Chaitanya, these two Supreme entities have again united. I thus bow down to Him, who appears with the sentiment and complexion of Rādhikā even though He is Krishna Himself." (*rādhā kṛṣṇa-praṇaya-vikṛtir hlādinī śaktir asmādekātmānāv api bhuvi purā deha-bhedaṁ gatau taucaitanyākhyaṁ prakaṭam adhunā tad-dvayaṁ caikyam āptaṁ rādhā-bhāva-dyuti-suvalitaṁ naumi kṛṣṇa-svarūpam*).

45 See Bhaktivinoda Thakura's *Sri Chaitanya: His Life and Precepts*. (http://www.purebhakti.com/mission/bhakti-is-love-mainmenu-75/799-life-of-sri-chaitanya-mahaprabhu.html).

46 The tradition's textual source for claiming that Jagāi and Mādhāi were a fourth incarnation of Jaya and Vijaya can be traced to the *Śrī Gaura-gaṇoddeśa-dīpikā* (115): "Jaya and Vijaya, the two doorkeepers of the spiritual world, voluntarily appeared in Śrī Chaitanya's pastimes as the two devotees Śrī Jagannātha and Śrī Madhava." These latter names were awarded to Jagāi and Mādhāi after they converted to Vaishnavism.

Contemplating the words of his dear devotee, Chaitanya accepted Jagāi and Mādhāi as His own, but only on the condition that they reform their behavior. The brothers agreed and became devoted followers of Śrī Chaitanya's movement.

6. Conclusions

While Jaya and Vijaya were given three births as demons with which to learn their lesson and return to the spiritual world, we see that God, in His infinite compassion, gave them yet another birth in which they could achieve the highest level of liberation.

Generally, in Hindu culture, we learn of the *puruṣārthas*, that is, the four goals of man: *dharma* (religious duty, moral values), *artha* (prosperity, economic development), *kāma* (pleasure, love, sense gratification) and *mokṣa* (liberation from material existence). Most people go through a progression over many lives to attain *mokṣa*, or liberation. They evolve through levels of consciousness in the 8,400,000 species of life mentioned in Vedic texts, and when they come to the human form, the Puranic texts tell us, they often spend their lives like Jagāis and Mādhāis, in a nearly subhuman state of consciousness.

Through the hard knocks of life and little grace, perhaps, they gradually see the importance of religious activity, or *dharma*, and due to pious engagement, they may experience some prosperity as a result of their good *karma* (action/reaction schema). Even here, however, they usually squander their good fortune for sense gratification (*kāma*), and get lost again in the whirlpool of material existence.

Still, a fortunate few will use their good fortune to pursue liberation from material life (*mokṣa*), and by the grace of holy association and good sense, they may achieve some level of spiritual accomplishment. And if they perfect that, they may know true liberation from material existence. This is the highest attainment in most Hindu traditions.

That being said, Śrī Chaitanya came to give a fifth *puruṣārtha*, which is known as *premā*, divine love. This surpasses *mokṣa*, or, let us say, it is the highest form of *mokṣa*. By the grace of a pure devotee of the Lord, one may attain this higher destination, but it is rarely achieved.

Due to their fortunate interaction with Śrī Chaitanya and Nityānanda Prabhu, Jagāi and Mādhāi were able to attain such *premā*, thus liberating their real selves—Jaya and Vijaya—in the highest possible sense. This indeed is the perfection of reincarnation and of the entire spiritual pursuit.

Conflicts of Interest: The author declares no conflict of interest.

References

Narayan, Rasipuram Krishnaswami. 2006. *The Ramayana, a Shortened Modern Prose Version of the Indian Epic.* London: Penguin Classics. First published 1972.

Prabhupada, A. C. Bhaktivedanta Swami. 1972–2010. *Krsna, The Supreme Personality of Godhead, A Summary Study of Srila Vyasadeva's Srimad-Bhagavatam, Tenth Canto.* Los Angeles: Krishna Bhaktivedanta Book Trust.

Prabhupada, A. C. Bhaktivedanta Swami. 1977–1982. *Śrīmad-Bhāgavatam (SB).* Los Angeles: Bhaktivedanta Book Trust.

MDPI

Article

Belief in Reincarnation and Some Unresolved Questions in Catholic Eschatology

Bradley Malkovsky

Department of Theology, University of Notre Dame, Notre Dame, IN 46556, USA; bmalkovs@nd.edu

Received: 3 August 2017; Accepted: 30 August 2017; Published: 1 September 2017

Abstract: Mainstream Christianity has always rejected reincarnation teaching in all its varieties, e.g., Greco-Roman, Albigensian, Hindu, Buddhist, New Age, etc. as being incompatible with the biblical understanding of the uniqueness, dignity, and value of the human person, a teaching that is ultimately rooted in the radical understanding of divine mercy and love toward every human being proclaimed by Jesus himself. Nevertheless, there are two strong arguments advanced by reincarnationists against the teaching of one earthly life. The first argument regards reincarnation as a more reasonable expression of divine mercy and love than the disproportionate and unfair infliction of eternal punishment by God upon a human being for a single morally corrupt lifetime. The second argument finds reincarnation to be necessary for the continued exercise of creaturely freedom required for true moral and spiritual maturation. Catholic teaching, by contrast, asserts that a single earthly life followed by purgatory is sufficient for the perfection and completion of the human person. However, in both the satisfaction and sanctification models of purgatory the human person is entirely passive, not actively contributing to its own completion. Such an approach would seem to devalue free human participation in the process of perfection.

Keywords: reincarnation; purgatory; resurrection; Christian anthropology; punishment; free will; divine love; dualism

The compatibility of reincarnation belief with Christian teaching has been the subject of repeated theological discussion and often heated debate since almost the beginning of Christianity's history. Though regularly dismissed by Christian theologians as an incoherent and unpersuasive doctrine, reincarnation teaching has persistently reappeared throughout the centuries in both European and Asian cultures and now also in the Americas, equipped with formidable arguments both in its defense as well as in its challenge to the coherency of Christian teaching about a single earthly life.

We presently find ourselves in the third great period of Christianity's engagement with reincarnation teaching. The first period took place during the second to sixth centuries, when Christian theologians found themselves confronted by Gnostic, Manichaean, and Neoplatonist versions of reincarnation.[1] The second great encounter, not nearly as extensive as the first, took place from the twelfth to fourteenth centuries and involved the Cathars and Albigenses, heterodox Christian groups in France and Italy. This second confrontation was not treated primarily on the theological level, however. Rather, the Cathar attempt to harmonize reincarnation teaching and its attendant anthropological dualism with Christian faith was answered in large part with the violent Catholic

[1] There is no record from this time period as to whether reincarnation belief was an issue for Christian communities in India. Very little reliable information about Christianity in South Asia prior to the fourth century C.E. is available to the historian. The most comprehensive presentation of the history of specifically *Western* notions of reincarnation, including Christian engagement with reincarnation teaching, is Helmut Zander, *Geschichte der Seelenwanderung in Europa: Alternative Religiöse Traditionen von der Antike bis heute* (Zander 1999).

persecution of reincarnation's adherents.[2] The third and present broad encounter, beginning in the second half of the twentieth century, involves a wide range of reincarnation beliefs,[3] but as a whole the seeds for such beliefs seem to have been planted by exposure to traditional Hindu and Buddhist teaching on reincarnation in the late eighteenth and entire nineteenth century as more and more reliable information on the religious heritage of India began filtering its way down from the university lecture halls of European Indologists and philosophers to become more widely available to the non-specialist.

One of the striking characteristics of this present third great encounter, especially in recent decades, and what distinguishes it from the previous two eras, is that today there is less heated polemic taking place between advocates and opponents of reincarnation and more attentive listening going on, a greater readiness to acknowledge the merits of the other's argument while recognizing simultaneously the continued value but also the possible limitations of one's inherited teaching or at least the way that teaching has been articulated. We are no longer always talking past each other, as we have so often done during the past 2000 years. We often find ourselves today, representatives of different ancient faiths, grappling with the interlocking mysteries of life, death, human identity, and hope. Can we continue to learn from each other without compromising or abandoning the most precious insights of our wisdom traditions? How far can our doctrines bend and adjust themselves to the insights of the other without breaking? Or must we finally conclude that our respective positions on the human person and post-mortem existence are finally incompatible?

Traditionally, the main Christian response to reincarnation teaching has been flat-out rejection. The critiques of reincarnation presented by Christian apologetes have been expressed in various ways: sometimes the approach was more philosophical in nature; at other times it was more theological and Bible-based. What has been the general underlying conviction of all the different critiques is the incompatibility of reincarnation with the dignity, unity, and irreplaceable uniqueness of the human person. This understanding of the person is ultimately grounded in God's love for each and every human being. The Christian argument against reincarnation is, then, finally an argument based on divine love and mercy for the human person.

From the Christian theological point of view, then, it is not that reincarnation teaching is unreasonable—in fact, in some respects, and with certain presuppositions, it is a very reasonable position to take with regard to the afterlife—it is just that in the Christian understanding reincarnation is *unnecessary* in view of God's merciful preserving and transforming of the human person in its entirety after death. The Christian position, and not just the specifically Catholic position, is that God's love for each human being is so great that every person is called into permanent union with God *as this particular human individual*. I will come back to that point in a bit with some of the questions and objections that go with it.

It was while studying Catholic theology in Germany more than 30 years ago that I started thinking about reincarnation. I was involved in conversations with a number of people who believed in reincarnation, some of whom were Christian and some of whom were not. Why, they asked, did Christianity not teach reincarnation, when it was such an obviously reasonable and compelling doctrine that solves so many of life's questions, especially questions having to do with the inequality of human suffering and fate? The fact is, I did not know at the time whether the Christian theological and magisterial traditions had ever addressed the question of reincarnation. So I took up the topic for

[2] The Catholic persecution of the Cathars and Albigensians was not solely based on doctrinal disagreements, however. The new movements emerged as a deliberate challenge to the authority of the Catholic clergy and hierarchy, which were regarded as morally corrupt and unchristian. However, a Catholic theological —rather than violent—response to reincarnation from this period was offered by Thomas Aquinas in *Summa Contra Gentiles*, II, c. 83 and in *Scriptum Super Sententiis* IV, d. 44, q. 1, a. 1. Aquinas rejected reincarnation on the basis of his understanding of the soul's natural orientation to the body. See Marie George, "Aquinas on Reincarnation," (George 1996, pp. 33–52).

[3] See Ludger Mehring, *Die Sehnsucht des Menschen nach Heil: zwischen Reinkarnations-Faszination und Auferstehungshoffnung* (Mehring 1993, pp. 36–46). The entries from this footnote and Footnote 1 are evidence that the great bulk of Christian, especially Roman Catholic, theological literature on reincarnation comes from German-speaking countries.

my master's thesis in theology. What I learned surprised me. It turned out that Christian theology, not just that of the magisterium but also of a good number of Christianity's most famous and influential theologians over the centuries, had a long history of responding to reincarnation teaching, going back all the way to the second century. Throughout history, as indicated earlier in this essay, Christian theologians were responding in most instances to people who were not Christian or whom they did not regard as Christian: Gnostics, Manichaeans, and Neoplatonists in the early centuries; Cathars and Albigensians in the Middle Ages;[4] Hindus, Buddhists, and New Age adherents in modern times. It is clear that these reincarnation teachings are all very different, and so are their anthropologies. They do not all agree on what exactly it is that reincarnates[5] and into what forms of life. Most reincarnation models around the world teach the existence of a soul, but some do not. Some teach reincarnation in animal and plant life forms, while others teach reincarnation only in human bodies. Some even teach that the soul reincarnates in two human bodies at the same time. Yet the problem with all of these versions of reincarnation teaching, from the Christian point of view, even if reincarnation is limited to human life forms, is that they fall short of affirming the final value of the human person as a unique composite of body and soul. In the words of Paul Williams, the famous scholar of Mahayana Buddhism and a fairly recent convert from Buddhism to Catholicism, who converted in part because of his rejection of reincarnation: "Christianity is the religion of the infinite value of the person."[6] By person he meant the human being in her unique totality of body and soul.[7]

Of course, to say that Christianity is the religion that values the human person so highly is problematic, given what we know about the violence, exploitation, and other abuses that have been inflicted upon human beings in Christian history. However, theologically speaking, assertions about the extraordinary value given to the human person in Christian teaching should take as their starting point and justification neither the actual Christian historical record in its more dismal dimension nor its opposite, i.e., the positive achievements of Christianity with regard to the championing of human rights and social justice. The starting point, against which all subsequent Christian teaching and praxis about the human person must be measured, should be Christianity's foundation, which is biblical revelation, the unveiling of God's love for humanity, of how God interacts with people and for what purpose, a revelation history that begins with the Jewish people and culminates in Christ. According to biblical revelation, the human person is the focal point of divine mercy. The human person is so valued by God that he or she is called into a permanent union with the divine as this very same person who exists now on earth. All versions of reincarnation teaching are thus seen to fall short of this understanding of the uniqueness, dignity, and value of the human person before an infinitely merciful God who calls each person into a permanent union of love. The human person, then, in standard Christian teaching, is neither the soul alone nor pure changeless consciousness, despite the possibility of remarkable spiritual experiences that give great emphasis to awareness and little emphasis to the body. Even when a human being is able, in some rare instances, to attain a superior state of ego-annihilation, self-realization, or loving union with the divine on earth, as, for example, seen in such Hindu sages as Ramana Maharshi and Sri Ramakrishna, from the Christian point of view,

4 Of course, the Cathars and Albigensians saw themselves as decidedly Christian.

5 See Ivo Coelho, summarizing the position of Richard De Smet, SJ (1916–1997), a Catholic philosopher and Indologist, with regard to reincarnation in Hindu thought: "there is no unanimity about that which migrates, which tends to be understood in widely differing ways: as the *liṅgaśarīra*, or the *jīvātman*, or the *manomaya* (the soul-body unity), or the mind, or the *ahaṁkara*, or the *jīva* or the *liṅga*, or the *atman* understood in different ways … " In popular modern understanding these many concepts have been frequently reduced to simple language about the "soul." See *Brahman and Person: Essays by Richard De Smet* (Coelho 2010, pp. 18–19).

6 *The Unexpected Way: On Converting from Buddhism to Catholicism* note 27 (Williams 2002, p. 227); See also p. 83: "Reincarnation is incompatible with the infinite value of the person."

7 See here Julius Lipner, *Hindus: Their Religious Beliefs and Practices* (Lipner 1994, p. 241), who points out the "dualistic nature of the human person" that is "a basic presupposition of the doctrine of karma and rebirth." While he is here referring to specifically Hindu versions of reincarnation, I think that this assertion applies to most other varieties as well.

such spiritual attainment still does not go so far as to affirm the lasting value and completion of the human person in her unique totality, in union with God, in the face of death.

The transformation of the human person, whereby human identity and awareness are retained and elevated by God in the final state of perfection,[8] after one's time on earth has ended, is what is meant in Christian teaching by resurrection existence. Resurrection is the final perfected state of the human person, and it is caused entirely by God, given as a gift, just as our lives here on earth are a gift of God. Resurrection entails the completion of the human person in a new liberated mode of existence and awareness, a total integration and full participation of the human person in the life of the divine, whereby each person perfectly reveals the glory and beauty of the creator in a unique and singular way.[9] Resurrection is therefore not the transcending of the human as such, though it does involve the transcending of a previous limited way of being human in favor of a new mode of human existence, in what in Eastern Orthodox Christianity is called *theosis* or deification. Resurrection means the transformation of the human person in all her dimensions, including the bodily.[10] However, it is important to also note here the perfected awareness, the higher consciousness, as a component of this new state and not to focus exclusively on the new mode of bodily existence. Resurrection involves a full blissful awakening to the divine mystery, but it is also an awakening to one's particular human mystery, identity, and ultimate value in loving union with the divine.[11]

The Christian theological traditions have always been aware of the limitations of speaking about this new state of transformed existence.[12] It is a condition that transcends our present ontological categories and experience, though not entirely. Even the New Testament accounts of Christ's resurrection appearances, which provide the most important evidence of the nature of the final state that awaits all people, display a noticeable tension. Some passages witness to a degree of bodily *continuity* between the pre-Easter Jesus and the resurrected Jesus, while others emphasize the newness and *discontinuity* of the old body with the new mode of spiritual–physical existence. However, in each case Jesus has not appeared as a mere spirit or ghost. In at least one resurrection appearance he reveals the wounds of his crucifixion.[13] The two kinds of resurrection appearance passages found in the Gospels, i.e., both those emphasizing bodily continuity as well as those giving greater emphasis to discontinuity, must be read together as pointing beyond themselves to a new state of transformed creaturehood. The New Testament writings emphasize that it is the same Jesus in his entirety as a human being who God has made appear to his disciples. Yet this new mode of existence is, quite plainly, very mysterious. The various New Testament accounts should be read together as a kind of informed stammering about the mystery of resurrection existence, all based on the encounter of the disciples with their Lord in his new glorified mode of being. It is clear that there is much about resurrection existence that we are unable to grasp this side of death. Nevertheless, if resurrection stands for anything, it stands for God's infinite love and care for every human being. Resurrection, in

[8] For a good imaginative account of how post-mortem transformation deepens one's awareness and appreciation of their dignity and value as a human person in union with a God of love, see C. S. Lewis, *The Great Divorce* (Lewis 2015).

[9] See Bede Griffiths, "Moksha in Christianity," in X. Irudayaj and L. Sundaram (eds.), *Inter-Faith Dialogue in Tiruchirapalli* (Griffiths 1978, pp. 15–18).

[10] See Philippians 3:21: "He will change our lowly body to conform with his glorified body by the power that enables him also to bring all things into subjection to himself."

[11] Islam likewise teaches resurrection existence after death. With regard to the new perfected awareness that occurs in this final state, see the following famous saying, which is of unknown Muslim origin: "People are asleep, and when they die, they awake." Annemarie Schimmel (1922–2003), the great Christian scholar of Sufism, likewise writing about Muslim belief in the resurrection and emphasizing its dynamic growth in awareness, states: "Once the journey to God is finished, the infinite journey in God begins." Here she is summarizing the thought of Muhammad Iqbal (1877–1938). See her *Deciphering the Signs of God: A Phenomenological Approach to Islam* (Iqbal 1994, p. 239).

[12] See 1 Corinthians 2:9: "What eye has not seen, and ear has not heard, and what has not entered into the human heart, what God has prepared for those who love him." See also 1 John 3:2: "Beloved, we are God's children now; what we shall be has not yet been revealed. See, too, 1 Corinthians 15:35–44 comparing earthly and resurrection bodies.

[13] See John 20:20, where Jesus shows his hands and side.

Christian teaching, is the intended divine final goal for all of humanity. Jesus is therefore called "the first-born of the dead."[14]

Having said this, theological honesty means acknowledging that there are problems with the Christian teaching[15] of one earthly life. The problems are essentially two, and sometimes they are formulated by followers of other religions and philosophies against Christian teaching, and sometimes they are formulated by Christian theologians themselves.

The first objection against only one earthly life has to do with God's alleged punitive activity toward people after they die. This objection involves questions about the existence of hell and God's relation to it. If hell exists and is a place of physical torment, would a God of love really create such a place and send a person there for all eternity—let alone for even one moment—as punishment for the sins of a single lifetime on earth? This would seem to be unreasonable and unbecoming of a God who is supposed to be supremely loving and merciful. Reincarnation would thus seem to be a more reasonable expression of divine mercy and love than the disproportionate and unfair infliction of eternal punishment by God upon a human being for a single morally corrupt lifetime. However, with reincarnation, unlike standard Christian teaching, a person—or perhaps more accurately, a soul—would always get another chance to make amends for past moral transgressions and be able to start anew on the path toward spiritual perfection and liberation.

However, it is not at all clear that contemporary Catholicism actually teaches an understanding of hell as a place or a state of punishment *actively inflicted* by God, despite long-standing doctrine. There are today two Catholic theological positions in tension with each other, perhaps even in opposition to each other, with regard to God and hell. Ambiguity on this topic can be found even in official Church documents and pronouncements. The Catechism of the Catholic Church (CCC), for example,[16] appears to advocate teachings that speak both for and against the idea of God inflicting punishment. In support of the notion that God actively administers torment, the CCC cites certain New Testament passages. One of these is the Gospel of Matthew 13:41–42, where Jesus speaks of God's angels who will "gather ... all evil doers, and throw them into the furnace of fire."[17] In addition, phrases like "everlasting damnation" are used in the Catholic Catechism.[18] Here God actively inflicts punishment on sinners. Yet, perhaps surprisingly, a second position on hell can be found in the very same section of the CCC. Hell is understood now as "a state of definitive *self-exclusion*[19] from communion with God and the blessed." It is a "state" of being separated forever from God's mercy through one's own choice,[20] of freely and willfully refusing the offer of God's love, a love that is intended to complete a person and bring them into full participation in the divine life.[21] Here the

[14] Revelation 1:5. Cf. Roman 8:29.

[15] I will limit myself here primarily to Catholic eschatology, i.e., Catholic teaching on the final perfected state of the human person and the post-mortem process by which this state is made possible. Eschatology more broadly also refers to the final state of the world as a whole.

[16] The *Catechism of the Catholic Church* (hereafter CCC) was promulgated in 1992 by Pope John Paul II. It is a summary of Catholic teaching, written by cardinals, bishops, and other theological experts.

[17] See CCC, article 1034. It is understood here that these punishing angels are doing what God commands of them. However, there are no parallel verses in the other Gospels to these particular verses from Matthew. This raises the question as to whether the words here are authentically from Jesus or whether the writer of Matthew's Gospel placed them in Jesus' mouth.

[18] CCC 1022.

[19] Italics are mine.

[20] Yet we might ask ourselves under what conditions such a radical and free refusal would even be possible. St. Gregory of Nyssa (pp. 335–94), an early Christian saint and theologian, was convinced by the logic of God's infinite power that not only would all people be saved by God's love penetrating the walls of human resistance, but that even the demons themselves would be converted and rescued. Not all scholars today whose expertise is the early centuries of Christian theology are agreed that universal salvation was the expressed teaching of St. Gregory. However, his name does nonetheless regularly appear as an advocate of this doctrine, along with Origen (pp. 185–254) and Isaac the Syrian (pp. 640–700, also called Isaac of Nineveh).

[21] CCC article 1033. See similarly the late Pope John Paul II on hell: "rather than a place, hell indicates the state of those who freely and definitively separate themselves from God, the source of all life and joy." These words were offered at a General Audience at the Vatican on 28 July 1999. See https://w2.vatican.va/content/john-paul-ii/en/audiences/1999/documents/hf_jp-ii_aud_28071999.html. Pope Benedict, in his General Audience on 12 January 2011,

suffering experienced by the human person after death is not a physical torment willfully imposed by God, such as being plunged into a lake of fire. The pain is rather an interior and spiritual one, an inner darkness that is the result of the absence of love. It is the state of a self-destructive and self-enclosed ego that refuses all transcendence, all love, all wholesome inter-personal relations. The point is that in this particular Catholic understanding, hell is a state of willful separation from divine love.

Yet immediately after the pronouncement that hell is a freely chosen *state* of exile from God, we read that those who die in a state of mortal sin "descend into hell, where they suffer the punishments of hell."[22] This clearly sounds like a *place* of punishment and torment prepared by God. In the same discussion about hell in the Catechism there are also passages that quote Jesus—again, from the Gospel of Matthew—who speaks of God *actively banishing* sinners into hell, for example in 25:41: "Depart from me, you cursed, into the eternal fire."[23]

The ambiguity of hell as presented in the Catholic Catechism is ultimately rooted in uncertainty about Jesus' own teachings with regard to the relation of divine mercy and hell. It is clear from the Gospels that the center of Jesus' proclamation is a God of unconditional love and mercy. Jesus calls his listeners to emulate God's unending mercy, to be perfect as the heavenly Father is perfect (Matthew 5:48). This means an infinite readiness to forgive, even forgiving "seventy times seven times" (Matthew 18:22), which is Jesus' way of saying that we must forgive without end. We thus see here a tension with regard to God's activity in the Gospel of Matthew, but it is found in the other Gospels, as well.[24] This is not to deny that Jesus did, indeed, speak of hell and punishment; it is more a matter of how exactly he understood it.

Among contemporary Catholic theologians, despite the ambiguous teachings of the Catholic Catechism, the idea of God actively sending evil people to a place called hell has practically disappeared. The emphasis is now more on God's infinite mercy and how this mercy is greater than a judgment based on justice alone. Thus the argument that the God of reincarnation is more merciful than the God proclaimed by Catholicism is now more difficult to sustain than in the past, in view of contemporary Catholic thought.

Remaining a bit longer with the Catholic Catechism in its section on the resurrection, we find that reincarnation is briefly mentioned, but it is immediately rejected: "When 'the single course of our earthly life is completed, we shall not return to other earthly lives. 'It is appointed for men to die once' (Hebrews 9:27). *There is no 'reincarnation' after death*."[25] This is a succinct and unequivocal statement, but no explicit explanation is given here as to the possible problems associated with reincarnation teaching from the Christian standpoint, nor is there any discussion of the merits of reincarnation belief. The Catechism's rejection of reincarnation is explicitly based on scripture, in particular on Hebrews 9:27.[26] However, the next several verses provide an indirect explanation of why reincarnation is rejected, and this aligns with what has already been discussed in this essay. Reincarnation is rejected, because resurrection of the whole person is affirmed. "We believe in the true resurrection of this flesh that we now possess."[27] In other words, human beings are called into permanent union with God precisely as human beings.[28]

likewise spoke of purgatory as a process, not a place. "Purgatory is like a purifying fire burning inside a person, a painful experience of regret for one's sins." Consequently purgatory takes place both in this life and in the life to come. See https://www.ncronline.org/news/vatican/purgatory-process-not-place-pope-says.

[22] CCC 1035.

[23] CCC 1034.

[24] See Luke 3:7; 13:27–28; 13:34–35; 16:19–31; 21:20–24; Mark 9:43. There is noticeably less talk of hell in Mark, the oldest of the Gospels, than in the other three.

[25] CCC 1013. Italics are mine.

[26] "It is appointed for men to die once, but after this the judgment."

[27] *Catechism* 1017, quoting the Council of Lyons II from the 13th century.

[28] At this point it bears repeating that in Christian thinking, generally speaking, resurrection is not understood as a mere resuscitation of the person into unending life, by which they would live forever in roughly the same mode of existence as before, but rather it is a transformation and integration of the human person in the divine life in conformity with the divine mode of being.

This raises the question of whether any process is described in the New Testament by which God completes and perfects the human person after death. The answer is no. The question of "how" has not been crucial in Christian understanding to believing that this transformation occurs. It is simply the power of God at work. The conviction that this transformation does occur at all is based, as noted earlier, primarily and originally on Jesus' unexpected resurrection appearances to his disciples, as provided by the New Testament.[29] In the Christian understanding God made Jesus appear after death to his disciples in a new glorified state, but no theological explanation is provided in the key scriptural passages with regard to the exact nature of his resurrection body or the process by which God caused his resurrection.

The second objection to belief in only one earthly life is the possibility of integrating reincarnation into Christian teaching. It is based on the dignity of human free will and the idea that it might contribute to one's spiritual development and final liberation. In contemporary Christian theology reincarnation has sometimes been posited as a possible solution to a particular Christian dilemma involving human free will, a solution articulated most notably by one of Catholicism's most famous 20th-century theologians, Karl Rahner (1904–1984).[30] Rahner presented what to date is perhaps the strongest argument in favor of at least considering reincarnation on the basis of Christian theological principles. The dilemma he addressed concerned the extent and role of human freedom in the process leading to salvation. The problem may be summarized as follows.

According to Rahner[31], the perfection and final happiness or blessedness of a human being can only be thought of as the consummation of a real historical freedom. Rahner's starting point was the dignity of the human person and their exercise of free will. This has to be a freedom that can consciously and willfully choose to open itself to transcendence. Now the Christian doctrine that declares that at death human freedom is both ended and finalized[32]— in heaven, hell, or purgatory—must be seen as relating to the *normal* human life in which a real freedom has at least begun. What of the great number of lives in which a real human freedom, a real decision for or against transcendence, has not yet begun? Rahner's focus was on the death of the unborn and of very young children, but he did not exclude from his considerations the criminally insane and those who have suffered some kind of acute mental or spiritual damage. How are we to imagine the consummation of their freedom and love without their contributing in some way to their own development? How fragmented or abbreviated human lives can be completed after death remains a dilemma in Catholic theology. To imagine, as Catholic doctrine declares, that baptized infants may enter into a blessed state without having first experienced a real freedom is very difficult. How could this consummation take place? Must it be thought of as an external decree and miraculous intervention of God entirely disconnected from human choice and freedom? Such "blessed ones" (Seligen) would be actively loving God for all eternity through no choice of their own, i.e., without having first passed through the normal gate of human freedom. Rahner suggested that this solution did not take seriously the dignity of human nature and freedom. He therefore called it "horrible" (schrecklich).[33]

Rahner consequently raised the question of whether the doctrine of reincarnation, a teaching that has found broad acceptance in the history of religions, might provide some help in solving the dilemma as to how those human persons who have not enjoyed even the beginnings of a normal freedom might reasonably attain a consummation of their freedom in God. The answer would have to

[29] Jewish resurrection belief already existed prior to Jesus' own resurrection. The Pharisees believed in it, whereas the Sadducees did not. Resurrection, then, was a belief Jesus shared with the Pharisees, even before his own death and resurrection.

[30] Other Christian thinkers who have been more confident than Rahner in asserting the necessity of integrating reincarnation teaching into Christian doctrine include John Hick, Geddes MacGregor, Keith Ward, and Perry Schmidt-Leukel.

[31] See Rahner, "Fegfeuer," in: *Schriften zur Theologie* (Rahner 1980, pp. 435–49). See also his *Grundkurs des Glaubens*, in: *Sämtliche Werke*, (Rahner 1999, pp. 416–17).

[32] See *Catechism* 1021: "Death puts an end to human life as the time open to either accepting or rejecting the divine grace manifested in Christ."

[33] (Rahner 1980, "Fegfeuer" p. 447).

be some kind of modified reincarnation teaching, said Rahner, one that would only be *applicable to some people, but not to most*. It would only apply to those human beings who have never truly experienced earthly freedom. Reincarnation would offer the possibility of a moral and spiritual development after death on the basis of an ongoing, self-determining freedom.

The emphasis on the freedom of the will as a necessary component of spiritual development resonates with Hindu theologies as well. Both Hindu and Christian theologians value the freedom of the will to help shape one's final spiritual destiny. Free will is at the heart of their respective soteriologies. In addition, both Hindu teaching on reincarnation and Catholic teaching about purgatory converge with the conviction that spiritual development is possible after death. There is, in fact, post-mortem transformation. However, as Rahner pointed out, this transformation does not occur, at least according to Catholic doctrine, on the basis of a continued exercise of freedom after death. It is perhaps surprising, then, when free will is so highly valued in the Catholic vision of life, that Catholic eschatology rejects the possibility of human free will contributing in some way to one's post-mortem spiritual development. Reincarnation, by contrast, values free choice both in this life and in the life or lives to come. This would then seem to be the advantage of reincarnation doctrine over Christian teaching: it offers further opportunity after death for self-determining freedom.

However, Rahner wrote, were reincarnation teaching to be integrated into Christian teaching, it would face an insuperable anthropological obstacle: it would have to reduce the identity of the human person to a spiritual substance alone.

Understandably, after placing such restrictions on the process of reincarnation, Rahner was unable to even begin describing what this new Christian teaching of reincarnation might look like. He was only suggesting. He felt that any talk of reincarnation must inevitably run up against the kind of anthropological dualism that Christianity expressly repudiates, one that emphasizes the ultimate value of the soul alone, not of the human person in his or her entirety.[34] Rahner finally left such questions about the post-mortem completion of human beings who had never experienced earthly freedom to God's unimaginable mercy and power.

It is perhaps worth going a bit more deeply into Catholic teaching on purgatory, in order to understand both its value and its limitation in thinking about post-mortem spiritual development, especially when compared to reincarnation teaching. In Catholic teaching those who are in the state of purgatory will eventually reach a state of perfect union with God; there is no possibility of them being lost. However, as Rahner pointed out, quite correctly, in Catholic teaching, after death there is no continuation of decision-making for or against God, for or against the good, for or against love, transcendence, etc. Nevertheless, purgatory teaching, like reincarnation, recognizes the need for continuing spiritual development and completion after death, since the great majority of human beings die in an unfinished and imperfect state.[35]

There are two purgatory models here: "satisfaction" and "sanctification." The first is punitive; the second is not. The satisfaction model has, until recently, been the one more emphasized by

[34] This is perhaps the reason that Origen (ca. 185–254), one of the greatest Christian theologians of all time, postulated a novel theory of rebirth in his *First Principles*. Instead of teaching the journey of a soul through *multiple* bodies (he argues against this in his *Commentary on Matthew* and *Against Celsus*), he advocated that each person, existing as a *unity of body and* soul, traversed *multiple* worlds, i.e., a succession of ever-higher spiritual environments, until finding its completion in the resurrection. This allowed Origen to preserve the integrity of the human person as a composite of body and soul while allowing that person more than a single lifetime to reach its ultimate goal. This was a new version of the need for a succession of lives, but multiple worlds now replace multiple bodies. Origen considered human perfecting to be a very long process, indeed; hence the need for multiple lifetimes. His theory may be seen as evidence that biblical anthropology and biblical witness to Christ's resurrection finally dominated his thinking over his dualistic tendencies of valuing the soul alone. The emphasis that Origen placed on human freedom and the long road to perfection thus makes him an ancient precursor of a modern reincarnation motif, though he would not have advocated reincarnation itself.

[35] Some of the most creative thinking on purgatory in recent years has been offered by Jerry Walls. See especially his *Purgatory: The Logic of Total Transformation* (Walls 2012) and *Heaven, Hell, and Purgatory: Rethinking the Things That Matter Most* (Walls 2015).

Roman Catholicism, but nowadays Catholic theologians, including the late Pope John Paul II,[36] have begun articulating the doctrine of purgatory in more personalistic terms, describing the spiritual transformation that takes place after death when the human person finds herself in the unmediated presence of a personal God of infinite purity, love, mercy, and truth.[37] This more personalistic or even mystical understanding of purgatory is, then, the position expressed by the sanctification model.

In the alternative view of purgatory, i.e., in the *satisfaction* model, to put it somewhat crudely, divine justice demands that people be punished for earthly sins they have committed, even if God has already approved their eventual entry into heaven. According to this punitive understanding of purgatory, it is only right and just that people are forced to pay the price for their sins before being allowed to enter into the eternal presence of a God of infinite holiness and justice. In this model God *sends people away to a place* called purgatory, which may or may not be a realm of fire, depending on one's theology, in order to be punished and purified. Purgatory here is a place of strict retribution and divinely administered pain for venial or minor sins committed on earth. This is more or less a legalistic courtroom-like understanding of God, who is presented here as an exacting judge, more concerned with demanding justice and punishment than with offering mercy and boundless love. It is almost as if God is saying, "I will be your God of love and mercy, but I am so offended by your behavior and sin that I command you to be first sent away from my presence to a place of punishment. After you have paid the price for your sins you may experience my love in heaven." Some theologians who understand purgatory in this way add that the punishment meted out by God in purgatory is a way of *making people pure enough to enter into the divine presence*. This explanation is puzzling. It fails to explain how people are made pure through punishment or why a God of unconditional and infinite love would inflict it. It is not clear how a purely penal understanding of purgatory would help make the sinner holy. The God of love seems to have vanished and been replaced by a God of strict and unbending justice. The emphasis in the satisfaction model is not even on the sinner's possible contrition and remorse, but rather on the act of God's just punishment.

To counter this understanding of a God who does not allow impure persons to enter into God's presence, one need only cite the many passages in the New Testament that show God unconditionally loving and seeking out the sinner through Jesus, i.e., of Jesus reaching out to those persons in society who were regarded as the most impure and godless, such as the prostitute and the tax collector. He engages them as they are and even shares a meal with the tax collector Zacchaeus. All are allowed to stand in his presence. He does not preach to them from afar. He does not set conditions for their interaction.

By contrast, the *sanctification* model does not understand purgatory as a place set apart from the divine presence. Purgatory is rather a process of interior purification, suffering, and growth that takes place through one's *living encounter* with a God of infinite love, purity, truth, and mercy. Here judgment and mercy are one. Purgatory in this understanding is the process of painful and blessed change a person undergoes in the presence of a Person of infinite love, goodness, and truth. It is a process that deepens one's capacity to love God. It is a state whereby we become gradually detached from earthly attachments that prevent us from loving God as we ought. The sanctification model is thus a more spiritual and mystical understanding of purgatory than the satisfaction model. Yet in neither the satisfaction nor sanctification models of purgatory do we find anything like the active exercise of free will contributing to one's union with God. In both models the human subject appears to be entirely passive.

There are a number of other things here that I do not have time to address at great length, three of which are perhaps worth at least briefly mentioning. The first is the Catholic teaching, articulated

[36] See note 21 above and also especially the writings of Hans Urs von Balthasar (1905–1988).

[37] See here the now classic essay by Gerhard Lohfink, "Was kommt nach dem Tod?" in: *Naherwartung, Auferstehung, Unsterblichkeit: Untersuchingen zur christlichen Eschatologie* (Lohfink 1975, pp. 133–48). This theological reflection has never been translated into English.

especially by Aquinas, that after the death of the body the soul continues to exist in an interim or in-between state until the day of the resurrection, a time when the human person in their entirety as body and soul is restored and brought into perfect union with God. In this interim state the soul exists in an unnatural condition without the body, but the soul does exist, nonetheless.[38] This understanding of post-mortem existence has been challenged in recent decades by some Catholic theologians as dualistic and not in conformity with the biblical and more holistic understanding of the human person. What is striking about the interim-state teaching in the context of reincarnation discussion is that such a Catholic interim-state anthropology resembles much of Hindu reincarnation anthropology, the very anthropology that Catholic theology normally rejects as dualistic.

The second point is this: if the sanctification model of purgatory is to be regarded as an expression of divine love, then further theological reflection is needed to show how a person might grow in freedom and love after death without being able to exercise their free will. Is the human person entirely passive after death or not?

The third and final point has to do with issues involving the identity of the human person as including the body. This essay has not addressed these issues from a philosophical or psychological perspective. This is an approach that is central to the arguments of many adherents of reincarnation as they offer reasons why the body should not be regarded as an essential component of selfhood. This essay has attempted rather to respond to the value of the person and the hope of the resurrection from a theological point of view rooted in biblical revelation and the experience of God's love in Christ. However, these differing convictions about the body should not obscure the fundamental agreement between Christians and followers of other religions who believe in reincarnation, namely that bodily existence in the world is experienced as a problem to be overcome. One desires to transcend the limitations of earthly embodiment. The earthly body is finally experienced as unsatisfactory. It is a place of illness and disease. The body ages and withers, and one eventually suffers a gradual diminishment of physical and mental powers. People, in addition, experience themselves as a reality that transcends their own body. They experience the body as an object of their awareness. A person, therefore, has the conviction of being more than the body or, from a different perspective, as finally not being a body in any ultimate sense. One's relation to one's body is such a mysterious thing that it is no wonder that so many interpretations have been given to it by the different religions and philosophies throughout history.

In light of Christ's incarnation and resurrection, Christians are called to see each person they meet as an embodied expression of God's love, as someone loved by God into existence and called into eternal life as God's special beloved. Resurrection faith can lead to an opening of one's eyes, as it were, to a deepened appreciation of the particularity of the other. In the words of the Christian philosopher Chad Meister, "if you truly love someone, you would not want that person to cease to exist." (Meister 2014, p. 111).

Conflicts of Interest: The author declares no conflict of interest.

References

Coelho, Ivo, ed. 2010. *Brahman and Person: Essays by Richard De Smet*. Delhi: Motilal.

George, Marie. 1996. Aquinas on Reincarnation. *The Thomist* 60: 33–52. [CrossRef]

Griffiths, Bede. 1978. Moksha in Christianity. In *Inter-Faith Dialogue in Tiruchirapalli*. Edited by X. Irudayaj and L. Sundaram. Madras: SIGA.

Iqbal, Muhammad. 1994. *Deciphering the Signs of God: A Phenomenological Approach to Islam*. Albany: SUNY.

Lewis, Clive Staples. 2015. *The Great Divorce*. New York: HarperOne. First published 1946.

[38] Most Protestant eschatologies reject the interim state teaching. Rather the whole person dies, and the whole person is restored to life by God in the resurrection. There is no continuation of an immaterial part of a person, i.e., the soul, after death and prior to the resurrection. There is, therefore, also no purgatory after death.

Lipner, Julius. 1994. *Hindus: Their Religious Beliefs and Practices*. New York: Routledge.

Lohfink, Gerhard. 1975. Was kommt nach dem Tod? In *Naherwartung, Auferstehung, Unsterblichkeit: Untersuchingen zur Christlichen Eschatologie*. Freiburg: Herder.

Mehring, Ludger. 1993. *Die Sehnsucht des Menschen Nach Heil: Zwischen Reinkarnations-Faszination und Auferstehungshoffnung*. Altenberge: Oros.

Meister, Chad. 2014. *Philosophy of Religion*. New York: Palgrave Macmillan.

Rahner, Karl. 1980. Fegfeuer. In *Schriften zur Theologie*. Zürich: Benziger Verlag, vol. XIV.

Rahner, Karl. 1999. Grundkurs des Glaubens. In *Sämtliche Werke*. Zürich: Benziger Verlag, vol. 26.

Walls, Jerry. 2012. *Purgatory: The Logic of Total Transformation*. New York: Oxford University Press.

Walls, Jerry. 2015. *Heaven, Hell, and Purgatory: Rethinking the Things That Matter Most*. Grand Rapids: Brazos Press.

Williams, Paul. 2002. *The Unexpected Way: On Converting from Buddhism to Catholicism*. New York: T& T Clark.

Zander, Helmut. 1999. *Geschichte der Seelenwanderung in Europa: Alternative Religiöse Traditionen von der Antike bis Heute*. Darmstadt: Wissenschaftliche Buchgesellschaft, 869p.

Erratum

Erratum: Belief in Reincarnation and Some Unresolved Questions in Catholic Eschatology. *Religions* 2017, *8*, 176

Religions **Editorial Office**

MDPI AG, St. Alban-Anlage 66, 4052 Basel, Switzerland; religions@mdpi.com

Received: 15 January 2018; Accepted: 15 January 2018; Published: 19 January 2018

The editorial team of the journal *Religions* would like to make the following changes to the published paper (Malkovsky 2017):

For note 20 the "pp.", which appears three times, should be deleted.

We apologize for any inconvenience caused to the readers by this changes. The change does not affect the scientific results.

Reference

Malkovsky, Bradley. 2017. Belief in Reincarnation and Some Unresolved Questions in Catholic Eschatology. *Religions* 8: 176. [CrossRef]

Article

The Reality and the Verifiability of Reincarnation

Ankur Barua

Faculty of Divinity, University of Cambridge, Cambridge CB3 9BS, UK; ab309@cam.ac.uk

Received: 31 July 2017; Accepted: 22 August 2017; Published: 24 August 2017

Abstract: We investigate the topic of reincarnation by revisiting a recent debate from the pages of the journal *Philosophy East and West* between Whitley Kaufman, who presents five moral objections to karma and reincarnation as an explanation for human suffering, and Monima Chadha and Nick Trakakis, who seek to respond to Kaufman's critiques. Our discussion of four of the problems analysed in their exchange will suggest that while the rejoinders of Chadha and Trakakis to Kaufman consist of plausible logical possibilities which successfully rebut some of his criticisms, the scenarios that they sketch are grounded in specific metaphysical theses about the nature of the human person and the structure of reality. The cogency of the responses that Chadha and Trakakis formulate is integrally related to the acceptance of these metaphysical presuppositions which need to be highlighted more clearly as we seek to understand what is at stake in the dispute.

Keywords: reincarnation; karma; verifiability

1. Introduction

A conceptual survey of the source-texts and the extensive commentaries of classical Vedantic systems indicate that while they all point to liberation from the *karmic* cycles of reincarnation (*saṃsāra*) as the highest goal of human existence, they rarely take up the reality and the dynamics of reincarnation as topics for extensive discussion. The classic debates, for instance, between Advaitins and Viśiṣṭādvaitins are centred around the question of *who* or *what* seeks liberation from *saṃsāra* (according to the former, an individual self who is ultimately metaphysically insubstantial, and according to the latter, an individual self who is real and metaphysically dependent on the personal Lord). However, the great masters such as Śaṃkara, Rāmānuja, and others do not extensively discuss the *how* of the *karmic* processes of reincarnation which is said to guide the quest for liberation that stretches across aeons (*yuga*) of cosmological time. The non-Vedantic Hindu systems such as Sāṃkhya, Yoga, Nyāya, and Vaiśeṣika too, all with their distinctive conceptions of *mokṣa*, often presuppose the reality of reincarnation in sketching out their soteriological understandings. Thus, while classical Hindu thought is characterised by vigorous philosophical disputes over questions relating to the nature of the self, consciousness, the structure of logical reasoning, the status of universals, moral action, and others, the reality and the dynamics of reincarnation do not usually receive a systematic presentation, conceptual analysis, and rational defence through dialogical engagements with a doctrinal opponent (*pūrvapakṣa*). These themes, however, have become a matter of intense debate within contemporary circles of Hindu modernity, and more widely in some western philosophical circles, as reincarnation increasingly receives greater attention. An enormous base of literature has accumulated over the last five decades or so, which approaches reincarnation from the varied perspectives of the locations of the belief in Indic religions, theosophy, and New Age spirituality, and also the academic disciplines of (para-)psychology, psychotherapy, quantum physics, and others.

Our aim in this essay is not to provide a comprehensive survey of the diverse historical locations and the conceptual formulations of beliefs relating to reincarnation. We will specifically investigate the topic of reincarnation by revisiting a recent debate from the pages of the journal *Philosophy East and West* between Kaufman (2005, 2007), who presents five moral objections to *karma* and reincarnation

as an explanation for human suffering, and Chadha and Trakakis (2007), who seek to respond to Kaufman's critiques. Our discussion of four of the problems analysed in their exchange will suggest that while the rejoinders of Chadha and Trakakis to Kaufman consist of plausible logical possibilities which successfully rebut some of his criticisms, the scenarios that they sketch are grounded in specific metaphysical theses about the nature of the human person and the structure of reality. The cogency of the responses that Chadha and Trakakis formulate is integrally related to the acceptance of these metaphysical presuppositions which need to be highlighted more clearly as we seek to understand what is at stake in the dispute. This analysis of metaphysical foundations will not, of course, lead to a conclusive resolution of their debates. At one level, it is asking too much of any philosophical discussion that the disputants arrive at a consensus, and this cognitive failure can be seen as another instance of the 'rather depressing general truth' noted by Van Inwagen (2006, p. 2) that 'no philosophical argument that has ever been devised for any substantive thesis is capable of lending the same sort of support to its conclusion that scientific arguments often lend to theirs'. However, at another level, to understand *why* two parties arrive at divergent conclusions in a philosophical dispute we often have to sketch the distinctive metaphysical backgrounds against which their arguments are formulated.

As an initial example of how the disagreements between Kaufman, on the one hand, and Chadha and Trakakis, on the other hand, often turn around the axes of deeply contested metaphysical views, consider Kaufman's discussion of the death problem, which is the problem of explaining 'the paradigmatic case of innocent suffering: death itself' (Kaufman 2005, p. 23). Kaufman responds to his critics' charge that he has failed to appreciate the Hindu and Buddhist view that human existence is saturated with suffering with the assertion that for 'any reasonable person this claim is patently false. As anyone can attest, life is not merely suffering and pain, but full of happiness and pleasure as well (are they denying that pleasure and joy even exist?)' (Kaufman 2007, p. 558). In their earlier response to Kaufman, Chadha and Trakakis had drawn on the verse in the *Yoga-sūtras*, which states that for the discriminating individual 'all is nothing but pain', in their presentation of the 'bleak view' of the human condition in the classical Indic sources. Therefore, they conclude that the pursuit of worldly happiness 'will inevitably lead one into deeper trouble, since all life is suffering...Kaufman, then, does not pay sufficient attention to the theoretical background of the theory of karma and rebirth, and as a result fails to appreciate the way in which life and death are evaluated by the karma theorist' (Chadha and Trakakis 2007, p. 545). Kaufman's parenthetical remark indicates why the dispute here involves a fundamental metaphysical point: 'are they denying that pleasure and joy even exist?' While the classical systems of Yoga and Buddhism do not, in fact, deny that human beings occasionally experience happiness, they claim that even such moments, *because* all is impermanent, are suffused with suffering. They argue that people who claim to have found some amount of happiness (though not entirely unmixed with pain) and view the whole as positively good are in a state of spiritual ignorance. The metaphysical assumption that lies at the basis of this evaluative thesis can be phrased in this manner: that which is impermanent or subject to transmutation is deficient in worth, and the supreme end is an incomparably valuable state which cannot be lost or superseded. As Keith Yandell has pointed out: 'There is a tendency in Indian metaphysics (as well as elsewhere) to think in terms of what exists permanently or everlastingly as really existing and of what exists only for a time as existing defectively or not at all' (Yandell 2001, p. 173). Since the phenomenal world, according to Yoga and Buddhism, is transient, it cannot be the source of genuine satisfaction, even if it is the milieu of intermittent joys and pleasures. Our discussion of the exchange between Kaufman, and Chadha and Trakakis, on four problems, namely, the memory problem, the proportionality problem, the free will problem, and the verifiability problem, will indicate that the shape of their arguments and their counter-arguments is informed precisely by such metaphysical presuppositions. While we discuss these four problems in the same order in which they appear in Kaufman's original essay, we will see that the fourth problem relating to verifiability is the conceptual heart of the argumentative exchange. The memory problem, the proportionality problem, and the free will problem all lead to,

from three different but overlapping perspectives, the question of whether we have any rational means or procedures of verifying the theory of karma and reincarnation.

2. The Memory Problem

A recurring objection to belief in reincarnation in the literature is that since individuals do not usually recall their putative past lives, they cannot be held as morally culpable in this life for alleged crimes that they do not remember. Mariasusai Dhavamony (Dhavamony 1991, p. 162) argues that the 'doctrine cannot be reconciled with the fact that there is no continuity of consciousness of people between their past and present lives. Justice requires that the same conscious person who sinned must be punished for his or her own crime and no other'. Therefore, the processes of karma and reincarnation cannot serve as an instrument for moral education, since we do not know what our past errors are for which we are presently said to be undergoing suffering. Thus, Kaufman notes that 'the rebirth theory fails to respect the moral agency of the sinner in that it is apparently indifferent to whether or not he understands that what he has done is wrong' (Kaufman 2005, p. 20). At least three types of responses have been offered in defence of reincarnation. The first relates to a metaphysical point: even though we do not (usually) have such powers of recall, this epistemic inaccessibility does not in itself disprove the metaphysical reality of a reincarnating self. This point is tersely stated by S. Radhakrishnan: 'The metaphysical question of the continuity of the self is not in any way affected by the discontinuity of the memory' (Radhakrishnan 1988, p. 237). Just as merely because we do not remember parts of our early childhood, we do not conclude that those stages did not exist, the fact that most of us do not (claim to) have memories of another life does not conclusively demonstrate the falsity of reincarnation. The second is to claim that the (general) absence of recall is, in fact, beneficial to our moral progress, and is an integral aspect of the mechanism of reincarnation. If our mind was overburdened with memories of past transgressions, we would not be able to keep our attention focussed on the path ahead that leads to moral improvement. Therefore, there is a 'great blessing in this forgetfulness, for sometimes our past recollections prove to be most fatal to our progress. They hang over us like dark clouds overshadowing our destiny' (Paramananda 1961, p. 94). Swami Satprakashananda brings together these responses when he argues: 'We do not have the recollection of our childhood days even. Does it mean we did not exist as children? We are liable to forget early periods of this very life. No wonder we do not remember our former life or lives. And it is a great blessing we do not. Otherwise our present existence would have been complicated to the extreme' (Satprakashananda 1984, p. 5).

Chadha and Trakakis pursue aspects of these responses to argue, against Kaufman, that the conscious memory of past errors is not a necessary condition for an individual to acknowledge them as their own. They give the example of a drunk driver who kills a pedestrian, and then falls into a coma after colliding with a pole. Though on recovering consciousness, the driver does not have any awareness of the accident, a court of law would reasonably charge the driver as guilty. Likewise, even though we do not remember the specific details of past mistakes, the theory of karma requires us to acknowledge them (Chadha and Trakakis 2007, p. 536). As a response to Kaufman's charge that the doctrine of karma leaves no conceptual space for the vocabulary of moral improvement, Chadha and Trakakis rightly argue that individuals can accept that certain forms of punishment have been justly inflicted on them, and utilise these punitive measures as contexts for moral growth, even if they are currently unable to spell out the precise details of their errors. Thus, the driver can state: 'Even though I do not remember being involved with the accident, I vicariously repent for the errors of the *I* on that occasion, and I resolve never again to drink before driving'. However, another look at the scenario involving the driver indicates a crucial disanalogy. A driver who believes the statements offered by the court regarding the accident does so on the grounds of the belief that the legal authorities are not being deceptive and have reliable access to the truth of the matter. The basic point is whether, to sustain the analogy, we have such credible grounds for the belief that even though we do not remember past mistakes from a supposedly previous life, we did, in fact, commit them (Perrett 1987, p. 56).

The same disanalogy applies to the example relating to our childhood: we believe, on the grounds of the testimony of our parents whom we regard as reliable witnesses, that we existed during the childhood years of which we have no conscious memory. Once again, the vital point is this: given that we are not able to specify any correlations between our present suffering and past mistakes, whether there are any trustworthy witnesses whose reports regarding a reincarnating self are veridical.

The debate now turns on the metaphysical point whether, in fact, reincarnation is a reality. The third response to the memory problem (we noted two earlier) is that some spiritual adepts, who have undergone specific disciplines (*sādhana*), are able to access their past lives, the implicit claim being that there really are such prenatal existences (Abhedananda 1964, p. 29). Thus, the Buddha claims at various places in the Pali Canon the ability to recall past lives (for instance, *Majjhima Nikāya* I.248). The *Manusmṛti* (*c*. 200 CE) states in this vein: 'By reciting the Vedas constantly, by performing purifications, by engaging in ascetic toil, and by showing no hostility to any creature, he gets to remember his former birth'. We may regard memories as certain capacities or dispositions which are carried over across lives, and which link together multiple existences. Even though there are at present no conscious memories of previous lives, as individuals advance spiritually, they become capable of retrieving these deep memories from (subconscious) mental streams. Kaufman, however, discounts all such claims of putative pre-existence: 'I am unaware of a single verified historical example of anyone having a memory of one's deeds in a past life presented as explanation for present suffering' (Kaufman 2007, p. 557). The dispute between Kaufman, and Chadha and Trakakis, is therefore not simply over whether the theory of reincarnation is free from logical inconsistences and moral objections, but whether reincarnation has, *in fact*, taken place.

The acceptance of the theory of karma, which 'says nothing specific about *when* and *in what form* the rewards and punishments will be meted out' (Chadha and Trakakis 2007, p. 537), then, rests ultimately on trust. The argument will then run as follows: we believe that we are involved in cycles of reincarnation directed towards spiritual perfection, even though we have no knowledge regarding the 'how' of the underlying mechanisms, *because* we trust in (the omniscience of) figures such as the Buddha, the Hindu *yogis*, and so on. Stephen Phillips argues, in this connection, that just as sense perception has epistemic value in its ordinary operations, yogic perception too can reveal to us features of reality. We should not dispute the veridicality of yogic perception unless we have specific reasons to doubt its deliverances. Therefore, we should 'assume that meditation and other yogic experience has a noetic or cognitive quality, being both taken as informative about some pretty important matters, such as the death-spanning nature of our consciousness, and informative in fact. There is no general reason we should not trust our teacher's testimony' (Phillips 2009, p. 134). As debates in (Christian) philosophy of religion over the relation between 'faith' and 'reason' indicate, what is one's person's trust is another person's dogma. Thus, we find Chadha and Trakakis speaking of hope in the moral processes of reincarnation: 'The hope that a just punishment will be meted out the criminal at some future time is sufficient to sustain our faith in the legal system as a means of moral education, and a similar hope motivates the belief that the law of karma can allow for the moral development of the individual' (Chadha and Trakakis 2007, p. 537). Grounding the belief in justice on scripture, A. Sharma similarly writes that though the virtuous often suffer and the wicked prosper, Advaita Vedanta 'maintains that such injustice is only apparent and not real—that *ultimately* appearances notwithstanding, cosmic justice prevails' (Sharma 1990, p. 234). We are therefore enjoined by Swami Paramananda to 'work diligently and prayerfully and always remember that in this universe there is no such thing as chance or injustice' (Paramananda 1961, p. 56). For Kaufman, in contrast, it is precisely such affirmations of trust and hope, even when no karmic correlations across reincarnations have been or can be specified, that seem to involve a doctrinaire stance. He argues that the response of Chadha and Trakakis to the memory problem is 'simply the dogmatic insistence that one should simply have faith: karma tells us that our present sufferings are correlated with past deeds, and that's the end of the discussion. It should suffice that one knows one is being punished for an unspecified

wrong committed at an unspecified time and place, because that is what karma says' (Kaufman 2007, p. 557).

3. The Proportionality Problem

While the theory of karma and reincarnation states that there are necessary connections between moral acts and their deserts (in the form of rewards or punishments), the severity of the suffering that many people undergo seems grossly disproportionate to any evil that they may have committed. Regarding the sufferings of the inmates of Auschwitz, the agony of millions who have died of starvation and various incurable diseases, and so on, the proportionality principle would require that to undergo such horrendous torment in this life, they would have been viciously evil people in past lives. And herein lies the problem, according to Kaufman, for it is 'hard to see what sort of sins the sufferers could have committed to deserve such horrible punishment' (Kaufman 2005, p. 21).

Chadha and Trakakis rightly claim that the karmic theory is not presented as a predictive tool regarding the timing and the form of rewards and punishments, for only an enlightened one such as the Buddha is supposed to know the detailed workings of the karmic mechanisms. However, there are indeed some scriptural layers which are quite forthright in detailing connections between past error and present misery. According to the *Manusmṛti* 12.55–68, a Brahmin who steals becomes in a subsequent life a spider, snake, or vicious ghoul, while stealers of specific objects attain specific rebirths: by stealing grain one becomes a rat, by stealing deer a wolf, by stealing a horse a tiger, and so on (Olivelle 2004, p. 215). The voluminous *Purāṇas* do not hesitate, on occasion, to lay down such chains of consequentiality. For instance, the *Varāha Purāṇa* 203.13–18 says that people who deal in the flesh of animals suffer torments in hell, take birth as human beings with mutilated limbs, and suffer from various physical and mental ailments (Iyer 1985, Part II, pp. 623–24). The *Bhāgavata Purāṇa* VI.1.45 even provides a terse formula which highlights the presupposition of universal justice in the theory of karma and reincarnation: the same person enjoys the fruits of the same meritorious or demeritorious act in the next world in the same manner and to the same extent according to the manner and extent to which that act has been performed in this world (Tagare 1976, Part II, p. 779). The negative formulation of this principle of proportionality—no aggregation of finite human errors can be commensurate with everlasting punishment—is often employed in Hindu rejections of the possibility of eternal damnation: 'Even if we have made innumerable mistakes, we cannot suffer eternally, because for a finite action there cannot be an infinite punishment, since action and reaction must always be equal' (Paramananda 1961, p. 52). Swami Nikhilananda argues in a similar manner that '[t]o believe in the eternal punishment of the soul for a mistake of a few years is to go against the dictate of reason' (Nikhilananda 1968, p. 23). Interestingly, from a Christian standpoint, G. MacGregor uses this principle to argue for the compatibility of Christian soteriology and belief in karma and reincarnation. Pointing out that different individuals receive different sets of chances to respond to God in their widely different spans of earthly life, MacGregor argues: 'The notion that each is to be judged for all eternity on the basis of such disparate opportunities is totally incompatible with the concept of a beneficent and almighty God...The doctrine of transmigration fits perfectly as a Christian interpretation of Purgatory' (MacGregor 1991, pp. 94–95). The positive formulation of the principle—infinite perfection cannot be attained in the short span of just one lifetime—is developed by S. Radhakrishnan in this way: 'The self aims at fulfilment of function or development of individuality...We cannot in one life exercise all the powers we possess or exhaust all the values we strain after...There are no blind rushes to the goal. The children of a God in whose eyes a thousand years are as a day need not be disheartened if the goal of perfection is not attained in one life' (Radhakrishnan 1988, p. 229).

Therefore, given the correlation from the *Bhāgavata Purāṇa*, we could assume that individuals who have suffered horribly in this lifetime had been the equivalents of Hitler, Stalin, and others in their previous existences. Kaufman, however, objects precisely to such proposed correlations: 'People who suffer terribly really must have been horribly sadistic, brutal, and Nazi-like in past lives. But this is just my point: such a claim is highly dubious. Even a superficial knowledge of

history and of human nature makes it simply implausible that so many people could have been so evil' (Kaufman 2007, p. 557). The disagreement at this stage between Kaufman, and Chadha and Trakakis is, then, an evaluative-metaphysical dispute about the depths of human depravity. Since for every St Francis there is at least one (if not more) Nero, and for every Hitler at least one (if not more) Bartolomé de las Casas, a mere tabulation of Altruists versus Sadists down the centuries will not yield a conclusive answer to the question as to whether human beings are fundamentally good or fundamentally evil. Kaufman rightly cautions us that an '*a priori* conviction that karma is true can lead one into a distorted conception of reality' (Kaufman 2007, p. 557), to which one should add that an '*a priori* conviction that karma is false can also lead one into a distorted conception of reality'. Thus, the disagreement is over *who*, among the disputations, has the right 'conception of reality'. Consider, for instance, a theological scenario in which human beings are thoroughly depraved, and God, the dispenser of cosmic justice, inflicts punishments on them. These torments seem, from a human perspective, cruelly disproportionate, but from the eternal vantage-point of God, in whom there is no iniquity, they are exactly proportionate. While this possibility saves the theory of karma and reincarnation from the moral objections relating to the proportionality problem, it raises the metaphysical question of whether we actually inhabit this theological scenario. *If* we have reasons, independently of the dispute at hand, to believe that our world is indeed similar to the moral cosmos sketched above, there is ultimately no disproportion between present sufferings, however horrendous they may be, and past actions, however horrifically evil they might have been.

4. The Free Will Problem

The longest section of Kaufman's original article is devoted to various morally objectionable consequences that he claims are consequences of the theory of karma and reincarnation. At the heart of these objections lies the following dilemma: either the theory is a 'complete and closed account of evil and suffering or it is not'. If it is the former, we seem to have a form of strong causal determinism, according to which the present state of the universe is exhaustively explained in terms of its precedent states (which include human actions), so that while the theory can console us that there is no unmerited suffering, it is, in effect, a form of fatalism which denies free moral agency. If it is the latter, it loses its comprehensiveness as a systematic theoretical account of each and every particular instance of suffering that an individual undergoes (Kaufman 2005, pp. 26–27). This dilemma is spelled out in concrete terms through the case of a terrorist who is considering whether or not to detonate a bomb in a civilian area. If karma operates in rigidly deterministic fashion, then it is not up to the terrorist to do whatever that is, in fact, done, for whether or not people are killed is an eventuality that is determined by their karmic merits or demerits. If the bomb is indeed detonated, leading to civilian casualties, the terrorist can 'justify them to himself by saying he is merely an agent for karma, carrying out the necessary punishments for these "wicked" people' (Kaufman 2005, p. 25). However, if karma does not constrain human action in this ineluctably deterministic manner, so that it is up to the terrorist whether or not to detonate the bomb, we admit 'the genuine possibility of gratuitous evil, innocent suffering—just what the theory was designed to deny'. That is, if the terrorist, who exercises free agency in the matter of whether or not to detonate the bomb, does detonate it, he would inflict undeserved and random suffering on those who are killed.

The response of Chadha and Trakakis to Kaufman on this point rightly notes that the traditional presentations of the karma and reincarnation presuppose a libertarian, or at least a compatibilist, account of free will, so that even though one's character and dispositions have a causal history, these antecedents do not undermine one's free agency (Chadha and Trakakis 2007, p. 548). As Swami Paramananda points out: 'We have brought our ideas, our instincts, our good feelings and also our obstacles with us. But that does not mean that since this life is the product of Karma, its conditions are inevitable. No matter what we have brought, we can adjust and readjust and remould' (Paramananda 1961, p. 38). That is, persons are not simply congeries of events within karmic chains, but they can exercise some measure of agency over these causal sequences. The epic narratives, for

instance, often speak of individuals washing away their sins (*punāti pāpam*) through means such as austerities, sacrifices, and gifts (*Mahābhārata* 12.36.1) (Dutt 1997, vol. VI, p. 48). The *Garuḍa Purāṇa* I.230.42 states more assertively that even if the evil deeds of a person are as massive as the mountains, these are destroyed entirely by remembering Viṣṇu (Shastri 1980, Part II, p. 682).

Thus, revisiting the scenario involving the terrorist, the karma theorist can argue that the terrorist exercises genuine moral agency in deciding whether or not to detonate the bomb that will kill, say, 100 individuals. If he does detonate the bomb, he freely 'collapses' to a singular event the complexly-ramified (and possibly overlapping) karmic chains of the 100 individuals who would then receive their moral deserts. He cannot shirk moral responsibility by claiming that 'karma acted through him', for he retains some measure of free agency. While a fatalistic reading of the theory can support a form of amoralism, A. Sharma points out that the Hindu scriptures, in fact, instruct us to help others and avoid hurting them: 'The *same* doctrine of karma and rebirth, which holds us accountable for what happens to us, also urges us to perform good karma rather than bad karma and unattached karma rather than attached karma. Thus, just as doctors go about treating diseases that patients have brought upon themselves, those who subscribe to the doctrine of karma and rebirth are also under an ethical obligation "to help reduce the pain and misery in the world"' (Sharma 2008, p. 573). If, on the other hand, the terrorist does not detonate the bomb, the theoretical claim that all moral actions have necessary consequences, does not, however, lose its systematicity. All that would follow is that on this particular occasion, these 100 individuals did not receive the moral deserts of their karmic actions, but they will on a subsequent occasion through possibly other instrumental means and other causal pathways.

For concrete instances of how the belief in the causal efficacy of karma can be combined with the belief in karmic instruments, we may turn to U. Sharma's fieldwork in a village in Himachal Pradesh in 1966 and 1967 which indicates that the theory of karma is not the only explanatory tool that is used to rationalise the occurrence of suffering. A common way of accounting for misfortune such as chronic ailment is not directly through karma but through the sorcery practised by another person or the anger (*khota*) of a deity or a spirit. Sharma notes that it would seem that it is logically inconsistent to claim that karma accounts for the differential distribution of good and bad fortune and that a particular misfortune is to be explained through sorcery. When this question was put to the villagers, they replied that the latter type of explanations does not negate the efficacy of karma which works instrumentally through human instruments. If one is said to suffer from illness because of the malice of kinspeople, this is an explanation in terms of immediate causes, for if the individual had good karma they would not have succumbed to the sorcery practised upon them. Therefore, the principle of karma, Sharma notes, is 'logically prior to all other possible explanations in the sense that the latter can be reduced to or made compatible with the *karma* doctrine in the final analysis. Secondly, whilst the *karma* principle need not be the theory which the villager turns to first of all in his search for a meaning for the misfortune he suffers, it is generally the last which he will abandon' (Sharma 1973, p. 358).

The case of Judas Iscariot's betrayal of Jesus provides a parallel from Christian doctrine. If Judas were not free (in a libertarian or compatibilist sense) to abandon Jesus, and was predestined to do so in a strong sense, it would (seem to) be unjust on God's part if Judas were to be positively damned. If, on the other hand, Judas was truly free in the matter, and he chose not to betray Jesus, there would have been no crucifixion and resurrection, and hence no salvation for humanity. A possible resolution is, once again, through the horns of this dilemma. Judas did have free will, but even if he had not betrayed Jesus, God would have found ways other than the passion of the Son for the divine work of redemption of humanity. The point of this speculative exercise is not to settle an exceedingly fine dispute in the history of Christian doctrine but to indicate that the defender of karma and reincarnation can analogously claim that even if the terrorist did not detonate the bomb, God, here viewed as the governor of the karmic order, can work with the complexly-intertwined karmic chains of individuals to ensure that specific individuals receive their own moral deserts at some point or the other.

Once again, however, while such a theological scenario might rebut the criticisms of Kaufman, it has to bear a heavy metaphysical load. To begin with, we face the daunting task in the metaphysics of free will of defending an event-causal or agent-causal libertarian account, or a compatibilist account which is distinct from the thesis of causal determinism. Next, we have to operate within a theological universe where God works with and through the karmic chains, in this case of the 101 individuals, to ensure that every moral action has necessary consequences and there is no instance of undeserved suffering. While these interconnections are mind-bogglingly complex from a human perspective, God will, of course, comprehend them in their entirety at a single divine glance. Even if, as in the case of Buddhism, one removes God from the horizon, one still needs a gigantically complex crisscrossing network (*indrajāla*) of interdependent karmic chains, which is accessible not to unenlightened individuals but only to the Buddha and the highest level Bodhisattvas.

5. The Verifiability Problem

If we treat karma and reincarnation as an explanatory account, it seems to be consistent with both the presence and the absence of specific instances of suffering. Thus, to return to the terrorist and the undetonated bomb, if the terrorist had detonated it, the subsequent death of the 100 individuals would be explained by stating that their karmic fruits had ripened, whereas if he had not detonated it, their survival would be explained by stating that their karmic resides had not yet fructified. Karma, treated as a hypothesis, is therefore unverifiable because it has no predictive power, and in fact '[t]here is...not a single verified example in recorded history of a successful prediction being made on the basis of karmic causation' (Kaufman 2007, p. 559).

Chadha and Trakakis respond that while some of us may not have verified the karma theory *in practice*, the theory could still be verifiable *in principle*. For instance, we could be transported, in principle, to a higher form of consciousness where we witness our previous lives unfold in accordance with karmic mechanisms, so that the theory is verified. Alternatively, we could envisage, in principle, a form of 'eschatological falsification' where we enjoy the beatific vision of (the Christian) God who demonstrates the falsity of belief in reincarnation (Chadha and Trakakis 2007, pp. 549–50). While these logical possibilities rebut the charge that the theory is empirically vacuous, for we can indeed specify what kind of empirical content would verify it or falsify it, they do not give us substantive grounds for accepting the theory in the here and now. Those of us who have not yet received the miraculous transportation to super-consciousness, or attained the post-mortem beatific vision would seem to have no bases for believing the theory. Likewise, the analogy that Chadha and Trakakis develop regarding the causal relation between smoking and lung cancer, and karmic causation does not take us far. They claim that because of the presence of multiple factors, we cannot offer precise predictions in the following format: if P smokes x number of cigarettes, P will suffer from cancer of severity y after z years. Yet, 'a general, law-like statement of the form 'Heavy smoking tends to cause lung cancer' remains indisputable' (Chadha and Trakakis 2007, p. 550). However, no such incontestable nomic statements such as, for instance, 'Being benevolent towards human beings tends to cause rebirth in families who live near the forest', have been formulated and tested in the case of karmic causation. We could seek to reduce the degree of the disanalogy between the two cases by suggesting that just as in the case of smoking and lung cancer, even though we have not ourselves conclusively verified this empirical conjunction, we accept it to be true because of the cognitive authority of medical experts, doctors, and epidemiologists. Likewise, even though we have not ourselves verified the theory of karma, we accept it to be true on the testimony of spiritual virtuosi such as Hindu yogis and Tibetan Buddhist lamas, who claim to have supra-empirical powers to recall past lives.

An alternative route would be to straightforwardly deny that the belief in karma requires robust evidentiary foundations. For instance, A.R. Wadia argues, on the one hand, that the doctrine 'has to be accepted as a dogma which has not been proved and cannot be proved'. However, this failure does not imply, according to Wadia, that the doctrine is 'necessarily irrational', for it contains a rational core which is that human beings are born into a world that has been constructed out of their past

karma (Wadia 1965, p. 149). A. Sharma argues in this vein that 'while it might not be possible to prove the doctrine [of karma and rebirth] with absolute certainty, it seems to be equally the case that the doctrine cannot with absolute certainty be established as demonstrably false. As in the case of the existence of God it seems to be a doctrine about which reasonable persons might reasonably differ' (Sharma 1990, p. 232). More recently, M. Burley notes that the belief in karma is not based on empirical evidence, and that 'it has arisen, and persisted, in human communities independently of anything that would be recognized as data comparable to that which supports the connection between smoking and lung cancer'. While this belief indeed plays explanatory roles in the lives of people who accept it, it is not typically regarded as subject to empirical verification or falsification (Burley 2013, p. 156). Consequently, the disagreement over karma cannot be 'resolved by rational deliberation alone...but only by one or other party in the debate undergoing a change of perspective so transformative that it would amount to a change in form of life' (Burley 2013, p. 159). Because the parties to the debate share different frameworks and are applying different pictures, the debate continues to be intractable, and its resolution in the life of an individual would be akin to her undergoing a religious conversion. Burley argues that '[t]his is not to say that participation in argument and the accumulation of evidence cannot play their part in precipitating such a conversion, but it is to suggest that such factors are unlikely to be decisive independently of more general shifts in an individual's worldview, which shifts are apt to be tied to broader cultural changes' (Burley 2013, p. 163).

6. The Reality of Reincarnation

Our discussion in preceding sections indicates that the responses of Chadha and Trakakis, which successfully rebut some of Kaufman's critiques, are freighted with specific metaphysical presuppositions. Chadha and Trakakis themselves highlight this point when they charge that Kaufman's methodology is faulty—instead of locating the doctrine within the dense metaphysical contexts that are sketched out in the scriptural texts, he operates in an ahistorical fashion with an idealised and simplified account: 'By not giving sufficient attention to the ways in which the doctrine of karma has been interpreted, developed, and expanded, particularly in the original sources, Kaufman regularly neglects and misunderstands important aspects of the doctrine' (Chadha and Trakakis 2007, p. 535). While Kaufman sets up the doctrine of karma as a 'complete, systematic theory of the origins and explanation of human suffering' (Kaufman 2005, p. 18), the notion of karma is not presented in the classical Hindu sources as an account of the origins of evil (unlike the Genesis narrative), nor is it offered as a comprehensive explanation of the presence of suffering. The theory provides only an imprecise outline with 'few details' about 'the inner workings or mechanics of the karmic process' (Chadha and Trakakis 2007, p. 534).

The crux of the matter, then, is this: given that most of us (who are not, say, Hindu yogis) have not verified, in practice, the theory of karma, are we epistemically entitled in the here and now to hold it to be true? Around a hundred years ago, J.W. Peebles threw down the gauntlet in unequivocal terms by listing twelve reasons for rejecting the belief in reincarnation, the first of which is that it is not based on 'one sound, solid, demonstrated fact' (George 1914, p. 102). One response that we have suggested throughout this essay is that we can claim such epistemic entitlements by appealing to the reliable testimony of the spiritual adepts such as the Buddha, who we believe was omniscient and will not mislead us about the 'solid facts' of reality. However, this response assumes the falsity of some form of metaphysical naturalism, which states that a complete and exhaustive description of 'reality' can be provided in terms of the entities that are studied by the most advanced sciences, such as quantum physics. *If* metaphysical naturalism were to be true, all theories involving reincarnating non-physical substantial selves (in many forms of Hinduism) and event-continua of mental streams undergoing rebirth (in Buddhism) would be falsified. While towards the beginning of the original essay, Kaufman states that he will not discuss the metaphysical and scientific critiques of karma, because these have been dealt with by other authors (Kaufman 2005, p. 16), it is precisely this question of whether reincarnation *is* real that flows through the argumentative exchanges between Kaufman, and Chadha

and Trakakis as a subterranean current. For instance, to repeat, the analogy developed by Chadha and Trakakis regarding the drunk driver implies that there are, in fact, persons who are reincarnated across lifetimes, even if they cannot (usually) recall their earlier lives. The debate, therefore, turns around the momentous question of whether we have independent reasons, grounded in rational evidentiary considerations, for accepting the reality of reincarnation (Pasricha 1990).

Here we move into deeply disputed areas in epistemology and philosophy of science which have suggested that there is no direct 'deductive step' between a 'physical description' and a 'metaphysical explanation'. That is, different individuals can agree on what the indisputable facts are, and yet disagree over how to assess, classify, and evaluate them. For instance, two individuals can agree on the phenomenological contents of their visual fields, and yet view them through divergent conceptual frames. Thus both report seeing a 'shining ball of fire' in the night sky, and yet one claims that the celestial object was (merely) a comet and the other, while agreeing with the former, also that it was a divine sign. The distinction between these two levels is highlighted by Y. Krishan: 'There is a fundamental distinction between causation in the physical world and *kārmic* causation. *Kārmic* causation is a metaphysical explanation of suffering and inequality in life and for which science has so far failed to provide an answer. What is not explainable empirically is sought to be explained metaphysically' (Krishan 1997, p. 201). That is, while everyday scientific explanations are at hand as to why John had a *toothache*, karmic causation has to be invoked to explain why it was *John* and not Mary who was particularly susceptible on that day to this agony. Or to move to a vaster cosmic background, karmic causation is said to explain the deep levels of inequality that we see among human beings, while also providing them with a mechanism for working their way to their spiritual goal (Nikhilananda 1968, p. 15). That is, to believe in karma and reincarnation is, according to L. Hodgkinson, to inhabit 'a philosophy of life which answers many otherwise unanswerable questions. If not, you have no good explanation of why things are so monstrously unfair, why people are born into such widely differing circumstances, and why the guilty and the bad are very often not punished while the good seem to suffer' (Hodgkinson 1989, pp. 152–53).

7. Arguing for and against Reincarnation

A basic 'condition of possibility' for the reality of karmic causation, which is presupposed in these 'metaphysical explanations' of Krishan and Hodgkinson, is that (to focus specifically on a Vedantic Hindu context) there *is* a substantial self which moves through a series of re-embodiments towards liberation. For another instance of how two individuals can agree about the 'facts', and yet encapsulate them within divergent conceptual schemes, we can take A. Flew's response to Plato's argument that because we have certain concepts that could not have been empirically acquired, all learning is a process of 'remembering' the timeless archetypes from a period before our earthly embodiment. From a metaphysical naturalist standpoint, (the early) Flew argues: 'The moral to be drawn is not, because we can now remember doing something before we were even conceived, therefore, we must have pre-existed, but that, because we did not exist before conception, therefore, we cannot truly be remembering those previous, postulated, cognitive happenings' (Flew 1991, p. 112).

Let us spell out Plato's argument in these terms:

Premise 1: If we remember doing things before we were even born, then we must have pre-existed among the archetypes.

Premise 2: We remember doing things before we were even born.

Conclusion: We must have pre-existed among the archetypes.

Flew's response denies the consequence in Premise 1:

Premise 1: If we remember doing things before we were even born, then we must have pre-existed among the archetypes.

Premise 2*: We did not pre-exist among the eternal archetypes.

Conclusion: Therefore, we cannot (truly) remember doing things before we were even born.

Thus, both Plato and Flew can agree on the 'fact' that we remember events from a (putative) prenatal existence, and yet arrive at diametrically opposed conclusions from this premise, because their metaphysical worldviews, in which the 'fact' is situated, are opposed. Plato affirms, while Flew denies, the reality of an immortal soul that is immaterial and non-physical. Likewise, suppose we have cogent reasons for believing that there are, in fact, no immaterial and substantial selves of the type that is indicated in the *Upaniṣads*, the *Bhagavad-gītā* and other scriptural sources. We might reject the notion of an immaterial soul on the grounds that if such a non-physical entity can influence brain events, these interactions would lead to the violation of basic physical laws (Wilson 2015, p. 349). We would in that case be less likely to view favourably the 'evidence' for a reincarnating self, and seek alternative explanations for the 'evidence' which has been presented. For instance, Paul Edwards, who accepts the psycho-neural identity thesis of the mind-body problem, argues that people who believe in reincarnation suffer from deep cognitive inadequacies. The theory is not based on any observational evidence and seeks to exploits gaps in the scientific explanations for phenomena such as child prodigies, *déjà vu*, and so on (Edwards 2001, p. 279). On the other hand, if we are persuaded by the arguments for a substantial immaterial self, or accept its reality on the basis of scriptural testimony, we are more likely to accept the theory of karma and reincarnation even if we cannot provide a detailed outline of its operation. For instance, Radhakrishnan argues that an 'empirical conjunction is not a metaphysical necessity', so that while in our present embodiment our cognitive processes are based on physical brains, we should not conclude that we need brains to think even in a disincarnate state (Radhakrishnan 1988, p. 231). Therefore, while acknowledging that the 'mechanism of rebirth is difficult to know', he argues that 'simply because we do not understand the process we cannot deny the facts' (Radhakrishnan 1988, p. 234). The cruciality of background worldviews in evaluating 'evidence' can be highlighted by contrasting Radhakrishnan's measured agnosticism with I.H. Smythe's forthright rejection from a naturalist perspective: 'The "how" question is one of the most frustrating, though predictable, aspects of investigating karma. The nuts and bolts of the system are never discussed; instead there is a lot of hand-waving and talk of karma and rebirth being at work within the realm of metaphysics (whatever that might mean)' (Smythe 2015, p. 489).

8. Conclusions

Our analysis of the exchange between Kaufman, and Chadha and Trakakis, has highlighted some aspects of the metaphysical scaffolding that supports the logical structures of their arguments. One of the reasons why debates over the reality or otherwise of reincarnation end on a somewhat inconclusive note is because they are informed by deeply contested metaphysical propositions. Perhaps the most well-known line of empirical inquiry regarding 'the nuts and bolts' in recent years is the work of I. Stevenson among children between the ages of two and four, who displayed skills, unusual abilities, and phobias which, he claimed, could not be explained in terms of their environment. The children had memories of being individuals in a previous life, and these memories were corroborated by people who had known these individuals. One kind of cases which he investigated involved children with birthmarks and birth defects that seemed to resemble wounds, often fatal, that were suffered by deceased persons that the children claimed to remember. Stevenson searched out police records, wherever possible, to verify whether the birthmarks matched the wounds the deceased individual had received (Stevenson 1997). He argued in an interview in 1974 that for at least some of the cases he had examined reincarnation was 'the best explanation that we have been able to come up with. There is an impressive body of evidence and it is getting stronger all the time. I think a rational person, if he wants, can believe in reincarnation on the basis of evidence' (quoted in (Prabhu 1989, p. 75)). However, it is crucial to note that Stevenson (Stevenson 1974) does not claim that the voluminous evidence that he has gathered over several decades demonstrates the reality of reincarnation, only that it is 'suggestive' of reincarnation. Such cases have received alternative explanations ranging from unconscious deception, cryptomnesia or hidden memory, paramnesia where memories of this life are misinterpreted as those pertaining to another, altered states of consciousness, inherited memories,

and so on. Again, the argument that reincarnation is the best explanation for the existence of child prodigies can be countered by the response that with the advance of genetic sciences, we will be able to understand more precisely how genetic material shapes human development (Christie-Murray 1981, p. 258).

That is, while the parties to these debates start from the baseline of the same body of 'facts', these evidential bases are packaged within distinct, and sometimes radically diverging, worldviews. Consider A. Bodde's claim at the beginning of his book on karma and reincarnation: 'Let me point out that I do not think that we can yet prove reincarnation scientifically (and perhaps we never will). However, on the basis of the scientific research and experience available, and by using logical reasoning, we can *make an acceptable case* for the concept of reincarnation and that is plausible' (Bodde 1999, p. 2). However, his case turns out to depend crucially on the reality of an 'ethereal sphere' into which the soul moves, with an ethereal body and ethereal senses, after the dissolution of the physical body (Bodde 1999, p. 15). Bodde's (implicit) rejection of metaphysical naturalism is reiterated from a different perspective by P. Fenwick and E. Fenwick in these terms: 'If we want to speculate about the existence of, let alone the survival of, the soul, Western science, which deals only with the objective, external world, can do little to help us. Current Western science does not yet understand consciousness, and until we understand consciousness we can only speculate about reincarnation' (Fenwick and Fenwick 1999, p. 11). What these statements indicate is that the belief in karma and reincarnation is densely intertwined with various psychological, metaphysical, and eschatological themes, so that different individuals, depending on whether or not they inhabit specific worldviews, will differ in their evaluations of the 'evidence' that is being presented for the belief. Consider, for instance, the case of Jane, a three-year-old girl in Tucson, Arizona who begins to claim that she remembers her past lives, and even provides detailed descriptions of the different roles she claims to have inhabited in those lives. Now consider three scenarios: the first, her parents are Conservative Baptists who immediately denounce these claims as the works of the devil; the second, her parents are seekers of alternative spiritualities who are mildly intrigued by these claims; and the third, her parents are white American converts to Hinduism who readily accept the veridicality of these claims. The reason why these sets of parents in alternative universes reach divergent conclusions is because they are 'embedding' the truth-claims of Jane within world-systems which are structured by alternative, and sometimes mutually incompatible, metaphysical presuppositions. Thus, if philosophical reasoning and scientific experimentation do support the existence of states of consciousness which cannot be explained entirely in physicalist vocabulary, such evidential backing would remove certain epistemic barriers to the belief in karma and reincarnation, in that it would render the belief at least logically possible. Therefore, the debate between Kaufman, and Chadha and Trakakis is, in the ultimate analysis, one about the basic constituents of the universe that we inhabit.

Conflicts of Interest: The authors declare no conflict of interest.

References

Abhedananda, Swami. 1964. *Reincarnation*. Calcutta: Ramakrishna Vedanta Math.

Bodde, Albert. 1999. *Reincarnation and Karma*. Translated by J. Penton. Saffron Walden: The C.W. Daniel Company Limited.

Burley, Mikel. 2013. Retributive karma and the problem of blaming the victim. *International Journal of Philosophy of Religion* 74: 149–65. [CrossRef]

Chadha, Monima, and Nick Trakakis. 2007. Karma and the Problem of Evil: A Response to Kaufman. *Philosophy East and West* 57: 533–56. [CrossRef]

Christie-Murray, David. 1981. *Reincarnation: Ancient Beliefs and Modern Evidence*. London: David and Charles.

Dhavamony, Mariasusai. 1991. Christianity and Reincarnation. In *Reincarnation: Fact or Fable?* Edited by Arthur Berger and Joyce Berger. London: The Aquarian Press, pp. 153–65.

Dutt, Manmatha Nath. 1997. *Mahabharata*. Translated by Manmatha Nath Dutt. Delhi: Parimal Publications.

Edwards, Paul. 2001. *Reincarnation: A Critical Examination*. Amherst: Prometheus.

Fenwick, Peter, and Elizabeth Fenwick. 1999. *Past Lives: An Investigation in Reincarnation Memories*. London: Headline.

Flew, Antony. 1991. Transmigration and Reincarnation. In *Reincarnation: Fact or Fable?* Edited by Arthur Berger and Joyce Berger. London: The Aquarian Press, pp. 101–16.

George, Samuel, ed. 1914. *The Origin and History of Reincarnation: A Symposium*. London: The Power-Book Co.

Hodgkinson, Liz. 1989. *Reincarnation: The Evidence*. London: Piatkus.

Iyer, Subramaniam V. 1985. *The Varaha Purana*. Translated by Subramaniam V. Iyer. Delhi: Motilal Banarsidass.

Kaufman, Whitley R. P. 2005. Karma, Rebirth, and the Problem of Evil. *Philosophy East and West* 55: 15–32. [CrossRef]

Kaufman, Whitley R. P. 2007. Karma, Rebirth, and the Problem of Evil: A Reply to Critics. *Philosophy East and West* 57: 556–60. [CrossRef]

Krishan, Yuvraj. 1997. *The Doctrine of Karma*. Delhi: Motilal Banarsidass.

MacGregor, Geddes. 1991. Is Reincarnation Compatible with Christian Faith? In *Reincarnation: Fact or Fable?* Edited by Arthur Berger and Joyce Berger. London: The Aquarian Press, pp. 89–98.

Nikhilananda, Swami. 1968. *Man in Search of Immortality*. London: George Allen and Unwin Ltd.

Olivelle, Patrick. 2004. *The Law Code of Manu*. Oxford: Oxford University Press.

Paramananda, Swami. 1961. *Reincarnation and Immortality*. Cohasset: The Vedanta Centre.

Pasricha, Satwant. 1990. *Claims of Reincarnation: An Empirical Study of Cases in India*. New Delhi: Harman Publishing House.

Perrett, Roy W. 1987. Rebirth. *Religious Studies* 23: 41–57. [CrossRef]

Phillips, S. H. 2009. *Yoga, Karma, and Rebirth*. New York: Columbia University Press.

Prabhu, Joseph. 1989. The Idea of Reincarnation. In *Death and Afterlife*. Edited by Stephen T. Davis. Basingstoke: Macmillan, pp. 65–80.

Radhakrishnan, Sarvepalli. 1988. *An Idealist View of Life*. London: Unwin Paperbacks.

Satprakashananda, Swami. 1984. *How Is a Man Reborn?* Calcutta: Advaita Ashrama.

Sharma, Ursula. 1973. Theodicy and the Doctrine of Karma. *Man* 8: 347–64. [CrossRef]

Sharma, Arvind. 1990. Karma and Reincarnation in Advaita Vedānta. *Journal of Indian Philosophy* 18: 219–36. [CrossRef]

Sharma, Arvind. 2008. Karma, Rebirth, and the Problem of Evil: An Interjection in the Debate between Whitley Kaufman and Monima Chadha and Nick Trakakis. *Philosophy East and West* 58: 572–75. [CrossRef]

Shastri, Jagdish Lal, ed. 1980. *The Garuda Purana*. Delhi: Motilal Banarsidass.

Smythe, I. H. 2015. Objections to Karma and Rebirth: An Introduction. In *The Myth of an Afterlife: The Case against Life after Death*. Edited by Michael Martin and Keith Augustine. Lanham: Rowman & Littlefield, pp. 473–97.

Stevenson, Ian. 1974. *Twenty Cases Suggestive of Reincarnation*. Charlottesville: University of Virginia Press.

Stevenson, Ian. 1997. *Reincarnation and Biology: A Contribution to the Etiology of Birthmarks and Birth Defects*. Westport: Praeger.

Tagare, Ganesh Vasudeo. 1976. *The Bhagavata Purana*. Translated by Ganesh Vasudeo Tagare. Delhi: Motilal Banarsidass.

Van Inwagen, Peter. 2006. *The Problem of Evil*. Oxford: Clarendon Press.

Wadia, A. R. 1965. Philosophical Implications of the Doctrine of Karma. *Philosophy East and West* 15: 145–52. [CrossRef]

Wilson, D. L. 2015. Nonphysical Souls Would Violate Physical Laws. In *The Myth of an Afterlife: The Case against Life after Death*. Edited by Michael Martin and Keith Augustine. Lanham: Rowman & Littlefield, pp. 349–67.

Yandell, Keith E. 2001. Some reflections on Indian metaphysics. *International Journal for Philosophy of Religion* 50: 171–90. [CrossRef]

Article

Science's Big Problem, Reincarnation's Big Potential, and Buddhists' Profound Embarrassment

Ted Christopher

71 Azalea Rd., Rochester, NY 14620, USA; tchrist7@rochester.rr.com

Received: 20 July 2017; Accepted: 14 August 2017; Published: 19 August 2017

Abstract: Scientific materialism is the largely unquestioned basis for modern science's understanding of life. It also holds enormous sway beyond science and thus has increasingly marginalized religious perspectives. Yet it is easy to find behavioral phenomena from the accepted literature that seriously challenge materialism. A number of these phenomena are very suggestive of reincarnation. The larger test for science's paradigm, though, as well as for any potential general import from reincarnation, is the DNA (or genetics)-based model of heredity. If that conception-beget, DNA (deoxyribonucleic acid)-carried model can be confirmed at the individual level then in a very substantial way we would be confirmed as material-only creatures. In particular, can behavioral genetics and personal genomics confirm their DNA-based presumptions? During the last decade enormous efforts have been made to find the DNA origins for a number of health and behavioral tendencies. These efforts have been an "absolutely beyond belief" failure and it is here that the scientific vision faces its biggest challenge. The common pre-modern reincarnation understanding, on the other hand, fits well on a number of specific conundrums and offers a broad coherence across this unfolding missing heritability mystery. For people trying to make sense of a religious perspective or simply questioning materialism, you should be looking at the missing heritability problem.

Keywords: scientific materialism; genetics; reincarnation; soul; religions; science; Buddhism

1. Introduction

Modern science's understanding of life is a material-only (or physical-only) affair. Two recent books, Siddhartha Mukherjee's *The Gene: An Intimate History* (Mukherjee 2016) and Sean Carroll's *The Big Picture: On the Origins of Life, Meaning, and the Universe Itself* (Carroll 2016) illustrate this point. Mukherjee's book—despite literary and philosophical excesses—makes and maintains the point that "[i]nvoking special vital forces or inventing mystical fluids to explain life [is] unnecessary. Biology [is] physics." (Mukherjee 2016, p. 142) Carroll's physics-centered perspective was even nicely capped with an appendix providing a mathematical equation "Underlying You and Me" (Carroll 2016, pp. 435–41). Another interesting concise statement of materialism's reasoning was given in a recent *Scientific American* article in a quote of the physicist Richard Feynman that "[e]verything that living things can do can be understood in terms of the jigglings and wigglings of atoms" (Fromme and Spence 2017). These perspectives are regularly accompanied with idealisms about science and the presumed open nature of scientific inquiry. Consequently, the materialist perspective has essentially become the modern educated position. Alternative, and indeed religious, perspectives appear to be rarely taken seriously in intellectual discourse.

However, in contradiction to the assumptions of materialism are a number of accepted but unusual behavioral phenomena that have been largely ignored by the scientific community (likewise, of course, there are sincere works on taboo topics which raise serious questions) (Christopher 2016; Christopher 2017). Such phenomena are a good place to begin an inquiry into the validity of materialism, and after a brief look at taboo phenomena, that approach will be pursued here.

The much larger point, though, is with regards to the ongoing search for our individual-determining DNA (or genetic) specifics (our design-dedicated "jigglings and wigglings"). In a long and appropriate (and "most helpful") Amazon.com customer review of Mukherjee's *The Gene* it was stated that "[w]e used to think our future was in the stars. Now we know it's in our genes." Missing, though, in that review—as well as Mukherjee's book—is the fact that we have very little variability in our DNA (available to potentially differentiate individuals) and that it has been scoured extensively for the last decade to find essentially no DNA connections across large parts of our innate differences. One of the centerpieces of Mukherjee's book, as well as of genetics research in general, is efforts to identify the DNA-basis for the susceptibility to develop schizophrenia. The May 2017 issue of *Scientific American* in fact has a relevant review article in which the author concludes with regards to such DNA connections that they "didn't happen"; one researcher declares that such investigations "will have no impact on resolving the biology of schizophrenia", and another one saying that DNA might just provide "a general unspecifiable genetic background" to the disease (Balter 2017). This situation—and many analogous ones for other individual-distinguishing characteristics—represents an *enormous about-face* from the logic of genetics and their foundational place within scientific materialism. This kind of genetic failure underlies what one geneticist acknowledged was a "debate raging in human genetics" (Mitchell 2012). How then are we to deal with the many confident DNA-based suppositions we have encountered, such as Richard Dawkins' statement that DNA "created [you], body and mind" (Dawkins 1976, p. 20)?

In addition to elaborating on the above problems facing science, this paper will also consider some explanations available via the common pre-modern reincarnation understanding (in my other works the word used is "transcendental", reflecting phenomena that transcend one life). One key point I make is that the missing heritability problem, i.e., the inability to find the DNA responsible for many of our innate specifics, is consistent with a general influence from reincarnation, and as such could help this transcendental belief move beyond what has been characterized as an "underdetermined" status (Barua 2015).

Finally, some commentary on the associated possible significance to the religion-versus-science standoff is offered. A particular critical focus is placed on Buddhism in the modern world and the associated science-inspired detour it has experienced.

2. Findings

2.1. Science's Little Problems: Taboo Phenomena

Scientific materialism's dominance is so thorough that for the most part it isn't even explicitly acknowledged, and then when it is usually only as a formality. Occasionally when a taboo report—such as a near-death experience (Alexander 2012)—gains sufficient popular attention then some scientists and skeptics mount a vigorous counterattack.

One interesting testament to materialism's position can be found with regards to Elizabeth L. Mayer's fine *Extraordinary Knowing: Science, Skepticism, and the Inexplicable Powers of the Human Mind* (Mayer 2007). Mayer's writing stemmed her investigations into paranormal phenomena and its collision with her "rational" background as a prominent psychoanalyst, whose work also included positions in the psychiatry department at the University of California Medical Center, San Francisco, and also as an associate clinical professor of psychology at the University of California at Berkeley. This work was sparked by the amazing help Mayer had received while attempting to recover her daughter's harp which had been stolen in Oakland, California. In response to a friend's suggestion, the desperate Mayer had contacted a man in Arkansas who worked as a dowser. The initial response to her phone call to the dowser went as follows:

"Give me a second," he said. "I'll let you know if it is still in Oakland." He paused, then: "Well, it's still there. Send me a street map of Oakland and I'll locate the harp for you." After overnighting the man a map she got a call back two days later. "Well, I got that harp

located," he said, "It's in the second house on the right on D—Street, just off L—Avenue" (Mayer 2007, pp. 2–3).

Mayer then located that intersection and went on to place flyers offering a reward in the two-block area surrounding the specified house. Three days later she got a phone call from a man who claimed to have seen the missing harp in the possession of a neighbor. After some subsequent phone calls, Mayer arranged for a meeting in which she was able to recover her daughter's stolen harp.

Shortly thereafter Mayer had the thought that that experience *"changes everything"*, as chronicled in the book that launched her fourteen-year investigation which uncovered numerous instances of extraordinary knowing. These included several encounters with psychics and also a sustained look at some of the astonishing happenings witnessed during the remote viewing investigations at Stanford Research Institute (SRI) in Menlo Park, California.

The work at SRI had been initiated when a physicist Harold Puthoff's inquiry into a grant proposal on the possible "implications of quantum theory for life" somehow got into the hands of a New York artist named Ingo Swann. Swann then contacted Puthoff and suggested as an alternative that Puthoff investigate parapsychological phenomena.

In part due to simple curiosity Puthoff had then invited Swann out to SRI for a week during June 1972. A brief description by Dr. Puthoff of some of the events of that week went as follows:

> Prior to Swann's visit I arranged for access to a well-shielded magnetometer used in a quark-detection experiment in the Physics Department at Stanford University. During our visit to this laboratory, sprung as a surprise to Swann, [we asked him] to perturb the operation of the magnetometer, located in a vault below the floor of the building and shielded by mu-metal shielding, an aluminum container, copper shielding and a superconducting shield. To the astonishment of Stanford physics professor Dr. Arthur Hebard, whose experiments depended heavily on the magnetometer's much vaunted imperturbability to outside influence, Swann doubled the rate at which the magnetic field in the magnetometer was decaying. Then in response to Hebard's disbelieving subsequent request, Swann stopped the field change altogether for a period of roughly forty-five seconds. As if to add insult to injury, he then went on to "remote view" the interior of the apparatus ... by drawing a reasonable facsimile of its rather complex (and heretofore unpublished) construction. It was this latter feat that impressed me perhaps even more than the former, as it also eventually did representatives of the intelligence community [the CIA eventually became quite interested in the remote viewing phenomena] (Mayer 2007, pp. 105–6).

That visit sparked a sustained series of remote viewing experiments at SRI that resulted in a number of observations that were "anything but ordinary and just blew [the scientists'] minds [away]" (Mayer 2007, p. 108). Unfortunately, despite their findings—that "[t]here was so much good data and it was so damn compelling" (Mayer 2007, p. 108)—and despite the involvement of physicists no less, their work was largely unappreciated and has simply faded away.

Not unlike those remote viewing experiments, Elizabeth L. Mayer's *Extraordinary Knowing* was largely neglected. It probably didn't help that she died shortly after its publication. It also didn't help that intellectuals could well be a notch up on the rigidity scale from the considerable rigidity that confronts other adults. *Extraordinary Knowing* even opens with a prominent physicist, Freeman Dyson, offerings his tentative conclusion that "ESP is real but belongs to a mental universe that is too fluid and evanescent to fit within the rigid protocols of controlled scientific testing" (Mayer 2007, p. xi). Similarly, is it realistic to expect that instances of scientific breakthroughs or genius would occur under "controlled scientific testing" conditions? It is also worth noting that this is another testament to materialism's clout as it is apparently critical to have a scientist offer support for self-evident points.

Furthermore, there is a possible objection to Mayer's repeated conclusion that these type of phenomena *"change[] everything"*. In the modern intellectual and/or academic realms—which seem to

have completely cut themselves off from such possibilities—this might be true. On the other hand for people outside these realms the evidence can be quite strong. For example, I have had a number of psychic experiences in my life. However, is it realistic to think that these rare events—blips if you will—really amount to much significance? I do not think so and thus do not feel that they change much of anything (and I also think that there are very few people who regularly experience psychic phenomena). At the very least, though, Mayer's work argued convincingly for the existence of some psychological phenomena that violate materialism.

Another challenging taboo point is with regards to investigations into possible cases of reincarnation. In a 2013 blog entry for *Scientific American* the psychologist and self-identified skeptic Jesse Bering reviewed Ian Stevenson's reincarnation work (Bering 2013). That review, entitled "Ian Stevenson's Case for the Afterlife: Are We Skeptics Really Just Cynics?" conveyed the strength of Ian Stevenson's work and as well as Bering's positive assessment. In it Bering wrote that:

> when you actually read [the cases] firsthand, many are exceedingly difficult to explain away by rational, non-paranormal means. Much of this is due to Ian Stevenson's own exhaustive efforts to disconfirm the paranormal account. "We can strive towards objectivity by exposing as fully as possible all observations that tend to weaken our preferred interpretation of the data," he wrote. "If adversaries fire at us, let them use ammunition that we have given them." And if truth be told, he excelled at debunking the debunkers.

Bering also cited the support of one prominent scientist, the physicist Doris Kuhlmann-Wilsdorf, who found that Stevenson's work provided "overwhelming" evidence for the existence of reincarnation. A more recent and extraordinarily detailed case is chronicled in *Soul Survivor: The Reincarnation of a World War II Fighter Pilot* by Bruce and Andrea Leininger (with Ken Gross) (Leininger et al. 2009). In Leininger's book they chronicled their experiences with their son as he appeared to vividly recall experiences as a World War II fighter pilot. The strength of their case was significantly boosted by the fact that the father, Bruce, is a devout Catholic and went to amazing lengths to investigate the possible reincarnation explanation in hopes of debunking it. That book earned a "spectacular" review comment from Jim Tucker, Ian Stevenson's successor at the University of Virginia.

One could argue that Jesse Bering's points about Stevenson's work are self-evident. Stevenson really did go to extraordinary degrees to be critical and in particular to hedge against the reincarnation explanation. I personally found it to be overdone in that regard and it can make for awkward reading. It is also not clear that it would have been possible for Stevenson to have received approval from the entrenched skeptic camps. The larger question here is again the "So What?" question. If individuals with claimed memories from a previous life are exceedingly rare—Stevenson cited an approximate 1 in 500 occurrence rate from a unique study in India (Stevenson 2000)—and furthermore they could have rather limited impacts on the affected individuals—should reincarnation's potential influence be considered that significant? The growing big picture-case for reincarnation, along with Ian Stevenson's conclusions, will be returned to later.

2.2. Science's Little Problems: Unusual Accepted Phenomena

Here a number of very compelling and non-controversial examples will be considered that appear to violate materialism and thus could be considered supernatural. These examples are in part taken from an essay I wrote in the winter of 2017 (Christopher 2017) and which had also appeared in *A Hole in Science* (Christopher 2016).

You can read in Sean Carroll's *The Big Picture* about "the tremendous strides in understanding" made by neuroscience into how our brains work, but for a sober assessment you might better read an informed review article like that found in the March 2014 issue of *Scientific American* by Rafael Yuste and George M. Church (Yuste and Church 2014). After a splashy title—"The New Century of the Brain: Big science lights the way to an understanding of how the world's most complex machine gives rise to our thought and emotions" the article was very sober. The first paragraph read:

Despite a century of sustained research, brain scientists remain ignorant of the workings of the three pound organ that is the seat of all conscious activity. Many have tried to attack this problem by examining the nervous systems of simpler organisms. In fact, almost 30 years have passed since investigators mapped the connections among each of the 302 nerve cells in the round worm Caenorhabditis elegans. Yet the worm-wiring diagram did not yield an understanding of how these connections give rise to even rudimentary behaviors such as feeding and sex. What was missing were data relating the activity of neurons to specific behaviors.

The article went on to describe the extraordinary challenges facing neuroscience and then later closed with the pleading conclusion:

[w]e need collaboration among academic disciplines. Building instruments to image voltage in millions of neurons simultaneously throughout entire [human] brain regions may be achieved only by a sustained effort of a large interdisciplinary team of researchers. The technology could then be made available at a large-scale observatory-like facility shared by the neuroscience community. We are passionate about retaining a focus on new technology to record, control and decode the patterns of electrical spikes that are the language of the brain. We believe that without these new tools, neuroscience will remain bottlenecked and fail to detect the brain's emergent properties that underlie a virtually infinite range of behaviors. Enhancing the ability to understand and use the language of spikes and neurons is the most productive way to derive a grand theory of how nature's most complex machine functions.

Existing serious challenges are found elsewhere, though. Some individuals can function very well despite having very little brain tissue and such under-appreciated findings clearly challenge a brain-only explanation for human consciousness and behavior. A condition called hydrocephalus results in enlarged reservoirs or ventricles (holding cerebrospinal fluid) within the brain and thus people with this condition can have other brain tissue displaced and/or destroyed. In a *Science* article the neurologist John Lorber reported on hydrocephalus findings (Lewin 1980). Those findings had been based on the brain scans of over 600 patients with the condition spina bifida (most of whom also had hydrocephalus), and those patients had been categorized based on the fraction of their brain case (or cranium) that was occupied by the enlarged ventricles. Of particular note were cases in which the ventricles filled about "95 percent of the cranium". Individuals falling into this category constituted "less than 10 percent" of the patients. Among those in this category it was noted that "many" of them were:

severely disabled, but half of them have IQ's greater that 100. This group provide[d] some of the most dramatic examples of apparent normal function against all odds.

Lorber described one particularly startling example:

[t]here is a young student at [Sheffield University] who has an IQ of 126, has gained a first-class honors degree in mathematics, and is socially completely normal. And yet the boy has virtually no brain.

Given such findings why then do not a significant fraction of unaffected individuals (with normal-sized brains) function at extraordinary levels? What do such findings say about the evolutionary logic of Homo sapiens' growth in brain size? Readers can also juxtapose the above findings with Sam Harris' assertion that "[t]here is no place for a soul inside your head" (Harris 2014, p. 205).

Additional neuroscience/materialism-challenging observations can be found in studies of human memory performance. A *Scientific American* article, "Remembrance of All Things Past", by James McGaugh and Aurora LePort (McGaugh and LePort 2014) opens with an excerpt from an e-mail received by McGaugh from a woman Jill Price:

As I sit here trying to figure out where to begin explaining why I am writing you ... I just hope somehow you can help me. I am 34 years old, and since I was 11 I have had this unbelievable ability to recall my past ... I can take a date, between 1974 and today, and tell you what day it falls on, what I was doing that day, and if anything of great importance ... occurred on that day I can describe that to you as well. I do not look at calendars beforehand, and I do not read 24 years of my journals either.

McGaugh and LePort then followed up by extensively testing Price's recall. Her memory was eventually proved faulty in only one instance—the day of the week of one of the previous 23 Easters (and Price is Jewish). During this testing she "corrected the book of milestones for the date of the start of the Iran hostage crisis at the U.S. embassy in 1979." On smaller matters Price:

correctly recalled that Bing Crosby died at a golf course in Spain on October 14, 1977. When asked how she knew, she replied that when she was 11 years old, she heard the announcement of Crosby's death over the car radio when her mother was driving her to a soccer game [note an apparent typo in the article since Price couldn't have been 11 years old in both 1974 and 1977].

In the *Scientific American* article, the researchers related that Jill Price demonstrated "an immediate recall of the day of the week for any date in her life after she was about 11 years old". Yet she also "has trouble remembering which of her keys go into which lock" and "does not excel in memorizing facts by rote". Later in the article they describe similar memory abilities in about 50 people. Such memories were found to be "highly organized in that they are associated with a particular day and date" and that the process occurred "naturally and without exertion". These extraordinary memories did not appear to have a family history and thus do not lend support to a (remarkable) genetic explanation. However, the larger point here—and a point skirted in the article—is that such effortless memories seem highly implausible given the brain's apparent biological basis for memory (i.e., it is supposed to perform like a muscle). Readers can compare these findings with another comment by Sam Harris on the limits of minds, "I don't remember what I did on this date in 2011" (Harris 2014, p. 204). A related point here is that this kind of memory function appears similar to those reported in some near-death experiences (Holden et al. 2009, p. 306).

Another area where the scientific vision appears to be seriously challenged is with extraordinary intellectual abilities. In Darold A. Treffert's *Islands of Genius* (Treffert 2010) the following description is given of a musical prodigy:

By age five Jay had composed five symphonies. His fifth symphony, which was 190 pages and 1328 bars in length was professionally recorded by the London Symphony Orchestra for Sony Records. On a *60 Minutes* program in 2006 Jay's parents stated that Jay began to draw little cellos on paper at age two. Neither parent was particularly musically inclined, and there were never any musical instruments, including a cello, in the home. At age three Jay asked if he could have a cello of his own. The parents took him to a music store and to their astonishment Jay picked up a miniature cello and began to play it. He had never seen a real cello before that day. After that he began to draw miniature cellos and placed them on music lines. That was the beginning of his composing.

Jay says that the music just streams into his head at lightning speed, sometimes several symphonies running simultaneously. "My unconscious directs my conscious mind at a mile a minute," he told the correspondent. (Treffert 2010, pp. 55–56)

Treffert's book contains other examples that support his conclusion that prodigal behavior typically involves "know[ing] things [that were] never learned". Interested readers can look up descriptions of the historical musical prodigy Blind Tom. *Islands of Genius* also considers acquired savant syndrome in which the onset of savant behaviors follow a setback to the central nervous system. Thus, it would seem then that a three-pound neural organ could acquire skill as a result of damage. These cases of prodigal

and/or exceptional intellect offer big challenges to materialism, albeit challenges that are rarely if ever acknowledged by scientists (for Treffert's part he extrapolated an optimistic *NOVA* documentary on the epigenome, "Ghost in Your Genes", for a scientific-sounding prodigal explanation).

A final, non-controversial challenge to materialism can be found with the not too uncommon transgender phenomena. Some individuals strongly identify with the opposite gender and this identification can show up when they are very young. One transgender study found that among the subset that have undergone sex-change efforts (or transitioned) many "knew that they had been born into the wrong gender from childhood" (Landau 2009). Such an explanation would seem to require some kind of DNA mutation, which resulted in an individual whose brain then felt committed to identifying as the opposite gender and an associated agenda. It is worth noting here that from the materialist perspective that behind the scenes here are merely programmed molecular interactions and thus the perceived entities including self and free will are simply illusions. This is difficult to imagine.

From an article in the *New York Time Magazine* (Padawer 2012) a description of a 3-year-old included:

> he insisted on wearing gowns even after preschool dress-up time ended. He pretended to have long flowing hair and drew pictures of girls with elaborate gowns and flowing tresses. By age 4, he sometimes sobbed when he saw himself in the mirror wearing pants, saying he felt ugly.

> Such tendencies can present difficulties for parents, as one father put it, "I didn't know how to be the father of a girl inside a boy's body".

One eight-year-old's self-assessment found in Andrew Solomon's *Far From the Tree* (Solomon 2012) contained:

> "I'm a girl and I have a penis. They [her parents] thought I was a boy until I was six. I dressed like a girl. I said, 'I'm a girl.' They didn't understand for the longest time (Solomon 2012, p. 604).

The assessment went on look ahead (after considering possible ways to deal with their penis problem):

> [w]hen I'm a mommy I'll adopt my babies, but I'll have boobies to feed then and I'll wear a bra, dresses, skirts, and high-heeled shoes (Solomon 2012, pp. 605–6).

Do such behaviors really make sense within an evolutionary framework, and in particular as a function of DNA specifications?

Together with taboo examples like those considered earlier, I would argue that extraordinary behavioral phenomena offer clear rebuts to materialism. At least around the behavioral edges there are phenomena that do not make "jigglings and wigglings"-sense. These could again be exceptions to the big picture, though I suppose.

2.3. Science's Big Problem: Heritability

From the scientific perspective, human behavioral tendencies should follow some kind of nature (DNA-linked) plus nurture (environmental exposure-linked) causal combination. In fact, decades worth of studies appear to support the common intuition that the majority contributor to our particular tendencies is nature. In a simple overview of the supporting logic here is Steven Pinker on schizophrenia:

> schizophrenia is highly concordant within pairs of identical twins [about 50% of the time when one is affected so is the other twin], who share all of their DNA and most of their environment, but far less concordant within pairs of fraternal twins, who share only half of their [variable] DNA ... and most of their environment. The trick question ["What is the biggest predictor that a person will become schizophrenic?"] could be asked—and

would have the same answer ["Having an identical twin who is schizophrenic."]—for virtually every cognitive and emotional disorder ever observed. Autism, dyslexia, language impairment, learning disability, left-handedness, major depressions, bipolar illness, obsessive-compulsive disorder, sexual orientation, and many other conditions run in families, are more concordant in identical than in fraternal twins, are better predicted by people's biological relatives than by their adoptive relatives, and are poorly predicted by any measure of the environment (Pinker 2002, p. 46).

There are of course some environmental influences on our behaviors, though. The environment does provide for items like language, trauma-based fears, and apparently shows some influence towards family-based allegiances like political party affiliation (perhaps also involving fear) (Alford et al. 2005).

However, many studies—including those involving monozygotic (identical) twins, dizygotic (fraternal) twins, and also adoptees—have shown strong support for the nature component's contributions. Specifically, they have suggested that about half of the specifics of a person's complex behavioral traits (i.e., "whether they are smarter or duller, nicer or nastier, bolder or shyer", etc.) comes from their DNA (or genome). These findings also suggest that very little is contributed by the home environment which is most apparent through the limited impact observed in adoptees. The remaining mysterious contributor to one's behavior is supposed to be based on an individual's unique experiences and this most tangibly provides a basis for the differences between identical twins. An example of those differences can be found among male identical twins in which the concordance of exclusive homosexuality is only about 20%–30% (Collins 2010, pp. 204–5). Thus, despite all the certainty trumpeted about science's vision of life there is some officially acknowledged mysteriousness about individuality and this is reflected in a statement by Steven Pinker:

> a simple way of remembering [the three laws of behavioral genetics] is this: identical twins are 50 percent similar whether they grow up together or apart. Keep this in mind and watch what happens to your favorite ideas about the effects of upbringing in childhood (Pinker 2002, p. 381).

He also acknowledged that "something is happening here but we don't know what it is" (Pinker 2002, p. 380).

The critical testable question here is—can science identify a DNA basis for the other roughly half-ish of who we are? Can behavioral genetics confirm its own title? In parallel can personal genomics identify the DNA specifics behind our differing health trajectories and challenges? There is conclusive inferential evidence pointing towards innate contributions, which from a scientific perspective implies a DNA basis. On the other hand, there really are surprisingly large behavioral and health gaps between identical twins, which raise serious questions about the DNA paradigm.

Contributing to geneticists' optimism is the under-appreciated fact that the variable portion of our DNA is merely a small subset of the complete DNA code. Roughly then one might argue that we are all identical twins. However, not exactly, since the DNA codes of any two individuals differ by about 3 million letters out of 3 billion genomic letters (or about 0.1%) (Schafer 2006; Kolata 2013; Kingsley 2009). That small subset of variable DNA should then largely be the home of our innate differences and thus support the expectations of personal genomics and behavioral genetics. In a further crude sense then one could argue that the ongoing DNA searches are simply trying to identify some additional Y-chromosomes; that is variations in the genome, which can result in significant changes in the associated individuals (even if they are not visible in a mirror).

The minimally communicated problem facing genetics, though, is that despite searching for the expected DNA connections for about a decade now and they have found almost nothing. In a rare critical assessment of the situation, Jonathan Latham and Allison Wilson of the Bioscience Resource Project (Ithaca, New York) pointed out in 2010 that, with few exceptions (including genes for cystic

fibrosis, sickle cell anemia, Huntington's disease; and also some genetic contributions to instances of breast cancer and Alzheimer's):

> according to the best available data, genetic predispositions (i.e., causes) have a negligible role in heart disease, cancer, stroke, autoimmune diseases, obesity, autism, Parkinson's disease, schizophrenia and many other common mental and physical illnesses that are the major killers in Western countries (Latham and Wilson 2010).

Those two authors went on to ask "[h]ow likely is it that a quantity of genetic variation that could only be called enormous (i.e., more that 90%–95% of that for 80 human diseases) is all hiding in what until now [circa 2010] had been considered genetically unlikely places?" They added that "[b]y all rights then, reports of GWA [genome wide assessments] results should have filled the front pages of every world newspaper for a week". However, nothing like that happened.

That 2010 contrarian assessment had been preceded by an initial acknowledgement in 2008 by geneticist David Goldstein that:

> [a]fter doing comprehensive studies for common diseases, we can explain only a few percent of the genetic component of most of these traits. For schizophrenia and bipolar disorder, we get almost nothing; for Type 2 diabetes, 20 variants, but they explain only 2 to 3 percent of familial clustering, and so on (Wade 2008).

And further that:

> [i]t's an astounding thing that we have cracked open the human genome and can look at the entire complement of common genetic variants, and what do we find? Almost nothing. That is absolutely beyond belief (Wade 2008).

And finally in 2017, the same Goldstein added that the latest potential breakthrough in the genetic origins of schizophrenia—arguably "account[ing] for only a trivial amount of schizophrenia"—represents "the first time we have gotten what we wanted out of a GWA" (Balter 2017). He also reflected on the ongoing optimistic genetic reports by saying "[p]eople working in the schizophrenia genetics field have greatly over-interpreted their results". As an outsider who has followed the reports from the genetics literature I think that his criticism is appropriate to many areas of the field.

Given the circumstances—little variable DNA to consider and that years of genome research has yielded virtually nothing—their ongoing failure really is a very big one for the scientific model. The appropriate analogy here is not some long drawn out search for an esoteric, singular entity—like physics' Gibbs particle. A good analogy here is more akin to an extensive search through a small haystack for a whole bunch of needles. That they haven't found substantial DNA origins "(or needles) appears to be an "absolutely beyond belief" failure for genetics.

2.4. Reincarnation's Big Picture Potential

Ian Stevenson did extensive and impressive work investigating possible cases of reincarnation. His conclusions about reincarnation are therefore very noteworthy. In his condensed 1997 book, *Where Reincarnation and Biology Intersect*, Stevenson wrote that:

> I do not propose reincarnation as a substitute for present or future knowledge of genetics and environmental influences. I think of it as a third factor contributing to the formation of human personality and of some physical features and abnormalities. I am, however, convinced that it deserves attention for the additional explanatory value that it has for numerous unsolved problems of psychology and medicine (Stevenson 1997, p. 186).

In particular, Stevenson wrote that those contributions could include:

some cognitive information about events of the previous life; a variety of likes, dislikes, and other attitudes; and, in some cases, residues of physical injuries or other markings of the previous body (Stevenson 1997, p. 182).

The last point refers to reincarnation's possible contributions to birthmarks and birth defects and was a significant focus of his research (and in large part the basis for the book's title). In a later paper Stevenson had written more fully that:

> [s]everal disorders or abnormalities observed in medicine and psychology are not explicable (or not fully explicable) by genetics and environmental influences, either alone or together. These include phobia and philias observed in early infancy, unusual play in childhood, homosexuality, gender identity disorder, a child's idea of having parents other than its own, differences in temperament manifested soon after birth, unusual birthmarks and their correspondence with wounds on a deceased person, unusual birth defects, and differences (physical and behavioral) between monozygotic twins. The hypothesis of previous lives can contribute to the further understanding of these phenomena (Stevenson 2000).

Additionally, Stevenson went on to suggest in his 1997 book that "[w]e may, after all, be engaged in a dual evolution—of our bodies and of our minds or souls".

The scope of Stevenson's take on reincarnations' possible import, though, is still quite limited as a possible "third factor". Based on his studies we do not know how often it happens. Additionally, although Stevenson cited a 63 percent figure for cases involving an apparent violent death of the remembered individual, there are obviously events with many such deaths—as in any major war—and is there any evidence that there was an associated follow-up surge of remembered lives? These suggestive cases do appear to be very rare and unique, and I would argue that this limits their inferential leverage. Furthermore, I think Stevenson's over-reliance on investigating suggestive cases had him shortchange readily available indirect support from noncontroversial phenomena; for example with prodigies, the transgender phenomena, and also with the experiences of adopted children. Careful consideration of such phenomena, including the associated parental experiences, can offer some significant insights into possible reincarnation phenomena.

Moreover, since Stevenson's work a much bigger potential role—and intersection with biology—has come into view. That is genetics' missing heritability problem. With this unfolding problem—along with a sober assessment of the limits of environmental influences—the scope of the "not explicable (or not fully explicable)" is much bigger. This large opening, along with some additional possible behavioral support, represents a chance to advance the reincarnation research front considerably. At the end of this article I will return to a critical assessment of the contemporary reincarnation research situation.

Moving on, the coverage here on reincarnation begins with findings about the spiritual or religious understandings of infants, followed by some general points on reincarnation theory. This will be followed by a section on two potential reincarnation-based explanations and then another section on theory.

One can certainly gain confidence in the possible existence of reincarnation by looking at some individual cases and/or by examining relevant unusual behaviors. The substantial challenge, though, for a reincarnation explanation is finding a larger fit for it among the phenomena of life. There you have the opportunity of uncovering additional significance.

In Justin L. Barrett's book, *Born Believers—The Science of Children's Religious Belief*, he laid out some of the growing evidence that young children tend to have an innate understanding of the existence of souls/God/gods, that they are believers in what Barrett termed a "natural religion" (Barrett 2012). *Born Believers* contains some striking examples including ones in which the positions of atheists were rebutted by their young children. Barrett wrote that "[c]hildren are prone to be believe in supernatural beings such as spirits, ghosts, angels, devils, and gods during the first four years of life" (Barrett 2012, p. 3). Later he wrote that:

[e]xactly why believing in souls or spirits that survive death is so natural for children (and adults) is an area of active research and debate. A consensus has emerged that children are born believers in some kind of afterlife, but not why this is so (Barrett 2012, p. 120).

These remarkable observations were simply placed by Barrett within the materialist vision, though. Even as a practicing Christian, Barrett concluded that these are simply delusional tendencies derived from evolution and experience—"biology plus ordinary environment" (Barrett 2012, p. 20). It is a remarkable act of faith, though, to extrapolate our evolution-shaped genomes to provide a basis for such beliefs. That act of faith appears to be symptomatic of what one scientist acknowledged was the fact that "science is in many ways its own religion" (Adler 2013).

At the beginning of *Born Believers'* scientific take on our innate spiritual beliefs, though, there is also a traditional explanation offered. That explanation was confidently provided by an Indian man Barrett had encountered on a train. In Barrett's words that man had explained:

that on death, we go to be with God and are later reincarnated. As children had been with God more recently, they could understand God better than adults can. They had not yet forgotten or grown confused and distracted by the world. In a real sense, he explained, children came into this world knowing God more purely and accurately than adults do (Barrett 2012, p. 2).

That reincarnation perspective will be pursued here. First, it is noteworthy that these spiritual beliefs appear to be general. As such they offer possible broad support for the reincarnation hypothesis, in that while memories of a pervious embodied life are very rare, memories of the previous disembodied experience could be the norm. Additionally, the reincarnation perspective appears to have been a common pre-modern understanding as discussed in *M'Clintock and Strong's Cyclopaedia of Biblical, Theological and Ecclesiastical Literature*, "[t]ransmigration, dating back to a remote antiquity, and being spread all over the world, seems to be anthropologically innate, and to be the first form in which the idea of immortality occurred to man" (Head and Cranston 1967, p. 170). Chris Carter, in *Science and the Afterlife Experience*, also presented the broad historical background of the reincarnation belief (Carter 2012, pp. 18–20). Carter included a quote of Ian Stevenson who had written "nearly everyone outside the range of orthodox Christianity, Judaism, Islam, and Science—the last being a secular religion for many people—believes in reincarnation".

This belief can be divided into two components: the intuitive continuity of behavior/personality component and the more puzzling cause-and-effect or karma component. Of these two aspects it has been claimed that they were historically "in fact . . . virtually always conjoined" (Head and Cranston 1967, p. 10). Perhaps the apparent continuity of personalities across lives in small and relatively undistracted groups helped to establish the continuity hypothesis. The karma belief might have gained strength in parallel when observing individuals encountering their just deserts across lives. Perhaps these beliefs could have been furthered by the insights of dedicated mystics. Another explanation for the origin of these beliefs is that they were derived from reports of the previous lives by individuals (Carter 2012, p. 20).

As an introductory synopsis of some of reincarnation's potential explanatory power:

[one might] argue that in addition to offering a straightforward explanation for our natural religion, a [reincarnation] perspective also provides traction on some scientific conundrums including prodigies, transgender individuals, and the surprising variations in personality found amongst a number of species; a simple explanation for the mysteries associated with monozygotic twins; a backdrop for some controversial phenomena including near-death experiences; and finally a consistent framework for the missing heritability problem. In brief, the missing origins for a number of our innate specifics could be understood as carryover from previous lives and with some standout behaviors—as found with prodigious savants and prodigies—there could be some additional carryover consistent

with some of the remarkable descriptions of the intervening disembodied state (Christopher 2016, p. 9).

The continuity aspect of reincarnation would be consistent with individual cases of young children experiencing the apparent recall of a previous life (Stevenson 1997; Tucker 2005; Leininger et al. 2009) as well as exhibiting some consistent behaviors. Contributions from the karma aspect would also be consistent with the unexpectedly large health differences found between identical twins and more generally the disease susceptibility portion of the missing heritability problem. All together a number of under-appreciated phenomena—including the big missing heritability problem—might help push the reincarnation theory beyond what has been characterized by Ankur Barua as an "underdetermined" status (Barua 2015).

Another suggested point here is that reincarnation's import would likely overlap with, as well as be complementary to, that of DNA. If as was commonly believed the incarnating soul is drawn to their future parents, then the soul might tend to find some continuity in the DNA specifics produced by conception—beyond the default codes for species and sex. This could include DNA-determined unusual conditions as well as the general features of appearance. Of note here is that if such a parental-draw dynamic roughly represented a draw between similar beings—analogous to the assortative mating phenomena (Baron-Cohen 2012)—then that dynamic should produce its own crude heredity pattern. For example, if an incarnating relatively aggressive soul were drawn to similarly inclined future parents, then that dynamic should produce an apparent inheritance of the tendency to be aggressive. This would be true even in the absence of any confirmed DNA basis for that tendency (as is the case for aggression and more generally for behavioral genetics).

Another basic point is that the probability that the crapshoot that is conception could deliver a variable DNA match for a soul's overall trajectory is zero. If reincarnation were happening in a big way then the conception's DNA definition would have to be breached in many ways. This is a general collision point between reincarnation and the scientific vision. Consequently, to the degree that science can show that nature plus nurture roughly defines individuals, this would markedly limit the possible import associated with reincarnation phenomena. Note the "roughly" here since from a physical perspective there would also have to be some random contributions. For example, scientists are not surprised that the physical features of monozygotic twins (like freckle patterns) are not completely identical. In this way the efforts to confirm the expectations of behavioral genetics and also in particular to account for the substantial differences found between monozygotic twins are of interest.

Two possible explanations provided by reincarnation will next be considered next, followed by a little more on the reincarnation framework.

2.5. Two Reincarnation Explanations

The first idea considered here is with regards to monozygotic twins. This necessitates a bit of background. Such twins represent a number of mysteries. One such mystery is the cause of their origin, the initial split or division of a single cell zygote (Segal 2005, p. 2). This process only happens within some species.

Similar appearances aside, the realities of monozygotic twins represent a substantial challenge to the sacred DNA "created [you] body and mind" logic. Despite being DNA replicas, identical twins whether they were raised together or separately, have been observed to be on average more different than alike personality-wise. Twin pairs can closely share the same environment or inhabit separate ones (with whatever epigenetic implications), and yet they still appear to have comparably different personalities. Note that this nurture-challenging finding is also consistent with the findings of adoption studies. After reading about twin studies and/or having personal exposure to identical twins, it is probably not a surprise to hear that one conjoined (attached) monozygotic twin said that "[w]e are two completely separate individuals who are stuck to each other. We have different world views, we have different lifestyles, we think very differently about issues" (Harris 2006, p. 1). This behavioral genetics

mystery was the focus of Judith R. Harris' *No Two Alike* (Harris 2006) and also received considerable attention in Steven Pinker's *The Blank Slate* (Pinker 2002, pp. 372–99).

On the other hand, monozygotic twins can still share remarkably specific behavioral tendencies even when they were separated at birth. From small habits like "sitting out elections because they feel insufficiently informed" (Pinker 1997, p. 20), to the big life-defining stuff—like becoming dedicated volunteer firemen (Segal 2005, p. 14). Examples like these have been used to convey the power of DNA's influence, but when juxtaposed against twin differences they may simply add to the mystery.

The surprising health differences found between monozygotic twins were discussed in a review article (Kolata 2006). The article opens by describing a healthy and active 92-year-old and her identical twin. The other twin was "incontinent, she has had a hip replacement, and she has a degenerative disorder that destroyed most of her vision . . . [and] has dementia." These twins had grown up together, lived in the same city, but also had very different ambitions and personalities. This example leads to the article's main item, a discussion of the findings of a very large study of twins' longevity. Using standard procedure, that study had made comparisons between the longevity outcomes experienced by fraternal and identical twins to infer the general DNA impact on longevity. This study, involving 10,251 twins, found that identical twins died only a little closer together than fraternal twins and in particular that the deaths of monozygotic twins averaged "more than 10 years apart". Consistent with this, one of the studies author's concluded that "[h]ow tall your parents are compared to the average height explains 80 to 90 percent of how tall you are compared to the average person [but] only 3 percent of how long you live compared to the average person" follows from your parents longevity.

One final identical twin mystery considered here is the degree of closeness found between them. Steven Pinker pointed out that "when separated at birth and reunited as adults, . . . [they] say they feel like that have known each other all their lives" (Pinker 2002, p. 47). In one of my childhood neighborhoods I cannot even remember the local twins being apart. Given that siblicide is common in nature does this really make sense for twins (Tennesen 2006)?

These monozygotic mysteries can be approached from a reincarnation perspective. Such twins could have been close before their current life; maybe as siblings, close friends, coworkers, or spouses. Scenarios like these are consistent with some of the reports from investigations into cases suggestive of reincarnation (Stevenson 1997, pp. 171–72). That earlier closeness could have brought them together to be born as identical twins and further could have been the underlying cause of the initial split of the single cell zygote. Behavioral continuity across lives could have resulted in their roughly similar personalities, a crude similarity which appears to be found between those who are close. Such continuity also could have contributed to their shared behavioral preferences. Their remarkable closeness could have followed from their earlier connection, perhaps including shared experiences in the disembodied realm. Altogether then from this perspective monozygotic twins are, superficially replicas, but deeper down there are two separate beings with mostly separate backgrounds which would then account for their otherwise surprising differences.

For a Western historical perspective on such an explanation consider the following from the 1600s by Joseph Glanvill, Chaplain to King Charles II:

> Every soul brings a kind of sense with it into the world, whereby it tastes and relisheth what is suitable to its particular temper . . . What can we conclude but that the soul itself is the immediate subject of all this variety and that it came prejudiced and prepossessed into this body with some implicit notions that it had learned in another? To say that all this [individual] variety proceeds primarily from the mere temper of our bodies is methinks a very poor and unsatisfying account. For those that are the most alike in the temper, air, and complexion of their bodies, are yet of a vastly differing genius . . . What then can we conjecture is the cause of all this diversity, but that we had taken a great delight and pleasure in some things like and analogous onto these in a former condition (Head and Cranston 1967, p. 122).

Does any scientific literature even mention this intuitive quote?

Another place reincarnation could provide some explanatory insight is with regards to the wide range of personality found among animals. During the last decade or so, scientists have returned to investigating the personalities of animals (for quite a while this was a taboo topic). In a review article by Natalie Angier it was reported that:

> [in] the burgeoning field of animal personality research, the effort to understand why individual members of the same species can be so mulishly themselves, and so unlike one another on a wide variety of behavioral measures. Scientists studying animals from virtually every niche of the bestial kingdom have found evidence of distinctive personalities—bundled sets of behaviors, quirks, preferences and pet peeves that remain remarkably stable over time and across settings. They have found stylistic diversity in chimpanzees, monkeys, barnacle geese, farm minks, blue tits and great tits, bighorn sheep, dumpling squid, pumpkinseed sunfish, zebra finches, spotted hyenas, even spiders and water spiders, to name but a few. They have identified hotheads and tiptoers, schmoozers and loners, divas, dullards and fearless explorers, and they have learned that animals, like us, often cling to the same personality for the bulk of their lives. The daredevil chicken of today is the one out crossing the road tomorrow (Angier 2010).

Further she added, "[r]esearchers are delving into the source and significance of all these animal spirits." From a reincarnation perspective personality could be a relatively constant thread across different embodied lives. The experiences of a soul then could have helped create and solidify their personality—and then possibly change it. The alternative, i.e., of trying to materially manufacture a variety of personalities—even in tiny animals—appears difficult. As a final note interested readers can look up literature chronicling animistic beliefs for some possible insights there.

2.6. More on a Possible Reincarnation Framework

Earlier it was discussed how the two components—behavioral continuity and karma—of a reincarnation belief might have been established. Observations of the apparent continuity of personality, together with possibly more subtle observations of behavioral cause and effect, across lives in small groups could have helped form this common belief.

One interesting career-related example from outside the reincarnation literature involves an experience of Cornell University's nutritional scientist T. Colin Campbell. Campbell has spent the latter part of his career researching the under-appreciated possible health benefits associated with a plant-based diet (Campbell and Campbell 2004). While on sabbatical in Oxford, England in 1985, he came upon the writings of a London surgeon named George Macilwain who had researched and practiced in the early 1800's. Upon some subsequent genealogical research Campbell came to the conclusion Macilwain was his great-great uncle. Campbell subsequently wrote that:

> This discovery has been one of the more remarkable stories of my life. My wife Karen says, "If there's such a thing as reincarnation ... ". I agree: if ever I lived a past life, it was George Macilwain. He and I had similar careers; both of us became acutely aware of the importance of diet in disease; and both of us became vegetarian. Some of his ideas, written over 150 years ago, were so close to what I believed that I felt they could have come from my own mouth (Campbell and Campbell 2004, p. 344).

The possible reincarnation connection here would be behavioral continuity that played out along family lines as was commonly believed (Head and Cranston 1967, p. 173; Columbia University Press 2000, p. 2874). An underlying appreciation for a plant-based diet could have played itself out in a big way in Campbell's life. Looking beyond this, there is no apparent basis for a personality comparison other than the inference that both individuals were able to endure being outsiders in the health world.

A general reincarnation explanation would have to be rather complicated, though. By contemplating the realms of prodigies and transgender individuals one can get a sense of this. In the prodigy realm

somehow young children show up in amazingly focused adult modes and this can appear in families without relevant backgrounds (Christopher 2016, pp. 4–5, 46–47). Given that many adults can groove into quite focused existences—probably more commonly with males and their jobs—why then wouldn't prodigious children be more common? Some insight here and elsewhere might be available by considering the *Tibetan Book of the Dead* (TBD), a book written in the 8th century by a Buddhist religious teacher named Padmasambhava (Francesca and Trungpa 1992). The TBD contains instructions to aid a dying or recently deceased person in dealing with the presumed tumultuous intermediate state, and in particular at a minimum to obtain a good rebirth. The coauthor and late Tibetan teacher Chogyam Trungpa offered a modernized synopsis in his commentary:

> [t]here is something which continues, there is the continuity of your positive relationship with your friends and the [religious or spiritual] teaching, so work on that basic continuity, which has nothing to do with the ego. When you die you will have all sorts of traumatic experiences, of leaving the body, as well as your old memories coming back to you as hallucinations. Whatever the visions and hallucinations may be, just relate to what is happening rather than trying to run away. Keep there, just relate with that (Francesca and Trungpa 1992, p. 40).

Another teacher, Tulku Thondup, characterized the existence between lives or "bardo" experience as "like a dream journey, fabricated by our habitual mental impressions" (Thondup 2005, p. 10). Tibetan Buddhist-based images would then have seemed to have framed many of the TBD's descriptions. Trungpa's commentary emphasized an energy-oriented interpretation of the bardo experience, and then as described in the TBD, a soul might tend to unwisely grasp at proverbial straws facing such a helter-skelter energetic scenario. An exceptional rebirth outcome might then be explained as the result of a soul's exceptional grasping in which it inadvertently ended up catching a resonance (in a physics-sense) and obtaining a hyper-focused rebirth. From this perspective then a very strong tendency to obsess about one's work might then produce an overly focused prodigal-type rebirth. Analogously, it follows that a tendency to fantasy about the opposite gender (perhaps based on earlier experiences as that gender), might then produce a transgender rebirth (in some form).

Another possible insight provided in the pre-modern TBD text is with regards to the remarkable capacities of the soul which surface within the bardo. In that book it is stated repeatedly that the "mind becomes nine times more clear" in the bardo and also that even if before dying the TBD was "heard . . . only once and the meaning not understood" then after death "it will be remembered with not even a single word forgotten" (Francesca and Trungpa 1992, pp. 167–68). These capacities for memory and clarity might then be hypothesized to surface on occasion within an embodied existence and thus provide a basis for some extraordinary cognitive abilities, as for example with savants or perhaps with those individuals who, despite reduced brain tissues, still exhibit normal functioning. As a final input from the *Tibetan Book of the Dead* one can consider its description of an ultimate identity or soul. The book describes an elemental duality between an active (or "luminosity") component and also a passive (or "emptiness") component. Here is a sample description:

> [t]hese two, your mind whose nature is emptiness without any substance whatever, and your mind which is vibrant and luminous, are inseparable: this is the dharmakaya of the buddha. This mind of yours is inseparable luminosity and emptiness in the form of a great mass of light, it has no birth or death . . . (Francesca and Trungpa 1992, p. 87).

One might then hypothesize that this elemental identity contributes in some way to the missing "dark" aspects of the inferable universe. It is also noteworthy that this element-like description of the soul does not seem consistent with Buddhism's no-self theories.

3. Discussion

3.1. The Religion and Science Context

The standoff between science and religion is quite a one-sided stalemate. Since science—and certainly its bedrock position of materialism—has achieved overwhelming acceptance within intellectual and secular circles, the current impasse reflects at best a polite dismissal of religious perspectives. As discussed in a *Hole in Science* (Christopher 2016, pp. 115–28) that polite dismissal is pretty well characterized by the coverage of the *New York Times*. For many secular individuals it appears that questioning materialism is not an option, and further consideration of religious perspectives is even less likely.

One way to appreciate this skewed situation is to consider some of the highlights from the contemporary front lines of science versus religious or alternative views of life. A sampling of these highlights include Thomas Nagel's philosophical *Mind and Cosmos* (Nagel 2012), Bernard Haisch's physics-oriented *The God Theory* (Haisch 2006), and Stephen C. Meyer's intelligent design treatise *Darwin's Doubt* (Meyer 2013). Do any of these works, though, really present more than nuanced critiques of materialism? How much would it matter if there was some other ingredient present to explain consciousness—perhaps a novel particle? What meaning is provided by nodding our heads to very speculative quantum-based reasoning so that we can ask ourselves "[w]hat greater purpose could there be for each of us humans than that of creating God's experience?" Additionally, if there was some divine guidance which helped establish the current status of the biosphere—but that biosphere was itself simply defined by the ongoing "jigglings and wigglings of atoms"—would that really matter?

Perhaps the most widely respected questioning of scientific materialism comes from the so-called "hard problem" of consciousness, which asks how consciousness could have a physics-only basis? However, how much significance does this abstract question have (beyond keeping some philosophers occupied)? An alternative hard problem is explaining the differences between the two elderly identical twins previously described—in particular one healthy and the other very unhealthy—and then try to explain it. If this were a rare occurrence you could write it off as simply a result of random events. However, it isn't; it is symptomatic of the unfolding DNA deficit. Explanations based on the heavily leveraged linchpin of the scientific understanding of life, deoxyribonucleic acid, are striking out in a big way. Here is a hard problem that matters, even if philosophers have ignored it.

The fundamental questions that drive many of our deeper yearnings seem to pertain to two questions—"Who am I?" and "What is going to happen to me?"—and of course generalizing these to others. Unless one directly tackles scientific materialism the answers to those questions are very limited. If religions and the religious want to gain a foothold in the scientific era, what else can they effectively do?

As a relative outsider I view the deeper perspectives offered by religions as characterized by two modern heretical concepts. The first is the concept of a higher power (or powers). The second is the concept of a soul. One can think of these as representing top-down and bottom-up deeper aspects of reality, respectively. I think objectively arguing for the first of these is very difficult, although the innate aspect of this belief does offer a foothold. I think that arguing for the existence of a soul, on the other hand, is not difficult. To get started on the second argument—and also indirectly the first—it is probably best to argue against the bio-robotic vision of life.

3.2. Modern Buddhism: Science-ification as a Dead-End

One way of maintaining a religious perspective in the Science Era is to simply go with the flow and try creating bridges to science. At least in the West, Buddhism appears to have largely gone that route. This movement has a quite a history as pointed out in Donald Lopez's academic treatment, *The Scientific Buddha: His Short and Happy Life* (Lopez 2012) and also indirectly in a contemporary context in a *Tricycle* magazine article, "10 Misconceptions about Buddhism" (Buswell and Lopez 2013).

In *A Hole in Science* I started with references to the latter and then added some personal observations (Christopher 2016, pp. 131–42).

Let me begin my brief commentary here by offering a quote from another recent *Tricycle* article. In that article the author pointed out that he and many other modern Buddhists experience "profound embarrassment" over Buddhism's rebirth belief, but satisfaction over Buddhism's apparent "resonance with quantum physics, cutting edge neuroscience, and modern rationality" (Spellmeyer 2015). I think this aptly characterizes the cutting edge, modern intellectual wannabe-ism that has arguably become fundamental to the appeal of westernized Buddhism (along with enlightened wannabe-ism). The recent history of that movement—including the plunger-ing of quantum speculation, the prominent usage of a fake Einstein quote, and lately an imagined scientific endorsement for the efficacy of mindfulness meditation via neuroscience—has in fact furthered the decline of sincere Buddhist practice, as well as I would argue serious secular variants.

I consider here a recent statement from this science-ification of Buddhism. In a November 2014 *Scientific American* article, "mind of the meditator", by Mathieu Ricard, Antoine Lutz, and Richard J. Davidson the neuroscientific efforts to characterize apparent brain changes associated with meditation (in particular mindfulness, focused attention, and compassion and loving kindness) were described (Richard et al. 2014). The article opened with an acknowledgement of the Dalai Lama's foundational contributions to these efforts. The confident article worked its way up to proclaiming:

> [a]bout 15 years of research have done more than show that meditation produces significant changes in both the function and structure of the brains of experienced [10,000 h or more] practitioners. These studies are now starting to demonstrate that contemplative practices may have a substantive impact on biological processes critical for physical health.

And additionally that:

> [t]he ability to cultivate compassion and other positive qualities lays the foundation for an ethical framework unattached to any philosophy or religion, which could have a profoundly beneficial effect on all aspects of human societies.

The support for these glowing proclamations was, however, overstated. The article is only loosely quantitative and the one graph that purports to show enhancement in neural features derived from meditation shows small effects with significant overlap between the measurements of experienced meditators and those of controls. The authors also failed to respond to a published follow-up letter from a meditator regarding the possibility that selection bias distorted their results. Furthermore, how many lay people have a chance of joining the 10,000 h club (and thus the likelihood of selection bias)?

Even more seriously, though, why didn't the authors point out that similar and often secularly packaged meditation has been quite widely available in the West for at least 40 years? If such meditation was as self-help productive as presented in Richard et al.'s article then why didn't it sell itself—akin to an effective dieting routine—without the need for neuro-scientific re-packing? Any sober assessment of contemporary meditation movements would emphasize that these have largely been secular and that sustained involvement has been a big challenge.

In turns out that the contemporary participatory status of Buddhism, as well as derivative meditational efforts, is pretty well represented in the vicinity of Rochester, New York. Southeast of Rochester in Ithaca, New York is Namgyal Monastery which is the "North American Seat" of the Dalai Lama. As I have personally observed, they offer Tibetan Buddhist programs which are open to the public that are taught by very qualified Tibetan monks. These programs are presented in a very friendly atmosphere and are not expensive. Ithaca certainly appears to be a potentially supportive community as it contains Ithaca College, Cornell University, and also a sizable alternative community. Also in terms of a potential link between Buddhism and science, Cornell University happens to be one of our top universities in terms of their National Science Foundation (NSF) funding support. However, in fact—over at least the last decade or so—when Namgyal runs one of their monthly

weekend teaching programs (which open with a free Friday evening session) they end up e-advertising until the opening Friday in order to try to fill their venue. That venue, up until a recent move to a new facility, was a modest-sized living room, in a modest-sized house. Despite—or perhaps in part due to—the science-ification efforts of Buddhists like the Dalai Lama, those lonely programs offer a pretty good feel for the status of the religion of Buddhism in the modern world.

For a complementary feel on the status of serious secular meditation today one can travel 60 miles west of Ithaca to Springwater, New York. Springwater is home to the Springwater Retreat Center which got its completely secular start 35 years ago when Toni Packer left the Rochester Zen Center and dropped all adherence to Buddhism (she apparently didn't need to read Sam Harris' *Waking Up* which purportedly "start[ed] the conversation" about meditation sans religion). Despite Springwater's cutting-edge secular history (at one point in the eighties Toni Packer even labored through some early relevant neural literature) their (inexpensive and friendly) retreats appear to enjoy a comparable lack of participation as Namgyal's programs. One might then wonder if the latest secular re-packaging of meditation—mindfulness or whatever—will simply pan out as another superficial trendy episode.

Beneath the limited appeal of sustained involvement with meditation is the minimally discussed rarity of significant enlightenment or transformational experiences: a succinct, well-grounded assessment of that likelihood was given at the end of the Zen classic, *Zen Teaching of Huang Po*, by John Blofeld (Blofeld 1958). In it the Zen teacher Huang Po commented that:

> Ah be diligent. Be diligent! Of a thousand or ten thousand attempting to enter by this [Zen enlightenment] Gate, only three or perhaps five pass through. If you are heedless of my warnings, calamity is sure to follow. Therefore it is written, "Exert your strength in THIS life to attain! Or else incur long aeons of further [karmic] gain!" (Blofeld 1958, p. 132).

Even in a much less distracted era, a practice very much focused on this life in a Zen monastery saw very limited success. By comparison, how many modern Western meditational outfits—nominally Buddhist or derivative—do not grossly oversell the return on meditation?

The traditional appeal of Buddhist practice—certainly for lay people—was to make better use of one's life within an interconnected sequence of lives. Thus, a key commitment was to the betterment of "all beings". Without looking for an objective basis for that traditional Buddhist perspective—as with other religious perspectives—I doubt that it will last long.

4. Conclusions

For additional context here I review some of the challenges facing reincarnation research. The established research vehicle, of course, involves investigating cases of children who claim to remember a previous life. A good presentation of the status and limitations of this approach is provided in the final chapter of Jim Tucker's *Life Before Life* (Tucker 2005). There Tucker pointed out that "I would say that the best explanation for the strongest cases is that memories, emotions, and even physical injuries can sometimes carry over from one life to the next" (Tucker 2005, p. 211). Tucker also pointed out that "we must remember that what is true about the children who reported past-life memories may not be true for the rest of us" (Tucker 2005, p. 213) and further that "these cases do not answer the question of whether reincarnation is universal" (Tucker 2005, p. 214).

Tucker went on to point out the complexity of possible contributions from karma and thus the limitations associated with checking on them based only on an examination of the previous personality's (notable) actions (Tucker 2005, p. 221). Nonetheless he did find that their database of cases supported one possible karma-consistent connection. He wrote that:

> [s]aintliness in the previous personality showed a very strong correlation with the economic status of the subject and a significant correlation with the social status of the subject. This means that the more saintly the previous personality was considered to have been, the higher the economic status and social status that the child is likely to have. Saintliness did not correlate with the caste of the subject in the cases in India, and none of the other

characteristics of the previous personality correlated with the circumstances of the subject (Tucker 2005, p. 222).

The limitation here—and more generally for the case-based approach—is that there is a very small data set of admittedly unusual cases. They certainly do not want follow behavioral genetics' earlier lead with its history of false positives and in particular being "full of reports that have not stood up to rigorous replication" (Horgan 2015).

The main point being made herein is that there is an alternative broad avenue to investigating the reincarnation hypothesis. If the reincarnation phenomena were general and significant then it should effectively throw a proverbial wrench into the logic of genetics. Actual DNA support should then be markedly short of geneticists' expectations. Thus, *who we are* and *what happens to us* should present large conundrums to science. This is in fact what has been unfolding on a large scale and it offers a potential broad argument for reincarnation. On the other hand, if the ambitions of personal genomics are in large part met then that would markedly eliminate possible karmic influences on our health (which is a big part of *what happens to us*). In parallel behavioral genetics is in an under-appreciated showdown with the possible continuity contributions from reincarnation. It is significant here that the genetic searches are not limited to small numbers. The current genetics effort investigating the roots of schizophrenia and other mental disorders involves "more than 800 collaborators from 38 countries and samples more than 900,000 subjects" (Balter 2017). They are obtaining statistically significant results, they just happen to correspond to null findings. It is also noteworthy that this genetic deficit appears to be conceptually consistent with the intuition offered by the (Nobel laureate) physicist Eugene Wigner with regards to a possible conflict or contradiction at the intersection of the "laws of heredity and of physics" (Wigner 1960).

The other point I stress here is that there are other phenomena that challenge scientific materialism and simultaneously provide some support for reincarnation (Christopher 2016). As an outsider in a materialist/physics-based essay contest my simple essay, "Question the Big Picture and Expand the Horizon", drew quite a bit of praise by simply listing out some of these phenomena (Christopher 2017). One engineering professor conveyed to me that "in terms of logical constructs, your 'counter-examples' are a very powerful way of starting the thinking/questioning process that surrounds the whole materialist/scientism viewpoint. Well done" (Parker 2017). I am surprised that others trying to challenge materialism, and/or investigate reincarnation, are not looking into such examples, including those in the prodigy and transgender literature. Why in a huge book entitled *Irreducible Mind* would John Lorber's stunning minimal-brain observation show up only as two sentences in a footnote on page 263? I have passed the *Science* article describing Lorber's work (Lewin 1980) on to a number of scientific/technical individuals and have usually elicited emphatic dumbfounded responses.

One additional concluding point here is that simple behavioral continuity does not appear capable of describing some exceptional tendencies. Thus, I suggest that the rebirth process can be volatile and that this might be consistent with the common dread of death, and also some of the traditional post-death practices. As a concrete example, I do not think that reincarnation implies that Albert Einstein was preceded and/or followed by another Einstein.

It is not difficult to question scientific materialism, even in a big way. The associated mysteries are well worth our attention. One possible explanation is that there is some kind of non-material continuity happening between sequential lives. Along those lines, pre-modern beliefs in reincarnation could offer a number of specific explanations. Serious consideration of the reincarnation perspective appears to be overdue. Perhaps the results of simple observations long ago can provide some helpful insights into life and its challenges.

Acknowledgments: The author gratefully acknowledges the Central Library of Rochester and Monroe County. Several significant books were obtained there and the library also provided a good work space. The author also gratefully acknowledges the editing work of Cindi Rittenhouse. Beyond this the efforts and funding came solely from the author.

Conflicts of Interest: The author declares no conflict of interest.

References and Notes

Adler, John R. 2013. Personal communication with regards to a manuscript submitted to the journal Cureus. Palo Alto, CA, USA, August.

Alexander, Eben. 2012. *Proof of Heaven: A Neurosurgeon's Journey into the Afterlife.* New York: Simon and Schuster Paperbacks.

Alford, John R., Carolyn L. Funk, and John R. Hibbling. 2005. Are Political Orientations Genetically Transmitted? *American Political Science Review* 99: 153–67. Available online: https://www.cambridge.org/core/journals/american-political-science-review/article/are-political-orientations-genetically-transmitted/C6D3A60FBE6779C8E6E798600785A4C9 (accessed on 7 July 2017). [CrossRef]

Angier, Natalie. 2010. Even Among Animals: Leaders, Followers and Schmoozers. *New York Times.* April 5. Available online: www.nytimes.com.2010/04/06/science/06angi.html (accessed on 7 July 2017).

Balter, Michael. 2017. Schizophrenia's Unyielding Mysteries. *Scientific American* 316: 54–61. [CrossRef] [PubMed]

Baron-Cohen, Simon. 2012. Autism and the Technical Mind. *Scientific American* 307: 72–75. [CrossRef] [PubMed]

Barrett, Justin L. 2012. *Born Believers—The Science of Children's Religious Belief.* New York: Free Press.

Barua, Ankur. 2015. Revisiting the Rationality of Reincarnation Talk. *International Journal of Philosophy and Theology* 76: 218–31. Available online: https://www.repository.cam.ac.uk/bitstream/handle/1810/249040/Barua%202015%20International%20Journal%20of%20Philosophy%20and%20Theology.pdf?sequence=1&isAllowed=n (accessed on 7 July 2017). [CrossRef]

Bering, Jesse. 2013. Ian Stevenson's Case for the Afterlife: Are We 'Skeptics' Really Just Cynics. Available online: https://blogs.scientificamerican.com/bering-in-mind/ian-stevensone28099s-case-for-the-afterlife-are-we-e28098skepticse28099-really-just-cynics/ (accessed on 7 July 2017).

Blofeld, John. 1958. *The Zen Teaching of Huang Po.* New York: Dover Press.

Buswell, Robert E., Jr., and Donald S. Lopez Jr. 2013. 10 Misconceptions about Buddhism. *Tricycle*, November 19.

Campbell, T. Colin, and Thomas M. Campbell II. 2004. *The China Study.* Dallas: Benbella Books, Note revised versions are also available and in these the authors ordering has been reversed.

Carroll, Sean. 2016. *The Big Picture: On the Origins of Life, Meaning, and the Universe Itself.* New York: Dutton.

Carter, Chris. 2012. *Science and the Afterlife Experience.* Rochester: Inner Traditions.

Christopher, Ted. 2016. *A Hole in Science: An Opening for an Alternative Understanding of Life.* Rochester: Wise Media Group, First published in 2015. Self-published and available at Amazon and other online outlets. An (updated) third edition is expected in October 2017.

Christopher, Ted. 2017. Question the Big Picture and Expand the Horizon. Produced for a Foundational Questions Institute Essay Contest. Available online: http://fqxi.org/community/forum/topic/2783 (accessed on 7 July 2017).

Collins, Francis. 2010. *The Language of Life: DNA and the Revolution in Personalized Medicine.* New York: Harper Collins.

Columbia University Press. 2000. *The Columbia Encyclopedia.* New York: Columbia University Press.

Dawkins, Richard. 1976. *The Selfish Gene.* New York: Oxford University Press.

Francesca, Freemantle, and Chogyam Trungpa. 1992. The Tibetan Book of the Dead (pocket version). Boston: Shambhala Publications.

Fromme, Petra, and John C. H. Spence. 2017. Split Second Reactions. *Scientific American* 316: 62–67. [CrossRef] [PubMed]

Haisch, Bernard. 2006. *The God Theory.* San Francisco: Weiser Books.

Harris, Judith Rich. 2006. *No Two Alike: Human Nature and Human Individuality.* New York: W. W. Norton and Company.

Harris, Sam. 2014. *Waking Up: A Guide to Spirituality Without Religion.* New York: Simon & Schuster.

Head, Joseph, and S.L. Cranston. 1967. *Reincarnation and World Thought.* New York: Julian Press.

Horgan, John. 2015. Quest for Intelligence Genes Churns Out More Dubious Results. Available online: https://blogs.scientificamerican.com/cross-check/quest-for-intelligence-genes-churns-out-more-dubious-results/ (accessed on 18 August 2017).

Janice Miner Holden, Bruce Greyson, and Debbie James, eds. 2009. *The Handbook of Near-Death Experiences.* Santa Barbara: Praeger Publishers, Page 306 contains the index's entry for "life review" and a number of relevant pages are given there.

Kingsley, David M. 2009. From Atoms to Traits. *Scientific American* 300: 52–59. [CrossRef] [PubMed]

Kolata, Gina. 2006. Live Long? Die Young? Answer Isn't Just in Genes. *New York Times*, August 31.

Kolata, Gina. 2013. Human Genome, Then and Now. *New York Times*, August 15.

Landau, Elizabeth. 2009. CNN Article: Born in Male Body, Jenny Knew Early that She Was a Girl. Available online: www.cnn.com/2009/HEALTH/06/12/sex.change.gender.transition/ (accessed on 7 July 2017).

Latham, Jonathan, and Allison Wilson. 2010. The Great DNA Data Deficit: Are Genes for Disease a Mirage? Available online: https://www.independentsciencenews.org/health/the-great-dna-data-deficit/ (accessed on 7 July 2017).

Leininger, Bruce, Andrea Leininger, and Ken Goss. 2009. *Soul Survivor—The Reincarnation of a World War II Fighter Pilot*. New York: Grand Central Publishing.

Lewin, Roger. 1980. Is Your Brain Really Necessary? *Science* 210: 1232–34. Available online: www.rifters.com/real/articles/Science_No-Brain.pdf (accessed on 8 July 2017).

Lopez, Donald, Jr. 2012. The Scientific Buddha. Available online: www.tricycle.com/special-section/scientific-buddha (accessed on 7 July 2017).

Mayer, Elizabeth Lloyd. 2007. *Extraordinary Knowing: Science, Skepticism, and the Inexplicable Powers of the Human Mind*. New York: Bantom Books.

McGaugh, James L., and Aurora LePort. 2014. Remembrance of All Things Past. *Scientific American* 310: 40–45. [CrossRef] [PubMed]

Meyer, Steven C. 2013. *Darwin's Doubt: The Explosive Origin of Animal Life and the Case for Intelligent Design*. New York: HarperCollins.

Mitchell, Kevin A. 2012. I've got Your Missing Heritability Right here Available online: www.wiringthebrain.com/2012/02/ive-got-your-missing-heritability-right.html (accessed on 7 July 2017).

Mukherjee, Siddhartha. 2016. *The Gene: An Intimate History*. New York: Scribner.

Nagel, Thomas. 2012. *Mind & Cosmos: Why the Materialist Neo-Darwinian Conception of Nature Is Almost Certainly False*. New York: Oxford University Press.

Padawer, Ruth. 2012. What's So Bad about a Boy Who Wants to Wear a Dress? *New York Times*, August 8.

Parker, Kevin J. 2017. Personal communication with regards to my FQXI essay. Rochester, NY, USA, April.

Pinker, Steven. 1997. *How the Mind Works*. New York: W. W. Norton.

Pinker, Steven. 2002. *The Blank Slate: The Modern Denial of Human Nature*. New York: Viking Penguin.

Richard, James L., Antoine Lutz, and Richard J. Davidson. 2014. Mind of the meditator. *Scientific American* 311: 38–45. [CrossRef]

Schafer, Aaron. 2006. Stanford at the Tech Museum Understanding Genetics. Available online: genetics.thetech.org/ask/ask166 (accessed on 8 July 2017).

Segal, Nancy L. 2005. *Indivisible by Two*. Cambridge: Harvard University Press.

Solomon, Andrew. 2012. *Far From the Tree*. New York: Scribner.

Spellmeyer, Kurt. 2015. After the Future. *Tricycle*, fall.

Stevenson, Ian. 1997. *Where Reincarnation and Biology Intersect*. Westport: Praeger Publishers.

Stevenson, Ian. 2000. The Phenomenon of Claimed Memories of Previous Lives: Possible Interpretations and Importance. Available online: https://pdfs.semanticscholar.org/e8d7/78d20507be2d971858ffeac47ad455c6ad95.pdf (accessed on 13 August 2017).

Tennesen, Michael. 2006. Who Says You Have to Be Nice to Your Brother? *Wildlife Conservation*, September/October. Tastefully no photos were included.

Thondup, Tulku. 2005. *Peaceful Death, Joyful Rebirth: A Tibetan Buddhist Guidebook*. Boston: Shambhala Publications.

Treffert, Darold A. 2010. *Islands of Genius*. London: Jessica Kingsley Publishers.

Tucker, Jim. 2005. *Life Before Life—A Scientific Investigation of Children's Memories of Previous Lives*. New York: St. Martin's Press.

Wade, Nicholas. 2008. A Dissenting Voice as the Genome is Sifted to Fight Disease. *New York Times*, September 16.

Wigner, Eugene. 1960. The Unreasonable Effectiveness of Mathematics in the Natural Sciences. Available online: www.dartmouth.edu/~matc/MathDrama/reading/Wigner.html (accessed on 13 August 2017).

Yuste, Rafael, and George M. Church. 2014. The New Century of the Brain. *Scientific American* 310: 38–45. [CrossRef] [PubMed]

Article

Rebirth According to the *Bhagavad gītā*; Epistemology, Ontology and Ethics

Ithamar Theodor

Department of Religion and Spirituality, Zefat Academic College, Safed 1320610, Israel; theodor@orange.net.il

Received: 22 July 2017; Accepted: 10 August 2017; Published: 14 August 2017

Abstract: This paper is engaged with the topic of reincarnation in the *Bhagavad gītā*, better termed "rebirth". It first looks into the epistemological aspects of rebirth, and highlights the type of knowledge or terminology underlying the vision of rebirth, as opposed to a different type of knowledge that is not suitable for this purpose, and which leads to a different vision of reality. It then looks into the ontological aspects of rebirth, and having highlighted some *Upaniṣadic* sources, it highlights major *Bhagavad gītā* sections describing the soul and rebirth. Finally, it looks into the ethics derived from the concept of rebirth; it first characterizes these as "ethics of equanimity", and then expands these into the "ethics of enlightened action", which refer to action grounded in the idea of rebirth.

Keywords: *Bhagavad gītā*; reincarnation; rebirth

In a previous work, I have offered the metaphor of a three-storey house in order to describe the structure of the *Bhagavad gītā* (Theodor 2010, p. 5). Accordingly, the *Bhagavad gītā*[1] is divided into three metaphysical tiers or layers that could each be described in terms of epistemology, ontology and ethics. The lower level is humanistic and may be termed "the world of *dharma*"; the second level is spiritualistic and may be termed "the world of yoga", and the third level is liberated and may be termed "the world of *mokṣa*". The aim of this paper is to expand upon the middle level, which is grounded in the concept of rebirth or reincarnation. It aims at highlighting the epistemology or type of knowledge in which the idea of rebirth is grounded in the *Bhagavad gītā (Bhg)*, and then looking at the ontology of the self or soul, which forms the foundation of rebirth. Finally, it aims at highlighting the type of ethics derived from the concept of rebirth, which is the ethics of equanimity.[2]

In general, while Hinduism does not necessarily denote a religion with clearly defined boundaries, it nevertheless denotes a group of traditions united by certain common features, such as shared ritual patterns, shared revelation, belief in reincarnation (*saṃsāra*), liberation (*mokṣa*), and a particular form of endogamous social organization or cast (Flood 2003, p. 2). The *Bhagavad gītā* is one of the central doctrinal texts for Hinduism, and serves as a major source for doctrines and ideas concerning reincarnation. It is one of the three founding texts of the *Vedānta* tradition, known as *prasthānatrayī*, along with the *Brahmasūtra* and the *Upaniṣads*. The *Bhg* propounds, among other things, doctrines underlying the *Vedānta* traditions, of which the concept of reincarnation is central. In examining the topic of reincarnation or rebirth, the terms used by the *Bhg* to indicate the transmigrating entity may be examined; these are *dehin*, *śarīrin*, *dehabhṛt*, *dehavat*, and *kalevera*. All of these terms indicate a soul clearly distinct from its material body (Goswami 2015, p. 50). One may also look into the term *bhūta*, whose origin is in the verbal root *bhū*, which means to be, but also often means to become. In this sense, *bhūta* means one who has come-to-be, i.e., one who has become. The *Bhg* makes clear early on that the individual souls have always existed. Thus, what comes to be is not the soul itself, but rather

[1] Hence *Bhg*.
[2] Special thanks are due to my research assistant Mr. Omer Lahav for his help.

the soul's ephemeral persona, produced when the soul enters the body. A different way of stating this would be to say that *bhūta* arises when matter and spirit combine (Goswami 2015, p. 48).

1. Epistemology

Before entering the topic of reincarnation, we would like to look into the underlying epistemological assumptions, as epistemology is engaged with the theory of knowledge, especially with regard to its methods, validity, and scope (Pearsall 1998, p. 620), which may be relevant for our study. The *Bhg* defines three categories of knowledge. The first category is that by which the soul is to be understood, whereas the second and third categories are not conducive for the discussion of the soul and reincarnation:

> 18. 19 Knowledge, action and the agent are indeed of three kinds, divided according to the *guṇas*; hear now how is this division depicted through the *guṇa* doctrine. 20 Know that knowledge to be of the nature of goodness, through which one sees a single imperishable reality in all beings, unified in the diversified. 21 Know that knowledge to be of the nature of passion, through which one sees through division a variegated reality of many sorts in all beings. 22 Knowledge that attaches one to one kind of activity, as if it were all, which is not based on a reasonable cause, which does not aim at the truth, and which is minute and meagre, is said to be of the nature of darkness (Theodor 2010, p. 134).

Apparently, the first category of knowledge, which is defined as *sattvic* or transparent, is the relevant category. As such, according to this type of knowledge, the varieties of bodies seem secondary to the reality of the soul or self, which seems primary. As opposed to this category, according to the second category or type of knowledge, which is defined as *rajasic* or passionate, the varieties of bodies seem primary, whereas the soul seems secondary. The third type of knowledge, which is the *tamasic* or dark, is the lowest or most obscure; as such, it obscures the ability to see or to understand the soul and its reality, and is the least relevant for the study of the soul and rebirth. The present discussion may be approached from a different point of view, which considers: how does the self reflect upon itself when it thinks in terms of the first or *sattvic* category, or what kind of knowledge of itself does it have? In other words, the idea of the self implies a kind of detached vision, according to which one examines the working of the body from an external point of view. The *Bhg* offers a reflective vision according to which one thinks of oneself as detached from the body and mind, which are in actuality operated by *prakṛti,* or nature:

> 5. 7 He who is absorbed in *yoga,* who is a pure soul, who is self-controlled and has subdued his senses, and who is deeply related to all living beings, is never defiled even though he acts. 8–9 'I am not really doing anything', reflects the knower of the truth absorbed in *yoga.* While seeing, hearing, touching, smelling, eating, walking, sleeping, breathing, evacuating, receiving, opening or closing his eyes, he meditates and considers all these as nothing but the senses acting among their sense objects (Theodor 2010, p. 56).

As opposed to this detached self-reflection, which is grounded in the first or *sattvic* type of knowledge, one would think of himself differently while seeing through the *rajasic* or second category of knowledge.

> 3. 27 Although actions in every respect are performed by the *guṇas* of material nature, the spirit soul, confused by the ego thinks: "It is actually me who is the doer" (Theodor 2010, p. 46).

Apparently, this vision of oneself as the doer of actions is the *rajasic* vision, and it expands into a system of knowledge that identifies the self with the body, gross or subtle, as opposed to the *sattvic* vision, which expands into a system of knowledge that sees the self as a detached entity residing in the body but not directly operating it. This may raise the question of what is the differentiating element between the two types of knowledge, or wording the question differently: how is it that one person sees the self as detached from the body and mind, whereas another person sees the self

as identical with the body and mind? The *Bhg* addresses this question and considers lust or *kāma* to be the degrading force, i.e. that which, when absent, determines whether one is able to maintain a dispassionate vision of reality, and when present, clouds one's knowledge in such a way, so that the vision of the detached self is lost and replaced by the vision of the body and mind as the self.

> 3. 36 Arjuna said: What is it that impels one to commit evil, even against his will, as if driven by force, O descendent of Vṛṣṇi? 37 The blessed Lord said: It is lust, it is anger, originating from the passion-*guṇa*, and it is the great evil and the great devourer; know that to be the enemy. 38 As fire is obscured by smoke, as a mirror is covered by dust, and as the embryo is enveloped in the womb, so the living being is obscured by lust. 39 This eternal enemy covers even the wise one's knowledge, O Kaunteya, having taken the form of this insatiable fire—lust. 40 It is said to abide in the senses, the mind and the intelligence; through these it deludes the embodied soul and clouds its knowledge.

Considering the removal of lust, the cloud that obscures the knowledge of rebirth, the question may be raised: what is the self's role in the process of knowing? Apparently, the self is manifested in the knowing operation itself, and could be considered as self-manifesting or self-revealing (*sva-prakāśa*). The existence of the self can thus be perceived by its self-luminous nature. The self is the cognizer of the objects only in the sense that under certain conditions of the operation of the mind, there is the mind-object contact through a particular sense, and, as the result thereof, this object appears in consciousness (Dasgupata 2000, p. 69). As such, ideas of the mind, concepts, volitions, and emotions appear in consciousness and themselves appear as conscious states, as consciousness seems to be a natural and normal character of a person.

The *Bhg* indirectly speaks of knowledge, as seeing when it states that the soul possesses knowledge by nature (*jñānin*), but that ignorance covers or conceals it. Thus, five times in the *Bhg* it is stated that knowledge is covered or concealed (*āvṛtam*): by lust and anger[3], by one's eternal enemy lust[4], by "unknowledge" (*ajñāna*) or ignorance[5], and by darkness[6]. Light discovers what darkness covers, thus by dispelling the world's darkness. The sun enables one to see, and as such the *Bhg* twice compares knowledge in the sense of awareness to the sun; when knowledge destroys ignorance, then that knowledge, like the sun, illumines all around it[7]. Just as one single sun illumines this entire world, so the knowing soul, owner of the field representing the body, illumines the entire field with consciousness[8]. Nature's lower *guṇas* of *rajas* and *tamas* cover the soul's innate knowledge, but in contrast, the highest *guṇa* of virtue or goodness (*sattva*) permits the light of knowledge to shine, enabling one to actually see. Thus, four verses explicitly link virtue or goodness to higher knowledge: goodness, being unsullied, enlightens[9]; when all the body's gates (senses) are illumined, when there is knowledge, then one should know that goodness prospers[10]; when the converse occurs—when there is no light-, then the darkness mode prospers[11]; indeed, the light of knowledge symphonizes virtue[12] (Goswami 2015, pp. 99–100).

[3] *Bhg* 3.38.s.
[4] *Bhg* 3.39–40.
[5] *Bhg* 5.15.
[6] *Bhg* 14.9.
[7] *Bhg* 5.16.
[8] *Bhg* 13.34.
[9] *Bhg* 14:6.
[10] *Bhg* 14.11.
[11] *Bhg* 14:13.
[12] *Bhg* 14.22.

2. Ontology

Having offered this epistemological discussion, we may look deeper into the various aspects highlighting the nature of the soul or self. In general, the *Bhg* no doubt shares the vision according to which the universe is perceived as a place of constant rebirth:

> 8. 16 All the worlds, up to Brahmā's world, are subject to repeated births (Theodor 2010, p. 78).

Under Karmic laws, the soul in different bodies cycles through a universe that itself moves in endless cycles. On earth, one may observe cycles of days, night, and seasons, based on the cyclical motions of the earth, sun, moon, and other celestial bodies. The *Bhg* teaches that the entire universe, and the countless souls that populate it, move through grand cycles of cosmic creation and dissolution (Goswami 2015, p. 18). In doing that, it adopts the visions of both *Vedānta* and *Sāṅkhya* traditions by associating itself with both classical *Sāṅkhya* and the *Brahmasūtra*:

> 13. 1 The blessed Lord said: This body is known as the field, O Kaunteya, and one who knows it, is declared by the wise to be the knower of the field. 2 You should know me as the knower of the field as well, situated in all fields, O Bhārata. I deem knowledge of the field and of the knower of the field to be knowledge indeed. 3 Hear from me in summary what this field and its nature is, how it transforms and comes into being, who the knower of the field is, and what his powers are. 4 Seers have chanted this in many *Vedic* hymns in varied ways, as well as in the *Brahmasūtra* aphorisms, all of them authoritative and well-substantiated. 5–6 The great elements, the concept of ego, the intelligence and the unmanifest, the ten senses and the additional sense, the five sense objects, attraction and repulsion, happiness and distress, the aggregate, consciousness and inner conviction—all serve to sum up the nature of the field and its transformations (Theodor 2010, p. 103).

Apparently, the author of the *Bhg* is drawing on teachings that were current in certain philosophical schools that made the ontological distinction between a mortal body and an immortal entity functioning as the owner of the mortal body. Ownership was based upon the idea of transmigration, or rather re-embodiment, characteristic of the older *Upaniṣads* and early *Sāṃkhya* philosophy. *Upaniṣadic* ideas are recalled when death is described as a chance to acquire a new body and compared with 'weaving a new cloth' (*BĀU*[13] 4.4.5; cf. *BhG* 2.22). *Sāṃkhya* notions seem to be behind the emphasis of the transformational character of physical existence, such as the change between appearance (birth), disappearance (death), and various modifications in between (*vikāra*). This terminology is used in *Bhg* 2.25, when the immortal being is described as being the opposite of the products of nature (*prakṛti*): it is 'unmanifest' (*avyakta*), 'unthinkable' (*acintya*), 'not modifiable' (*avikārya*). Another connection with *Sāṃkhya* is established by emphasizing that death is not 'non-being' (*asat*), but only a change in appearance, because nothing that (truly) is (*sat*) can vanish into non-being (*asat*) (Malinar 2007, p. 66). As the idea of the soul or the self (*ātman, jīva*) is grounded in the *Upaniṣads*, before looking into the *Bhg*'s descriptions of the soul and the way it transmigrates from body to body, some *Upaniṣadic* sources may be quoted.

The *Chāndogya Upaniṣad* is one of the oldest and best known of the *Upaniṣads*; many important teachings are contained in it (Radhakrishnan and Moore 1989, p. 64), such as the statement:

> 7 Now, people here whose behavior is pleasant can expect to enter a pleasant womb, like that of a woman of the Brahmin, the *Kṣatriya*, or the *Vaiśya* class. But people of foul behavior can expect to enter a foul womb, like that of a dog, a pig or an outcast woman. *Chāndogya Upaniṣad* 5.10.7 (Olivelle 1996, p. 142).

[13] The *Bṛhadāraṇyaka Upaniṣad*.

The *Śvetāśvatara Upaniṣad* is one of the later *Upaniṣads*; in it, some of the ideas of the *Sāṁkhya* and *Yoga* philosophies—both of which are dualistic systems—and of *Advaita* (non-dualism) find clear expression (Radhakrishnan and Moore 1989, p. 89). The *Śvetāśvatara Upaniṣad*, 5.9. offers a somewhat physical description of the soul's size:

> When the tip of a hair is split into a hundred parts, and one of those parts further into a hundred parts, the individual soul (*jīva*), on the one hand, is the size of one such part, and, on the other, it partakes of infinity (Olivelle 1996, p. 262).

The *Kaṭha Upaniṣad* is perhaps the most philosophical of the *Upaniṣads*. Among its important features are: the dialogue between Nachiketas and Yama (the god of the world of departed spirits) on the question of the immortality of the self, in which Nachiketas chooses knowledge above all worldly blessings; the theory of the superiority of the good (*śreyas*) over the pleasant (*preyas*); the view that the *ātman* cannot be known by the senses, by reason, or by much learning, but only by intuitive insights or direct realizations; the doctrine of the body as the chariot of the self (Radhakrishnan and Moore 1989, pp. 42–43). The *Kaṭha Upaniṣad* indeed includes some important statements that later appear in a similar version in the *Bhg*:

> 2. 18 The wise one—he is not born, he does not die; he has not come from anywhere; he has not become anyone. He is unborn and eternal, primeval and everlasting. And he is not killed, when the body is killed. 19 If the killer thinks that he kills; If the killed thinks that he is killed; Both of them fail to understand. He neither kills, nor is he killed. 20 Finer than the finest, larger than the largest, is the self (*ātman*) that lies here hidden in the heart of the living being. Without desires and free from sorrow, a man perceives by the creator's grace the grandeur of the self. Sitting down, he roams afar. Lying down, he goes everywhere. The god ceaselessly exulting—Who, besides me, is able to know? 22 When he perceives this immense, all pervading self, as bodiless within bodies, as stable within unstable beings—A wise man ceases to grieve. 23 This self cannot be grasped, by teachings or by intelligence, or even by great learning. Only the man he chooses can grasp him, whose body this self chooses as his own. 24 Not a man who has not quit his evil ways; Nor a man who is not calm or composed; Nor even a man who is without a tranquil mind; could ever secure it by his mere wit. 25 For who the Brahmin and the *Kṣatriya* are both like a dish of boiled rice; and death is like the sprinkled sauce; Who truly knows where he is? (Olivelle 1996, pp. 237–38).

Upaniṣads are emphatic in their declaration that the two are one and the same. But what is the inmost essence of a human being? It seems that the term "self" itself involves some ambiguity, as it is used in a variety of senses. As such, the *Upaniṣads* deconstruct the human person into various layers, pointing at the pure self as the innermost essence of the human and apparently the non-human person. Thus, so far, one consists of the essence of food (i.e. the physical parts of men); he is called *annamaya*. But behind the sheath of this body, there is the other self that consists of the vital breath, which is called the self as vital breath (*prāṇamaya ātman*). Behind this again, there is the other self (consisting of will) called the *manomaya ātman*). This again contains within it the self "consisting of consciousness", called the *vijñānamaya ātman*. But behind it, we come to the final essence; the self as pure bliss (the *ānandamaya ātman*) (Dasgupata 2000, p. 46). As mentioned, the *Bhg* not only adopts the vision of the *Vedānta* tradition, but also the dualistic vision of *Sāṅkhya* as well. Accordingly, the world represents a mixture of the living entity with nature, or *puruṣa* and *prakṛti*. As such, there are eight elements comprising nature, and besides them exist the spirit souls:

4. 7 Earth, water, fire, air, ether, mind, intellect and ego—these eight comprise my separated lower nature. 5 But you should know that beside this lower nature, O mighty-armed one, there is another higher nature of mine, comprised of spirit souls, by which this world is sustained. (Theodor 2010, p. 70)

Having quoted some *Upaniṣadic* sources, and having pointed at the non-dual *Vedānta* vision and the dual *Sāṇkhya* vision, which both characterize the *Bhg*, we may look at this very famous section of the *Bhagavad gītā*, where Krsna begins his speech addressed to Arjuna:

2. 10 O Dhṛtarāṣṭra, between both armies, Hṛṣīkeśa smiled, and thus addressed the dejected Arjuna. 11 The blessed Lord said: while speaking words of wisdom, you lament for that which is not to be grieved for; wise are those who do not lament either for the living or for the dead. 12 Never was there a time when I did not exist, nor you, nor all these kings, nor in the future shall any of us cease to exist. 13 As childhood, youth and old age befall the soul within this body, so it comes to acquire another body; the wise one is not swayed by illusion in this matter (Theodor 2010, p. 30).

This section clearly offers the vision underlying reincarnation, which is grounded in the existence of the soul. It commences in reinforcing the vision according to which the subject is actually eternal, and moreover, describes childhood, youth and old age as bodily states befalling or occurring to the soul. It also describes the transfer from one body to another, or birth and death. What follows is a section that echoes the *Upaniṣadic* vision of the soul and its nature:

2. 16 There is no becoming of the unreal, there is no unbecoming for the real; the seers of the truth have reached both conclusions. 17 Know that to be indestructible, by which everything is pervaded; there is none who can destroy the imperishable. 18 For these bodies the end is sure, whereas that which is embodied in them, the indestructible and immeasurable soul, is said to be eternal. Therefore, O Bhārata, fight! 19 He who deems the soul is the slayer, and he who thinks the soul is slain—both of them do not know, for the soul slays not nor is it slain. 20 The soul is never born, nor does it ever die; nor having come into existence, will it ever cease to be. Unborn, eternal, unending and primeval—it is not killed when the body is killed. 21 The person who knows the soul as eternally imperishable, that it was not born and is indestructible—whom does he kill? Whom does he cause to kill? 22 As one, having cast aside his old and worn garments, takes on other new ones, so the embodied soul, having cast aside its worn and old bodies, takes on other new ones. 23 Weapons do not pierce it, fire does not burn it, water does not wet it and wind does not parch it. 24 The soul cannot be cut, it cannot be burned, it cannot be wetted or dried indeed, for it is eternal, all pervading, stable, fixed and primeval. 25 It is said that the soul is not manifested, it is inconceivable and beyond transformation; therefore, having understood the matter in that way, you should not grieve. 26 Moreover, if you assume that it is continually born or continually dies, you still have no reason to lament, O mighty warrior. 27 Death is inevitable for all that is born, and inevitable is rebirth for the dead; therefore, you should not grieve over the inevitable. 28 Beings are not manifested in their beginnings, are manifest as they continue to exist, and not manifested at their end; therefore, O Bhārata, why lament about it? 29 For someone to see it is a wonder, for someone else to speak of it is a wonder, for another to hear of it is a wonder, and even having heard of it, no one understands. 30 The soul within everyone's body is beyond destruction; therefore, you should not mourn for any living being.

This is indeed a classic section: the nature of the soul is implicitly contrasted with that of the body; the soul is eternal and primeval, it is not subjected to birth nor to death, it changes bodies just as one changes garments, it is wondrous, difficult to comprehend, permanent, and unchanging. As opposed to the soul, which cannot be harmed by fire, water, or weapons, the body is transient and mortal by

nature. The sharp distinction between the body and the soul is also expressed through terming the soul 'the body's owner', an expression that hints at a situation in which the owner exists in a bodiless state, i.e., the state of immortality or liberation. Having described the nature of the soul, the *Bhg* describes the process of transmigration from one body to another. This process apparently is centered around the mind,[14] which carries the soul to its next body, according to its focus and contents:

> 15. 7 The eternal soul existing in this world of souls is indeed my fragment; it draws towards itself the six senses including the mind, which are all rooted in material nature. 8 When accepting a body or when relinquishing it, the prevailing soul carries along with it the six senses, just as air carries fragrances from their sources. 9 Through hearing, sight, touch, taste and smell, as well as the mind, it experiences the sense objects. 10 At times it remains within the body, at times it departs from it and at other times it takes pleasure under the *guṇas'* spell; the deluded cannot see all this, but rather those who possess the sight of knowledge. 11 The striving *yogīs* see it as situated in the self; however, the mindless who have not achieved self-realization, will not see this however they strive to (Theodor 2010, p. 118).

The six senses gather around the soul and accompany it in its journey through *saṃsāra*; it seems that the physical form is shaped around and based on the subtle form, as when the soul migrates from one body to another, and the accompanying senses shape the new body. The soul then experiences the world through the senses that perceive their objects, while the pleasure it derives from the world depends upon the *guṇas*. This vision is somewhat mystical, and as such is not open to all; only self-restrained *yogīs* can attain it, whereas others, presumably those who are under the lower *guṇas*, are unable to see all this. Having offered a description of the soul, we may now turn to the paper's third part, which looks at the ethics derived from the vision of rebirth.

3. Ethics

The vision of rebirth naturally entails a unique set of values. If indeed there is no rebirth, and life, particularly human life, is a single and onetime event, then thriving for prosperity and pursuing humanistic values would be natural. Alternatively, if this life is but a chapter in the ongoing experience of rebirth, and moreover, if this life is perceived as a chance to break the chain of rebirth, then the corresponding set of values may be different altogether. In this regard writes Joel Kupperman:

> Bearing this in mind, we can ask just what Arjuna will be doing if he kills his relatives. In our ordinary way of looking at things, this is first and foremost his bringing about loss of life . . . In a culture that takes reincarnation entirely for granted, though, there will have to be a different ordinary way of looking at things. Generally speaking, Kṛṣṇa reminds Arjuna, to die is to enter a new life. The relatives that Arjuna is about to kill will live again. Therefore, to kill them is not in fact, to deprive them of life. How, then, can it involve harming them? This metaphysical reflection may seem to lead to an ethics of profound indifference, although in fact, it does not (Kupperman 2001, p. 45).

As Kupperman rightly observes, according the *Bhg*, the idea of death does not in fact exist; moreover, the idea that this life is but a single chapter in the sequence of lives naturally leads to what he terms "ethics of profound indifference". A famous section presents these ethics, which may also be termed "ethics of enlightenment"; Gandhi considered this section to be the "essence of the *gītā*"[15]:

[14] *Manas.*
[15] The full section considered by Gandhi to comprise the essence of the *Bhg* is verses 2. 54–72.

54 Arjuna asked: He who is established in steady enlightenment, and situated in *samādhi*, O Keśava—How can he be described? That enlightened one—how does he speak? How does he sit, and how does he walk? 55 The Blessed Lord said: When he forsakes all desires arising from the mind, becomes satisfied in the self and by the self alone, then he is said to have attained steady enlightenment. 56 One not agitated despite all kinds of distress, whose aspiration for happiness is gone, and who is devoid of passion, fear and anger—such a sage is said to have attained steady enlightenment. 57 He who is not attracted to anything, and having attained this or that, good or bad, does not rejoice but is not averse either—his wisdom is firmly established. 58 When one is able to withdraw his senses away from their objects under any circumstance, just as a tortoise withdraws its limbs into the shell—his wisdom is firmly established. 59 When the embodied abstains—the objects of the senses fade away, but the taste for them remains; however, even the taste fades away, when one attains the vision of the Supreme.

These ethics of enlightenment or knowledge of rebirth may also be characterized as the "ethics of equanimity"; in other words, one who is established in steady enlightenment is not agitated in time of distress, has no aspirations for happiness, and is able to withdraw his senses away from their objects, just as a tortoise withdraws its limbs into the shell. The path of knowledge might at first glance appear easy, as it calls for awakening and self-realization. However, the path of knowledge is a steep path associated with the ascetic renunciation of action and rigorous, disciplined meditation; it is by and large neither practical nor accessible to the average person (Lobel 2011, p. 92). Right from the beginning, along with the preliminary exposition of the existence of the *ātman*, the corresponding ethics of equanimity are presented. Accordingly, the ethical outcome of *ātman* realization is indifference toward sensual pleasures, and steadiness in both happiness and distress:

2. 14 Heat, cold, happiness and distress—sensual perception alone produces them all, and it is impermanent, coming and going; you should seek to endure them, O Bhārata. 15 The wise one whom these do not disturb, who thus remains even tempered in both happiness and distress, is fit for immortality, O bull among men.

However, the *Bhg* does not only further ethics of equanimity and indifference; it is known also as a gospel of action. The type of action it furthers is an enlightened type of action or *Karma-Yoga*, a type of action grounded in the vision of rebirth. The question may be raised: how can the idea of withdrawal and detachment be reconciled with the *Bhg's* call for action? In this regard, Julius Lipner writes:

The *gītā* also confronts us with the other side of the ethic of desire, *viz. an* ethic not of withdrawal from the world (*nivṛtti*) but of active engagement with it (*pravṛtti*) through the offering up of one's everyday duties (*sva-dharma*) in devotion to the Lord (Lipner 2000, p. xi).

As such, the *Bhg* expands this to a set of virtue ethics, and lists a set of corresponding values that represent living in this world in an enlightened mode:

13. 7 Absence of pride and arrogance, nonviolence, forbearance, honesty, attendance upon the *guru*, purity, firmness, self control, 8 lack of attraction to sense objects, absence of ego-notion, visioning the distress and evil of birth, death, old age and disease, 9 detachment, aloofness from sons, wife, home and the like, constant equanimity toward desired and undesired events, 10 single-minded devotion to me supported by *yoga*, preferring of solitary places and avoiding the crowds, 11 constantly contemplating knowledge of the self, envisioning the purpose of knowledge concerned with the truth—all these are declared knowledge, whereas all else is ignorance (Theodor 2010, p. 104).

This list of values is presented in reply to Arjuna's request to know about knowledge, and may be termed "supportive ethical values", as they support knowledge of rebirth. Interestingly, in his reply, Kṛṣṇa does not address the question directly; rather, he presents this list of qualities. These represent

knowledge, while their absence signifies the absence of knowledge or ignorance. In other words, the underlying logic is that the consequence of possessing knowledge of rebirth is manifesting the qualities listed. The type of knowledge under discussion is not quantitative, intellectual, or encyclopedic knowledge; rather, it is knowledge of a different sort, intuitive or perhaps even mystical, acquired through inner transformation. The values described may be termed "supportive"; they are necessary for maintaining the vision of rebirth. However, adopting a wider point of view, the *Bhg* may be read as a manual of purification, to be accomplished in the midst of life (Kupperman 1999, p. 127). This purification is based upon the vision of rebirth, and the attempt to attain the state of realization of the vision through *pravṛtti,* or engagement with the world. In this regard, Diana Lobel writes:

> Action takes on a different character when this new viewpoint is adopted. We come to a new understanding of our essential identity; we realize we are not really the agent of action. Actions are affected by the three qualities (*guṇas*) of nature (*prakṛti*). It is only when we are deluded by ego-identification that we think "I am the actor"[16]. We can become the witness, rather than the doer, observing the semi-autonomous movements of nature's qualities, which we experience as human emotions: we can witness hurt, reacting to a loss; the hurt develops into sadness, and someone else's anger arises in response. However, we ourselves identify as the eternal self who is watching the qualities of nature responding to other qualities, recognizing that our true nature is deeper and separate, unaffected by the qualities of nature. We lose our egocentric viewpoint and assume the viewpoint of the eternal Self within. We now act purely for the sake of *dharma* in both its senses: we fulfill our sacred, social duty and uphold the world order and ritual cosmos (Lobel 2017, pp. 130–31).

This description perhaps captures the essence of the *Bhg's* ethics, which may also be termed an "ethics of enlightened action"; these are grounded in the knowledge of rebirth and take the form of an ethical ladder, or a ladder of action grounded in duty or *dharma*. This ethical ladder is transformational and composed of various stages that enable one to rise from one stage to another while undergoing transformation. As we have elaborated on this topic elsewhere (Theodor 2010, pp. 17–24), we may not elaborate on this here, but suffice it to say that this ethical ladder is grounded in the vision of rebirth, and that by rising up the ladder, each step or stage takes one further away from rebirth.

Conflicts of Interest: The author declares no conflict of interest.

References

Dasgupata, Surendranath. 2000. *A History of Indian Philosophy.* Delhi: Motilal Banarsidas, vol. 2.

Flood, Gavin, ed. 2003. *The Blackwell Companion to Hinduism.* Oxford: Blackwell.

Goswami, Hridayananda Das. 2015. *A Comprehensive Guide to the Bhagavad gītā.* Krishna West: Gainsville.

Kupperman, Joel J. 1999. *Learning from Asian Philosophy.* New York: Oxford University Press.

Kupperman, Joel J. 2001. *Classic Asian Philosophy: A Guide to the Essential Texts.* New York: Oxford UniversityPress.

Lipner, Julius. 2000. Prolegomena. In *The Bhagavad Gītā for Our Times.* Edited by Julius Lipner. New Delhi: Oxford University Press.

Lobel, Diana. 2011. *The Quest for God and the Good; World Philosophy as a Living Experience.* New York: Columbia University Press.

Lobel, Diana. 2017. *Philosophies of Happiness: A Comparative Introduction to the Flourishing Life.* New York: Columbia University Press.

Malinar, Angelika. 2007. *The Bhagavad gītā; Doctrines and Contexts.* Cambridge: Cambridge University Press.

Olivelle, Patrick. 1996. *Upanisads.* New York: Oxford University Press.

Pearsall, Judy, ed. 1998. *The New Oxford Dictionary of English.* Oxford: Oxford University Press.

[16] *Bhg* 3:27–28.

Radhakrishnan, Sarvepalli and Charles A. Moore, eds. 1989. *A Sourcebook in Indian Philosophy*. Princeton: Princeton University Press.

Theodor, Ithamar. 2010. *Exploring the Bhagavad gītā; Philosophy, Structure and Meaning*. Surrey: Ashgate.

Essay

One-Birth, Many-Births: A Conversation Reborn A Response to "Perspectives on Reincarnation: Hindu, Christian, and Scientific," a Thematic Issue of *Religions*

Francis X. Clooney, SJ

Harvard Divinity School, 45 Francis Avenue, Cambridge, MA 02138, USA; fclooney@hds.harvard.edu

Received: 22 June 2018; Accepted: 28 June 2018; Published: 2 July 2018

"Interrogating Rebirth: Hindu-Christian Debates and Their Contemporary Relevance" was a panel at the Dharma Association of North America (DANAM) meeting in conjunction with the American Academy of Religion Annual Meeting in November 2016. The panel contained four papers, by Nalini Bhushan, Gerald Larson, Jeffery Long, and Bradley Malkovsky, which in their finalized form appear in the current issue of *Religions*. I was the respondent to the panel.

The panel aimed at putting forth relevant and substantial materials regarding multiple births as a teaching and lived practice of Hindu tradition, and, in many of the essays, as a plausible and relevant doctrine still workable in the 21st century. As such, it succeeded in raising many of the right issues. Well before the panel occurred, I had had a conversation with Jonathan Edelmann, one of the contributors to this thematic issue of *Religions*, on the state of theology and Hindu theology in academe, and the need for scholars to take up and analyze issues of faith in terms of scripture, history, culture, reasoned argumentation, and ethical ramifications, lived and theorized. While the temptation today is to treat matters of faith as personal, even private, and hardly to be debated, we thought that we should be able to discuss the matter, even debate it. After all, what would be more worrisome than to find (as we fear may be the case) that it is almost impossible to have a sustained conversation or intelligent argument on the topic today? The impression may be given that no religious position is open to reasonable scrutiny, because none is reasoned. But it takes hard work to show that this is not the case, that as all traditions have believed, reasoning can be a valuable tool and ally in advancing the understanding of religious beliefs in a tradition, and across the boundaries of traditions.

We wanted, then, to show that with all these factors in mind, we could move forward a conversation in an academic setting that would take seriously theology across religious borders. We thought—as I recall our informal conversation—that the topic of "one birth, many births"—a double theme, since it cannot be just the latter that is interrogated—seemed an ideal topic for academic consideration, because it relates to intimate matters of death and life, is relevant to how humans see the meaning of life, tests the limits of reasoned argumentation on a difficult and subtle matter—and is, to be sure, the site of ancient and long-running controversies across religious boundaries.

I was happy then to see the 2016 panel take shape and to be asked to be respondent to it. I am all the more happy to see this journal issue take shape, enriched by the papers of the original authors and now with ten more papers, and to have it come out so very well. Together, these fourteen papers constitute a promissory in favor of future discussions we may now better undertake, know more, and better, about why the topic is important. Like my response at the DANAM panel, what follows is however simply a reflection on several of the issues arising in or across the essays.

(Full disclosure: Although I have been studying Hinduism for over forty years, I am a practicing Catholic, a Catholic priest, and a Jesuit. I am a one-birth believer, but not because I have been overwhelmingly convinced by the Christian apologetic arguments, nor because I disrespect toward those who believe in multiple births. Rather, in ways that will be intimated below, I hold to a one birth

view of life because of my sense of the infinite love of God manifest in Jesus Christ, more than enough to affirm the value of this life, its adequacy, and to enable people to reach perfection now. But I offer that only as context, since I turn now to the essays, in order to focus on them and the issues they raise.)

First, some of these essays simply give us a richer sense of the Hindu traditions which have believed, imagined, vividly portrayed, and explained in a rational manner multiple births as a meaningful claim on, interpretation of life. Ithamar Theodor, Steve Rosen, Chris Chapple, and Jonathan Edelman all serve us well by showing the coherence and depth in Hindu religious tradition of multiple births discourse, how people have thought, imagined, and lived out the prospect of multiple births. These essays show us that in practice arguments defending multiple births are most usefully thought of as consequent upon the living out of the multiple births view of life. The views and experiences of the people who live in accord with this belief come first, and rational explanations, for insiders or in defense against the competing views of outsiders, come later. Without it, we run the risk of abstraction, vague claims about what "they" say about multiple births, or reasons purporting to lead to faith, rather than faith prompting the finding of the reasons.

C. Nicholas Serra and Lee Irwin remind us of the complicated modern reception of multiple births, reminding us that belief in multiple births is not to be relegated to the East, or India, or the ancient Mediterranean, but has also flourished in modern times in the West. Serra draws on the example of William Butler Yeats while Irwin distinguishes and connects the many strands of the complicated American scene. It has become Western and American too, and in ways that do not simply replicate ancient Indian versions of the same. This new rebirth exploration does not mesh or conflict with Christian views according to the standard models. The old arguments do not directly and completely work against these new formulations of belief in multiple births. Indeed, Christians too need to think about one-birth and multiple births, since the latter is no longer simply what "they" believe "over there".

In this context the essays by American scholars Gerald Larson and Jeffery Long are doubly valuable, since they complement their considered arguments in favor of multiple births with some personal perspective. Larson writes into his study of the language of multiple births in Samkhya and Yoga a poignant perspective on late-life issues. His statistics on life expectancy get our attention right at the start, on the limits of life, satisfactory or not, in this world, and the need we have to find meaning in and beyond death, and thus postulating a deeper meaning for life before death. One's life is in one's own hands and by one's own deeds: Larson finds this a satisfactory view, and finds no need to turn, as Jews, Christians, Muslims, and at least some Hindus do, to a saving God. Long takes a different but still personal path, reviewing rebirth in light of his memories of his original Catholic identity and the choices he has made over many years as a Hindu. He makes his case for multiple births without entirely dismissing the Christian viewpoint known to him in his youth. Both Larson and Long are defenders of multiple births, and hold to its reasonableness, and personal meaningfulness. This makes good sense, and is a corrective to a deracinated approach which would reduce the whole matter of one-birth and many-births to sets of reasons pro and con, as if only the debating points count.

As I mentioned above, "one birth" beliefs ought not be taken for granted, as unchanging (and unyielding) and as perfectly univocal and clear. They too have complex histories, not just in apologetic contexts, but in people's lives, and as such stand in need of explanation and personal narratives of their meaning in people's lives. We must then rethink the Christian, for instance, on the model of these essays; in the longer run, many more essays will be required to take seriously and learn from how Jews, Christians, and Muslims make sense of the one birth scenario. If the essays by Serra and Irwin just mentioned help us to recast the Western and Christian context in the modern era, Colas writes from a still longer historical perspective. His case study shows the motivations behind and pitfalls in trying to untie the one birth-many births knot simply by very clear reasoning and very pointed arguments. He takes up the case of an 18th century Sanskrit translation of a Tamil-language Jesuit text originally by Robert de Nobili, the 17th century missionary in Tamil Nadu. My own research regarding the Jesuits of the 17th–18th centuries—in Japan and China, in Vietnam, in Tibet and India—suggests

that their attacks on the idea of multiple births were intended to undercut the very foundations of the religions of Asia, the religious economy of their logic. Such texts were not merely occasional pieces in the repertoire of preachers. Reading the Sanskrit translation of de Nobili closely, Colas pinpoints philosophical and linguistic choices, choices in vocabulary and in some case the invention of new analogues, all offered in the hopes of creating mutual understanding as a prelude to persuasion and possibly too refutation. The result is creative, fresh, interesting—but perhaps a failure too since, as Colas points out, the novelty of the Jesuit arguments—crammed as it were into Sanskrit terminology—made it hard or impossible for the Hindus to respond to new arguments and new implied worldviews, only seemingly couched in familiar Indian terms. Nor did European thinkers on the whole show much interest in these Jesuit versions of the attack on multiple births, if they even knew of a text such as this one. Later Jesuits, even in the 18th century, kept up the project of attacking multiple births, but with increasingly sophisticated comparative and historical sensitivities.

Nalini Bhushan reports and assesses the arguments in the 20th century debate between the famed Christian missionary and professor of philosophy, A. G. Hogg and Hindu scholar Subrahmanya Sastri. The debate circles issues of ethical import, since ttheir argument is in part about whether the multiple births doctrine enhances or hinders responsible human life in this world. Bhushan reports too the added rejoinder by S. Radhakrishnan, who argued that contrary to Hogg's critique, responsibility for the neighbor is innate to Hinduism too, and not simply a Christian value incompatible with the self-focused economy of karma. Again, we see that the argument about rebirth, as an item on the missionary agenda and as a substantive philosophical issue, ends up having to do with life in this world now, and the kind of human community we envision. How does it matters now, that we envision this to be our only life, or one of many?

Bradley Malkovsky's magisterial essay still further broadens our understanding of the Christian one birth viewpoint. He gives us an overview of Christian views regarding multiple births, noting three stages of Christian thinking on one birth and many births. First, the earliest Christians had to clarify and defend their views among great and powerful pagan majorities across the Graeco-Roman that were comfortable with the idea of multiple births. Second, the matter had a new life internal to the Church in the 12th to 14th centuries, when the Albigenses sought to reimagine Christian identity by a new calculation of purity and of how souls and bodies relate, with the corollary that many births could be desirable. This was an inner debate, which unfortunately was resolved by deadly force rather than by honest debate and shared reflection on scripture and tradition. Third, in the midst of today's increasing pluralism, Christians have to face up to issues of secularism, and the prioritization of individual personal meanings over questions about community. The essays by Serra and Irwin again come to mind here. Issues that were once simply outside the Church, or relegated to the status of unfortunate heresies, are now regaining a certain vitality within Christianity.

Writing too as a theologian, Malkovsky correctly notes how the Christian experience of God's love in Christ is the primary value at the heart of the Christian one birth worldview, rather than an embrace of the notion of eternal reward and eternal punishment. The language of hell and damnation has been central for a long time, and now is relatively easy to reject, given the spiritual and moral implausibility of an unending, eternal sentence of condemnation. Distaste for what seems a merciless model rather easily opens the way for a model that offers more chances: the death penalty and life in prison without parole, vs. limited punishment and rehab. But attention to the advantages of multiple births over the mercilessness of hell has obscured the overwhelming message of divine love most fundamental to Christian tradition (and, with different nuances, to Judaism and Islam). Christians see things in terms not of what humans fail at, over and over, but according to what God has done, finally and in deep love. If God's love is profound and abundant, then even one birth is quite sufficient. So too, one might add, the Christian belief in the resurrection of the body is relevant here. For a Christian, the body is not the problem, and escape from it is not the solution. Changing bodies turns out, from their perspective, to demean even one's current body.

But for all of this to become clearer, Christians will have to do a better job in presenting what is important in the Christian worldview. Insofar as Christian theologians can let go of the old polemics against multiple births, they will better be able to present positively and in depth the positive reasons why they are content with the prospect of one birth, despite all the very obvious imbalances and injustices of our so brief existence on earth. The arising of new voices among Christians who want to be Christian and also hold to believe in many births, needs to be attended to respectfully, but without overlooking the crucial positive reasons why most Christians have opted to find that one birth suffices.

In any case, we have, or should have, a lot to argue about, or so I hope. At the start of this response I mentioned my concern, in conversations with Edelmann, that if we can no longer argue about one birth and many births, we will find ourselves in an unhealthy situation that will turn out to be detrimental to both Hindus and Christians. Believers might then, in their silence, seem to agree with the skeptics who think that none of these religious issues can be seriously thought, much less argued. But if we believe that reason plays a role in the life of faith, then the matter is too important simply to agree politely to disagree. But arguments todau cannot be merely historical—repeats of the past or exposure of minority views in the past—nor merely by way of polemic, fueled by general ideas we have about what the others actually say in detail.

Deracinated philosophical considerations are therefore insufficient. Context therefore matters greatly, lest the issue of one birth, many births be argued by a deracinated rationality that itself is detached from the traditions it seeks to defend or offend. Ankur Barua's essay offers insightful comments on a recent debate in *Philosophy East and West* around a 2005 essay by Whitley R. P. Kaufmann, on the reasonability of the one birth position and the inadequacy of belief in multiple births. Barua notes approvingly the response to Kaufman several years later in the same journal by Monima Chadha and Nick Trakakis. Barua agrees with them on the limited value of rehearsing and assessing religious arguments on strictly rational grounds, particularly if this proceeds as a matter of logic and without taking note of the metaphysical presuppositions—for example, regarding the body, the identity of a human being, the cultural frame for our experience as human beings. The large cultural and religious context is needed to make full sense of any particular arguments put forward, and so there is no way around the hard work of reading deeply in the traditions, and getting to know people of the other tradition, if we are to make any progress in really understanding one another.

Yet we would be risking another kind of violation of responsible research and argumentation were we to ignore the data of new modes of research. The way forward must include respect for the latest scientific evidence on identity and memory, and likewise surveys, interviews and personal narratives regarding how attitudes toward one-birth and multiple-births shape attitudes toward death and the meaningfulness of life here and now. Ted Christopher's welcome essay shows us how we can bring scientific data to bear, for instance on the nitty-gritty technicalities of DNA and heritability. Science can support, clarify, and challenge religious beliefs. But the opposite is true as well, as religious wisdom regarding karma residues can provoke us to think differently about what scientists discover and propose. But as in other areas of study where science and religion converge and conflict, science is not on its own decisive since such information will be received and interpreted according to religious or non-religious dispositions that themselves need to become topics for discussion.

To conclude: this excellent set of essays merits the attention of all who wish to go deeper into the mysteries of one birth and many births. As excellent, they show themselves to be only a start, not a conclusion. The new conversation will be costly, but worth the price, since it will require much more hard reasoning and argument, *after and in the context* of the deeper involvement of religious intellectuals with one another. We need to tell our stories about this life and listen to others' stories, without being so tone-deaf as to reduce personal stories to arguing points or th emerely anecdotal. More interreligious learning will be necessary, situated in better communities that are humane, academic, and spiritual, if we will really be able usefully to debate this issue, without enmity or caricature. One birth or many, life is too precious to waste on merely repeating ourselves without actually listening.

Conflicts of Interest: The author declares no conflict of interest.

MDPI

St. Alban-Anlage 66

4052 Basel

Switzerland

Tel. +41 61 683 77 34

Fax +41 61 302 89 18

www.mdpi.com

Religions Editorial Office

E-mail: religions@mdpi.com

www.mdpi.com/journal/religions

CPSIA information can be obtained
at www.ICGtesting.com
Printed in the USA
LVHW020355210520
656047LV00004B/24

9 783038 975359